Let's Entertain
Life's Guilty Pleasures

I am not an athlete anymore; I am an entertainer. Dennis Rodman

Walker Art Center
Minneapolis

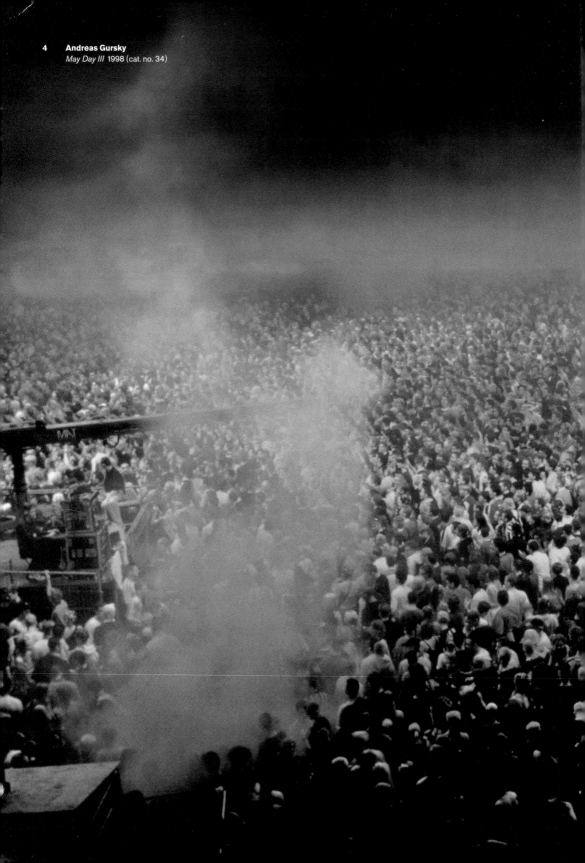

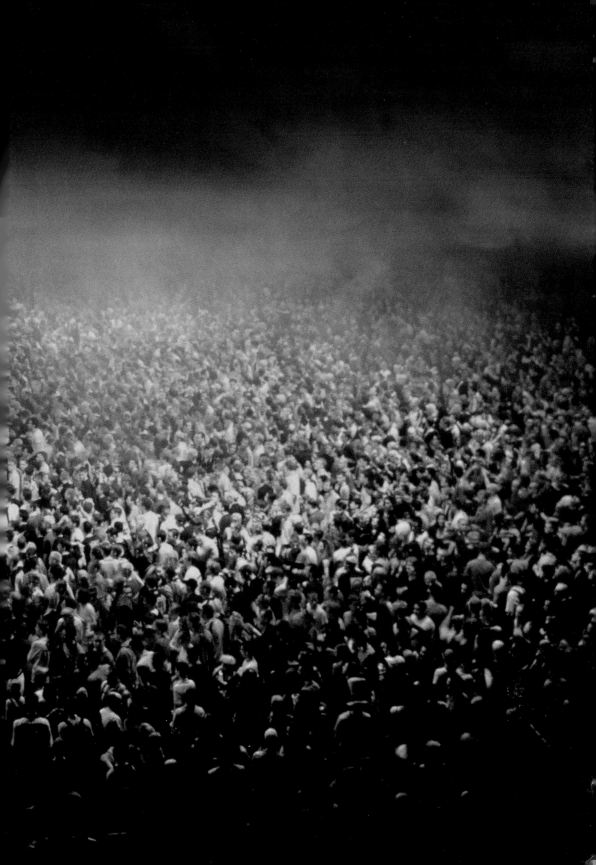

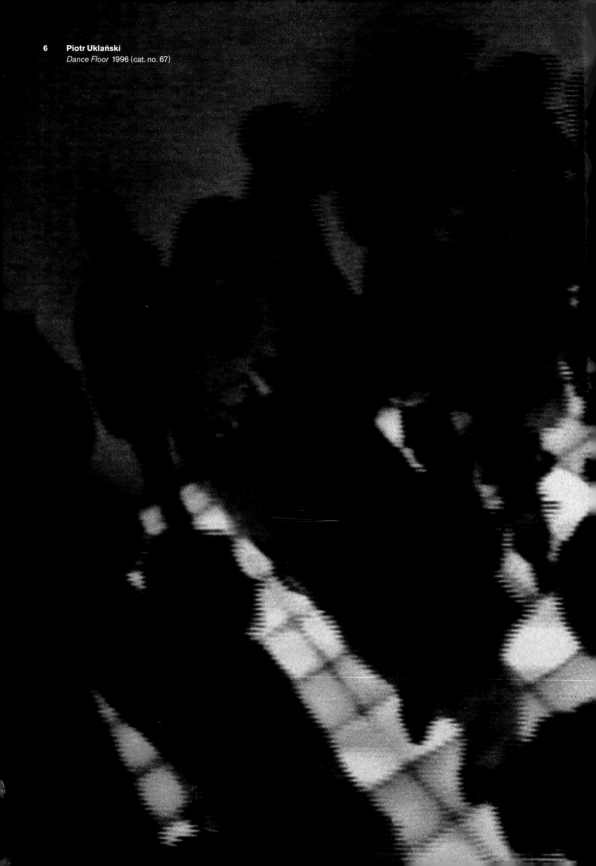

6 **Piotr Uklański**
Dance Floor 1996 (cat. no. 67)

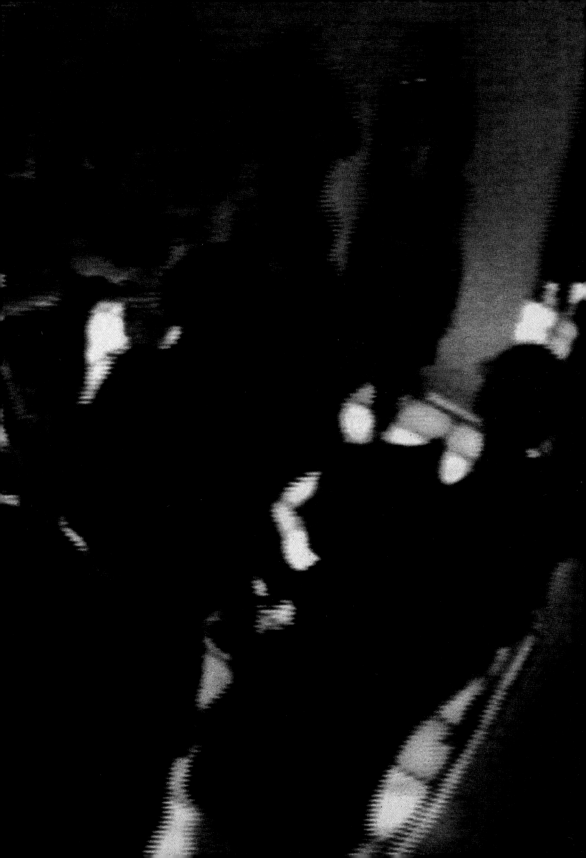

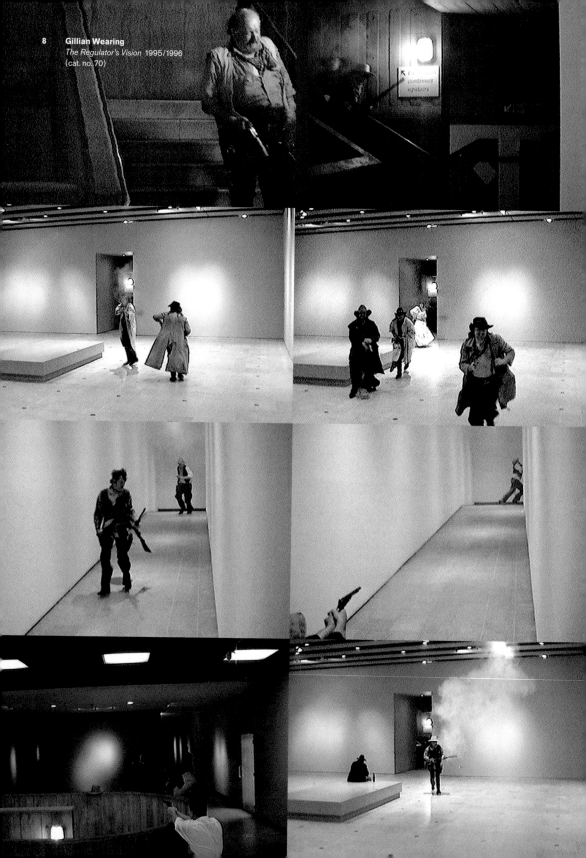

8 **Gillian Wearing**
The Regulator's Vision 1995/1996
(cat. no. 70)

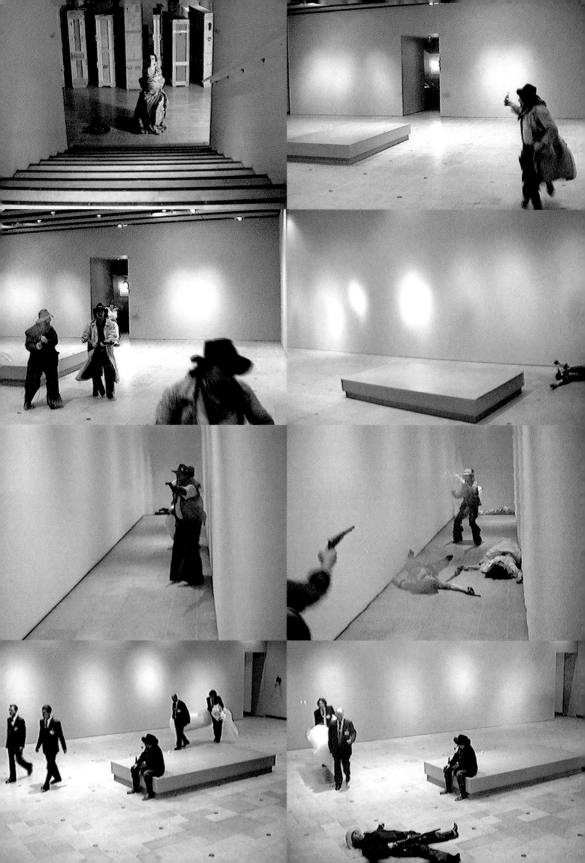

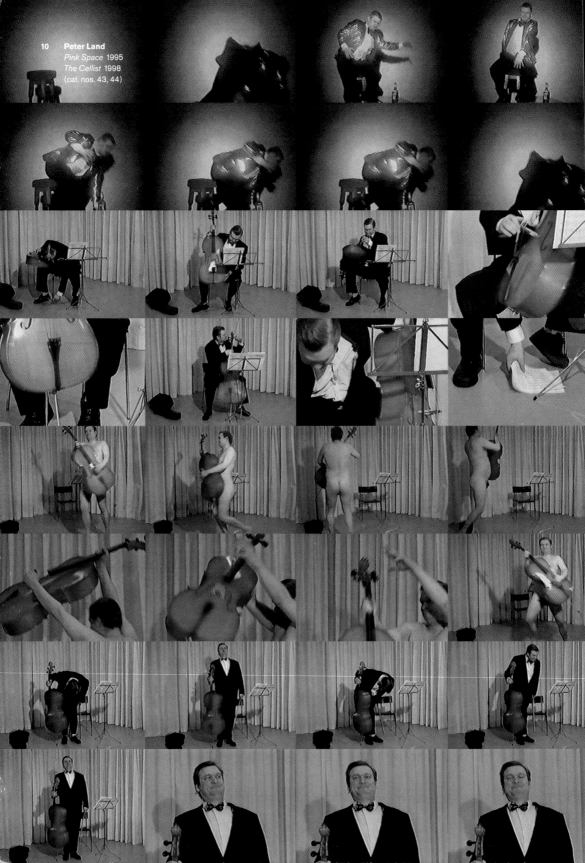

Peter Land
Pink Space 1995
The Cellist 1998
(cat. nos. 43, 44)

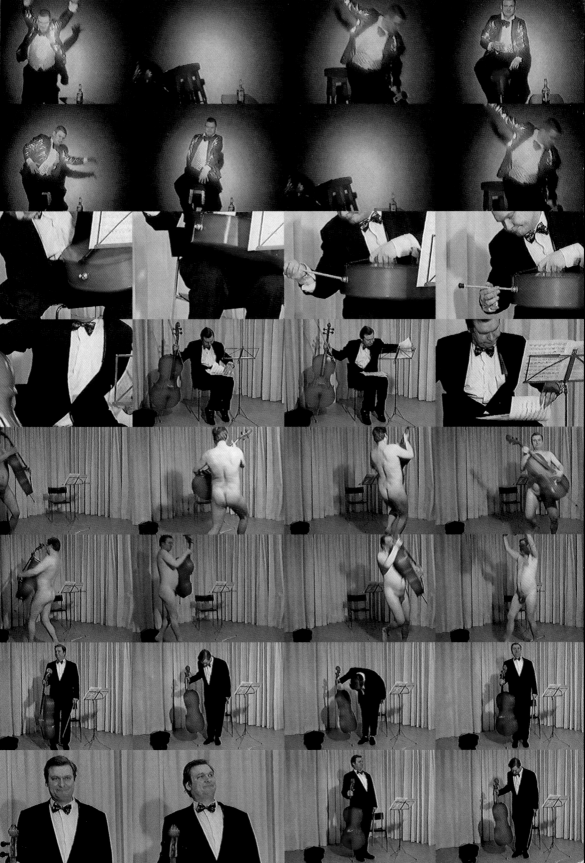

Copyright/Contents

Published on the occasion of the exhibition **Let's Entertain,** organized by Philippe Vergne for the Walker Art Center and coproduced by the Centre Georges Pompidou, Musée national d'art moderne, Paris.

Walker Art Center
Minneapolis, Minnesota / February 12 – April 30, 2000
Portland Art Museum
Portland, Oregon / July – September 2000
Musée national d'art moderne, Centre Georges Pompidou
Paris, France / November – December 2000 (presented as *Sons et lumières*)
Museo Rufino Tamayo
Mexico City, Mexico / June – August 2001
Miami Art Museum
Miami, Florida / September – November 2001

Let's Entertain is made possible by generous support from The Bush Foundation; The Andy Warhol Foundation for the Visual Arts; Gary and JoAnn Fink; PRO HELVETIA Arts Council of Switzerland; the Asian Cultural Council; Étant donnés, the French-American Fund for Contemporary Art; SamGoody.com; Gallery Shimada; the British Council; Mondriaan Foundation Amsterdam for the advancement of the visual arts, design, and museums; and Tate Access Floors, Inc.

The exhibition catalogue is made possible in part by a grant from the Andrew W. Mellon Foundation in support of Walker Art Center publications.

Art Entertainment Network is made possible by generous support from Aveus.

Major support for Walker Art Center programs is provided by the Minnesota State Arts Board through an appropriation by the Minnesota State Legislature, The Bush Foundation, the Doris Duke Charitable Foundation through the Doris Duke Fund for Jazz and Dance and the Doris Duke Performing Arts Endowment Fund, The Pew Charitable Trusts, the Dayton Hudson Foundation on behalf of Dayton's, Mervyn's California, and Target Stores, The McKnight Foundation, General Mills Foundation, Coldwell Banker Burnet, the Institute of Museum and Library Services, the National Endowment for the Arts, American Express Minnesota Philanthropic Program on behalf of American Express Financial Advisors Inc. and American Express Travel Services Co., Honeywell Foundation, The Cargill Foundation, The Regis Foundation, Star Tribune, The St. Paul Companies, Inc., U.S. Bank, and the members of the Walker Art Center.

Northwest Airlines, Inc. is the official airline of the Walker Art Center.

Designers Andrew Blauvelt and Santiago Piedrafita
Editor Karen Jacobson
Copy Editors Pamela Johnson and Kathleen McLean
Publication Manager Michelle Piranio
Curatorial Assistant Olukemi Ilesanmi

Printed and bound in Germany by Cantz.

Available through D.A.P./Distributed Art Publishers 155 Sixth Avenue, 2nd floor, New York, NY 10013.

Library of Congress Cataloging-in-Publication Data not available at time of publication.
ISBN 0-935640-66-5

Note: Catalogue numbers (cat. no.) refer to the checklist on page 296.

Contributors

Dike Blair is an artist and writer who lives in New York City. Since the early 1990s he has been writing about art and a variety of other topics, including science fiction, architecture, industrial design, robotics, comics, and computer games. His articles and interviews have appeared in magazines such as *ArtByte*, *Flash Art*, and *Purple*. He also teaches painting at the Rhode Island School of Design.

Akiko Busch has written about architecture, design, and crafts for publications such as the *New York Times*, *ID*, and *Wallpaper*. She also serves as a contributing editor of *House & Garden* and *Metropolis* magazines. In 1998 she was guest curator of the exhibition *Design for Sports: The Cult of Performance* at the Cooper-Hewitt National Design Museum in New York. She is the author of several books on architecture and design, including, most recently, *Geography of Home: Writings on Where We Live*.

Susan G. Davis is a professor in the Department of Communication at the University of California, San Diego. She held a Guggenheim Fellowship in 1991–1992. She is the author of *Paradise and Power: Street Theatre in Nineteenth-Century Philadelphia* and *Spectacular Nature: Corporate Culture and the Sea World Experience*.

Steve Dietz is the founding director of new media initiatives at the Walker Art Center and curator of the Walker's online "Gallery 9." He co-organized the series of online exhibitions and discussions entitled *Shock of the View: Artists, Audiences, and Museums in the Digital Age* and co-initiated the award-winning educational site ArtsConnectEd in collaboration with The Minneapolis Institute of Arts. In 1998 he curated the online exhibition *Beyond Interface: net art and Art on the Net*, which received a Web100 award from the American Center for Design. He curated the *Art Entertainment Network* online exhibition for *Let's Entertain*.

Emma Duncan is currently the media editor of the *Economist*. She began her career at Independent Television News, the news service for commercial television in Great Britain, and later moved to the *Economist*, where she initially focused on Asia. She spent two years in Delhi reporting on the Indian subcontinent and wrote the book *Breaking the Curfew: A Political Journey through Pakistan*. She then moved to the business side of the magazine and has been covering media, including the Internet, for two years.

Joshua Gamson is assistant professor of sociology at Yale University. He is the author of *Freaks Talk Back: Tabloid Talk Shows and Sexual Nonconformity* and *Claims to Fame: Celebrity in Contemporary America*.

Olukemi Ilesanmi, curatorial intern of visual arts at the Walker Art Center, provided curatorial assistance for *Let's Entertain*. A 1998 graduate of Smith College, she has assisted on several Walker projects, including the exhibitions *Unfinished History* and *Edward Ruscha: Editions 1959–1999*, and the 1998–1999 residency of Glenn Ligon.

Mike Kelley is a Los Angeles–based multidisciplinary artist with a background in performance. His contribution to this volume, a poster offering an incisive but slightly absurd response to the industry of celebrity, reflects the satirical aspect of his work.

Pierre Lévy is a professor in the Department of Communication and Leisure at the University of Quebec at Trois Rivières (UQTR). He is the author of *Becoming Virtual: Reality in the Digital Age*, *Collective Intelligence: Mankind's Emerging World in Cyberspace*, and *Cyberculture: Rapport au Conseil de l'Europe* (planned publication in English by the University of Minnesota Press).

Greil Marcus is the author of *Invisible Republic: Bob Dylan's Basement Tapes*, *Lipstick Traces: A Secret History of the Twentieth Century*, *Mystery Train: Images of America in Rock 'n' Roll Music*, and *The Dustbin of History*. He contributed an essay to the catalogue for *The Architecture of Reassurance: Designing the Disney Theme Parks*, an exhibition that traveled to the Walker Art Center in 1997, and in 1998 he curated the exhibition *1948* at the Whitney Museum of American Art in New York. He lives in Berkeley, California.

Neil Postman is Paulette Goddard Chair of Media Ecology, chair of the Department of Culture and Communication at New York University, and founder of its program in media ecology. He has written several books, including *Amusing Ourselves to Death: Public Discourse in the Age of Show Business*, *How to Watch TV News*, *The Disappearance of Childhood*, and *Building a Bridge to the 18th Century: How the Past Can Improve Our Future*.

Richard Shusterman is professor and chair of the Department of Philosophy at Temple University, Philadelphia, and program director at the College International de Philosophie, Paris. He is author of *Pragmatist Aesthetics: Living Beauty, Rethinking Art*, *T. S. Eliot and the Philosophy of Criticism*, and *Practicing Philosophy: Pragmatism and the Philosophical Life*. He has also served as the editor of several collections, including, most recently, *Bourdieu: A Critical Reader*. In addition to his philosophical articles, he has written articles for the *Nation* and an essay on the work of Rosemarie Trockel and Carsten Hoeller for *Politics, Poetics: documenta X, the Book*.

Philippe Vergne is curator of visual arts at the Walker Art Center and organizer of the exhibition *Let's Entertain*. Prior to coming to the Walker in 1997, he was director of the Galeries Contemporaines des Musées de Marseille (MAC) from 1994 to 1997. His recent publications include the exhibition catalogue for *Art Performs Life: Merce Cunningham/Meredith Monk/Bill T. Jones* and *L'art au corps*.

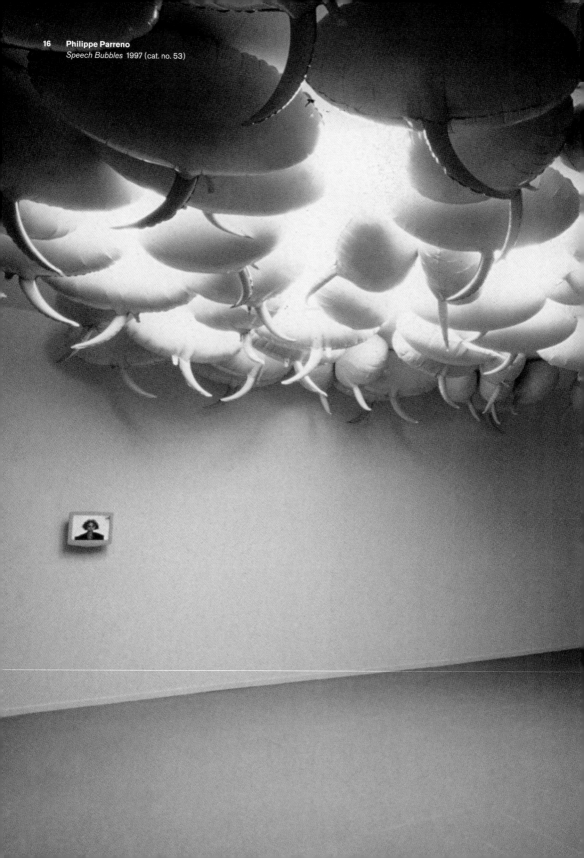

Conversation

January 30, 1999—Rainforest Cafe, Mall of America, Minneapolis. The simulated storm has ended. The animatronic animals are coming out of the bushes, and an electric rainbow is coming out of the fake rain. Soon a gorilla will run out of a plaster cavern pounding its chest, not even startling the customers. The staff seem to have stepped out of a movie like *The African Queen* or *Out of Africa*, but our waitress does not look like Katharine Hepburn or Meryl Streep. Nobody is sweating, everything is scheduled, everything is safe, and you can't smoke. The sound effects are so loud that you can barely speak with your companion. The whole place kills the idea of a conversation, or perhaps one goes there because conversation as a social art is already dead. At a small table between a large translucent aquarium and a screaming parrot, Olukemi Ilesanmi and Philippe Vergne of the Walker Art Center are talking. The food seems correct and the drinks colorful. Both are animated. Someone would have to come closer to hear a discussion about entertainment…

Philippe Vergne: It seems fitting that we are starting our conversation at the Mall of America. Founded in 1992 in Minneapolis, it is one of the largest, if not *the* largest, shopping and entertainment complexes in the world, and America's most-visited destination.[1] It is five times as big as Red Square in Moscow and twenty times larger than Saint Peter's Basilica, and it has been described as "monolithic and imposing in the manner of a walled city." It has "the disturbing magnetism of a mirage."[2] I can't think of a better place to contemplate the relationship of entertainment and art.

Olukemi Ilesanmi: Minnesota, after all, is the home of Duane Hanson, the Coen brothers, the Artist Formerly Known as Prince, and the first indoor mall—a lethal combination. Let's talk about how this exhibition started. Did living in the city of *the* mall help bring it about?

PV: I first began to think about this exhibition while I still lived in Europe, before coming to the Walker Art Center. But in a way it is related to the Walker because the Fluxus exhibition that the museum produced in 1993 intrigued me, particularly the idea that the Fluxus artists tried to merge art and amusement. I was especially interested in Henry Flynt and his demonstration against "Serious Culture"[3] as well as the lecture "From Culture to Veramusement," in which he railed about human "suffering caused by serious cultural snobbery" while standing before a large picture of the Russian poet Vladimir Mayakovsky as the audience was ushered into the room by first stepping on a print of the *Mona Lisa* that served as a doormat. I was particularly interested in the Fluxus movement because the artists used trickery rather than seduction to engage their audience. When you look at the history of Fluxus, you notice that very often they used the structure of existing forms of spectacle, like theater and concerts, but twisted them into something else. People like Dick Higgins and Ben Vautier would rent theaters and advertise something like a concert, but instead they would do performances that involved throwing water on people or breaking violins, torturing pianos and audiences. They were using the lure of traditional entertainment to produce a project that was about changing or destroying the norm.

OI: Well, they certainly tried to break the audience out of any complacency they may have felt about life or art. Dada, of course, preceded this Fluxus impulse by several decades.

PV: One of the best moments in the history of our century was, for me, when Dada artists started using art and performance to protest the brutality of World War I and to critique standard ideas about art. Cabaret Voltaire in Zürich changed the whole history of art. Dada and Fluxus were earlier investigations into issues of pleasure, entertainment, amusement, and art as well as political awareness.

OI: So much of that work was about knocking the audience into a totally new and different space, so that they were even moved to attack the artists, so repulsed and provoked were they.

PV: It was provocative and also quite deceptive to tease audience expectations, to use the audience's expectations to make them think or to lead them to another place. I also don't want to forget Surrealism, as I don't think you can look at Salvador Dalí without thinking of the idea of entertainment and the entertainer. I remember when I was a kid, the first time I encountered an artist, and maybe one of the first times I encountered art, was a TV ad for chocolate featuring Dalí, funny mustache and all. He was a talking head on television, saying in his very peculiar accent: "*Je suis fou du chocolat Lanvin*" (I am

crazy for Lanvin chocolate). But we can also go back to Edouard Manet and Edgar Degas in the nineteenth century to see how the idea of modern art was linked to cabaret and entertainment even before Dada. In his paintings Degas tried to reflect the idea of electric lighting in cabarets, and Manet, with *Olympia*, showed the sleazier side of entertainment to an unsuspecting audience.

Getting back to Fluxus, the artist Ben Vautier recently told me why he has been doing Fluxus performance featuring hip-hop music. He hires a band, and as they perform, he reinterprets well-known Fluxus performances of the 1960s and 1970s. I asked him why he was interested in hip-hop given the generation gap between him and the musicians, and he told me that young people don't care about Fluxus, don't know anything about this movement. He thought that they should, so he decided to link his art practice to something they know, a language they are familiar with, the language of rap music. Through the music they like, the music they know, they could be led to another kind of knowledge, which is art-related. Another reason might be that new popular music has embodied social and political protests, which were traditionally led by avant-garde artists.

This reminds me of an early piece by Philippe Parreno. In 1994, during the inauguration of a museum in France [the Galeries Contemporaines des Musées de Marseille (MAC)], he hired a very famous impersonator to deliver an inauguration speech ten minutes before an official political representative, the authentic inauguration speaker, arrived to do the very same thing. Of course, the audience recognized that this was theater and yet was totally enamored of this impersonator, who read a text written by Parreno and generally imitated a politician.

OI: And the politician knew nothing about this opening act?

PV: Exactly, so when he arrived ten minutes later for the official proceedings, the audience was kind of bored, because for them the real inauguration was the spectacle and it had already taken place. The real politician became not the bad copy, but the false copy of what happened ten minutes earlier. And that's typical of the way that artists of this generation are totally appropriating structures or events that people encounter on an everyday basis, and it's often things related to systems of pleasure.

OI: Certainly some of what artists today are tapping into is the reality of the media-savvy consumer. Parreno's performance, hiring this impersonator, would not have worked if the audience wasn't able to understand that politics is performance and that the performance of the actor was no less real than that of the official politician. There's this kind of fictive continuum on which they both fit, yet the politician is not allowed to acknowledge this publicly. The audience is bound by no such rules. To get around in our heavily mediated and media-saturated world, they have to be able to read the signs, to sort out questions of performance versus authenticity.

Of course, here in Minnesota our governor is the flashy ex-wrestler and maverick politician Jesse Ventura. He really tickled voters, especially young ones, with his ads featuring an action doll based on himself beating up his opponents. A big part of his appeal is the theatricality of his past life as wrestler and outrageous talk-show host, and he brings the same energy to his governorship. He seamlessly merges politics and entertainment in the most candid way. He was elected by an incredibly young, media-friendly crowd. Ventura's expertise at handling the media and his realization of how politics could segue with his earlier life were his keys to victory. It was fascinating to watch it all happen.

PV: Watching him at his inauguration celebration a few weeks later was even better. He had a "People's Celebration" at the Target Center stadium and arrived wearing a headband, fringed leather jacket, and Jimi Hendrix T-shirt. He was using all the codes of youth and rock-and-roll-culture—obviously to seduce, but also to cultivate a certain image. It also relates very much to Alexandre Périgot's *Fanclubbing* (pp. 170–171). This work is about how image, music, and clothing are strong means of rupture, self-identification, and protest for teenagers. Through these cultural readymades one can access and appropriate a larger self-concept.

OI: It's about branding to a certain extent. It's about expert packaging as well as abduction of language codes.

PV: If you relate that to the exhibition, it is why we were so interested in having writings by Neil Postman and Joshua Gamson that deal with the modern-day phenomena of celebrity, self-identity, and politics. Postman is represented in this book by an early text inspired by Ronald Reagan, the actor who played a president, his last and most magnificent role. Is that merging of art and life? And now we have Bill Clinton as the president who is constantly acting and using the tools of the celebrity industry. This parallel to the political world is not really new but may be becoming beyond control lately. In a way the audience for politics has been converted into an audience for celebrity. Parreno's inaugural speech performance piece is really about what Gamson identified as a "severe alienation from the democratic process."[4]

OI: It's about branding to a certain extent. It's about expert packaging as well as abduction of language codes.

Finally, both Postman and Gamson are analyzing what Herbert Marcuse was anticipating when he wrote in 1964, "If the language of politics tends to become that of advertising, thereby bridging the gap between two formerly very different realms of society, then this tendency seems to express the degree to which domination and administration have ceased to be a separate and independent function in the technological society…. But their domination has been incorporated into the daily performances and relaxation of the citizens and the 'symbols' of politics are also those of business, commerce, and fun."[5] More than thirty years after this statement, how do we deal with what is the only existing reality? What are our options? Punk? Despair? Cynicism? Hiding from the world? Becoming the Unabomber?

OI: This is probably a good time to ask how you define the word "entertainment." What is it that you're thinking of, and why did entertainment become the overarching theme of this show? Why not spectacle or amusement?

PV: It was very pragmatic at the beginning. An early inspiration for the title of the exhibition came from an American cartoonist popular in France, Tex Avery. His cartoons are very critical of gender and race issues; they are mean but hilarious in a Simpsons kind of way. He always used the line "let's entertain." I think it would be interesting to examine why his work is not as popular in America as it is in Europe.

But to go back to "entertainment," I like it as an organizing rubric instead of "spectacle"

because spectacle would lead to something too precise, too linked to the stage, like the circus or Fellini, almost nostalgic. The idea of entertainment gives a broader scope because it can include media, music, games, and fashion as well as retail architecture, restaurants, and technology.

OI: The Latin roots of the word entertain are *inter*, which is "among," and *tenere,* which is "to hold."

PV: Well, the Oxford dictionary defines "entertain" as "to hold the attention of, pleasantly or agreeably"; "to divert, amuse." So for me it's the best way to describe what's happening in everyday life. We are more and more involved in fictions that are built beyond us, which may trap or contain us or try to make us think about something else. It is no secret why amusement parks became so big, why theme restaurants became so big. I recently read a book by Jacques Portes, a French historian, about the history of mass culture in

PV: Of course, one of the ideas of the project is the impossibility of looking at our society of spectacle from the outside. Our position of response or critique is always immanent, never outside the structure. I think this affects art practice.

America and the cultural switch from spectacle to larger entertainment.[6] America moved from Buffalo Bill extravaganzas, twisted Shakespeare performances, and vaudeville at the turn of the century to the dominance of movie culture in this century. Hollywood, of course, became the world's major international entertainment industry starting in the 1930s. Movie theaters were developed in busy districts of cities, and moviegoing became one of people's most popular activities. It was about escapism and fantasy for working-class citizens.

OI: I'm interested in how entertainment has become so diffuse because it is such an inevitable and pedestrian part of our lives. A recent book refers to the United States as the "Republic of Entertainment" because you can't escape its reach in politics, in advertising, in the mall, or even in death, when you think of JonBenet Ramsey or John F. Kennedy Jr.[7] It becomes a circular track where we all want to escape into entertainment as fantasy, but then our supposedly ordinary lives become part of the entertainment as well. There's this complete blurring of the line between the two.

PV: I am not very comfortable commenting on this phenomenon, what Neal Gabler calls "dementia Americana." First, a curator is not a sociologist or an economist; I think that the writers we invited to participate in this book are more qualified to do that. Second, I don't want to be moralistic about our subject. Third, the idea of this project came from looking at art and speaking with artists, and I don't want to overinterpret their works with my curatorial babble. And, last, I believe this exhibition is about contemporary art practice and not just a commentary on a particular theme.

Of course, one of the ideas of the project is the impossibility of looking at our society of spectacle from the outside. Our position of response or critique is always immanent, never

outside the structure. I think this affects art practice. This generation of artists—Douglas Gordon, Maurizio Cattelan, Pierre Huyghe, Mariko Mori, Takashi Murakami, Mathieu Briand—recognize that, like it or not, we're all a part of this republic of entertainment. It doesn't mean that we're not critical, but it's too easy to denounce entertainment and yet continue to buy Nike shoes. We're all still part of the system. Philippe Parreno refers to the "aesthetic of alliance" as a way to fight against or be critical *within* the system, in a constructive way. This concept also recognizes that when a significant part of the population is attracted to something, there is likely something to be learned from that. A seminal book on vernacular architecture and signage, *Learning from Las Vegas*,[8] demonstrated that almost thirty years ago. We still have much to learn in terms of exhibition, in terms of art practice, from what these people in the larger entertainment industry are putting together. This idea is not about populism, but if art is to engage an audience in this day and age, it behooves us to look at how the entertainment industry relates to its audience. Maybe we should start with what really gives people pleasure. But then one needs to define what pleasure is, and I would refer to Richard Shusterman's essay in this book.

OI: Well, that's a good segue into the fine points of learning from the leisure industry, which both seduces and satisfies the general population—the same public that museums are in the business of serving. What kinds of lessons on being "customer-savvy" and providing a pleasurable experience can museums learn from Disney or the Mall of America? Where does the museum fit in this larger cultural and experiential system?

PV: I don't have a simple answer, but your question is very legitimate. I remember when EuroDisney opened, in 1992, I never went because I was thinking, "It's not for me, I don't want to give credit to that." But then in 1997 the Walker hosted the exhibition *The Architecture of Reassurance*,[9] an analysis of how the architecture and city plans of Disney were initially conceived and have since influenced the larger culture. While working on that show, I visited Disneyland for the first time.

At the beginning I was a little arrogant, saying, "Oh, yes, this is stupid" or "I don't want to be part of this." But by the end, when I was in Space Mountain, I was totally seduced. I began to be a part of it because I was fascinated by the skill, by the visual seductiveness of it all. And at the same time I was scared because, as someone in the field of visual culture, how could I propose an alternative to that? Although I think it's a question that many artists are asking today as well, my first thought was about being within a cultural institution. How could we provide an experience in a museum setting that is not a gimmicky, controlled experience, but open-ended, challenging, thoroughly engaging, *and* pleasurable for our audience?

In terms of public space, there are simply not many options in cities today. In a city such as Minneapolis, one can wonder, where is the plaza, the center for public meeting and enjoyment? Susan Davis' essay for this book addresses how public space across the country has become commercialized, so that even a trip to Nike Town becomes a multisensory experience with the end goal of reinforcing brand image and making a sale.

OI: Museums have become one of the few alternative, noncommercial sites still open to all—all who can pay the admission price, that is. Referring back to the aesthetic of alliance, however, the museum cannot ignore its larger environment, one fed on mass culture and amusement. The nineties way is to expect some kind of all-immersive

Disneyesque experience at all times. Of course, the museum must enter this terrain to remain viable and relevant, but that should not mean giving up a constructively critical stance. Shusterman writes about pleasure as taboo in art. There was a time when pleasure and art were not mutually exclusive, but in the last century of secular modernism we've come to the point where pleasure has become a guilty experience in an art setting. How do we bridge that gap between reality, desire, and custom?

PV: That is very complex to answer because the idea is not to be populist, which is politically questionable. For instance, in ancient Rome citizens were given bread and circuses to keep them quiet. When you look at the way people behave in public spaces such as malls or theme parks, it's about comfort, gratification, and indulgence more than about transcendence and contemplation. One can also say that we are facing a totalitarianism that is not literally suppressing freedom of speech or thought but is reducing the faculty of choice and self-determination via the means of leisure and amusement. The audience is captivated by what they see, what they watch, what they wear, what they eat, what they smell. It is a smooth totalitarianism, offering nothing but escape.

OI: How do we leave room for audiences to come up with their own ideas, their own dreams of what entertainment is, what a museum is, and how the works we've chosen for this exhibition either do or don't tell a story?

PV: I think that we have two issues here. One is the idea of pleasure in the arts. The other is whether pleasure exists within an artwork whose ambition it is to tell the audience something critical about the world. It is similar to the way Bertolt Brecht questioned theater and its ability to represent the contemporary world. According to his analysis, this is possible thanks to the "estrangement effect," which breaks down pure representation and involves a critical dimension. But Brecht recognized that theater is pleasure and entertainment and that, therefore, entertainment does not exclude thinking and studying. This is pretty much what Marcuse was recognizing when he wrote, "Entertainment may be the most effective mode of learning."[10] I think that the generation of artists we are dealing with in this exhibition are looking for the same balance.

OI: Is this a Trojan horse of sorts?

PV: It is kind of a Trojan horse. It's an open question, maybe it's a lie, but it's ultimately up to the audience to answer. I don't like the idea of a "blockbuster," but I would be very happy to bring people into the museum with an exhibition of living artists, a contemporary art exhibition. A successful museum experience shouldn't mean that you have to show Impressionism or advertise names like Picasso or Francis Bacon.

Anyway, rather than the idea of the Trojan horse, I would refer to Robert Linhart's book *The Assembly Line*.[11] The author describes how and why he decided to go to work at a Citroën factory, hiding the fact that he was a scholar. His goal was to learn about working conditions as well as to politicize the workers. His ambition was to create a revolution from the "inside." The book is about his hopes and his disappointments and is, in the end, very melancholic. To a certain extent, that is how I am thinking about the exhibition so far. The idea is to be part of what you are studying, not removed, not distanced.

OI: So, with this show as evidence, it's becoming more common for artists today to adopt the strategies or the look of entertainment in their work, but hasn't it been this way for some time? After all, works in the show run from 1977 to 2000. Are there some works in the show that provide a kind of firm historical context for the latest ones?

PV: When we look at the idea of the show, I think it would have been possible to start the exhibition with Manet, but doing that, or even starting in the 1960s, would present the danger of justifying living artists' work with historical material and making their work appear dependent on historical material. So one of the first ideas was to consider what our generation has been looking at and who are the artists who built the way we look at art now. If I deal only with my generation, I have to start with artists from the late 1970s. I would hesitate to use the term "historical" because most of these artists are still alive. In my eyes, Dan Graham is a "young artist," as are Dara Birnbaum and Cindy Sherman, because their work is still very active and stimulating on so many levels.

These three artists are a starting point for the exhibition. I love that Dan Graham decided to publish his *Homes for America* photographs in *Arts Magazine*. It was a way to combine Pop Art and Minimalism in a more democratic, or accessible, medium or context. Also Dara Birnbaum's early appropriation of television images and form was a very important move in the direction of using entertainment tools. There were many artists in the 1970s working with video and trying to infiltrate the TV or media world, but, for me, Birnbaum is the epitome of that. *Technology/Transformation: Wonder Woman* of 1978–1979 (p. 248) deals not only with the idea of media, which would have been a little dry, but also with larger political and gender issues through the popular icon of Wonder Woman. We can say the same about Cindy Sherman and the way she used the *Untitled Film Stills* (pp. 29, 200–203, 292, 319) to speak about the history of photography and the moving image as well as gender representation.

OI: Museums have become one of the few alternative, noncommercial sites still open to all—all who can pay the admission price, that is.

OI: How about Jeff Koons?

PV: Jeff Koons is one of the major artists of his generation. If we look at what we've been speaking about—the idea of pleasure, the aesthetic of alliance—the artistic and critical insight that Koons' work brings to the table fulfills the mandate of the show in almost every way.

OI: Well, it definitely deals with the idea of celebrity that pervades our culture. A number of the artists in the show are mining the attitude or the garment of celebrity, which has become a far more accessible commodity in the last two decades. MTV recently held a contest for celebrity wannabes, and Tinseltown, a dinner theater of sorts, opened near Los Angeles. It provides fake paparazzi, autograph seekers, and an Oscar-night party for your every celebrity fantasy. Warhol's quip about everybody's fifteen minutes of fame has become the ultimate cliché, and Koons turns this lens on the art world.

PV: What I really like about *Buster Keaton* (p. 246), the Koons work in this show, is the way questions of taste are foregrounded. A tragicomic movie icon becomes an object of kitsch, a life-size, three-dimensional representation of something you might find in an airport gift shop or even at Disneyland. I'm really interested in the way Koons deals with the imagery of leisure. Even his most sexually charged work is really concerned with

the role and parameters of morality in Western culture. What is maybe even more Duchampian than the "displacement" method is, in Koons' case, the joy, the delight, the pleasure that the work seems to convey.

OI: He often uses his work to foreground and challenge our most puritanical biases and discomforts. The sexual becomes spiritual, and self-conceit becomes a moment for the collective imagination. American double standards about sex and violence, in media and in real life, are held up to the light in a startling way. Yet Koons does this through a combination of the classical, the ecstatic, and the popular.

PV: Koons provides the same critical rupture in this show that Andy Warhol would have provided in a show a decade or two ago. We are trying to represent Warhol in this exhibition in a way people would not expect, with episodes of *Andy Warhol TV* (pp. 240–243) and *Andy Warhol's Fifteen Minutes*. Koons, however, is pushing the agenda so far that the work becomes disturbing. Where Warhol was still playing with the idea of being underground, Koons puts it all out on the table. There's something about Koons' invasion of the mainstream that you accept, with trepidation perhaps. That's also a conversation I would like the show to carry on: Can an artist deal with those kinds of concerns in a legitimate way? What is the moral issue that this kind of work embodies? What is the moral responsibility of the artist?

PV: The work has become more and more reflexive, more and more attracted by the seduction of pleasure and entertainment in popular culture, but it simultaneously deals with larger issues. The works in the exhibition move from irony or cynicism to hedonism to a certain melancholic quality.

Rainforest waitress: Would you care for some sweets?

In the car, on the way back to the Walker, watching the endless suburbs roll by. "If you lived here, you'd be home already," says a billboard. But there's no place like home here.

OI: *Let's Entertain* encompasses a fairly diverse roster of artists and artworks—across geography, media, generations. Could you take us through some of the choices?

PV: If we start with the generation of the late 1970s and 1980s—Jeff Koons, Richard Prince, Cindy Sherman—we can see that they often tried to subvert established norms through the idea of appropriation—appropriation of image, appropriation of systems.

The next generation of artists—Takashi Murakami, Piotr Uklański, Jessica Bronson, Alexandre Périgot, Minako Nishiyama—have dealt with this issue in a very different way. This is a generation that really plays with this culture and pushes it in a very lively way. The work delves into that forbidden pleasure zone in a very sophisticated fashion. This makes for

attractive work, but always with complexities. For instance, Lily van der Stokker's "pretty" wall drawings (pp. 258, 260–261) subvert the idea of Minimalism by dealing directly with pleasure. Artists, however, have also inserted a certain melancholy into their works. For instance, Gabriel Orozco twists the playful and the beautiful by distorting the rules of games like chess. Contemporary work has become more and more reflexive and contemplative, more and more attracted by the seduction of pleasure and entertainment in popular culture, but it simultaneously deals with larger issues. The works in the exhibition move from irony or cynicism to hedonism to a certain melancholic quality.

OI: The audience is confronted with several different, sometimes contradictory, notions of entertainment. Grand conclusions are left up to them. You've told me before how you would like this show to avoid moral judgments about the role and value of entertainment in contemporary society. Thus, the exhibition presents no final pronouncement about the good or the bad of entertainment.

PV: Many of the works contradict one another, which I like. I really think it's true that through the mental challenge of contradiction you can get to the next place. You also have to consider that we're talking about the Walker Art Center, which has a larger program, of which this exhibition is but one part. We already mentioned the Disney exhibition, but we should also mention the 1998 exhibition that Francesco Bonami and Douglas Fogle curated, called *Unfinished History*.[12] This show, which was about the continuing ebb and flow of past histories even as we stand on the brink of the next century, offered a similarly wide range of works. The interesting thing is that some of the artists—Maurizio Cattelan, Gabriel Orozco, Doug Aitken—are in both shows, but the exhibitions tell two very different stories. I like the idea that the exhibition could be considered a movie, with the visitors to the exhibition as the protagonists. Each protagonist activates the exhibition as he or she goes through it; thus, there is always the possibility of multiple conclusions.

OI: In keeping with the movie theme of the exhibition, David Shea provides those protagonists with a sound track of ambient sounds as they wander the galleries. It's a multisensory experience. We also have Mathieu Briand's project with the video glasses. Visitors who wear them will involuntarily change visual channels as they encounter others wearing the same glasses. Briand sees this as a comment on the cultural and psychosocial schizophrenia at the end of the twentieth century. It also comments on the inescapability of our present condition in a technological, media-saturated world.

PV: Returning to the sound track concept, you cannot enter the mall or the supermarket or an elevator without having this kind of ambient music. You cannot stop it. Your brain is overwhelmed by the music. The idea of having the David Shea experience in the galleries is that you can have the music but you can choose to stop it, you can rewind, you can build your own narrative through the sound track. It's electronic music, it's sampling and collage music, which you can link to a visual experience. He borrows from the world of cartoons and movies, from Tex Avery to Jean-Luc Godard to Jackie Gleason.

OI: Do you think the idea of "high" and "low" is still relevant? Looking at these artists, there is this complete crossover of what we've traditionally thought of as high or low culture, so that you have Damien Hirst making huge spin paintings not unlike those one might make at a state fair (p. 262) and Takashi Murakami doing these exquisitely beautiful sculptures that combine comic-book characters with ecstatic Baroque sculpture (pp. 110, 113).

PV: The idea of a distinction between "high" and "low" is totally in question because artists

like Murakami or Mariko Mori embrace cultural experiences ranging from animated movies to early Japanese painting or temples. They link those two worlds and produce something that doesn't belong to either. Murakami is an artist who, in a very deliberate way, blurs the distinction between high and low by producing works for retail—puppets, balloons, stickers, T-shirts—involving in his creative process people known as "comic" artists. I would think that the distinction is no longer valid in his eyes, as any space is legitimate to diffuse his artworks. His intent is to find a use for these available venues. I believe that the artists in this exhibition are developing a form that goes beyond the distinction between high and low.

Notes

1. Roger Burbach, Orlando Núñez, and Boris Kagarlitsky, *Globalization and Its Discontents: The Rise of Postmodern Socialisms* (London and Chicago: Pluto Press, 1997).

2. David Guterson, "Enclosed, Encyclopedic, Endured: One Week at the Mall of America," *Harper's*, August 1993, 49–56.

3. "On February 27, 1963, accompanied by his Harvard friend, the musician and later film- and videomaker Tony Conrad, and by the filmmaker Jack Smith, Flynt picketed outside of the Museum of Modern Art, Philharmonic Hall at Lincoln Center, and the Metropolitan Museum, where the *Mona Lisa* was then being exhibited to record crowds. The three artists carried signs bearing the slogans: DEMOLISH SERIOUS CULTURE! DESTROY ART! DEMOLISH ART MUSEUMS!" Kristine Stiles, "Between Water and Stone—Fluxus Performance: A Metaphysics of Acts," in *In the Spirit of Fluxus* (Minneapolis: Walker Art Center, 1993), 77.

4. Joshua Gamson, *Claims to Fame: Celebrity in Contemporary America* (Berkeley: University of California Press, 1994), 193.

5. Herbert Marcuse, *One-Dimensional Man: Studies of the Ideology of Advanced Industrial Society* (Boston: Beacon Press, 1964), 103.

6. Jacques Portes, *De la scène à l'écran: Naissance de la culture de masse aux États-Unis* (Paris: Éditions Belin, 1997).

7. Neal Gabler, *Life the Movie: How Entertainment Conquered Reality* (New York: Alfred A. Knopf, 1998).

8. Robert Venturi, Denise Scott Brown, and Steven Izenour, *Learning from Las Vegas* (Cambridge: MIT Press, 1972).

9. See Karal Ann Marling, ed., *Designing Disney's Theme Parks: The Architecture of Reassurance* (Montreal: Canadian Centre for Architecture; Paris and New York: Flammarion, 1997).

10. Marcuse, *One-Dimensional Man*, 66–67.

11. Robert Linhart, *The Assembly Line*, trans. Margaret Crosland (Amherst: University of Massachusetts Press, 1981).

12. See Francesco Bonami, *Unfinished History* (Minneapolis: Walker Art Center, 1998).

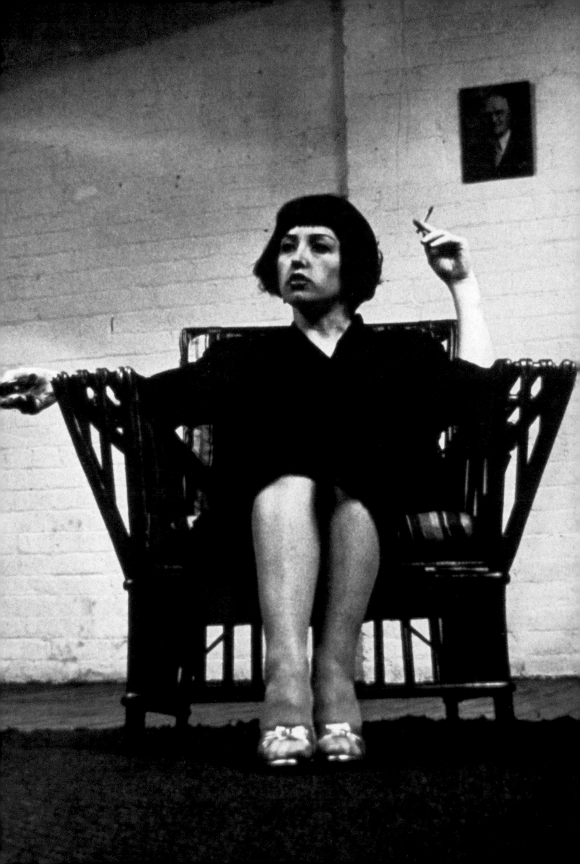

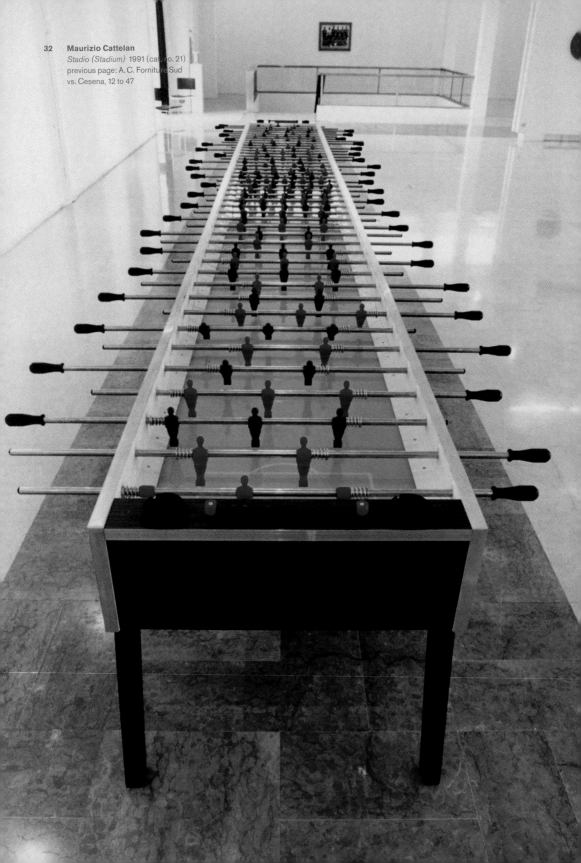

32 **Maurizio Cattelan**
Stadio (Stadium) 1991 (cat. no. 21)
previous page: A.C. Forniture Sud
vs. Cesena, 12 to 47

Come Back to Pleasure
Richard Shusterman

Despite his image as the sober genius of high modernism, T. S. Eliot often spoke of art as essentially amusement. The poet, he claimed, "would like to be something of a popular entertainer…would like to convey the pleasures of poetry…. As things are, and as fundamentally they must always be, poetry is not a career, but a mug's game." Such deflationary remarks are striking in their contrast to the lofty claims made for art since romanticism. Debunking the artist's putative status as world legislator, prophet, and savior, Eliot claimed he would be pleased to secure for the poet "a part to play in society as worthy as that of the music-hall comedian."[1] But his view of art as amusement was much more than an ironic rhetorical thrust against romantic attitudes. In suggesting what art is and how it satisfies, he revived the classical ideal of aesthetic pleasure, which had been buried by almost two centuries of modernity's sacralization of art.

Though Plato condemned art for distorting reality and corrupting character, his admiration for beauty as the source of our highest enjoyment never wavered, nor did his recognition of art's hedonistic rewards. Art's very danger, he argued, was that its seductive pleasures hide its corrupting errors and distract us from the truth. Aristotle countered that art's pleasures derive from mimetic truth, that we take pleasure in recognizing images of things that would horrify us in real life. Thomas Aquinas, the foremost medieval philosopher, defined beauty as what gives pleasure in immediate perception, while the Enlightenment's Denis Diderot (renowned as the inventor of modern art criticism) echoed Horace's classic claim that art's "supreme merit lies in combining the pleasant with the useful." Even the puritanical Prussian Immanuel Kant insisted that however much duty and truth dominate the practical and scientific spheres of life, pleasure rules when it comes to beauty and art. He in fact defined the "feeling of pleasure" (or contrasting "displeasure") as "the determining ground" of aesthetic judgment.[2]

Up until modern times, to identify art with the pursuit of pleasure was not at all a way of trivializing it, for pleasure was anything but a trivial matter, even for philosophers. The ancients (most notably the Cyrenaics and Epicureans) often defined pleasure as the prime good and usually saw it as an essential component of happiness. Even Plato, to make his case for philosophy's superiority to art and other practices, needed to argue for its superior joys. Looking back on the ancients at the very dawn of modern thought, Michel de Montaigne confirmed the primacy of pleasure: "All the opinions in the world agree on this—that pleasure is our goal—though they choose different means to it." Even, he adds, "in virtue itself, the ultimate goal we aim at is voluptuousness."[3]

Montaigne's unabashed hedonism was not a plea for radical debauchery with the aim of asserting difference from conventional morals. It was simply an affirmation of the common recognition that "pleasure is one of the principal kinds of profit" and a necessary ingredient in "this most valuable of all the arts, the art of living well." If, as Montaigne stated, "our great and glorious masterpiece is to live appropriately," then we should not deny our natural pleasures but more skillfully organize our life to increase their number, power, and enjoyment. "It takes management to enjoy life," he concluded. "I enjoy it twice as much as others, for the measure of enjoyment depends on the greater or lesser attention that we lend it."

Montaigne could emphasize the profit of pleasure because pleasure (in the post-Aristotelian tradition) was not conceived as a mere passive, pleasant sensation. It was instead construed as a quality of any activity that enhances that activity by making it

more zestful and rewarding and thus intensifying our interest in it. Our pleasure in regarding an artwork helps us look more intently and fruitfully at it, enabling us to ward off sensations that would distract us from our aesthetic activity. By strengthening our activity, pleasure can be identified with the perfection of life. As Aristotle praised pleasure as the enhancing completion of activity, so Benedict de Spinoza later defined it as "the transition of man from a lesser to a greater perfection," asserting that "the greater the pleasure whereby we are affected, the greater the perfection to which we pass."[4]

In short, even when recognizing the value of other ends, philosophy affirmed pleasure as a crucial, incontrovertible ingredient of life. "Whether we choose life for the sake of pleasure or pleasure for the sake of life," wrote Aristotle (far from a radical voluptuary), "they seem to be bound up together and not admit of separation, since without activity pleasure does not arise and every activity is completed by the attendant pleasure."[5]

Evolutionary theorists corroborate this ancient linkage of life and pleasure. Not surprisingly, many of life's most powerful pleasures are closely connected to biological activities of nourishment and procreation, which are necessary for the survival of the species. Pleasure's logic of desire guides us to what we need long before (and much more forcefully than) deliberative reason can. More than making life sweet, pleasure makes continued life possible by offering the promise that it is worth living. But if pleasure enhances activity and advances life by such enhancement, what, then, are the special forms and values of *art's* pleasures?

One powerful tradition, inspired by Kant, insists on a very specific type of aesthetic pleasure, narrowly defined as the intellectual pleasure of pure form that arises from the harmonious free play of our imagination and other cognitive faculties. Distinguishing the beautiful from the pleasant by its being totally disinterested and remote from sensual and emotional satisfaction, Kant denounced as aesthetic "barbarism" any taste that demanded "charm and emotion for its delight." Even in fine art, where ideas and concepts come fruitfully into play, Kant nonetheless insisted "that the essential element consists in the form."[6]

Other modern traditions in aesthetics, however, such as Nietzscheanism and pragmatism, construe the pleasures of art more generously than those of pure form. Art first affords, at the most basic level, the variegated pleasures of sense: rich qualities of color, shape, sound, texture, and so on. One should not forget that the term "aesthetic" derives from the Greek word for sense perception. The pleasures of intensified perception, typically derived from the artwork's particularly rich or intense sensory qualities, are part of what makes it stand out from the ordinary flow of perception as a special aesthetic experience worthy of the name of art. Heightened affect or emotion is also a commonly noted pleasure of art. And then there are art's pleasures of meaning and expression, which satisfy our need for significance and desire for communication. Such pleasures motivate the creating artist as well as the critic and the public, who engage in interpretation both to explain the pleasures they derive from the work and to deepen them.

The pleasures of meaning and expression point to another crucial dimension of art's enjoyment, which is often obscured—its deeply social dimension. Too often it is assumed that art's enjoyment is subjective, hence essentially private and narrowly individualistic. But even if one feels one's aesthetic pleasure in one's own mind and senses, this neither precludes the shared character of our enjoyment nor prevents our enjoyment

from being heightened by our sense of its being shared. Whether in the theater, the concert hall, the museum, or the cinematheque, our aesthetic experience gains intensity from the sense of sharing something meaningful, of communicating silently yet deeply by communally engaging the same potent meanings and visions of beauty and by experiencing shared pleasures. Art's power to unite society through its enchanting by pleasures of communication is a theme that resounds from Friedrich von Schiller to John Dewey, who boldly claimed that "art is the most effective mode of communication that exists."[7] By creating and reinforcing group solidarity through the sharing of communicative pleasures, art's entertainment performs a crucial social function whose role in the evolution of human culture and society should not be overlooked.

Individually these different points about art's pleasures are reasonably familiar, but it is worth recalling them together to remind us of the diversity of art's pleasures. The common critique of art's pleasures and entertainments—that they are trivial, devoid of substantive value, and degrading of art's genuine worth—rests on ignoring this diversity by making two false assumptions: first, that there is basically one kind of aesthetic pleasure in art's entertainment and, secondly, that this pleasure is always a shallow and trivial one, which distracts us from interest in art's real meaning and truth.

Since Alexander Baumgarten invented modern aesthetics and Kant established it as a central philosophical discipline, German philosophy has dominated the philosophy of art. The decline of pleasure's prestige in recent aesthetics can be seen in its critique in twentieth-century German thought. Disdaining the value of "merely artistic enjoyment," Martin Heidegger insisted that art's defining function "is the setting-into-work of truth." Hans-Georg Gadamer likewise attacked the immediate pleasures of aesthetic experience by insisting instead on art's meaning and truth, apparently assuming that these values are somehow inconsistent with more immediate pleasures.[8]

The conflict of these values is still clearer in the writings of Theodor Adorno, who (together with Max Horkheimer) coined the disparaging phrase "the culture industry" in order to denigrate all popular art that does not eschew pleasure and entertainment. For Adorno, artistic pleasure and cognition are starkly opposed: "People enjoy works of art the less, the more they know about them, and vice versa." In the contest of values, it was clear for Adorno that pleasure must be sacrificed to truth: "In a false world, all hedone is false. This goes for artistic pleasure too." Art should "not seek pleasure as an immediate effect…. In short, the very idea that enjoyment is of the essence of art needs to be thrown overboard…. What works of art really demand from us is knowledge or, better, a cognitive faculty of judging justly."[9]

Sadly, recent American aesthetics have sometimes followed this puritan line of denying art's pleasure in order to affirm its meaning and cognitive import. Overextending Marcel Duchamp's remark about his famous artwork *Fountain*, Arthur Danto claims that "aesthetic delectation is a danger to be avoided," since it trivializes art as something "fit only for pleasure," rather than as a vehicle of deep meaning and truth, something profound and important, even metaphysical.[10]

However different the aesthetic philosophies of Heidegger, Gadamer, Adorno, and Danto, what they all share, besides their antihedonism, is a common heritage in Hegel. It was Hegel's ambitiously metaphysical idealism that displaced the classical connection of art and pleasure. Founding the fatal modern tradition that makes fun the

enemy of true art, Hegel instead subordinated art's role to the quest for spiritual truth. This quest, he argued, leads us beyond art to the higher realm of religion but ultimately culminates in the spiritual pinnacle of philosophy.

To grasp the fateful logic of Hegel's strategy, it is worth looking more closely at his argument. While recognizing that "art can be employed as a fleeting pastime to serve the ends of pleasure and entertainment," Hegel complained that such art is not "independent, not free, but servile" to "alien objects." In contrast, he asserted that "fine art is not real art till it is free." But art's freedom, for Hegel, turns out to be subordination to truth, since its "independence" is expressed only in the quest for "the attainment of truth." Art achieves this freedom only "when it has taken its place in the same sphere with religion and philosophy, and has become simply a mode of revealing to consciousness and bringing to utterance the Divine Nature, the deepest interests of humanity, and the most comprehensive truths of the mind."[11]

From such a starting point, we can readily trace our sad aesthetic trajectory of sacralizing art by denying or denigrating its pleasure, particularly its more earthy pleasures of robust sensuality. In secular society, museums and concert halls have replaced churches as the places one visits on the weekend for spiritual edification. The dominant mood of the audiences is reverently solemn and humorless. Joy and laughter are altogether out of place. People now attend the sacred halls of art as they once attended church, gratified that they have come and gratified that they soon may go.

With this sacralization of art comes the rigid hierarchy of high and low (a counterpart of the sacred-profane distinction). Entertainment is automatically relegated to the sphere of profane lowness, no matter how aesthetically subtle, sophisticated, and rich in meaning it may be. Even in the realm of high art, Hegel introduced a rigid hierarchy of art styles and art genres, based on their level of spiritual truth and their remoteness from materiality. Architecture, sculpture, and painting lie at the bottom of the ladder because of the physicality of their media. Poetry, in contrast, stands at the top because, through its ideal medium of language, it approaches the spirituality of pure thought.

The sacralization of art that Hegel initiated is not only an enemy of art's pleasures; it also undermines art's potency and value by subordinating its functions to the aims and biases of idealist philosophy. Art may share the heights of absolute spirit with religion and philosophy, but only as an inferior member that, still worse, has essentially outlived its usefulness. According to Hegel, art's most important spiritual truths have already been superceded by those of Christian religion and idealist philosophy (especially his own). "Art no longer affords that satisfaction of spiritual wants which earlier epochs and peoples [like the Greeks] have sought therein and found therein only." Having "lost for us its genuine truth and life," art has become (in Hegel's dire words) "a thing of the past." To prevent its degeneration into the entertainment function of "immediate enjoyment," Hegel insists on turning to aesthetics as the science of art. No longer able to generate new spiritual truths, art can at least provide the subject matter for scientific truth about its realm of spirit.

Hegel's choice of art's truth over its pleasures thus reflects not only his subordination of art to philosophy but also his more radical view that the crucial spiritual role of art has already reached its end. But if art's spiritual career is over, why not return to pleasure and forsake the idealist project of sacralizing art to ensure its importance?

ed, knowingly,

היתו מתורגם, ב

it were a ball threatening to

המאיים לפנות לכל הכיוונים,

g written, that

לכתיבתו, שיתגל

to the space openly unfolding

אלא על המרחב הנפרש פתוח

me facets which

במלואם. אבל ב

Imagine, if you will, a desert

מדבר.

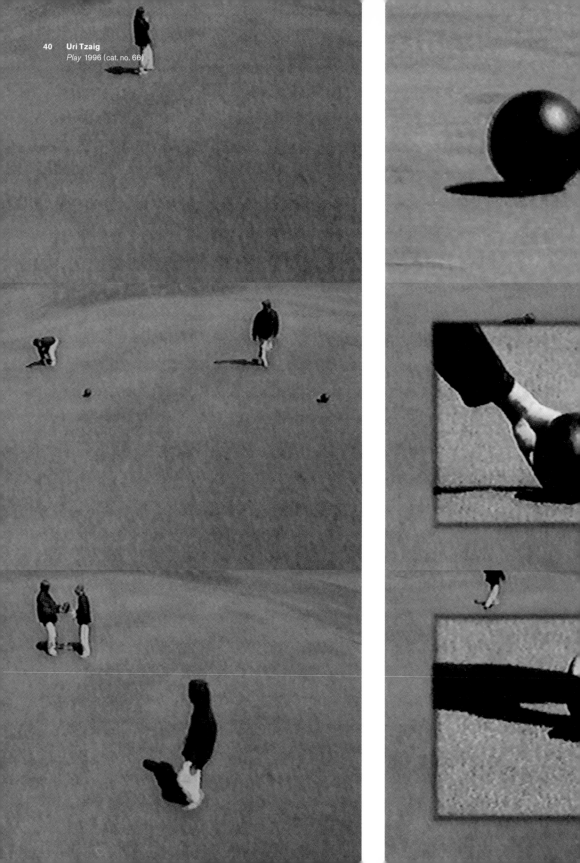

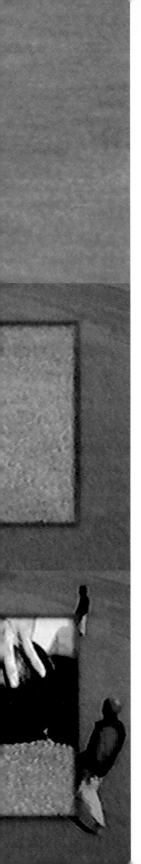

Idealist sacralization once gave art energy and value. As the nineteenth and twentieth centuries moved us toward a more secular world view, the abiding religious energies and habits of worship that could no longer find their object in traditional church dogma were displaced into the field of art, engendering the extremes of romanticism and "art for art's sake," where aesthetics seemed to subsume religion as the most exalted expression of spiritual creation. By now, those religious habits have worn thin, as has art's sacred aura. The loss of that aura, through new modes of mechanical reproduction, forms the focus of Walter Benjamin's reflections on popular entertainment.[12]

So what can be gained today by persisting in Hegel's sacralization of art through the rejection of entertainment? His dour program of progressive spiritualization prescribes not only art's subservience to truth and its inferiority to religion and philosophy but also its demise as a vehicle for new spiritual discoveries. Is it not time for aesthetics to reconsider the neglected promise of pleasure? There is surely a need to challenge the dogmas that belittle art's pleasures and deny the merit of its role as entertainment.

One dogma that needs questioning is the triviality of pleasure. This dogma is already rendered suspect by the arguments of pre-Hegelian philosophy and post-Hegelian evolutionary theory, cited earlier, which testify to pleasure's crucial, vital, and wide-ranging role in our lives. Pleasure's importance is often intellectually forgotten, since it is unreflectively taken for granted. We tend to forget its deep significance because we also assume its uniformity and tend to identify pleasure as a whole with its lightest and most frivolous forms. A similarly misleading presumption of uniformity is operative when we conclude that popular art must be aesthetically inferior because we identify such art with its worst examples and assume that its character and value should be more or less uniform in all its works.

For this reason, it is important to emphasize once again the variety of pleasures in art and life. Think of how this variety is strikingly expressed in our vocabulary of pleasure, which goes far beyond the single word. While theorists of pleasure have long contrasted the extremes of sensual voluptuousness (*voluptas*) with the sacred heights of religious joy (*gaudium*), there is also delight, satisfaction, gratification, gladness, contentment, pleasantness, amusement, merriment, elation, bliss, rapture, exultation, exhilaration, enjoyment, diversion, entertainment, titillation, fun—and the list could go on. While the pleasures of fun and pleasantness convey a sense of lightness that may seem close to insignificance, those of rapture, bliss, and ecstasy clearly should remind us just how profound and potently meaningful pleasures can be. Such pleasures, as much as truth, help constitute our sense of the sacred and help found our deepest values.

But in highlighting the power and significance of these exalted pleasures, it would be wrong to dismiss the value of the lighter ones. Merriment can offer welcome relief from the strains of ecstasy but also provides a useful contrast to highlight its sublimity; besides, lighter pleasures have their own intrinsic charm. The purpose in learning the diversity of pleasures is not to select only the highest and reject the others, but to profit best from enjoying them all, or at least all that we can happily manage.

Aesthetic thinkers have not always been blind to the varieties of pleasure. In the eighteenth century Edmund Burke usefully analyzed the differences between the pleasure of beauty and the delight of the sublime.[13] Perhaps today we could learn something useful from comparable analyses that contrast the amusement of TV sitcoms to the

161

174

exultation of rock concerts and the titillation of erotic cinema. In any case, the manifold array of pleasures that constitute our appreciation of the arts presents a wide and inviting field for new aesthetic research. This is as much a field for artists to investigate through their work as it is a site for critical and philosophical analysis.

Besides the triviality and uniformity of pleasure, we must confront perhaps the most stubborn dogma of all: the opposition of pleasure to meaning and truth. This presumed conflict lies at the heart of the rejection of art as entertainment. Hegel wrongly assumed that if we seek and find pleasure in the arts we cannot also find truth and understanding. High-minded post-Hegelians like Heidegger, Adorno, and Danto seem troubled by the same fear, expressed most baldly in Adorno's claim that the less we understand art, the more we enjoy it, and vice versa. The misguided opposition of pleasure and knowledge rests on the false assumption that pleasure is an overpowering sensation that is unrelated to the activity through which it occurs and can even distract from that activity through its own felt power. This assumption rests in turn on a shallow empiricism that equates experience with passive sensation rather than activity.

In contrast, the classic appreciation of pleasure finds support in Aristotle's idea that pleasure is an inseparable part of the activity through which it is experienced and which it "completes" by contributing zest, intensity, and concentration. To enjoy tennis is not to experience agreeable feelings in one's sweating racket hand or running feet; it is rather to play the game with gusto and absorbed attention. Likewise, the enjoyment we derive from art is different from the pleasant sensations that we may experience while regarding an artwork or that we might obtain from something else, like a cup of good coffee or a steam bath. To enjoy an artwork is rather to take pleasure in perceiving and understanding the work's qualities and meanings. Such pleasure tends to intensify our active concentration on the work, thus enhancing our perception and understanding.

This classic understanding of pleasure has not been altogether abandoned in modern times. Reformulated with the technical refinements of analytic philosophy by Oxford's Gilbert Ryle,[14] it also found a more accessible, aesthetic expression in the words of the poet-critic-philosopher with whom this essay opened. Affirming art's essential linkage of pleasure and meaning, of enjoyment and understanding, Eliot wrote: "To understand a poem comes to the same thing as to enjoy it for the right reasons…. It is certain that we do not fully enjoy a poem unless we understand it; and on the other hand, it is equally true that we do not fully understand a poem unless we enjoy it. And that means enjoying it to the right degree and in the right way, relative to other poems."

As pleasure does not preclude but rather strengthens understanding, so advocacy of enjoyment does not entail a leveling of evaluative standards. Some works should be enjoyed more and differently than others, because they are better or different in style. Bad works should not be enjoyed when properly understood, Eliot concludes, "unless their badness is of a sort that appeals to our sense of humor."[15] Drollery, we should not forget, also belongs to the multiform pleasures of art.

I close with a cautionary reminder. Advocating art's pleasures should not mean substituting them for the pleasures of life while also neglecting those victims of injustice who know more misery than joy. Nor should we forget that even art of radical social protest gains power from the zest of righteous anger and the thrill of common struggle, pleasures that enhance or complete (in Aristotle's sense) the activity of protest. To think

that prizing pleasure means condemning art to frivolity and narcotic escapism is one more fallacy based on the presumption that all pleasures are uniform and shallow. This belief also rests on the trite but deadly dogma that opposes art to life.[16]

Notes

1. See T. S. Eliot, *The Uses of Poetry and the Use of Criticism* (London: Faber, 1964), 154.

2. See Denis Diderot, "D'Alembert's Dream (Conclusion of the Conversation)," in *Diderot, Interpreter of Nature: Selected Writings* (New York: International Publishers, 1943), 119; and Immanuel Kant, *The Critique of Judgement* (Oxford: Oxford University Press, 1952), 41.

3. Quotations from Montaigne in this essay are from Donald Frame's translation in *The Complete Essays of Montaigne* (Stanford: Stanford University Press, 1965), 57, 123, 835, 851, 853.

4. See Benedict de Spinoza, *The Ethics*, in *Works of Spinoza* (New York: Dover, 1955), 174.

5. Aristotle, *Nicomachean Ethics*, 1175a, in *The Basic Works of Aristotle* (New York: Random House, 1968), 1100.

6. Kant, *Critique of Judgement*, 65, 190.

7. John Dewey, *Art as Experience* (Carbondale: Southern Illinois University Press, 1987), 291.

8. See Martin Heidegger, "The Origin of the Work of Art," in *Poetry, Language, Thought* (New York: Harper, 1975), 68, 71; Hans-Georg Gadamer, *Truth and Method* (New York: Crossroads, 1982), 58–90.

9. Theodor Adorno, *Aesthetic Theory* (London: Routledge, 1984), 18–21.

10. Arthur Danto, *The Philosophical Disenfranchisement of Art* (New York: Columbia University Press, 1986), xiv, 13.

11. G. W. F. Hegel, *Introductory Lectures on Aesthetics* (London: Penguin, 1993), 9, 12, 13.

12. See Walter Benjamin, "The Work of Art in the Age of Mechanical Reproduction," in *Illuminations* (New York: Schocken, 1969).

13. See Edmund Burke, *A Philosophical Enquiry into the Origin of Our Ideas of the Sublime and the Beautiful* (1757; London: Routledge, 1958).

14. See Gilbert Ryle, *The Concept of Mind* (London: Hutchinson, 1949).

15. These last quotations are from T. S. Eliot, *Of Poetry and Poets* (London: Faber, 1957), 115.

16. For more on these issues, see Richard Shusterman, *Pragmatist Aesthetics: Living Beauty, Rethinking Art* (Oxford: Blackwell, 1992; 2d ed., New York: Rowman and Littlefield, 2000), and idem, *Practicing Philosophy: Pragmatism and the Philosophical Life* (New York: Routledge, 1997).

Thoroughly Entertained
Interviews by Dike Blair

I sometimes pose a rhetorical question to my students: "Who is the more important twentieth-century artist—Walt Disney or Pablo Picasso?" I am not trying to initiate a discussion of high versus low art; my motive is to open the students' minds (minds that from birth have been more saturated with entertainment than mine ever was) to the serious contemplation of those art forms that are vernacular and, especially for my argument here, commercial and entertaining. My preconception of *Let's Entertain* is that it will demonstrate a number of complex relationships between art and entertainment, one of them being a breakdown of the barrier between the two. I would argue that the accelerated injection of commerce and marketing into all aspects of our culture has made the already thin membrane between art and entertainment even more permeable. Many artists and thinkers (Andy Warhol and Marshall McLuhan being early and notable examples) have been addressing this phenomenon, either directly or indirectly, since the 1950s and 1960s, and I see it as one of the repeating patterns in the fabric of the interviews collected here. Although these interviews were never intended to be published as a collection, there are more than a few common threads that connect them, and this introduction is an exercise in retroanalyzing the weave.

Visual artists have always known that entertainment—to give pleasure, to divert, to amuse—is the glue of art. They have used it as subject and theme (ukiyo-e woodblocks); as business (Frederic Church's nickel admission to view his cinematic panoramas); and as a primary approach to subject, theme, and business (Disney and Warhol come to mind). Of course, pleasure and diversion are subjective–one person's El Greco is another's LeRoy Neiman. And to different minds, or to the same mind at different times, the dramatic and tragic may be as entertaining as the comic and the sensual. Whatever their approach, all artists use entertainment, in one form or another, to keep the viewer engaged in their art.

All five of the subjects of these interviews—three industrial designers (Jonathan Ive, J Mays, Gordon Thompson III), an architect (Karen Daroff), and a novelist (Jack Womack)—create or respond to entertainment. Ive, Mays, and Thompson are directly employed by corporations; Daroff works almost exclusively for corporate clients. I refer to their art as "commercial." Womack is a self-employed "noncommercial" or "fine" artist, but that simply means that he has no immediate boss or client, not that he's indifferent to commercial success or patronage. Rather than employ new labels (like "dependent" and "independent" artists), I've decided to stick to more familiar ones, but I hope that the reader understands the different approaches and roles of these artists without making these distinctions hierarchical.

The evolution of culture, including commercial and fine art, is slow and steady, with sudden surges of inspiration. It's tempting to see our millennial present, and those I've interviewed, as representing a creative spurt. I'm not sure that this is the case. All forms of culture are dependent on those that precede them, but the creation of new forms requires a surprising and sometimes violent and misunderstood creative rupture—the big spurt. The work of

the corporate-aligned interviewees (novelist Womack is the obvious excep-
tion) is generally not about that kind of creative rupture, perhaps because
corporations are rarely tolerant of or able to accommodate drastic change.
These commercial artists do possess an advanced understanding of fields
that are experiencing evolutionary leaps: communications, technology, and
marketing. Mays is designing beautiful cars, but the inspiration for them is
dependent in part on our memories of innovative models like the original
Beetle and the Thunderbird. Ive has created a new and somewhat radical form
for a computer, but the design of the iMac itself has a fairly familiar retro-
futuristic quality. Daroff has created imaginative and technologically sophis-
ticated flourishes in her entertaining interiors, but she adds little to the larger
formal vocabulary of architecture, and her gestures, like those of much post-
modern and most entertainment architecture, tend to be most engaging on
the surface. The exception here may be Nike's Thompson. The evolution from
the sneakers of the 1960s to the athletic shoes of the 1990s was dramatic.
Athletic shoe designers, with Nike leading the way, utilized ergonomics, high-
tech materials, and startling, loopy forms that may have previously been
applied in the automotive and aerospace industries but had never before
been seen on people's feet, creating products that were more formally
advanced and affordable than anything coming out of the fashion world. And
Thompson's design of Nike Town (in collaboration with John R. Hoke III) was
an imaginative conflation of the best in postmodern and entertainment
approaches to architecture.

Where all these commercial artists succeed and excel is in the area of
design distilled by branding, visual marketing, and entertainment. I feel the
need to digress for a moment and venture into what may be familiar territory
to many but is necessary to my argument. Market research is currently prac-
ticed at a level of sophistication that qualifies it as a science, albeit one still in
its infancy. Other sciences, psychology and sociology in particular, have been
absorbed into marketing's program and are employed to profile what we
want now, what we will want in the future, how to make us want more, and
how to help us consummate these wants. Using sophisticated market
research, computer modeling, Internet cookies, retail sociology, cool hunters,
and focus groups, corporations know and guide our desires in ways that some
find fantastic and others disturbing. There are three things that seem certain:
we are obsessed with celebrity, we want our products to define our individu-
ality, and we want to be entertained.

"Branding," which is the promotion of a product as if it were a celebrity,
is a fashionable advertising and marketing strategy that nicely unites the pos-
sibly contradictory notions of mass consumption and individuality. Celebrities
usually entertain, and by definition they represent individuality, even, or per-
haps preferably, if that individuality is cartoonish and iconic. (I've also noticed
that most of the commercial artists I've interviewed have personal, or at least
corporate, PR people who actively cultivate their celebrity status.)

Another hot marketing technique is "visual marketing." The idea of visual

marketing is to distill a product's essence into a handful of characteristics—catchwords and catchphrases—and then to contour everything about that product around those key words and phases. So all this market research, all this knowledge, now goes not only into the selling of the product but directly into its conceptualization as well, becoming an elemental design imperative. At the postproduction level, the use of entertainment to sell the product is obvious and familiar. Entertainment is less easy to quantify as part of a basic creative design program, but it's there. The entertainment quotient is implicit in branding and is always present as some adjectival or adverbial bit of the visual-marketing process.

But to get back to noncommercial visual artists, as I said above, they know that entertainment is also the glue of art. As the "narrative" left the canvas, it migrated into the artist's biography (think Jackson Pollock). Even if they don't personally crave fame or celebrity, artists have always understood that branding themselves is practically essential to the promotion of their work in the world. Both the private and the institutional sectors of the art world have increasingly employed strategies from the worlds of marketing and entertainment, not only because those strategies are necessary for their financial survival but also because dealers, museum administrators, and curators are as much part of this culture as are the artists and audiences—and because those strategies are the means of the moment to convey information effectively. International art exhibitions have become Disneylands for the more intellectually inclined and are sometimes housed in pavilions—Frank Gehry's Guggenheim Museum Bilbao, for example—that enhance this atmosphere. And, of course, *Let's Entertain* is a participant in as well as an observer of the art/entertainment interface.

The boundaries between work and leisure have blurred (it may be that blur that defines our age), and the blurry genre of "infotainment" has evolved as a necessary escape from a hard-edged reality that, for many, includes stultifyingly boring labor. But I don't think *Fahrenheit 451*–style escapist pacification of the labor class is what's going on here. Hyper marketing and the efficient prediction of our tastes are a necessity that extends far beyond the narrow interests of corporate boards and their shareholders. We're an increasingly global culture, and our resources and social complexity demand heightened cycles of production and consumption to keep the engines running. I choose to see those engines not as exploitative and destructive but as the motors that could drive us somewhere better—maybe they'll help create a relatively stable and increasingly democratic globe. But the same engines will exploit, pollute, and vapidify the world without proper emissions testers and people to throw monkey wrenches in the gears. Artists are, and have always been, among those pesky testers and wrench throwers. Their outsider status, especially in Western culture, is part of their desirable function; they offer criticism and spiritual options, sometimes hidden in well-designed and well-marketed Trojan horses. The inclusion of the Womack interview in this collection is emblematic of the artist's role. His freedom to

function in that role is reliant on the fact that he has only one thing to sell—his literary vision.

There is one last important thread that unites these interviews: me. My primary occupation is that of visual artist, but I am suboccupied with teaching and journalism. The latter suboccupation gives me access to people—artists, filmmakers, writers, scientists, designers, architects, and so on—who are creating things that are of interest to me. Those things usually already have a physical analog in my studio (artist's studios are invariably cranio-architectures) or represent some kind of information that I want to inject into my work. So my journalism allows me to feed my art, and vice versa. For example, I carry a residual image of a nonspecific plasticine model of an automobile that formed while talking to Mays. That and more specific images derived from Mays' work flicker on my brainpan and are no doubt elements of the forms that I'm currently trying to craft.

My interest in "entertainment architecture" probably goes back to childhood memories of the 1964 New York World's Fair, which I recovered while visiting EPCOT at Walt Disney World Resort in the 1980s. My 1991 exhibition at the now-defunct Ealan Wingate Gallery in New York contained works (two of which are included in this exhibition) that were inspired by EPCOT and installed in an EPCOTesque environment of carpet, light, and music. I would like to think that the interviews with architect Daroff (who has worked extensively with Disney) and Ford Motors designer Mays contain enhanced information and entertainment value because my twelve-year-old self sat in the backseat of a new 1964 Mustang convertible that made a sweep through Ford's "Magic Skyway" pavilion (designed by Disney) at the World's Fair. The Mustang drove from the dawn of time, past dinosaurs and Audio-Animatronic cavemen, to the futuristic (year 2000) bubble-domed City of Tomorrow. Our present bears little resemblance to that projected future, but Ford, Disney, and entertainment architecture have prospered, and I am still, as I was then, thoroughly entertained by them.

The five interviews collected here were conducted over a five-year period, and I present them in descending chronological order for no reason other than that some order must be imposed. I've written an introductory update to each, but as most of the interviewees work in volatile industries, these updates will also be dated by the time this book is published. I would like to thank Philippe Vergne for selecting these interviews and visualizing them as a collection, and I would also like to thank Karen Jacobson for her invaluable and astute editorial assistance.

Auto-Emotive Design:
Interview with J Mays (January 1999)

This is the most recent of the interviews collected here, and not much has transpired in terms of new J Mays projects. The newly released Taurus and Sable were, for the most part, designed before his arrival and imprint at Ford. I did get the opportunity to see, in person (I'd only seen pictures at the time of the interview) at the 1999 New York Auto Show, the Lincoln Blackwood and the Thunderbird and (my) Mercury concept cars. No production date has been set for the new T-bird, but it looked like it would be a big success. Showgoers found the (my) very intriguing, although no decision has been made as to whether it will be produced.

For decades the automobile's sculpted metal, glass, chrome, and plastic have reflected our collective desires and moods, our socioeconomics and technologies. Today automobiles mirror the esoteric retail sciences of visual marketing and branding. Architecture and design forms have always been driven by function and by the desire to express the identity of both the user and the maker, but highly sophisticated market research has helped manufacturers zero in on the self-expressive and emotional benefits of products and integrate them into the design program at the conceptual level. This approach does not debase design; quite the contrary, it clarifies it. In a marketplace of seemingly infinite options,[1] consumers are given visual shortcuts to fulfilling their desires. A good example of this approach is Volkswagen's retro-futuristic New Beetle. The car was designed to grab consumers' attention, to evoke simplicity and optimism, and to tap into the emotions of those who lived the 1960s as well as those who only imagine them. The concept of reviving the Beetle belongs to J Mays, and it has worked phenomenally well.

Forty-three-year-old Mays was born in Oklahoma and says that his childhood was that of a fairly typical car-nut kid. He received a B.S. in transportation design at Art Center College of Design in Pasadena, California. He then worked for the Audi division of Volkswagen AG for fourteen years, first in Germany and later in California, where he headed the Audi design studio and where, in 1994, he designed the VW Concept One, the car that would eventually become the 1998 New Beetle.[2] Mays left Audi in 1994 to start an automotive studio with the design and consulting firm SHR Perceptual Management.[3] While consulting for Ford Motor Company, he so impressed the company and its design chief, Jack Telnack, that when Telnack retired in 1997, Mays was offered his job. As vice president for design, Mays currently oversees the design of Ford's seven brands (Ford, Mercury, Lincoln, Mazda, Jaguar, Aston Martin, and Volvo car). The first signs of his imprint were seen at this year's auto show, where Ford previewed its Thunderbird concept car, which is stunning and echoes design strategies that were successful with the Beetle; the Lincoln Blackwood, a luxury four-door pickup; and a concept SUV known as the (my) Mercury.[4]

So what does Mays bring to a field that has, in his words, "done just about every shape in the universe in the last seventy years"? Emotion, something that "is going to tug

"We're trying to create products that people desire rather than rationalize. I'm of the opinion that you buy a product because you're prepared to spend part of your life with it, and that's just like your relationship with your spouse or your boyfriend or girlfriend. You buy for emotional reasons, and then you rationalize your purchase to your friends."

on their heartstrings."[5] In a phone conversation with Mays I was struck not only by his intelligence and his ability to articulate his design philosophy but also by his ability to combine corporate loyalty with a design philosophy characterized by integrity. His work demonstrates that market research–driven design can be daring and excellent.

Dike Blair: Do you go along with the notion that an equilibrium has been reached in terms of quality among all car brands and that styling is where value is added?
J Mays: I don't think there's a total equilibrium in quality. Among the domestic manufacturers we still lead by a reasonable margin. We're benchmarking other manufacturers in Germany and Japan, and we still have a lot of gains to make in overall quality and craftsmanship. Those things can be very value-added in the mind of the customer.

DB: Is "fun" something that defines American design, say, in contrast to German design?
JM: There's some of that in there. If you look at German design—whether it's automobiles or Braun razors or coffee pots—it's elitist. And there's nothing wrong with that; I admire it, it's modern design as it was meant to be. It's Mies van der Rohe; it's the classic understanding of proportion and line. But that's not what Ford's about. We're not an elitist company, and we don't produce elitist products—that's not what the founder was thinking about when he designed the Model T. Ford is a populist, democratic company that produces products that are accessible to as many people as possible. If you think about it, that's very much in line with what our country's about. We've got a pretty good life for just about everyone in it, and taking design not quite so seriously as our German counterparts is what gives us the ability to have a little bit more fun, produce products that are a little bit more overt, ostentatious, humorful…I could go on. But I think being playful is part of our culture.

DB: Are there things that you miss about working for Audi?
JM: The overview of what I was doing [laughter]. That was a little bit easier because I was working on four different automobiles, as opposed to seventy-two. At Audi, in 1990, we were selling about 470,000 automobiles a year, at Ford we sell 400,000 Explorers alone. This year Ford produced about seven million units. The sheer scale is a big difference.

DB: I suspect that you draw and sculpt much less.
JM: I do, but I find that I think strategically to a far greater extent than I did at Audi. Part of the reason is scale, and part of it is that at Audi you basically had small, medium, and large but all the same design philosophy. At Ford each brand has its own philosophy, feeling, and design vocabulary. If you dissect, or deconstruct, that design vocabulary into shape, color, material, and texture, it becomes very important in that the designers and engineers have an inherent understanding of that vocabulary. So when it is reconstructed in a tangible form, an automotive product, they are able not only to verbalize what they're producing but also to visualize it for the customer. I've been doing a lot of that over the last fourteen months.

DB: Was it a shock to you and the industry when you were offered the Ford job?
JM: It was a very big surprise because I had left the automotive industry mainstream in

58 right (top to bottom)
J Mays, Ford Thunderbird,
Lincoln Blackwood, and the (my) Mercury

'94. I'd made a very conscious decision after the launch of the Beetle product to really reevaluate how you design cars and examine consumers' reactions to them. That decision led me to leave Audi and form a consultancy group with SHR in order to rethink the whole idea of how we go about designing a vehicle. And it really changed my entire thought process in terms of how I approach automotive design. It's no longer just about what J likes; it's also about what the customer's needs are and giving them a visual receipt. It's about creating a total sensory experience for the customer.

DB: Is that the "branding" approach you bring to design?
JM: Well, everything that you touch, smell, or hear has to be in line with the brand, but it also has to be a quality experience.

DB: You must look at architects and product designers—who do you like?
JM: I look very closely and even have contact with them. I know Thom Mayne at Morphosis a little bit, and he spoke at one of our design forums. I had a little contact with Frank Israel before he died, and I have a lot of respect for his work. I don't know Frank Gehry, but I follow his work very intimately. Those are probably the three architects I've looked at over the last five years. I'll follow people like Helmut Jahn or Philippe Starck out of pure interest to see where they're going.

DB: What are your feelings about the iMac? It reminds me of your Beetle.
JM: I like the iMac a lot, and I think it says a lot about creating a product that people purchase for its vision. The iMac does do things more simply than some other computers, but the real reason you buy it is because it's got a translucent plastic skin and it looks great. It's an emotional decision.

DB: I noticed that the (my) Mercury has an unusual tint to its windows. Any relationship to the iMac?
JM: No, actually the inspiration for tinted windows came from some work I did as a private consultant for Oakley sunglasses. Like many sunglasses on the market, Oakley's have an amber tint to them. I thought that it would be very nice to have an amber tint, almost an aviation feeling, to the windows on the (my).

DB: You mention emotional content and design. Can you expand on that?
JM: We're trying to create products that people desire rather than rationalize. I'm of the opinion that you buy a product because you're prepared to spend part of your life with it, and that's just like your relationship with your spouse or your boyfriend or girlfriend. You buy for emotional reasons, and then you rationalize your purchase to your friends.

DB: You prefer the label "heritage" to "retro" design?
JM: Well, I personally prefer it. I'm not saying that there isn't retro design. There is and there's lots of it. I try not to do it as just a blatant one-for-one: here's the old car done in an old way. When I do a car, I try to employ modern form vocabulary, which is far more geometric, far more graphic, far more architectural—it's not so sheet metal–driven as some of the competition's vehicles. There's a conscious effort on our part to try to take

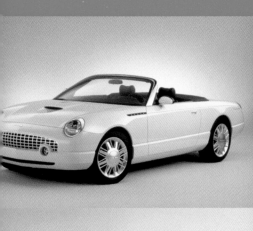

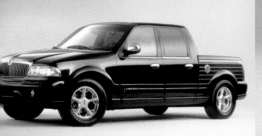

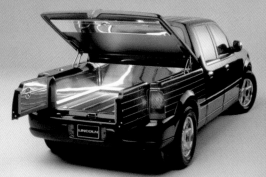

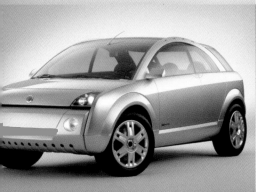

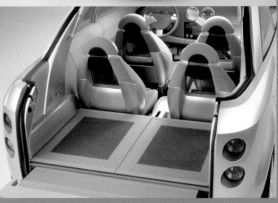

the next step forward while retaining the essence of the original idea.

DB: Any plans to redo the 1961 Lincoln Continental?
JM: I will only tell you that I love that car. We've got a lot of projects on the burner right now; we must have around fifty or sixty clay models going.

DB: So the computer and hologram[6] haven't replaced clay models?
JM: We've got a lot of technology that allows us to design in the computer, and we do for certain things. But we're not comfortable designing completely in the computer simply because you don't have the ability to walk around the car in real time. We don't have a big enough screen to accurately portray the size of something like an automobile. At the moment, the best way for us to design an automobile is the good old-fashioned clay model sitting on a measuring plate in the studio. We work it, we put tinted foil over it to create the illusion of metal and give it a color, and we roll it out into the sunlight and see how sun and light and shadow play off those shapes. That's still the best way to ascertain if you're doing the right thing.

DB: I read that you like *Empire of the Sun*. Are you a Spielberg or a Ballard fan?
JM: I'm more of a Spielberg fan, and it may have something to do with the unabashed way he goes after peoples' emotions. I'm fascinated that you can charge people eight dollars to walk into a dark room and have their emotions played with. People need an escape and an experience that is different from their day-to-day lives. I often use that analogy to our car designers; we're not creating great automobiles, we're trying to create great experiences. And that goes far beyond simply trying to create a beautiful product. It gets into all the psychological aspects of what a person does with their life, what they use the vehicle for, and its hierarchical importance to their lives. You start looking at products that way, and it creates an infinite number of possibilities.

DB: The display you created for Ford at the last Detroit Auto Show reminded me of *Gattaca*, with its Frank Lloyd Wright sets.[7]
JM: There was a little of that in there. That one and Terry Gilliam's *Brazil* have a lot in common in terms of films with futuristic settings with retro qualities. I love both of those films for that reason.

DB: What's the sensation of seeing your work on the streets?
JM: I'd be a liar if I told you I'm not thrilled. It's very exciting. What I always like to do is see who's driving it. I just look at them and wonder, "What made you go buy that?" I know what the vehicle looks like. I'm most interested in who buys it.

Originally published in *ArtByte* 2 (April–May 1999): 30–35.

Notes

1. Auto companies have been reducing the number of model platforms and using more common parts for models, but they are also building a huge variety options within each platform.

2. Reviving the Beetle was something that VW management had been decidedly against since the last Beetle was sold in 1979. Once Mays got the idea, he had to be somewhat covert and political to get the project the serious consideration he felt it deserved. Because he headed the Audi design studio, which was neighbor to the design studio of Audi's sister company, Volkswagen, he had to work in secret to avoid stepping on Volkswagen toes. After he had developed the concept, he went to Germany and presented it, in private, to his superior at Audi, Hartmut Warkuss. For a more complete version of the story, go to: www.teleteam.com~/raleigh/vw/html/concept.html.

3. SHR Perceptual Management is based in Scottsdale, Arizona, and specializes in the kind of visual design and marketing that is also Mays' specialty. In a conversation I had with SHR's marketing manager, Andrew Depoy, he described a mutual teaching/learning process between the firm and Mays' studio.

4. The T-bird was begun before Mays' arrival at Ford, but the influence of his design strategy is clear. Another concept car, the Blackwood, is a Lincoln Navigator with a hardcover pickup bed. The bed is appointed with interior running-board lights and exotic African woods. It seems suited for either an affluent rancher or suburban golfer, and it reflects another design trend, the hybrid—odd combinations of car and truck types. The (my) is another hybrid, blending car, truck, and SUV. It has five doors and a glass roof, and the rear doors open to the back. It looks cute, as if it could be called the Turtle, and the lowercase, parenthetical name reflects this.

5. Katherine Yung, "Job No. 1 for Mays: Redo Cars," *Detroit News*, 19 April 1998.

6. At the 1999 auto show, Ford exhibited its hydrogen fuel cell concept car, the P2000 Prodigy, in the form of the world's largest full-color display hologram.

7. Mays was intimately involved in the creation of Ford's 96,000-square-foot display, which featured exotic materials and artful arrangements and cost roughly $30 million.

Bondi Blue: Interview with Jonathan Ive (June 10, 1998)

As I write this update, my interview with Jonathan Ive is almost a year old, and as with all things related to the computer, a lot has happened. The iMac's stunning success played a big part in the close-to-miraculous revivification of Apple Computer Inc. (Other factors include the introduction of the fast and competitively priced G3 CPU and the downsizing of a number of Apple divisions and products.) The company is again among the top five U.S. computer makers and has posted six consecutive profitable quarters. The new iMacs, which went on sale in 1999, were released in five different Life Saveresque colors, and its success has confirmed consumers' desire for individuated product design when it comes to PCs. Apple won't discuss the product, but a clamshell-shaped "consumer portable" (something between a notebook and a subnotebook), sheathed in translucent plastic, was released in 1999. It sounds like the portable version of the iMac, and Ive's team has no doubt been fast-track designing it. If it is as successful as the iMac, Apple will be close to fulfilling the destiny that Steve Jobs envisioned when he returned to the company. Making any prediction about this industry is risky, but I am willing to predict that Ive has created another innovative and appealing design.

In 1997 I participated in a "focus group" that consisted of Macintosh clone users. Its purpose was to find out what it would take to lure us back to buying Macs. Aside from competitive pricing and a conflict-free operating platform, what the group members wanted was an objet d'art rather than a generic box on their desktops—I kept my fondness for the beige box to myself. It would seem that our group accurately reflected Apple's marketing data because six months later the eMate notebook, which looked like notebook hardware encased in a giant flattened jelly bean, hit the market. And in August 1998 Apple introduced the iMac, which is an entry-level computer being marketed as an affordable yet powerful (G3 chip) machine with one-button Internet access and cutting-edge design.

Shortly before its debut I saw one of the half-dozen prototypes of the iMac at a NYMUG (New York Macintosh User's Group) meeting, where it was surrounded by a mob of curious Mac mavens. Although the crowd was grumbling about its lack of a floppy drive and had serious questions about peripheral hookups, the design itself was an overwhelming success.

To my mind, beige and gray are to the computer what white and stainless are to the refrigerator—colors that beg to be changed but are rarely improved upon. The [original] two different-colored plastics of the iMac's shell, however—a translucent teal that Apple calls Bondi blue and a cool, translucent white, called ice—come close to changing this fogy's mind. "Bondi" refers to Bondi Beach, which is near Sydney and has gotten a reputation similar to Miami's South Beach—a happening place for young, attractive urbanites, especially those who love to surf. The color's name conjures the aquatic sensation of seeing the iMac's innards through blue plastic, and its liquidity suggests ease and fluidity of use. (The ability to surf the Net with ease is one of this machine's attrac-

tions.) And "ice" is maxed-out cool—hard, smooth, muscular water—pretty clever color monikering if you ask me.

The iMac's space-capsule look falls into the ubiquitous design style that I'll call "ovoidism" (which Ive, Apple's vice president of industrial design, tells me is sometimes called monoform design). The twentieth century began with Antonio Gaudi's and Victor Horta's fanciful curvilinear designs, and toward its end, after the modernists' romance with less baroque geometries, we've returned to Art Nouveau's whiplash ellipses, at least in consumer electronics and automotive design. If we look at the spectacular success of the VW New Beetle and the designer spaghetti dish of *Lost in Space*, it seems that we want ovoidism to extend into the new millennium as well.

The iMac's design reminds me of Henry Dreyfuss' hugely successful, and somewhat ovoidish, designs for the Trimline phone and Polaroid's Swinger camera. The Trimline was intended to promote the idea of a second phone (especially in the teenager's bedroom), and the Swinger was meant to introduce entertainment picture-taking to young adults. Like the iMac, both designs imbued technology with fun, friendliness, and speedy modernity. Their design, however, wasn't self-consciously disposable, which was a sensation I received from the iMac. There is a thinness implicit in the colors, materials, and forms that gives the iMac a toylike quality—an effect that was no doubt intended, as toys are friendly and fun. Perhaps my parents had a similar sensation when handling the Trimline and Swinger. Or maybe, given that the computer has become the most obsolescence-prone expensive appliance, this reflects an ironic integrity (if such a thing is possible). But, if so, it is a little insidious—like the labels on cans of generically branded food where fake printing flaws are meticulously reproduced. But so what. Successful consumer product design is intended to make us desire an object, and excellent design can make us love it. The Bondi blue and the fun, friendly ovoidishness of the iMac did tweak my desire to possess it, and if I do, who knows, love could follow.

Ive heads Apple's design team and is responsible for the design of the iMac (and Bondi blue) and of Apple's newest line of computers. Since Steve Jobs returned to the company in 1997, Apple has pruned the corporate tree, disenfranchised its clone makers, and concentrated its efforts into three areas in which it has excelled: professional computing (especially multimedia and graphics), notebooks, and user-friendly desktops. Ive and his department have played a major role in Jobs' plan to put Apple back on its original innovative track.

Ive (thirty-one at the time of this interview) was born in London. He has created award-winning designs for products ranging from VCRs to hair combs. He worked for the hip, highly successful London-based design group Tangerine. In 1991 Ive and Tangerine consulted on design studies for the PowerBook. In 1992 Ive left Tangerine to join the Apple design team.

Dike Blair: Can you describe the general design program that Apple presented you with for the iMac?

Jonathan Ive: Basically we were trying to create a hard-core consumer product. The iMac is based on incredibly compelling technology; its capabilities are extreme. The power PC chip is incredibly fast. So much of Apple's roots and equity have been in its

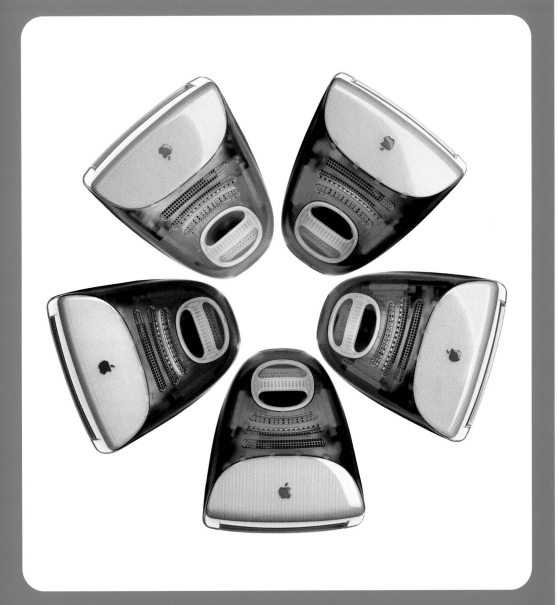

"It's been interesting to us how people have been talking about this sense of future nostalgia. That was completely intentional, although I don't like the word "nostalgia" because it sounds prissy and, from a creative standpoint, can mean a little laziness. I'd rather call it an object that references the familiar."

understanding of the emotional value of objects. Recently the company cared less about that and shipped products that don't reflect that.

DB: Who named Bondi blue?
JI: We're a really small design team, and a couple of the guys had lived in Sydney. It's a beach near Sydney.

DB: It conjures a lot.
JI: It kind of struck a note with people.

DB: Was the eMate your design?
JI: That was done when I was design director. This is one of those incredibly frustrating things. You're talking to me as the designer, but these projects were very much a team effort, and I wish you could be talking to everyone.

DB: When was the iMac design initiated?
JI: We started work on it about ten months ago.

DB: Fast work.
JI: It was really intense, and it coincided with the return of Steve Jobs to the company. Steve has more than appreciation for design; he has a deep understanding of the emotional importance of objects. He's a fantastic collaborator.

DB: Any specific or general inspirations for the design, like the original Mac?
JI: Not really. The goal was to take this incredible technology and connect that up with an object. When you spend time with the iMac, you realize that it is very familiar yet it also lives quite comfortably in the future. It's been interesting to us how people have been talking about this sense of future nostalgia. That was completely intentional, although I don't like the word "nostalgia" because it sounds prissy and, from a creative standpoint, can mean a little laziness. I'd rather call it an object that references the familiar.

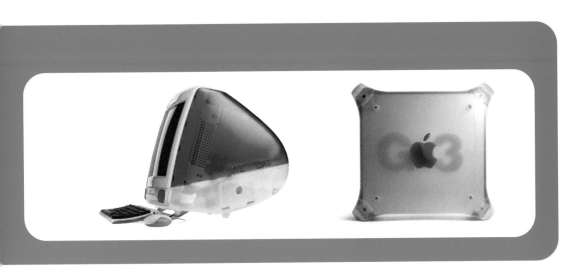

DB: The iMac reminds me of Dreyfuss' aerodynamic stationary objects.

JI: Well, his work reflects the fundamental design principle, that of simplicity. And we wanted the machine to be very simple, or *apparently* very simple.

DB: I think the back of the machine is gorgeous—the sveltest-backed computer ever.

JI: Thank you. Actually Steve Jobs has said that the back of the iMac looks better than the front of anybody else's. One of the things that makes the backs of most computers look so agricultural is the ton of cables pouring out. We moved the connectors to the side, which, functionally, makes them much easier to get to and keeps the back quite simple. The back of my computer may as well be its front in terms of what you see.

DB: Do designers have a term for this kind of ovoid design?

JI: Not really. Some people refer to it as "monoform" in that it's not composed of discrete, primary, formal elements that are then formed together—it's sort of one singular form. But I don't think there is a term that effectively describes what we're doing.

DB: Are there any practical benefits from this design?

JI: The advantages would have to do with the simplicity of the surface. Some people would say that it's easier to move around, to hold, or to clean, but those are fairly dubious arguments. Those weren't the primary objectives of our design.

DB: While we're on form and function, are there any moving parts that one sees through the translucent plastic?

JI: Yeah, there are—on the mouse, for example, which I think is one of the particularly successful parts of the system. If you know how mice work, it's quite intriguing. You see through the Apple logo, like a little window on the top of the mouse, into this little mouse factory. You see the ball moving on twin axles—well, it's actually pretty complicated and intriguing what goes on inside the mouse besides the ball rolling. We've tried fairly hard to layer what you can see inside. For the most part you just get a sense of what's inside—a sense of materials reflecting light and a sense of forms and shapes. It's

only occasionally that you get a more literal view of what's going on inside.

DB: Have there been advances in plastics technology that encouraged your designs?

JI: Not really…. A lot happened in the 1970s with plastic, but through the 1980s and 1990s very little of the potential of plastic's properties was really exploited. When you look at things like the use of translucent PVC back in the 1960s and 1970s, I think, in some ways, we're just rediscovering the material—realizing just how much you can do with it. Our team has the sense that we've just scratched the surface of what's possible. We're looking at some very interesting processes for our future work.

DB: Has CAD affected what you do?

JI: It's been liberating and made things more achievable, but it's only a tool. You can look at early automotive design and see that those guys had no problem—well, maybe "no problem" is an exaggeration—designing incredible surfaces and forms without the aid of a computer.

DB: A tough question: My impression of the iMac was that it had a disposable look. Does one design for that? Do you know what I mean?

JI: I totally understand you. We didn't want it to look trashy. There's a fine line you walk between affordable and cheap. We certainly wanted it to appear affordable, and we wanted to make it clear that this isn't a terrifying technology—a technology that still alienates a huge number of people. We wanted to pop this bubble of, "Computer means: I don't understand this, I don't know how this fits in my living environment." We wanted to create this understandable object. It's weird, but when you do that, you start to reference things that are not intrinsically and terrifyingly valuable. We had some latitude in addressing these issues because the fundamental technology was beyond debate in terms of how powerful and capable it was. What we didn't have to do was use the industrial design to describe its core capability. Do you know what I mean?

DB: I do. iMac's speed and power were well established months in advance of its release. You got "youth" and "fun" in the design, but what about older folks who may have missed the personal computer revolution? I don't really see the design appeal for oldsters, but perhaps they are not your concern?

JI: It was designed for consumers and to be consumed in great volume—and to be relevant to a great number of people. From an appearance perspective we could debate what something like that should look like, but I do hope that the simplicity and functionality—things like the one large handle on the back, which makes it extremely moveable—make it transcend style preferences.

DB: There's a little bit of a hubbub about the exclusion of the floppy drive.

JI: The floppy is a really antiquated technology, and at some point it's really appropriate to move on. At that point of transition, there's always friction. That's just a general statement about the decision not to include the floppy. There have been announcements about third-party producers making USB super disk drives that will connect to the iMac and read standard floppies as well as larger disks.

DB: Your team was involved in the new G3 PowerBooks, which are really beautiful.

JI: Thank you. We were really pleased. It was frustrating in some senses because the iMac was so new and resonant that many people tended to ignore the new Power-Books. Now the reception for the PowerBooks is becoming equally animated.

DB: You've said that this century ends with more of a sense of unfulfilled expectation than one of alienation. What expectations do you expect to fulfill in the new millennium?

JI: Oh, God [laughter]…I think it's going to be an incredible downer because people will see that nothing has really changed. The big challenge will be to get over that. In the beginning there was incredible promise in personal computing, and the industry has never really delivered on that promise. As products become more pervasive and ubiquitous, there will be some really interesting opportunities for designers. At the moment we've created these really artificial categories—it's a bit of an anathema to more progressive design.

DB: What do you think of the idea that organic design in consumer electronics is a prelude to the merger of body and machine? Do you give it any thought?

JI: We think about it a bunch. It's interesting in terms of how designers relate to nature. There's obviously a very literal combination of that which is organic with that which is technological, and then there's the approach of learning natural principles, which can provide an interesting understanding of systems and how systems work. They can provide understanding of structure.

DB: The iMac makes me think of female pubescence. Do you visualize your design as having any age or gender?

JI: Rather than personifying stuff, we try to keep the emotive qualities of the product very general. Color choice was something that we were very conscious of in terms of gender. The Bondi blue was something that we hoped would be universally appealing.

Originally published in *Purple*, no. 2 (winter 1998–1999): 268–275.

Better than Life: Interview with Karen Daroff (January 8, 1997)

Since our 1997 interview Daroff Design has completed a number of projects, including a new interior for Harrah's Smoky Mountain Casino in North Carolina, two Rainforest Cafes, and Disney's Coronado Springs Resort Lake Buena Vista in Florida. In April 1999 I visited Mars 2112, a Daroff Design project near Times Square in Manhattan, which opened in late 1998. Its narrative conceit is that of a simulated space shuttle dinner trip from twenty-second-century Earth to a colony on the Red Planet. Although the decor reminded me of the Fantasea Reef Buffet, which I was so enthusiastic about, the details were very shabby and the food abysmal. And there is a good reason why the experience and the restaurant felt like failure: low cash flow. Late in 1998 the theme restaurant business crashed: most chains' revenues and stock prices have plummeted, many restaurants are up for sale, and the construction and development of new projects have drastically slowed.

The reasons usually given for this turnaround, which took the industry by surprise, are overbuilding, poor management, bad food, and lost novelty. It is only the last item that is a design issue. Design firms like Daroff's take the somewhat self-serving position that what's needed to maintain a restaurant's novelty is frequent renovation of the design and decor. But one wonders if any design or decor, any "built" environment, can keep pace with desires and expectations set by the entertainment industries, by film and TV. Although the restaurant side of its business is off, the range of Daroff Design's clients, from Harrah's to Disney, ensure that the firm is still busy and strong.

Atlantic City casino architecture has been relatively unexciting compared with the architectural extremes of Vegas. A November 1996 visit to the renovated Harrah's casino in Atlantic City suggested that things are changing. The casino is saturated with a blue marine glow and adorned with lots of transparent surfaces. Long, abstract aquatic curves and bubble machines lend an almost serene quality to a room that is the leisure equivalent of the floor of the New York Stock Exchange. At a far end of the casino is the Fantasea Reef, a buffet restaurant and gift shop situated in a faux-coral grotto. Shifting

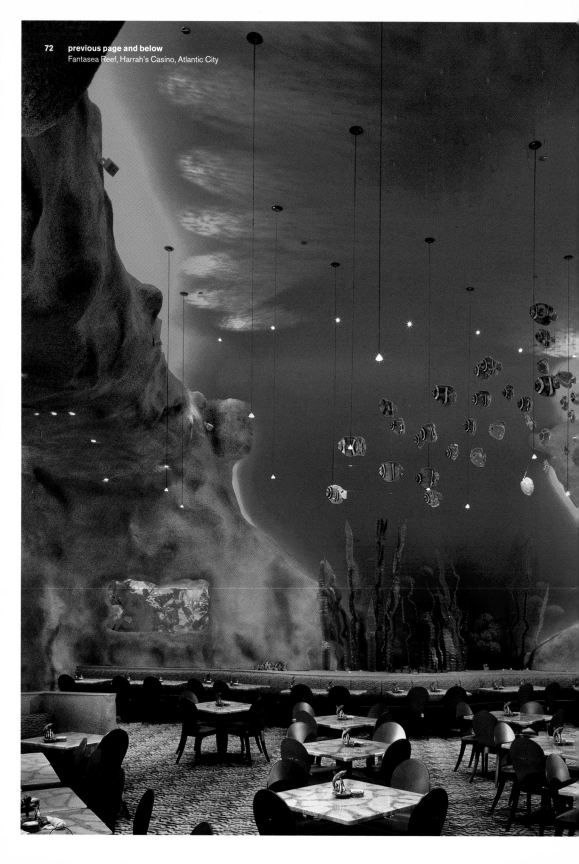

previous page and below
Fantasea Reef, Harrah's Casino, Atlantic City

pattern lights on the ceiling suggest the movement of light on water, and above the banquettes one views ultramarine dioramas through plastic kelp. Multiscreen television aquariums are sunk into the glittering curved walls, and fixed to them are hundreds of realistic silicone sea anemones with interior fiber-optic lights that shift through the spectrum in unison. It all feels like Dr. No's living room on acid. I was curious about who was responsible for this curiosity, and Harrah's referred me to Daroff Design in Philadelphia.

Daroff Design was founded by Karen Daroff in 1973. Her firm had designed a number of corporate offices when, in the early 1980s, it was commissioned to do a major architectural renovation and interior design of the Victorian-era Sagamore Hotel in Lake George, New York. That project spotlighted Daroff Design's ability to work with "hospitality" and "theme" architecture. Wing Chao, a senior vice president of design at Disney, was looking for designers who could design in theme, and after a visit to the Sagamore contacted Daroff, thus initiating their long-standing relationship. The firm did a major interior renovation of Disney's Contemporary Hotel and designed all the public spaces of the Dixie Landings. Among the many (non-Disney) projects in the works at the time we spoke were three Rainforest Cafes. Plans for this "eatertainment" restaurant include an elevator in the interior of a waterfall to raise diners from mall level to a fantastic world under a canopy of artificial foliage where a menagerie of animatronic gorillas, elephants, hippos, and crocodiles, as well as live fish and birds, await them.

I interviewed Karen Daroff in her Philadelphia offices, which house Daroff Design's architects, interior designers, graphic artists, show coordinators, and project managers (fifty-plus employees). Daroff was gracious, articulate, forceful, and resolutely positive in her thinking. Her situation is one that many architects would envy—her firm is in such demand that she can pick and choose her clients.

Dike Blair: What is the difference between interior and exterior architecture?
Karen Daroff: Architecture is architecture. We concentrate on the occupancy use, not the base building, core, and shell. We do frequently team with architects, and we have our own architectural division.

DB: How do you refer to what I would call entertainment/retail design?
KD: I really tend to think of what we do as having more of a capital *M*, marketing, approach rather than a capital *A*, architecture, approach.

DB: Was the shift from corporate interior design to entertainment/retail, or marketing, design a major shift in strategy and practice for the firm?
KD: It was a natural progression for our firm. Toward the end of the 1980s we found ourselves working with companies like Merrill Lynch and Revlon, and the work that we were doing had a strong marketing orientation. Corporate executives wanted to create interior environments that marketed to their employees—environments that would help attract and retain employees. We started thinking more about marketing, and that, coupled with our interest in hospitality design, caused a natural evolution in this direction.

DB: Have you found nonentertainment corporate clients getting more interested in entertaining or marketing architecture?

KD: Yes. I think we're experiencing a really natural crossover between the various types of work we do. You see the computer companies in Silicone Valley using a marketing approach, wanting to create facilities for their employees that are entertaining—when they go into their dining facilities, they're more like restaurants.

DB: There seems to be a confluence of "name" and commercial architects around entertainment/retail/marketing architecture—is there still a class difference?

KD: When I was young and first saw Morris Lapidus' Fontainebleau Hotel, I thought, This work is off-the-wall. I now appreciate where he was coming from. And that's only happened now that my own style and preferences have developed over the twenty-eight years that I've been in practice. The Eiffel Tower is entertainment architecture; Kew Gardens is entertainment architecture. So there can be timeless entertainment architecture when it's done well.

DB: One always hears about the manipulative casino labyrinth. How much of that came into play in your design for Harrah's?

KD: I know that some of the gaming clients have done that in the past; they want to siphon you into the gaming area. We've never done that. In fact, on the contrary, we manipulate in order to reinforce a sense of comfort and orientation. We tried to have continuity of theme lead you through the space so that you're never disoriented. We also tried not to have visual disruptions but rather to have interesting ends of vectors.

DB: Your design is more subdued and delicate than what one usually sees in casinos. Was that a hard sell?

KD: Quite the contrary. Restraint was one of the criteria that was given to us by Harrah's. Management changes and evolves as does marketing. Most of our gaming experience has been with Harrah's, and they've always conveyed to us their interest in making the guest feel welcome, comfortable, and oriented. They want to treat the design in a way that will make both men and women comfortable. As you know, early on, gaming was a male-dominated environment. I think we've worked very hard to make an environment that is welcoming, warm, and gender-friendly.

DB: I don't know if you were ever in the old Atlantis Casino. It had views going out to the sea. Maybe it failed because it reminded the gambler that there was a world outside?

KD: The use of natural light is an interesting issue when working with theme and fantasy. We want the fantasy to be complete, which means not introducing reality. You can make use of natural light through atriums that let in skylight but don't let in visual disruptions. In some cases, like our work with Fantasea Reef or Rainforest Cafe, natural light would be inappropriate. You want to completely control the environment.

DB: What is Disney like as a client?

KD: One of the most thoughtful, creative, and careful clients that we've worked with, and the more I work with other clients, the more I appreciate the very thorough diligence that's applied to every decision in a Disney project. I don't think anyone does it better.

"The use of natural light is an interesting issue when working with theme and fantasy. We want the fantasy to be complete, which means not introducing reality…. You want to completely control the environment."

DB: Disney's Contemporary Resort Hotel interior looks minimal, but more in style than in philosophy.

KD: When we renovated Disney's Contemporary Resort Hotel, we wanted something that was timeless, contemporary design—but not futuristic. The risk of designing something futuristic is that it will look dated. The minimal style we chose was not a cold, hard, overly restrained minimalism. We had a program to do contemporary design for the space, and we interpreted that design in a colorful and lively way. Minimalism can be overly constrained and does not appeal to the public at large—it is aimed at a very small portion of the public—so we needed to be careful not to be overly minimal.

DB: In your mid-1800s "Cotton Exchange" theme at Dixie Landings Hotel, certainly there is no allusion to the role slavery played in the cotton trade?

KD: As in any theme, there are positive and negative elements. It's almost like giving birth. It's very, very painful, but when you look back on it, it is a wonderful and positive experience. In any of our themes what we want to do is to make it bigger than life, exaggerate it, enhance it, and pick out only the most positive aspects of it and make it something that will delight the guest. And that's what we've done here. I don't think that we're ever trying for a slavish re-creation of history. Sometimes reality is very brutal. The whole concept of entertainment is to delight the guest—to have it be fantasy, have it be magical, and have it be a distraction from daily life.

DB: Was there a political correctness meeting around the inclusion of the cigar store Indian in front of the general store?

KD: I think the cigar store image was so appropriate to the period that it would have been missed had it not been incorporated. I think there may have been discussion around not being controversial or wanting to offend—when you're trying to welcome, amaze, and delight, you don't want to be controversial. It's not controversial design.

DB: You understand that I'm looking for inconsistencies between public relations and reality—and revisionist history?

KD: I think it's really all about marketing. Disney is extremely interested in a positive guest experience. They are interested in not misrepresenting history, but they are not making a slavish re-creation of it either. If we show artifacts in the cafe, it is extremely important to Disney that these are real artifacts. There is a combination of reality with fantasy.

DB: Where does Disney draw the line between the real thing and the simulacrum?

KD: All of the work that we've done for Disney has been done in an intellectual pursuit using historic data and reinterpreting it into designs that reflect a spirit of the period in a better-than-life interpretation.

DB: You're now working on the Rainforest Cafe. Would you describe that project?

KD: The rain forest is a happy combination of many different elements of multisensory stimulation. It is just the right formula—of aroma, of sound, of visual attraction, of stuff that makes you smile and feel good. It's really difficult to analyze, but when it all comes together, it's an amazing success. It's not pure design, it's certainly not minimal design,

and it doesn't have the attention to minute detail that some of our projects have, but the overall effect of bubblers, parrots, talking trees, foliage all around you, and also sound…it's better than a rain forest. It's an illusion, a magical experience that makes people feel good and also encourages them to enjoy the shopping experience.

DB: In your brochure you mention that the Rainforest's mission statement incorporates the "Five E's—Entertainment, Education, Environment, Employees and Earnings." How is the restaurant educational?

KD: The Rainforest Cafe conducts tours for schoolchildren to teach them about the rain forest environment. They take them and introduce them to the parrots, and all the fish in the aquariums are identified. So the schools choose to come visit the Rainforest, and it is an educational experience for them.

DB: Did the demolition of the Landmark or the Dunes stir anything in you?[1] How do you feel about the disposability of entertainment/retail architecture?

KD: We would all like to be doing architecture that would survive twenty, forty, one hundred years. I hark back to Kew Gardens and the Eiffel Tower and even Howard Johnson's orange roof or the Golden Arches. These are memorable architectural or graphic forms that have lasted a very long time. Some become landmarks, and some become disposable. It really depends on the original client's goals and objectives. One would always want to honor the Eiffel Tower and preserve it. I don't think that the Dunes and the Landmark fit into that category.

DB: The Landmark was pretty great…

KD: Certain elements. But I don't think it was built to last. We work for clients, and the client has certain marketing and fiscal considerations. It's our job as professional consultants to support and enhance those ideas.

Originally published in *Purple Prose*, no. 12 (summer 1997): 168–176.

Notes

1. The Dunes, which was demolished in 1993, was a Las Vegas hotel and casino that stood in the spot now occupied by hotel and casino impresario Steve Wynn's Bellagio. The "implosion" itself was a major entertainment/publicity event that coincided with the opening of Wynn's Treasure Island Resort Hotel and Casino. The Jetsonesque Landmark was a restaurant and casino that was demolished in 1995. Its former site is now used by the Las Vegas Hilton as a parking lot. The Landmark demolition was executed with little fanfare, but it was filmed for the 1996 Tim Burton movie *Mars Attacks!*

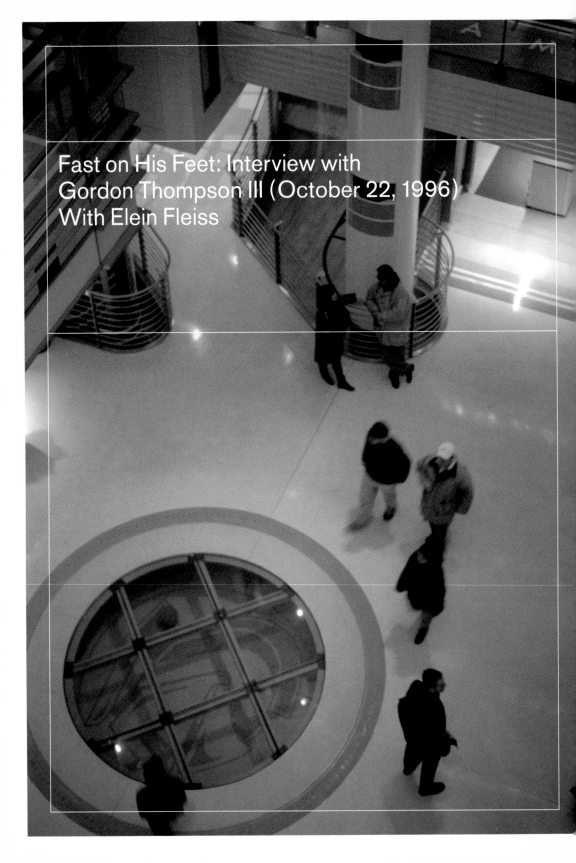

Fast on His Feet: Interview with
Gordon Thompson III (October 22, 1996)
With Elein Fleiss

Everything—art, science, philosophy, and athletic shoes—is subject to the whim of fashion. The Nike swoosh no longer has the street cool it did in 1996, when Elein Fleiss and I interviewed Gordon Thompson III. At that time Nike owned the athletic-shoe market, and the company was golden. Since then, however, Nike has suffered some setbacks, and although it remains the top athletic shoe company and its stock has recovered from a 1998 low, both the company's market share and its profit margin are down. Only eleven of the twenty Nike Town stores initially planned have been opened. Nike is a flexible and diversified corporation, however, and several of its lines, such as the USG gear, are doing quite well. Entertainment architecture has been particularly vulnerable to early aging, so I recently revisited Nike's flagship store, Nike Town NYC, to see how it was holding up. I was somewhat surprised and impressed to find its architecture almost as exciting and entertaining as it was when it opened, and much credit for this must go to the designers, Thompson and John R. Hoke III.

In July 1999 Thompson moved to Nike subsidiary Cole Haan as creative director. Cole Haan is a luxury footwear and accessory brand that Nike wants to infuse with some fun and fashion appeal. Thompson's design strength, his perceptive sense of trend, and his expertise in developing branding strategies and concepts bode well for the future of Cole Haan.

Nike Town NYC, the flagship superstore for Nike, opened in midtown Manhattan (at Fifty-seventh and Madison) on November 1, 1996. It's a unique and remarkable construction. There are no architects credited for the building—rather it was "designed" by Gordon Thompson III and John R. Hoke III, who, not surprisingly, used to work in Michael Graves' firm. Nike Town NYC is state-of-the-art entertainment/retail architecture.

The store is housed in an entirely new building, but its conceit is that a contemporary space has been built inside the shell of a Depression-era public high school gymnasium. The gym is treated as a landmark that Nike, out of consideration for the proud tradition and history of athletic endeavor, preserved. Here and there, details like bleachers and scoreboards are revealed through the new construction. Nike describes the concept as "a ship in a bottle," but it is really more like a microwave oven placed inside a wood-burning stove. One enters at street level through the PS 6453 (telephone code for Nike) facade and passes through a vestibule resembling a fluorescent-lit Nike footwear mausoleum and into a steeply vertical atrium surrounded by five separate shopping levels. Within the atrium is a gigantic sports clock with a twenty-minute countdown. When it hits 00.00, a curtain lowers over the gigantic Palladian window on Fifty-seventh Street, and a mammoth scrim descends the length of the atrium. An inspirational Nike commercial with superb production values is projected on the scrim.

There are quite a few wonders sprinkled throughout Nike Town NYC. Customers can use the NGAGE digital sizing system for highly accurate infrared scans of their feet. And if one decides to make a purchase, the order is carried from the basement to anywhere in the store in one of twenty-six transparent Lucite shoe tubes. This is the sixth and most ambitious Nike Town to open, but in the next three to four years, twenty others are slated to open in cities such as London, Paris, Berlin, and Tokyo.

The Nike swoosh is perhaps the most recognizable corporate logo in the world. Since the 1970s Nike has invented or reinvented almost every aspect of the athletic shoe and sporting apparel market. Its founder and largest stockholder, Phil Knight, delivered one of our favorite quotes: "There is no value in making things any more. The value is added by careful research, by innovation and by marketing."

We wanted to talk to a Nike designer about the shoes and the corporation, and were led to Thompson, the company's vice president of research, design, and development. Thompson struck us as energetic, talented, quick, and insightful—a fast-on-his-feet spokesperson for Nike. It was clear that he is partly responsible not only for Nike's amazing footwear but also its beautifully crafted image.

Dike Blair and Elein Fleiss: How long does it take to design a shoe?
Gordon Thompson: It depends on the athlete who's going to wear it, who it's designed for. It takes more time if there is a lot of new technology, and it depends on how the shoe's going to be manufactured and put together. We've had shoes take all of three years—from concept to shelf. On average the design time of a shoe is about six months—that's design development to the sales meeting. Average design time itself is about three months. Then it takes a year to commercialize the product.

DB AND EF: What about ideas—research and development?
GT: In footwear design there's advanced product engineering that begins one to three years prior to the delivery date. We look at running, for example, in the future and decide what we need in terms of new fabrics, materials, cushioning systems, and other new ideas. And then there's a group that works three to seven years ahead of delivery date. It's made up of twelve people who get really abstract about the way things are going and how we're going to progress. Foot dimensions, smart product, customization—they consider all those things.

DB AND EF: Do you have any plans for computer chips in the shoes?
GT: We've knocked that idea around a lot. I think someone will get there first; I don't know if it will be us. What a chip does for you, and what it tells you, is something of debatable value when you talk to an athlete. For the average runner, it would be great to know how far you ran, then you could get your average split time, your timing per mile—chips could do all these things. It can get pretty complex. We think the technology is there to connect something you'd wear on your wrist to something you'd wear on your feet; it's just how to implement that idea that's the problem. We've worked with Apple, Microsoft, and the Media Lab at MIT; they're a great source of inspiration to us.

DB AND EF: What are other ideas for future product?
GT: A lot of the concepts have to do with injury prevention and with customization—my left foot's larger than my right foot, so how do I accommodate for that when I'm buying a pair of shoes, how do I make the fit better?

DB AND EF: You make decisions that have less to do with comfort or injury prevention than with style. Do these decisions masquerade as technological innovations?

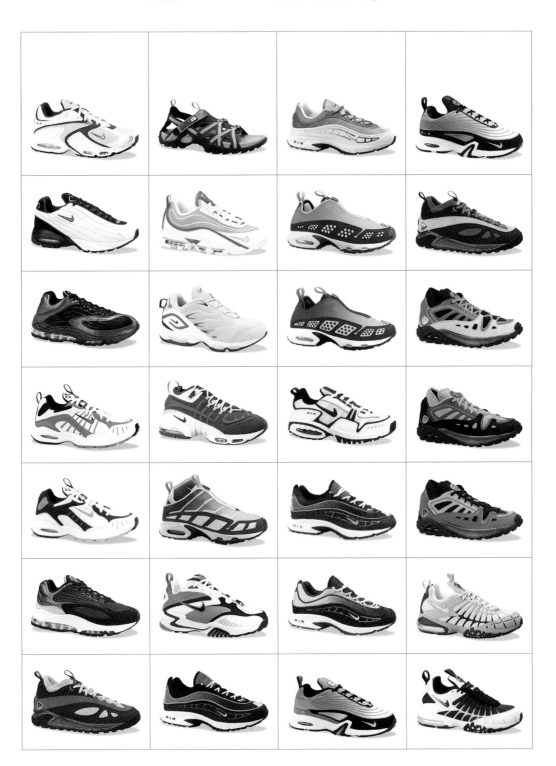

"We don't make gratuitous design decisions. If we're going to do an interesting lacing system on a shoe, we'll make sure it works. It may be aesthetically pleasing, but it had better work."

GT: I think that's a matter of how you define innovation. We don't make gratuitous design decisions. If we're going to do an interesting lacing system on a shoe, we'll make sure it works. It may be aesthetically pleasing, but it had better work. When I discuss this fashion question, I always say that when you're designing for Pete Sampras, Andre Agassi, and Michael Jordan, they're not going to take crap and stick it on their foot. They wear the exact same product, so we're dealing with a pretty high level of product integrity.

DB AND EF: Are there collectors who have all the shoes?
GT: There's one store in Tokyo that has all the old Nike products. I went there with the head of apparel design and the head of footwear design—we were on a kind of junket. We laughed so hard; it was like the Nike Hall of Shame. Horrible product, and they were charging thousands of dollars for this stuff that I designed five years ago. I remember thinking, "I can't believe someone would pay this much for this shit"—but they did and they are.

DB AND EF: How many models are there at the moment?
GT: Too many [laughter]. We design about three hundred shoes a year. And, even worse, within worldwide footwear, apparel, and equipment there are between ten and eleven thousand projects a year. We're putting a lot out there.

DB AND EF: Is there a design star at Nike?
GT: We're not much on the "Gordon Thompson for Nike" sort of thing; it's not our style. People have said we should do that, but so far we haven't gone down that road.

DB AND EF: Do you pay attention to fashion designers—like Comme des Garçons and Yohji Yamamoto?
GT: Of course. The best designers always know what's going on in the world. We know what's going on in film, in sports, in fashion—where all the trends are going. Do we sit and ponder what Yohji's going to come up with this season? No. I'll think of someone like Issey Miyake, partly because I think his product is amazingly engineered. I'll look at how he seams something together and what kind of materials he used. You can definitely take inspiration from something like that.

DB AND EF: Do you look at what kids do to your shoes—do you get inspiration from streetwear, like lacing variations?
GT: Not really. We're a pretty focused company; we make products for sports. People can take the product and do what they want with it, but we need to make a basketball shoe that's good to play basketball in. All the other stuff is the by-product of having a brand that people are excited about.

DB AND EF: Isn't the percentage of nonathletic people wearing Nike increasing?
GT: It may be increasing, but I think that young people are increasingly athletic.

DB AND EF: Rock bands are wearing the shoes. You don't design for the nonathlete?
GT: Like rock bands? [Laughter.] No. Then we'd totally lose our focus. If we go down that

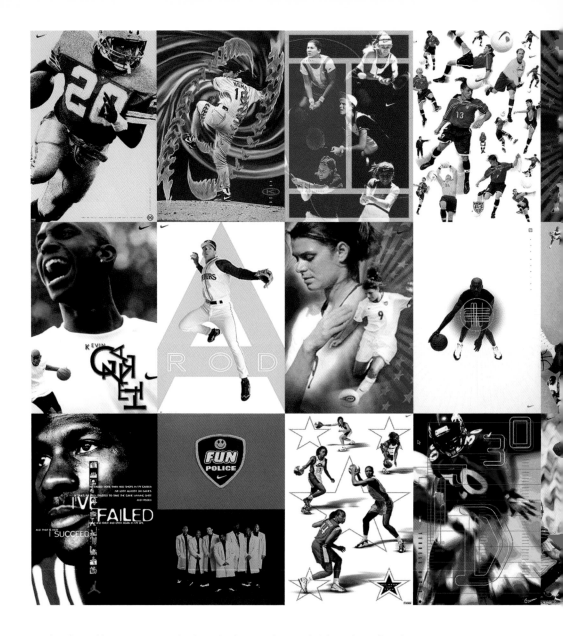

road and an athlete puts on a pair of tennis shoes and severely injures herself, we're hosed. We've totally blown the idea of our product.

DB AND EF: Even the design of the nonperformance aspects of the shoe?
GT: I don't think we need to pull in some young punk who's customized his laces and suggest that we copy it. We should be leading—Nike is not about following. I wouldn't work for Nike if it began following.

DB AND EF: Are more concessions made to nondesign departments than you would like?
GT: I'm a designer, so of course I think the answer is yes. [Laughter.] Nike's a matrix organization. Since we're set up in matrix, there's lots of dialogue and lots of communi-

cation. Any concessions are not made solely by design. Instead of saying, "Design has to take $10 off the price of a shoe," it's more like, "Let's take $5 off the design and $5 off the advertising." In general, people in the company have a good sense of design and realize that design is what makes the product exciting, new, and innovative.

DB AND EF: Who designed the Nike logo?

GT: The swoosh? It was designed by a woman in Eugene, Oregon, in 1972. Carol something. [Caroline Davidson—ed.] She was an art student. Phil [Knight], the head of Nike, needed something that fit on a shoe and asked her to come up with something. She was paid $35.

DB AND EF: What does she do now?

GT: I think she's a housewife in Oregon.

DB AND EF: Is she now on welfare?

GT: No, I think Phil has taken quite good care of her.

DB AND EF: What do you think of the malling of America and the globe?

GT: For a long time retail was in a funk, and I think that department stores were responsible for that—mass marketing overtook creative merchandising. Where retailing really got going was in bringing brand names to life. In this city [New York], Bergdorf's, Macy's, and Bloomingdales became their own brand. The one thing those stores had in common was that they used creative presentation, but somewhere along the way that got lost. Now people want a product that says what it stands for and what the company stands for. We started Nike Town in 1990 in Portland, and it created this whole new entertainment retailing—which kind of makes me gag—but I think it convinced retailers that they had to do something about the state of retail and about giving consumers more than, "Here's a hanger with something on it." What do you think?

DB AND EF: We imagine that once the world is a homogeneous mall—when entertainment retail is everywhere—interesting design will start to grow between the cracks.

GT: We call that Zip-code design.

DB AND EF: Do Nike Towns have to make money?

GT: They have to break even. Otherwise we wouldn't do it. We have stockholders we have to satisfy. But that's not the only objective. We wouldn't have torn down a building and built a new one if profit was our only motive. We want to give consumers more information about Nike than they can get in thirty seconds on the box in their living room.

Originally published in *Purple Prose*, no. 12 (summer 1997): 114–124.

LET'S PUT THE FUTURE BEHIND US

"A remarkable novel . . . The grimmest, funniest, and one of the most cannily on-target accounts yet about the helter-skelter fast lane of life in the New Russia."—*The Boston Globe*

A NOVEL BY

JACK WOMACK

It's Always the Same: Interview with Jack Womack (August 1995)

I'm particularly happy to have this interview with Jack Womack included here, not only because I admire his work but also because he represents the only artist in this collection without a corporate boss. For obvious reasons the various corporate designers were loath to respond to the difficult or critical questions with anything other than well-spun, positive answers. This can be frustrating for an interviewer, especially one who is also a bossless artist. Womack represents only his art and has less to lose by revealing the relentless self-criticism that is implicit in the creation of good art, "commercial" or "fine." I like the fact that the engine that drives many of Womack's plots is the nefarious fictional megacorporation Dryco. After the corporate feel-goodness of the prior courses, Womack's bleak world view and sardonic humor provide an antidotal dessert.

In 1996 Womack published his sixth novel, *Let's Put the Future Behind Us*; it's a non-Dryco book set in present-day Moscow, and it received very favorable reviews. His new novel, *Going, Going, Gone*, is due out sometime in 2000 and will conclude his Dryco series. All his earlier, out-of-print novels have been republished.

We live in a world nervously approaching the millennium, with little in terms of surety other than the fact that the future is getting here, and getting here fast. More and more people, our writers included, are spending more and more time trying to find the formula that predicts what tomorrow will bring. With tomorrow being today's subject for many writers of contemporary fiction, it seems quaintly antiquated that we apply the label "science fiction" to only a few. Jack Womack's books take place in a possible future of a world much like ours, so they have been marketed as science fiction and are sometimes grouped with the cyberpunks, for the lack of a better category. On a literary level, however, Womack has more in common with Cormac McCarthy than with Bruce Sterling, and his visions are more Charles Dickens than Neal Stephenson. Womack's 1994 book, *Random Acts of Senseless Violence*, has found success with a mainstream (non-sci-fi) audience.

Womack has published five novels—*Ambient* (1987), *Terraplane* (1988), *Heathern* (1990), *Elvissey* (1993), and *Random Acts* (1994)—which, taken together, plot (non-sequentially) a timeline that begins in a very near future and ends roughly fifty years hence. They can easily be read independently of one another, and calling them a series does not seem entirely accurate. They share a world, some characters, and Dryco, a transnational corporation that functions as a combination of family, government, and church. But each novel features very distinct (if uniformly bleak) voices and visions. Womack takes our most frustrating and demoralizing problems—violence, homelessness, injustice, and exploitation—then amplifies and extends them. His future does not titillate with wonderful and strange possibilities but terrorizes with the grimmest possibility of all—more of the same. The most impressive thing about these works is that, as they chronicle the development of Dryco, they also plot an evolution of the English language. Womack mutates grammar and etymology to create a WomackSpeak that is perfectly molded to the unique and depressing contours of WomackWorld.

Dike Blair: You use many of the same devices as other contemporary fiction writers, but it seems that by choosing the science fiction genre you avoid the annoying auctorial voice. Your near future is not so different, for example, from the one created by Martin Amis in *London Fields*.

Jack Womack: No, it's not. What I've done in all my novels is to use a first-person narrator—something that goes against conventional wisdom if one is not writing an autobiography. I try to sink myself deeply in the character before I begin writing, so that if I get the voice right in the first ten or twenty pages, I can use it effectively and relatively effortlessly for the rest of the book. I try to sound like reports from the future, a Russian writing in English or a twelve-year-old girl writing a diary. So far I've been lucky with this. At the same time, I think I've developed a distinctive enough style that my voice permeates the novel—a kind of WomackSpeak. I do know what you mean by that annoying voice. I try to keep the auctorial hand as invisible as possible.

DB: Is that a result of writing within a genre in which there are certain rules?

JW: I never knew what the rules were—with science fiction at least. I'd never read science fiction, except maybe Jules Verne when I was a kid, and in the 1970s I read *Man in the High Castle* because of a Paul Williams article I'd read in *Rolling Stone*. When I was writing *Ambient*, I realized that it was going to take more than one volume to get what I wanted. I was unaware at the time that one of the most popular forms in science fiction, almost a standard practice, is the trilogy. It's not really used that much in regular literature. Of course, as I went on, I became aware of the conventions of the genre, so when I wrote *Elvissey*, perhaps my most science fictional work, I tried to turn those conventions inside out. For instance, the Gibsonesque razor implants in my character's fingers—they seemed to be very convenient things to have if you wanted to kill yourself. So when I used them for the members of my security force, who would naturally be homicidal-depressives, I put them to the obvious use. I was pleased when *Elvissey* was a co-winner of the Philip K. Dick Award, as he is one of the few science fiction writers whose work, by and large, I've liked.

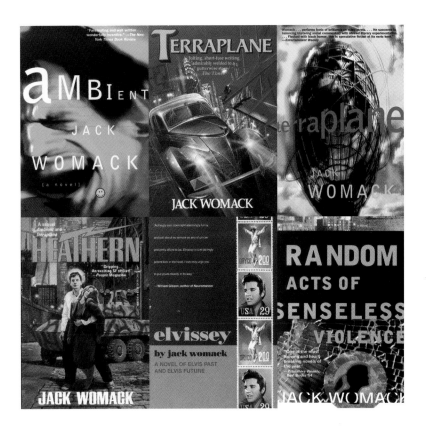

DB: What about J. G. Ballard?

JW: Ballard's another one, but I hadn't read him until *Ambient* was already out. A reviewer in the *Village Voice* described me as a neo-Ballardian, so I borrowed *Crash* from a friend and really enjoyed it. Even if they're coming out of the field, both these guys' world views end up being very different from traditional science fiction, and they're more talented writers as well.

DB: I imagine that the literary quality of your work doesn't appeal to Hollywood.

JW: Actually, I've sold options on two of the books. *Ambient* has been in the hands of Bruce Willis' people for a few years. When they reoptioned it this year, it enabled me to quit my day job.

DB: How does your stuff go over with the traditional sci-fi audience?

JW: A friend of mine always berates me for not literally designing the organizational structure of Dryco. I tell him it's a metaphor. I've gotten complaints from people like, "everyone uses that plot line," but I think they're missing the point.

DB: The fact that some of your extrapolations fairly obviously won't happen makes them more disturbing than if they were plausible.

JW: Anybody can take Microsoft and just make it bigger—then you essentially have a business textbook. That's one of my big problems with science fiction—so much time is taken explaining how something works. I prefer to say "here it is—deal with it." Some readers really like that, and some really hate it.

DB: What are the ingredients of WomackSpeak?

JW: For *Ambient* I took contemporary English and pushed it a degree. AmbientSpeak itself resembles Elizabethan language. I borrowed from Thomas Nash's *The Unfortunate Traveller*, a great sourcebook for this kind of thing. In terms of the rhythms, I always read aloud to make sure it's got the right beat—not a metric beat, just a rhythmic pattern.

DB: While reading *Random Acts*, I was struck by your vision of the tenuousness of any kind of physical security in our society.

JW: Everybody in America is one paycheck away from disaster. We convince ourselves that we're not, but you get two bad weeks in there, and you have real trouble. In *Random Acts* I'm saying, "This could happen to you—think about it."

DB: Your books suggest that your politics are pretty radical. What are they?

JW: I'm pretty far left—I'm pretty anarchic. The thing is, the left, here and in England and Europe, has been pretty much in utter disarray for about the last thirty years. I want to kick my fellow leftists, although I certainly don't have any solutions to the problems of the day. You can see where things are heading, but that doesn't mean you just throw up your hands and say, "Well, it's A.D. 500, and the King and his minions live up on the hill in the castle and everyone else lives out in the horse shit surrounding."

DB: One can stay vigilant and conscious?

JW: Right. One can be aware of what's going on. Any artist hopes that whatever he, or she, does is, first, for the artist's satisfaction then, second, to make an impact on one single person's mind. That's why the writer tries to seek the broadest possible audience. I know that I will never have the audience of a James Michener or a Stephen King; I just don't have that popular touch. I know my limitations and abilities and try to do the best I can artistically. What I try to do is just write, try to get the ideas across in a nondidactic way, because nothing turns an intelligent reader off more than being hit over the head with politics.

DB: The left seems to have no political model upon which to build, and this also seems to apply to our technological ideologies.

JW: We're fortunate/unfortunate enough to live in an age that is the equivalent of the late 1700s in England, where you not only had fairly sweeping political changes but also changes from an agrarian society into an industrial one. No one in 1750 England could guess what 1850 England would look like—there were no futurologists at the time, and one could simply not have guessed what would come. Even now, with all our experience with projections and computer models, there's still no way of telling what things will be

like fifty or sixty years from now. We can figure things will probably be, to some degree, the same.

DB: You've said that people don't learn from history.

JW: We'd certainly like to think that people learn from history, but they don't—certainly not in America, where things that happened six months ago may as well have happened in 1840. This is not only in a broad political sense but in people's personal lives as well. I think this is just human nature. Sometimes I fear that this fairly low opinion of human nature lands me in the same territory as people with much more conservative agendas. Where we differ is that they would leave things as they are, while I would change them— I just don't know how.

DB: For someone with seemingly populist politics you don't seem to have much faith in "the people."

JW: Well, again, that's what puts me uncomfortably close to certain conservatives who have an elitist outlook. My view of human nature makes me elitist in a number of areas. I think there are very few people who actually know what's going on. I have an equally jaundiced view of liberal-elites who tend to get so detached from reality that their well-intentioned master plans go wildly astray for no other reason than their inability to under-stand the human dynamic. Shall we just say that I think both sides should be equally bashed? I would hope that saves me from being a standard elitist, but probably not.

DB: Do you spend time on the Internet?

JW: Very little. I use it for e-mail, and I check out some alternative sites. I don't really want to go on a bulletin board with people who, if they're not fourteen years old, act like it. The whole debate about whether the Net is a good thing or a bad one is like that Certs ad— is it a breath mint or a candy mint? Both sides end up looking equally idiotic. Any new communication technology breeds this enthusiasm about how smart and well informed people will become, but ultimately it only seems to further distance people from one another. Its the same with these utopian hopes that arise around new technologies.

DB: Shouldn't we be grateful for utopian fantasies?

JW: They keep people going. Many of my characters are, at heart, utopians placed in dystopic situations. Hope helps keep them going.

Originally published in *Purple Prose*, no. 10 (winter 1996): 74–80.

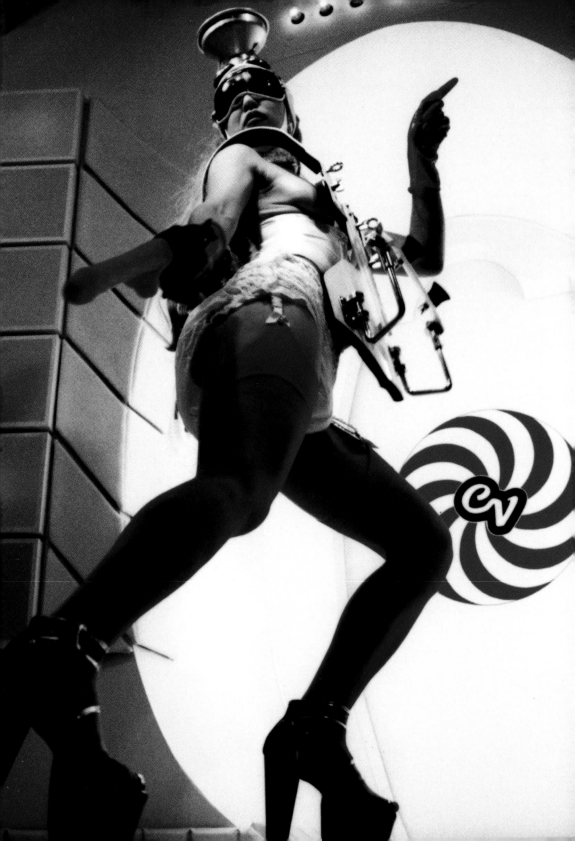

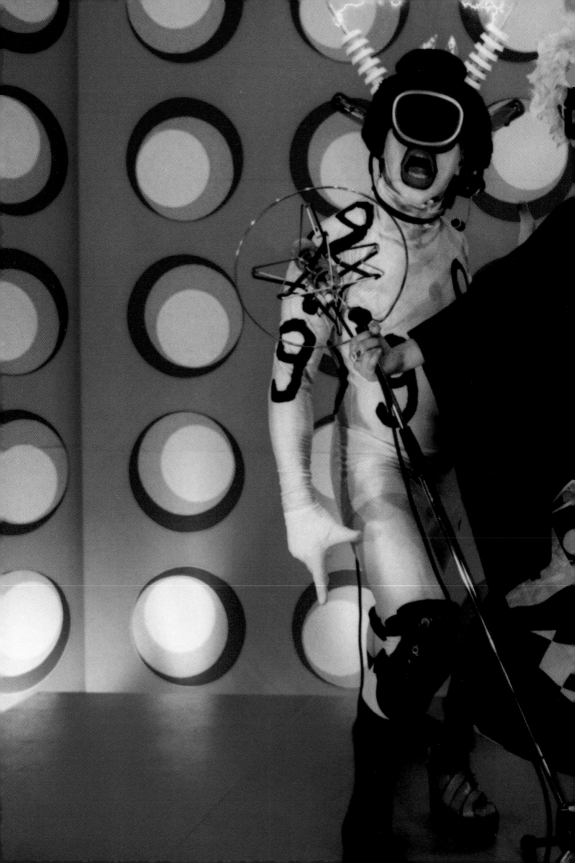

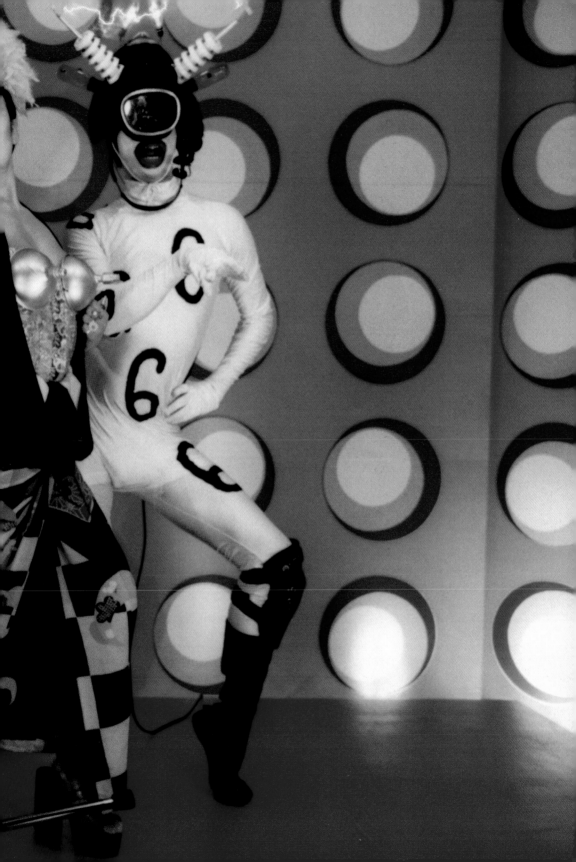

below and previous pages:
Kyupi Kyupi I++ 1999−2000 (cat. no. 42)

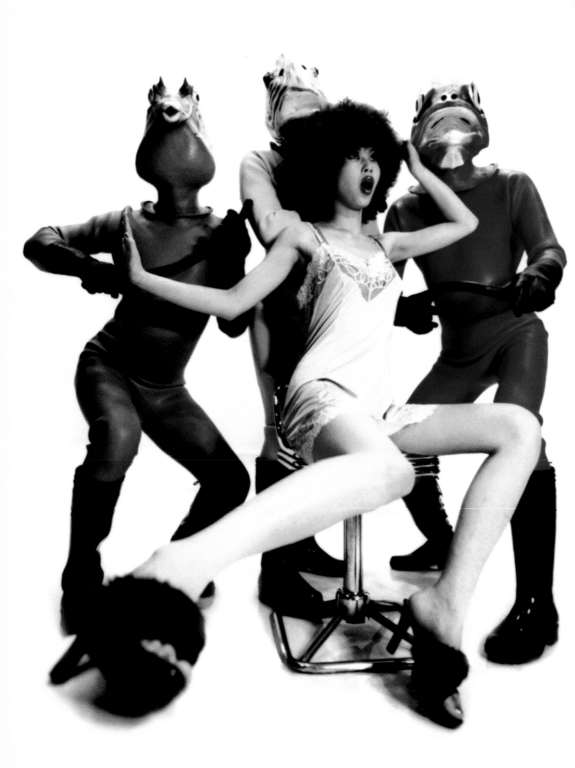

The Business of Fun
Emma Duncan

Entertainment is a global business run from a village. Draw a rectangle from New York's Central Park, five blocks across and twenty blocks south, and within it you will find most of the world's most important media companies. Time Warner, Seagram, News Corp, Viacom, and Bertelsmann's music and television interests are all run from there, as are NBC and CBS, two of America's big broadcast networks. ABC has made a wild, individualist break for freedom, moving a few blocks up the west side of Central Park.

The entertainment industry is not a huge business by the standards of some other industries. Its biggest company, Time Warner, is, by market capitalization, around one-third the size of the biggest oil and pharmaceutical companies. But because entertainment has such a huge impact on our lives—through the way we spend our leisure time and the power that its images have over our society's self-image—it holds a far greater fascination than do most businesses. And, right now, the entertainment industry is going through a particularly interesting time.

The entertainment business consolidated dramatically during the 1990s. In the United States, in the five years between 1991 and 1996, the top six companies' share of the industry grew from just over thirty percent to just under sixty percent. By 1996 there were seven huge companies: Time Warner, Walt Disney, Bertelsmann, Viacom, Sony, and News Corp had been joined by Seagram, a Canadian beverage company, whose scion, Edgar Bronfman, thought that the entertainment business looked more interesting than the whisky business.

Since the beginning of the decade, the entertainment companies have transformed themselves in two ways. They have grown up as businesses, transforming themselves from the fragmented fiefdoms of powerful individuals into huge corporations that have consolidated around a particular, recognizable strategic model, and they have all pushed their boundaries out into the world. But now these great global money-making machines face a great uncertainty: will the digital revolution that is now taking place make them more powerful still, or will it replace them with Internet-spawned upstarts?

The Model of a Modern Media Company

Here's how it works. 20th Century Fox, the Hollywood studio owned by Rupert Murdoch's News Corp, created The X-Files in 1993. It was licensed to News Corp's Fox Broadcasting Company and was received unenthusiastically by reviewers and public alike. Made by anybody else, it would have sunk without a trace. Because its producer also owned television outlets, however, it got a second run. The video was released and, mysteriously, became exceptionally popular in Japan. It was licensed to News Corp's forty percent–owned BSkyB in Great Britain. BSkyB, a newish satellite service desperately short of product because the British incumbent broadcasters refused to sell it any programming, was pathetically grateful for the series and ran it wall-to-wall. The British public fell for The X-Files. News of British X-Files madness spread to America, helping to propel the series to stardom there.

In America the series was then syndicated on broadcast stations. (Fox owns twenty-two of them, which helps.) It showed on Fx, News Corp's cable entertainment network. Fox Interactive produced two games related to the series; HarperCollins, News Corp's publisher, brought out books; Fox Music brought out CDs; Fox Licensing and Merchandising took care of the T-shirts and the dolls—all of which multiplies the profit to

News Corp. If News Corp just made the programs, companies controlling all the other distribution outlets would rake off those margins. News Corp would still do well out of a hit like *The X-Files*, but not nearly as well as if it controls the whole process.

This is the logic behind the "event" movies that the entertainment companies all talk about these days. *Godzilla* tried and failed to be one. *Star Wars Episode 1: The Phantom Menace* tried and succeeded, even though it was a lousy movie. The scale of these huge companies ensures not only that they control all the outlets but also that they have the cash and clout to conduct huge marketing campaigns that sear their latest product into everybody's memory.

This is branding, and branding is what the entertainment business is about these days. Brands do not have to start life as movies. Viacom has turned its television cartoon series *Rugrats* into a brand; one of Time Warner's most successful brands, Batman, began as a comic-book hero. What all of these brands have in common is that they appeal either to children or to teenagers, and they are universally appealing. Everybody, from Papua New Guinea to Peoria, understands the superhero in the Batman or Superman movies; everybody shivers to the supernatural, as in *The X-Files*; everybody even has horrible children like the Rugrats (though the rest of the world does tend to think that this is an area in which America specializes).

Think of a wheel: this is how these companies work. At its hub lies content creation. The spokes that spread out from it are the many different ways of exploiting the brands that the content creators have come up with: the movie studio, the television broadcast network, the cable network, the publishing, the music, the video games, the toys, the Web site, the theme parks. For the companies, the brands spin in a wonderfully virtuous circle. Each of the outlets is both a way of making money and a way of promoting the brand. So every *Little Mermaid* video reminds children of her cute little nose and splashy tail, which encourages them to nag their mother to buy them a *Little Mermaid* pencil case, which drives them to yell harder for another trip to Disneyland, and so on.

Adopting this model poses two sets of problems: putting the pieces in place and getting them to work together. Over the past decade the big companies have made a grab for the bits of the business that they reckoned they needed to make it work. Most of them have now got what they thought they needed. Businesses that did not fit have been spun off: Viacom, for instance, sold the educational side of its book subsidiary, Simon & Schuster, to Pearson last year.

Time Warner, which has all its spokes in place, has got television production, film production, a broadcast network, cable networks, theme parks, a music company, a publishing company, shops, and hefty investments in the Internet. Disney, similarly, has got the whole model in place; Viacom has everything except the music; News Corp has everything except the theme parks; Bertelsmann lacks the cable networks and the theme parks; Seagram has everything except publishing and broadcast television.

But putting together the pieces is not enough. The bits of the business have to be managed so that they add value to one another. Most people would call this "synergy," but the word has bad vibes in the entertainment business. It was used too often in the 1980s, when the Japanese companies that made television sets bought the Hollywood companies that made television programs, and is therefore associated too closely in people's minds with large amounts of money being lost. So many in the entertainment

business these days try to find a synonym.

Disney, however, has been working long enough at creating synergies within the company not to be embarrassed by the word. It was Walt Disney, really, who invented the model that other companies are now emulating. He established his happy band of Imagineers, the core content creators, whose job was to dream up ideas that all the other divisions in the company could use. That is how the company still works, and there is even a central synergy department, with about fifty people spread around the various divisions. The job of the synergy managers is to make sure that the company's divisions work together so that all possible value is squeezed out of each piece of original content.

Within the great Disney empire, the model has been developed as far as is reasonable and beyond. After the films came theme parks and consumer product divisions, then book publishing, magazines, music, a cable channel, stores, cruise ships, sports teams, hotels, time-shares, and even a town. The latest expansion is the biggest risk yet: buying ABC, the broadcasting network. So far, it does not appear that ABC is contributing much to Disney, or Disney much to it. Most likely, however, as the costs of creating programming for broadcast networks continue to soar, ABC will become for Disney what the broadcast networks that Time Warner and Viacom have created are for them: ways of promoting, and thus creating value in, television programs that will then be sold profitably in broadcast syndication or on cable networks.

Synergy is also proving a bit of a struggle for Time Warner. Before the merger with Ted Turner's company, Time and Warner were not working together at all. Somehow, though, the Turner merger seemed to make sense of what until then looked like a bad match. It may be that Turner's cable systems worked better with Warner's film business and Time's publishing business than either did with the other. It may also be that Ted Turner's rough-and-ready management style knocked together two standoffish teams. In any case, Time Warner is beginning to stick together as a company.

Bertelsmann is the odd-one-out of these seven giants, not just because it is the only European company among the pack but also because it is privately held. It is owned and controlled by a foundation set up by the founder's family. And the idea of decentralization, of the independence of the different divisions within the company, is deep within its culture. Whereas American companies emphasize how interdependent their divisions are, Bertelsmann's executives pride themselves on their separateness. Gerd Schulte-Hillen, chairman of Gruner+Jahr, Bertelsmann's magazine publisher, calls independence "the motor of innovation."

But this is changing. Bertelsmann's new boss, Thomas Middelhoff, who took over in November 1998, has a different view. While respecting the company's history, he believes that it needs to move somewhat in the direction of the American companies. This need has been brought home sharply for him by the Internet, which none of the company's executives had focused properly on.

The Internet is not just a huge opportunity for Bertelsmann but also a massive threat. Bertelsmann's business was based in book clubs. Book clubs—which recommend titles and offer them at a discount to members—are made redundant by the Internet. Think about it: Amazon.com is a book club. It recommends titles and offers them to buyers at a discount. So Bertelsmann suddenly woke up last year and realized that its business was being ripped out from under it. The company has now reacted

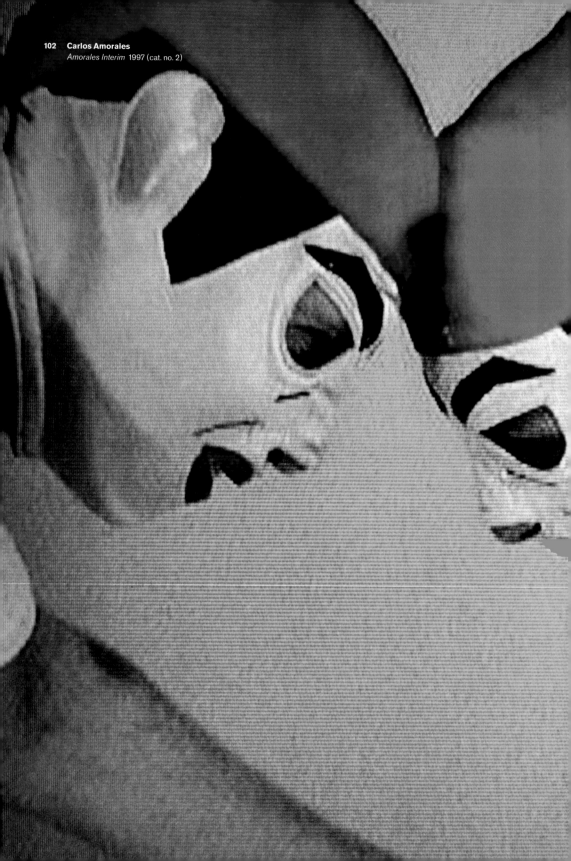

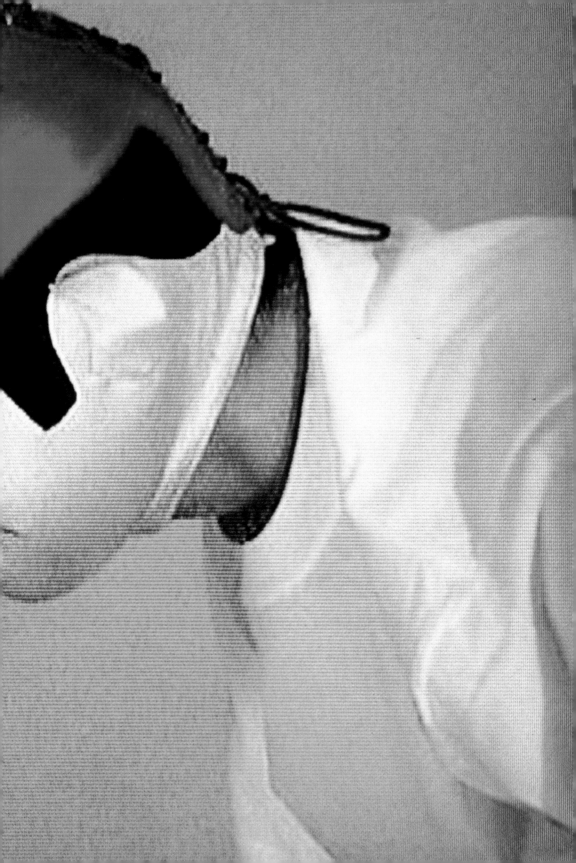

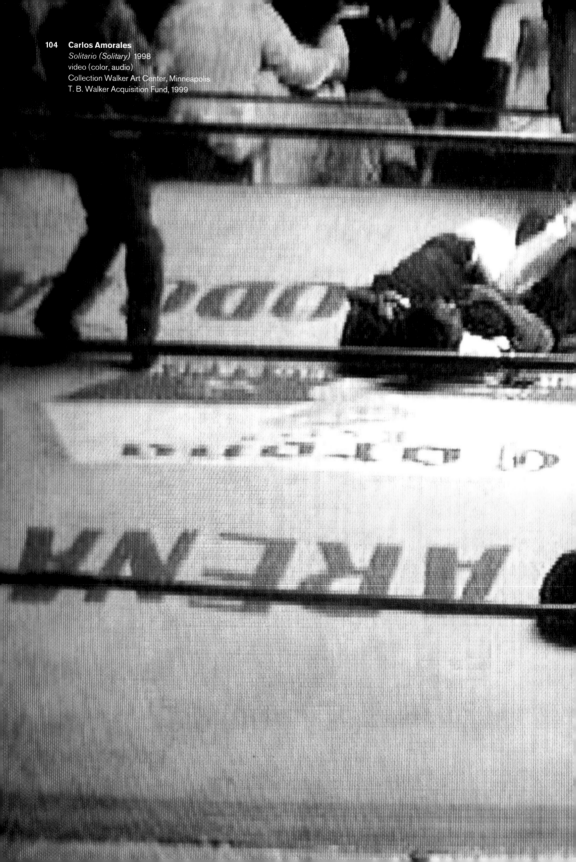

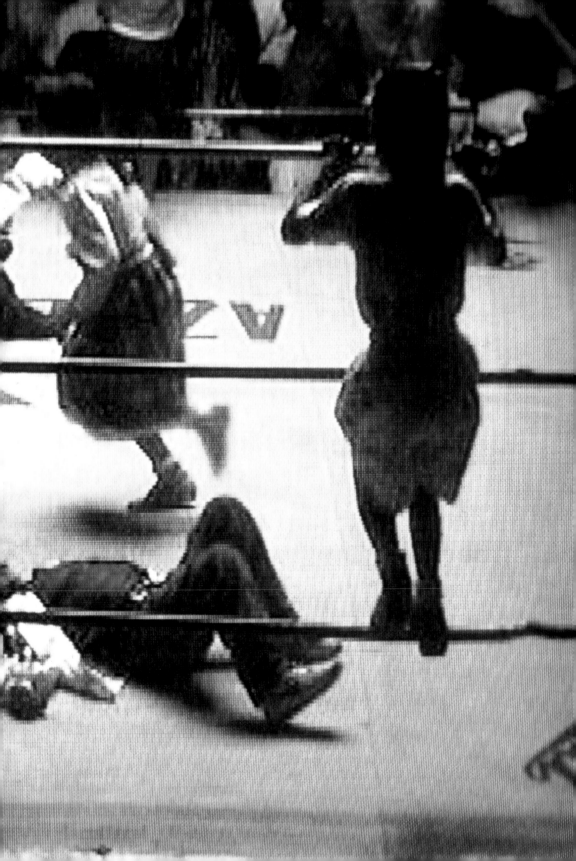

sharply, spending $200 million to buy fifty percent of barnesandnoble.com, the American bookseller's Web business. At the same time Middelhoff is trying to impress on the company that the nature of new media means that the divisions have got to think more about how to work together. It's been a valuable lesson, but an expensive one.

Synergy does have its downside. For an entertainment company with a news division, it presents a particular problem. How should such a company cover stories about itself? In October 1998 this problem was highlighted sharply by an incident in Disney's ABC News division. Its *20/20* news magazine program had been preparing an item about the Disney theme parks' lack of cooperation with the police in child sex-abuse cases, but the item was dropped halfway through. ABC said that Disney put no pressure on it to abandon the story, but it looked bad.

It is usually Rupert Murdoch who gets into trouble on this score. In early 1999 his publishing company, HarperCollins, rejected a manuscript for a book by Chris Patten on his years as governor of Hong Kong, which it had previously agreed to publish. The book was critical of the Chinese government, whose favor Murdoch needs to help his Star TV satellite broadcaster. The story was splattered across British front pages— except that of Murdoch's *Times*. And in September 1998, when Murdoch's BSkyB agreed to buy Manchester United football club, some of his newspapers said that supporters were keen on the move. In the rest of the British press, whose hostility to Murdoch had been stoked by a newspaper price war he started, fans were said to be devastated and tearful. In reality, there seems to have been widespread indifference. But the episode served to strengthen suspicions that you cannot trust what you read about the media in Murdoch's papers and you cannot trust what you read in other media about Murdoch. The moral? Where the value of a product lies in its independence, synergy can damage it. A new advertising campaign for the *Guardian*, a competing British daily, homes in on this, proclaiming "No proprietor, no ties."

Still, even if a few people were driven away from the *Times* to the *Guardian*, these little embarrassments do not impinge too much on the business of entertainment. As a way of making money, synergy works; so the huge entertainment companies of today will be the model in the future too.

Hello, World

While the entertainment companies have been building their models, they have also been colonizing the world. All the big companies have based themselves in the United States—even the entertainment divisions of Japan's Sony and Germany's Bertelsmann— because the American market is the biggest in the world. But America alone is not enough for them. Even though the prospects there look pretty good for most parts of the business, it is a mature market. Demand for entertainment is growing faster outside America than inside, and new technology is allowing the big entertainment companies to satisfy that demand. "Music is global already," says John Rose, a director of McKinsey. "The other entertainment businesses aren't. Those who don't exploit their assets globally risk missing some huge opportunities."

Analog broadcasting technology limited the number of channels available. Since people generally like to watch programs about themselves, locally produced content was given pride of place. Governments reinforced the preference for local stuff. But

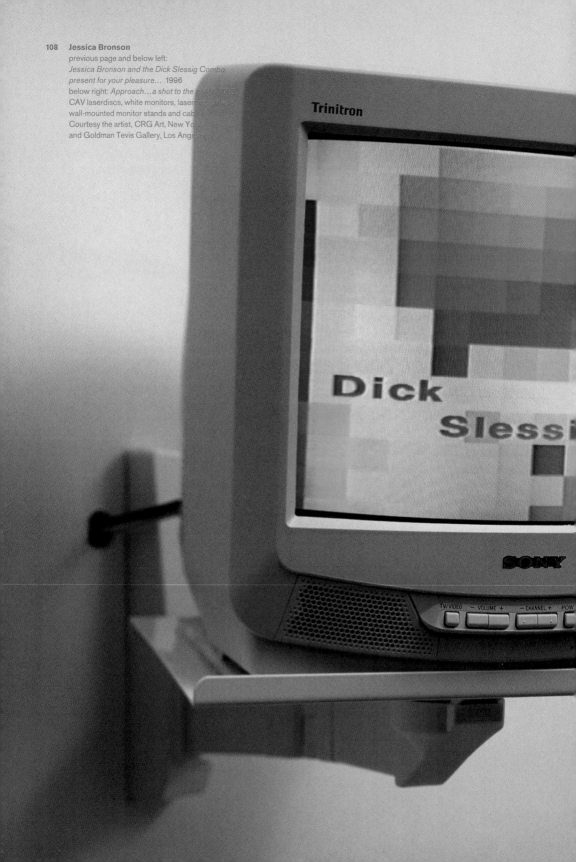

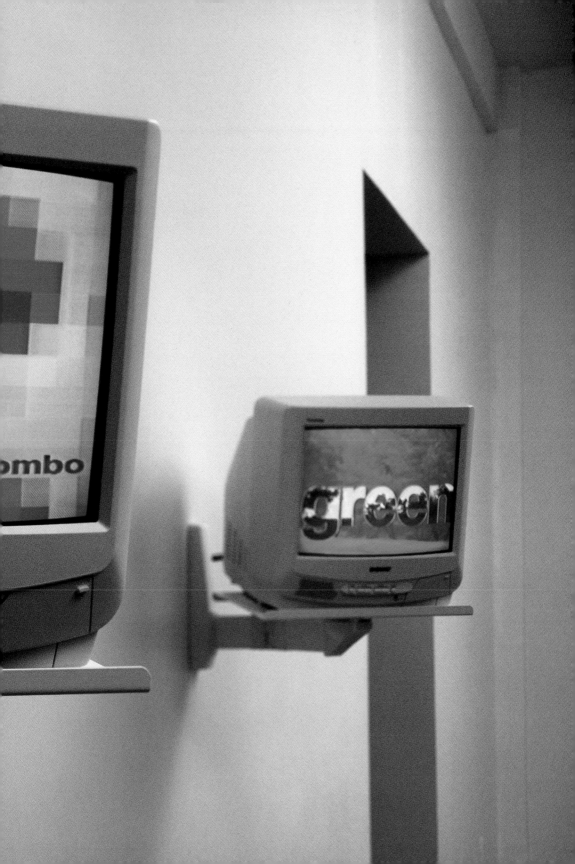

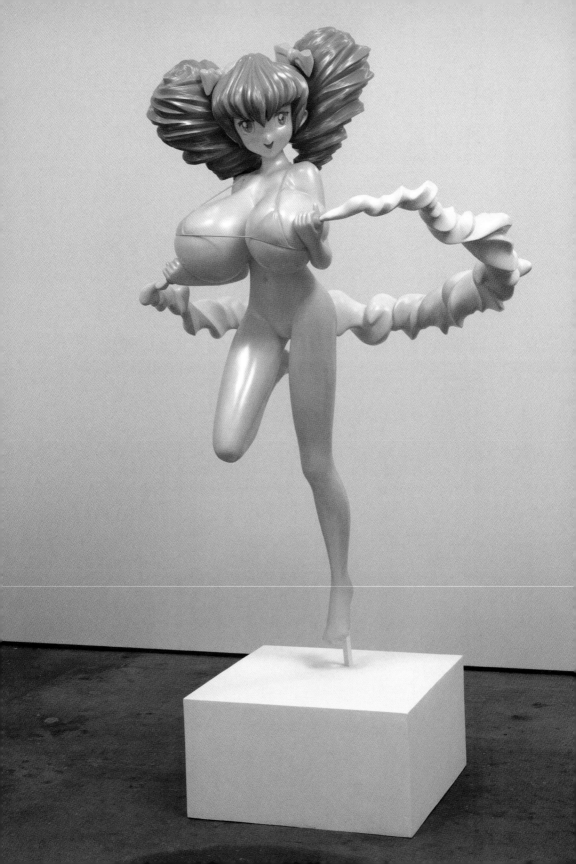

over the past decade the television business all over the world has been turned upside down by the proliferation of channels.

The growth of multichannel television has had a direct effect on American entertainment companies' bottom lines. The early stage of a market's development is always particularly lucrative for big content producers. For example, they did well in Britain in 1989, when Robert Maxwell's BSB and Rupert Murdoch's Sky were both trying to corner the best movie rights. Germany has recently proved even more profitable. Prices of movie rights doubled overnight when media mogul Leo Kirch was trying to bag them for his DF1 digital broadcaster and freeze out his competitor, Premiere. Europe is sucking in ever-larger quantities of American programs, whereas its own film and television exports to America remain negligible.

For global companies, the question is how deeply they should get involved outside their home market. Just selling programs leaves profit to local packagers and distributors. Some of them, such as Viacom and Turner, have decided that selling branded channels—such as MTV, Nickelodeon, or CNN—is the best way to make money.

But flogging American culture around the world has turned out to be trickier than the big companies first thought. Entertainment does not travel as smoothly across borders as do drugs or oil. The global consumer, it turned out, does not exist. "Kids want to know what's going on in the rest of the world," says Tom Dooley, vice-chairman of Viacom, "but they don't want it in their face all the time." MTV reaches 320 million households worldwide, but local competitors, better attuned to local ears, were beating it, so over the past two years MTV has been localizing its content. That has meant cutting staff in cities such as London and Singapore and setting up production offices in places such as Milan, Stockholm, and Bombay, pushing up costs by around 10 percent.

Some foreign markets are saturated. In Britain, for instance, a country with only six million multichannel homes, there are now four children's channels: News Corp's Fox Kids, Viacom's Nickelodeon, Time Warner's Cartoon Network, and Disney. A local competitor, the Children's Channel, packed up earlier this year. India, where companies have more or less given up on trying to collect subscriptions because there is so much piracy, has three music channels and three news channels.

Elsewhere, governments make life difficult. Germany, for example, with nineteen million cabled households, sounds like a great market for pay television, but it has (depending on the area) up to twelve free-to-air broadcast channels, so demand for pay television is limited. And then there are the regulators. Each of the sixteen German states has its own regulatory board to vet channels that want access to the local cable systems. "You know those circus dogs that jump through burning hoops, and just as they've been through one, another one pops up?" asks Nickelodeon's Herb Scannell. "That's how you feel."

Now big companies are starting to get deeper into the packaging business, through movies. Movies, along with sport, are the mainstay of every pay-television business. And although the big companies have been paid good money for their output and access to their libraries, they reckon they could get some equity out of it too. "We saw all these companies like Canal Plus and BSkyB that had built good businesses on the back of our programming," says Jeff Schlesinger, president of Warner Bros. International Television, "and we thought we could do it instead of them."

112 Takashi Murakami
previous page: *Hiropon* 1997 (cat. no. 47)
right: *My Lonesome Cowboy* 1998 (cat. no. 48)

Since no one company's film library is big enough to program a channel, bitter rivals have come together in partnerships around the world. In Latin America, for instance, HBO Ole brings together Warner, Sony, and Disney; in Asia, HBO Asia brackets Warner, Sony, Paramount, and Universal; in Japan, Star Channel—an amalgam of Warner, MGM, Paramount, and Universal—battles against Sky, made up of Fox and Sony. "It's really becoming an interesting jigsaw," says Schlesinger.

The next stage along the value chain is operating the platforms—satellites or cable systems—that deliver programs to people's homes. Only News Corp has taken globalization that far. This is the business with the highest risks and the biggest potential rewards. So far it has paid off superbly in Britain, where heavy spending on football rights has ensured that BSkyB, News Corp's satellite platform, dominates the pay television business. In Asia, by contrast, Star TV is still losing money.

Some companies have been putting their toes in the water of production abroad, but they do not much like it on the whole. Only Sony—driven, perhaps, by its weakness in the American market—is doing it with much conviction or success. Sony is making local programs and running television channels successfully in several Latin American countries. It is also one of the only foreign companies making money out of India's recent television boom. The world may be an unfriendly place for the big entertainment companies, but the potential profit out there makes it worth trying.

The Digital Decade

While the world's big entertainment companies are getting themselves in shape and taking on the world, the world is changing around them. The digital revolution—in which all music, text, and pictures are being translated into the zeros and ones of computer language—is well under way. All technological changes—the invention of moving pictures, radio, television—have turned the entertainment business upside down, but this one is more fundamental than any of those. The previous revolutions just created new ways of distributing entertainment. This one changes all the existing forms of distribution. It is rather like introducing the automobile into a horse-drawn economy, and its effects will probably be as widespread and unforeseeable.

This revolution has filled the big entertainment companies with terror and exhilaration. New technologies always contain within them both threats and opportunities. They have the potential both to make the companies in the business a great deal richer and to sweep them away. Old companies always fear new technology. Hollywood was hostile to television, television terrified by the VCR. Go back far enough, points out Hal Varian, an economist at the University of California, Berkeley, and you find publishers complaining that "circulating libraries" would cannibalize their sales. Yet whenever a new technology has come in, it has made more money for existing entertainment companies. The proliferation of the means of distribution results, gratifyingly, in the proliferation of dollars, pounds, pesetas, and the rest to pay for it.

All the same, the old companies have good reason to fear what is going on. New technologies may not threaten their lives, but they usually change their role. Once television became widespread, film and radio stopped being the staple form of entertainment. Cable television has undermined the power of the broadcasters. And as power has shifted, the movie studios, the radio companies, and the television broadcasters

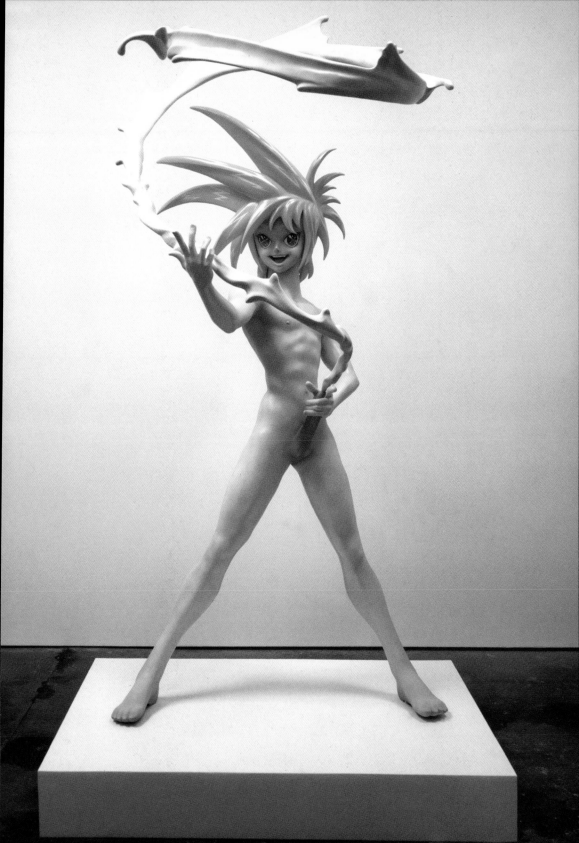

have been swallowed up. These days, the grand old names of entertainment have more resonance than power. Paramount is part of Viacom, a cable company; Universal, part of Seagram, a beverage and entertainment company; MGM, once the roaring lion of Hollywood, has been reduced to a whisper because it is not part of one of the giants. And RCA, once the most important broadcasting company in the world, is now a record label belonging to Bertelsmann, a German entertainment behemoth.

The early manifestations of the digital revolution, as far as the entertainment companies are concerned, are digital video discs (DVDs, also called digital versatile discs), digital television, and the Internet. All of them generally look like good news for the entertainment companies.

DVDs are, in effect, CDs with movies on them and promise to do for the movie business what CDs did for the music business: make some easy money as consumers replace their blurry, stretched tapes with sharp new discs. All the studios are beginning to release their movies on DVD, and sales of DVD players have now taken off in the shops. Studios worry about piracy through recordable DVDs, but they had the same worry about tapes, and illegal homemade compilations did not much reduce the piles of money they made.

Digital television is a bit of a mess in America. Although digital started, via satellite services such as DirecTV, in the mid-1990s, the satellite platforms serve only a small minority of people. The big broadcast networks are torn between using digital signals to offer people more channels or to give them high-definition television (HDTV). They promised the politicians that they would offer HDTV in return for the free bandwidth they had been given to go digital, but since the sets required to receive those signals cost two to eight thousand dollars, people are not rushing to the shops. Anyway, the broadcasters are embroiled in an argument with the cable companies, through whom most people receive their broadcast signals: the cable companies do not want to carry HDTV because they say it uses up too much capacity.

In Europe, digital has got further. Britain, for instance, already has a digital terrestrial broadcaster, which launched in 1998; its satellite broadcaster, Murdoch's BSkyB, went digital in 1998, and its cable companies are expected to go digital later in 1999. The number of channels available in Britain has therefore risen to more than one hundred since the transition started. For a country in which most people still get only four channels, that makes a big difference, and for television companies trying to sell people more product, the environment has also changed radically. The short-term prospects for making lots of money out of all of this look gloomy, but the television companies are all convinced that, in the long term, there is plenty to be made once digital television can offer programs on demand plus a whole load of interactive services.

The Internet's biggest impact so far is on the music business, because it is so much easier to compress music signals than video ones. After an initial panic about the susceptibility of digital signals to piracy, the entertainment companies have decided that the opportunities are greater than the dangers (and that, anyway, if they don't take them, somebody else will). So they are all piling in now, setting up sites from which the tracks to which they own the copyright can be digitally downloaded. Piracy aside, the Internet should do wonders for them. Once consumers have the necessary hardware (which is already widely available and inexpensive), music can be bought far more eas-

ily than it can be in a world in which you have to trek to a record store. And the Internet affords a whole new flexibility in how music can be bought and sold: pay little to play a track once, pay more to play it a thousand times, compile your own CD, get a free sampler, and so on.

It may be that, in time, the Internet will do the same thing for moving pictures that it certainly will do for the music business. Not everybody agrees about that, however. Plenty of people think that pictures will stay on television, because the machines and software are still fundamentally different, and while televisions can do the business, it will not be worth investing in making PCs able to cope with pictures.

But alongside these opportunities come real fears. They spring from the fact that, as the entertainment business turns digital and starts to talk in the same zeros and ones as the computer business, it bumps up against both the computer and telecommunications industries in all sorts of different areas. The telecommunications people own the wires along which the pictures and music travel, and the computer people produce the systems that allow the pictures to be seen and heard. What entertainment companies fear is that one of these industries will establish a stranglehold somewhere along the line.

The people who run the entertainment business are therefore understandably nervous. They compare their industry's growth over the past couple of decades, and its market capitalization, to that of the computer and telecommunications businesses, and they wonder whether the much-talked-about convergence for all these business will in reality mean that the other two will walk all over them.

The Internet is an obvious area where the computer and entertainment businesses overlap. "The entertainment companies are terrified of being blindsided by the Internet, as the broadcasting networks were blindsided by the cable companies in the 1980s," says Peter Kreisky of Mercer Management Consulting. Both sides see it as an extension of their business: for the content people, the Internet is just another means of distributing entertainment; for the computer people, it is just another sort of application.

As it turns out, the computer companies—fortunately for the entertainment companies—have not turned out to be much good at creating content. They took some time to learn that lesson. Microsoft poured huge sums into creating original content on the Internet, with little to show for it. These days the computer companies are more likely to do content as a joint venture with a content company.

Where the balance of power will lie on the Internet is far from clear at present. The huge capital values that the Internet-based companies have been commanding lately argue that it has shifted a long way in their favor: how else could there be constant rumors that AOL was about to buy CBS? But the Internet-based companies still need the real-world companies badly. That is why they are spending large amounts on, and giving away slices of their equity for, the real-world promotion that only the real-world media companies can offer them.

But while they worry about losing power on the Internet, the entertainment companies are also concerned about the threat from cable. Their concern is that huge sums of money are being invested in the "broadband connection"—the way of pumping entertainment, services, and data into people's homes via cable, satellite, phone lines, or wireless—and that if any one means of transmission proves to be far better than the others, then those who own that pipeline will hold power over the people who want to

pump stuff down it. Digital, in other words, may have widened the gate, but there may still be a gatekeeper.

A lot of people now seem to believe that cable could be a gatekeeper. The billions of dollars in debt that the cable companies have accumulated over the past five years upgrading their systems now seem justified. Cable companies are commanding higher and higher prices. AT&T—which during 1999 turned itself into America's biggest cable company, owning or part-owning two-thirds of the country's cable systems—evidently believes that cable is the future.

The entertainment companies are wrong to worry, though. Communications technology is moving too fast for any one means of distribution to be declared the winner for long. The beauty of digital technology is that zeros and ones can be transmitted in all manner of ways. The telecommunications companies are pumping money into turning their wires into broadband pipes; wireless companies are working furiously on offering cheap Internet access; the falling price of memory will allow satellite broadcasters to download hundreds of hours of programming and masses of data into set-top boxes; even electricity companies are talking about Internet access down their wires. The chances that any one means of transmission will gain a monopoly seem remote.

So it appears that, as the digital revolution unfolds, among the winners will be those entertainment companies that have all their spokes in place. They have the economic power to make the huge, increasingly expensive movies that the public seems to want; they are the best positioned to distribute and promote their content; they can most easily ensure that the brands they create stick out in a crowd. They are not the hottest stocks in the marketplace; they seem old-fashioned and unhip compared with the e-everything companies that command the high prices and the flattering articles these days. In the long run, however, the big, rich companies that own the words, music, and pictures that people want will get bigger and richer still.

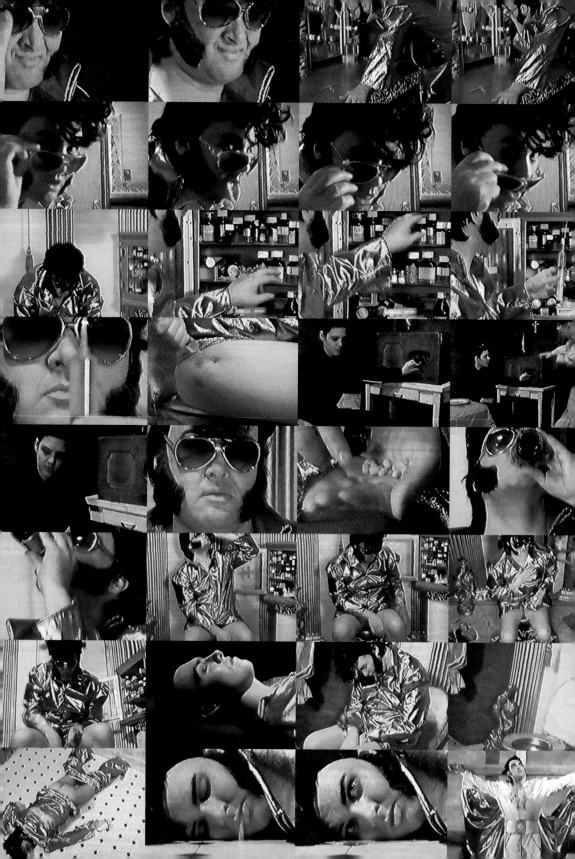

March 27, 1999—Bellagio Casino and Art Gallery, Las Vegas.

Olukemi Ilesanmi and Philippe Vergne continue their conversation. As we meet them, they are sitting on a bench in front of the casino, watching the "dancing waters" with 125 other visitors.

Olukemi Ilesanmi: So is Bellagio everything you expected and more?

Philippe Vergne: Yes. I have no idea where I am. It is my first time in Vegas, and I feel that I am not equipped for it. It is very shiny. Up to now my only Vegas experiences were through fiction, movies: *Leaving Las Vegas* by Mike Figgis in 1995 and *Fear and Loathing in Las Vegas* by Terry Gilliam in 1998. How is your suite? Mine is okay. I watched Jerry Springer.

OI: Pretty nice; I have a great view of the strip.

PV: What I really love is the big billboard that reads, "Now Appearing: Henri Matisse, Vincent van Gogh, Pablo Picasso." I think it's a brilliant publicity campaign.

OI: "Have Lunch with the Masters" is another good tag line. Do you think cultural institutions like museums can learn from Bellagio?

PV: Oh, yes. I think we learn something from the fact that Bellagio exists and appears to be succeeding thus far. I kind of like the idea that you can gamble in the proximity of masterpieces of twentieth-century art, but I don't know how to judge that…or even if I want to judge that. I don't know if I should be alarmed about this initiative or not.

OI: When we last talked, we were getting into some of the stickier issues. Tell me, were there any artists who were a little hesitant to be included in a show called *Let's Entertain*?

PV: Yes, some of the artists questioned the project. At least one, Gabriel Orozco, questioned it strongly, which I think was very healthy. When I talked to him early in the planning stages, he was hesitant to be included in an exhibition with such a title and questioned the overall topic of the exhibition. We had an exchange of letters, and I explained to him that the title of the show is a comment on packaging and marketing that is suggestive of a provocation or a joke. After all, one can joke only about serious things. Obviously the exhibition is not an uncritical celebration of the entertainment industry, but a way to question it and to learn about it. I wanted very much to include his work in the show because he has done several pieces that alter the idea of games and, more than that, the idea of rules. In particular, I am thinking about *Horses Running Endlessly* (pp. 44–45), a work that challenges the notion of an "end goal" as well as the idea of a definitive "winner," thereby challenging fundamentals in our culture. *Horses Running Endlessly* is a chessboard that has only horses—no queens, kings, or bishops—so you can only move sideways. Thus, the game becomes a circular loop, and traditional chess strategy is useless.

OI: I recently read an article by Salman Rushdie in which he wrote about his obsessional love of soccer and how this love of the game dovetails with so many other issues about identity and place.[13] One of the most interesting things to me about Orozco's pieces and Maurizio Cattelan's *Stadio* (p. 32), an elongated foosball table, revolves around games as a site of identity construction, as a moment of inclusion in or exclusion from a cultural

group. Their works are about the increasingly complicated notion of self-identity in a world that is becoming smaller and smaller, yet more complex, through travel, the Internet, and various cultural border crossings.

To my mind, these works have an interesting link to the history of cabaret in Paris. The cabaret was one of the few places in post-Revolutionary Paris where criticism, veiled but barbed, could be raised about the political situation. Ironically, this ode to spectacle and theater was also a major site for real structural critique. It was, similarly, a twisted game. A Japanese artists' collective in this show, Kyupi Kyupi, uses the cabaret structure in its work (pp. 94–98). They use performance, in funny and selective ways, to critique archetypes of Japanese society and gender norms through a kind of fantastical and futuristic dream. Again, entertainment can be used to make fundamental societal criticisms.

PV: This project is not about fighting. It is about how a major cultural phenomenon affects artistic practices. The leisure industry is affecting our economy so deeply, and there is no reason to think that the cultural field should or can remain isolated.

PV: Regarding the history of cabaret, we should refer to Greil Marcus' book *Lipstick Traces*, in which he asks, "Is the cabaret a place where the spirit of negation is born, or is it where that spirit goes to die?" In a way, I think one could ask the same question about *Let's Entertain*. Marcus also refers to an anecdote that T. J. Clark mentioned in *The Painting of Modern Life* about Thérésa, a singer at the Alcazar in Paris in the 1870s and 1880s. Thérésa was adored by all of Paris. She was stocky, unlovely, and powerful, and the lyrics of her songs were carefully monitored by government censors. The only part that they were not able to control was her body language, her voice, her gestures. As Clark noted, "Thérésa had the knack of turning a casual aside into a condemnation of the whole social order."[14]

That is the very special balance that I would like to give this exhibition. That is why I mentioned earlier both Cabaret Voltaire and the Fluxus concerts. *Let's Entertain* is something between organized leisure and distanced reflection with no excessive empathy and feeling, but with this "estrangement effect."

OI: Is there a space for melancholy in entertainment and in this exhibition?

PV: Absolutely. I would say that the whole show has a melancholic quality. As we said at the beginning of this conversation, the first dream of some of these artists was to compete with or question the system by infiltration. Perhaps that came out of a utopian dream that has not held for later artists. Doug Aitken and Douglas Gordon are artists who don't need to compete with the massive media industry because they are a part of it, grew up with it, and know how to use it. When you look at Gordon's early video work, you can't escape the fact that it's coming from popular culture, from someone who is appropriat-

Let's Entertain
Life's Guilty Pleasures

Conversation Part II
Philippe Vergne and
Olukemi Ilesanmi

121

ing and distorting movies. His generation developed a huge knowledge of movies, not necessarily in movie theaters but at home watching videos. Gordon's work draws from this field of mass culture. The VCR generation is now making art. They are standing in this "forest of signs" in the same way that Dürer's figure of Melancholy sits surrounded by symbols reflective of that time and place—from geometric instruments to tools of humanistic learning—meditating on the struggle to achieve artistic or aesthetic harmony.

In answer to your question about melancholy, I would like to mention Kodwo Eshun and the way he explains how and why a generation of musicians are using "sampling" or "remixing" of preexisting music. In Eshun's view, this way of making music is not a form of postmodern irony driven by exhaustion. The quotation or the citation is not about ironic distance, but the opposite. It is about being overwhelmed; it is about "perceptual disturbance" and "the impossibility to stay ironic."[16]

To a certain extent, I think that artists such as Douglas Gordon or Pierre Huyghe, who use film footage in their work, are working in the same direction. Beyond just sampling, they investigate sociopolitical and cultural history and psychological phenomena. The way they work has more to do with recontextualization than with appropriation. How can this material coming from popular culture inform us about larger issues?

I would say that this melancholy, if it *is* melancholy, is not about being doubtful regarding our time and space, but about a generation of artists who have learned how to be pragmatic and are fighting the present machinery of the culture industry as well as the commodification of "free time." Yet this mix remains complicated and controversial. To illustrate what I mean, I have a great quote from Douglas Gordon, in which he challenges some of the questions raised by this exhibition: "Entertainment is not a museum issue. It should never be discussed in the context of the museum. Museums offer a different experience to this thing. It should never be the entertainment industry."[17]

OI: But, again, I think that entertainment has so pervaded our world that it becomes inescapable, and Gordon may have already lost the battle as he defines it. The aesthetic of alliance is always lurking, so even though Gordon talks about the museum as a non-entertainment space, he draws directly from the entertainment world for much of his work. *Something between My Mouth and Your Ear* (pp. 142–143) features the most popular music on the radio before and after the artist's birth—he possibly heard these songs while in his mother's womb. He's pulling these found objects directly out of popular culture and commenting on the way it forms our identity long before we can intellectualize or resist it. I just don't think it's something that can be escaped. I think we must put up the "good fight" to keep some lines of demarcation between the museum and the entertainment industry, but the lines seem to keep fading away.

PV: Ultimately I would like to ignore the exhibition title and consider it an exhibition about art practice over the last twenty-five years. This project is not about fighting. It is about how a major cultural phenomenon affects artistic practices. The leisure industry is affecting our economy so deeply, and there is no reason to think that the cultural field should or can remain isolated. The fascinating thing about the marketing of Volkswagen's new Beetle is that it is not the selling of a car, but the selling of a whole experience. I recently read an article about the "experience economy," whose authors argue that nowadays successful companies promote experiences, themes, fictions, not products. Here is the way Andrew Grove, chairman of Intel, describes the role of his company: "We need to

look at our business as more than simply the building and selling of personal computers. Our business is the delivery of information and lifelike interactive experience."[18]

So we go back to the Rainforest Cafe, where we did our first interview, and to the museums that are trying to appropriate strategies from the leisure industry, and realize that we are caught in a shift from a service economy to an experience economy. Even in the architecture of a museum and its exhibitions, this economy of experience is reflected.

OI: In our many conversations about this exhibition, you've often talked about how this show could be misperceived as a celebration of entertainment, yet it is also quite threatening to the status quo. In Zha Jianying's book on Chinese culture,[19] she writes about the potential democratizing of that society through popular entertainment. She argues that totalitarian regimes will often discourage or regulate true popular expressions because they realize just how innocent they are *not*.

PV: One of the best examples of a moment of panic that led to heavy regulation of popular entertainment happened in England in 1991 as the rave youth culture was in full swing. This phenomenon of all-night parties with hundreds of young people in attendance was linked to electronic music, mind-altering drugs like ecstasy, and an alternative economic structure that eluded the authorities. This was a cultural activity organized without authorization from the established power structure, totally independent from major record labels yet heavily involved with a new kind of music production. The organizers took advantage of emerging technologies such as e-mail, as well as more traditional methods such as strategically placed flyers and word of mouth. Through totally underground methods, huge rave parties, sometimes lasting several days, took place all over England and the rest of Europe. Ravers were there just to party, just to let go, just to reach an altered state. Subsequently, in the summer of 1991, the British Parliament passed an entertainment bill to attempt to control this cultural movement. The authorities had thus far been unable to do that, so the entertainment bill was passed to forbid it outright. They cited the economic and drug reasons, but I think one of the main reasons was to control this very powerful cultic and anarchic culture. Popular culture is an extremely powerful force. As Matthew Collin writes, "For a government whose reason for being is to control people, here was a very frightening example of people saying: 'We can and will do whatever we like.'"[20]

OI: Hip-hop culture took a similar route out of the postindustrial wasteland of American urban cities at about the same time. The kids who were creating this new music could not afford musical instruments, so "sampling" was developed as a basic artistic tool that infused appropriation and collage into popular music. The music and lifestyle of hip-hop, from break dancing to block parties and graffiti, eventually attracted the attention of government and cultural regulators. The legitimacy of the music's message, called black people's CNN by rapper Chuck D, has been attacked by everyone from Tipper Gore to C. Delores Tucker. What's really exciting, or what kind of comforts me, is that no matter how quickly regulatory agents step in, someone always figures out a way to create new possibilities for all of us. Now the Internet offers many of those possibilities—MP3, early album releases on the Web, and so on.

PV: Rap music is also a very good way to explain, in terms of artistic practices, what the exhibition is about, because rap music has become a model of social and political practice. Rooted in a history of subversive African-American politics and serving as a menace

to the social status quo, hip-hop is definitely about sociopolitical activism as well as an elaboration of new cultural practice. This is a cultural practice that is both popular and artistic and aims to undermine the dichotomy between "legitimate" high art and popular entertainment. The thing that is so interesting about movements like hip-hop or electronic music is that they use a pleasurable experience to deal with larger issues and take these messages mainstream.

That's also why the exhibition opens with a video of John Lydon (a.k.a. Johnny Rotten) and Public Image Ltd. performing on *American Bandstand* in 1980. We're not speaking about the punk revolution, which, if we go back to Greil Marcus' *Lipstick Traces*, could be linked to Dada or Cabaret Voltaire or Situationism. Here we're speaking about another generation that wanted to deal with the revolution in different way. They take what is available and play differently with the same tools. John Lydon's performance on *American Bandstand* is perhaps the moment we realized that the punk movement was over as a valid counterculture. The minute he agreed to perform on this television show, he was doing something else.

OI: I see questions about the sacralization of art space as well as comments on the notions of the hero/villain, Manifest Destiny, and perpetual progress that are so much a part of the American myth.

OI: An old professor of mine always said, "There's no text without context." Throughout these conversations we've touched on issues of global homogenization versus cultural specificity as it resonates through the themes of the show. Could you address how this broad umbrella theme of entertainment mutates and changes in different geographical, cultural, and social contexts?

PV: Earlier I spoke of this exhibition in terms of art practice. I'm very curious to see how art practice differs across the world and to analyze what we mean by "global." In our current "borderless" global situation, this show is an opportunity to analyze the dominant artistic practices in different cultures. For instance, it can be challenging to look at work by Japanese artists because there is a cultural context, a cultural history, which is very different from the one we're living in—even though they have been influenced by Western culture for more than a century. For example, Takashi Murakami was trained as a traditional Japanese painter, yet his current sculpture and paintings draw heavily on *manga* and *anime*, comic books and animated cartoons. He uses a mix of the traditional and the contemporary to mount a critical argument about the violence and the sexual charge in these comics. But he also says that it's about how he can bring traditional Japanese visual culture to the next place and still reach an audience. What is interesting with someone like Murakami is our perspective on the work as Westerners. Perhaps Murakami is just giving us what we want to see from Japan—for instance, the archetypal sexually available Japanese female. This is the part of *manga* and *anime* culture that

most fascinates Westerners, and Murakami probably knows this and perhaps manipulates our desire for the other.

OI: British artist Gillian Wearing's *The Regulator's Vision* (pp. 6–7) is a similarly complex piece about art practice and identity. It's an American West–style shoot-out in an art gallery setting. In the West, art is something to be revered, almost a kind of secular religion. This has not gone without challenge, of course, in recent art practices, but it is still hard to find someone talking at even a normal volume in an art gallery or museum. I see questions about the sacralization of art space as well as comments on the notions of the hero/villain, Manifest Destiny, and perpetual progress that are so much a part of the American myth.

PV: I read the title and remember that in a western the "regulator" is the character who distinguishes the good from the bad. So I understand that this work is telling me something about cultural hierarchy and the way to monitor it. It is about disorder and, as you said, transgression.

PV: When I met with Gillian Wearing last year, we spoke about this work. It was shot with surveillance cameras in the empty Hayward Gallery in London. The participants are not professional actors; in fact, she found them in a London pub where they gathered regularly to play out fantasies and scenes as cowboys and cowgirls. It's quite remarkable that there are groups of people in England dreaming about the good old days in their most remarkable former colony. Of course, their fantasies are really a pastiche drawn from old films and myths and captured by very modern technology. In this context the American West becomes the nostalgic past or a totally exotic and ideal world. Wearing is talking about art, the art gallery, fictionalization, and movie icons, but I think that she's mostly talking about cultural identity through something that looks like a western.

OI: I think it's talking about a kind of cultural transgression. I went to a really intriguing lecture a few years ago by a Dutch professor. He talked about how American symbols—the American West, New York City, Route 66—often become a shorthand for positive transgression or openness in European advertising. Mythic American ideals of progress and possibility are heightened in this different cultural context, even though the same ideals are daily being questioned within our own borders. One particularly captivating ad featured a black New York drag queen primping in the back of a yellow taxi. Again, America stood in for a kind of racial, sexual, and cultural border crossing. I think Wearing is tapping into some of those notions with *The Regulator's Vision*.

PV: The transgression in the piece is about civilization, going from one civilization to another, from one culture to another. But what is very interesting to me are the codes and stereotypes the artist is challenging. I see a western, a film genre that often carries a strong moralistic statement about "the good, the bad, and the ugly." I see this drama coming

Let's Entertain
Life's Guilty Pleasures

Conversation Part II
Philippe Vergne and
Olukemi Ilesanmi

125

from popular culture and happening in a museum, a temple of high and legitimate art, a cultural regulator. I watch this drama through the video surveillance, the control system of this museum. I read the title and remember that in a western the "regulator" is the character who distinguishes the good from the bad. So I understand that this work is telling me something about cultural hierarchy and the way to monitor it. It also raises the question of the museum as a cultural regulator. Is the Met better at it than the Brooklyn Museum? It is about disorder and, as you said, transgression.

And then this work takes me back to the British "entertainment bill," which I see as a social regulator. Speaking about these issues and disorder leads me to Leigh Bowery and a transgression vehicled by cross-dressing and the drag-queen phenomenon. Beyond the pure gender implication, this phenomenon carries the discomfort and the energy of freedom and transformation from one status to another. This capacity to be endlessly in movement pretty much defined Bowery and his very provocative way of challenging gender, taboo, and the cultural establishment through his active involvement in the club scene, the performing arts, music videos, fashion, the art world, and show business. He influenced everyone from fashion designer Vivienne Westwood and painter Lucian Freud to pop star Boy George and dancer-choreographer Michael Clark.[21] I wouldn't even call Bowery an artist. He is *the* entertainer above all—seductive yet critical and provocative at the same time. I don't know if he was aware of it, but he totally over-lapped several avant-garde movements of this century, including the Viennese Actionists. By being constantly in motion, always ready to change yet again, Bowery resisted categorization and was finally in control of his own life, which is very rare. My feeling is that he built for himself, through a very noble sense of dilettantism, the life he wanted. It might seem simple, but I understand it as a great statement.

Notes

13. Salman Rushdie, "The People's Game," *New Yorker*, 31 May 1999, 56–65.

14. Greil Marcus, *Lipstick Traces: A Secret History of the Twentieth Century* (Cambridge: Harvard University Press, 1989).

15. On *Dürer's Melancholia I* (1514), see Erwin Panofsky, *The Art and Life of Albrecht Dürer* (Princeton, N.J.: Princeton University Press, 1917), 157–71.

16. Kodwo Eshun, *More Brilliant Than the Sun: Adventures in Sonic Fiction* (London: Quartet Books, 1998).

17. Conversation between Douglas Gordon and Jan Debbaut in *Douglas Gordon: Kidnapping* (Eindhoven: Stedelijk Van Abbemuseum, 1998), 32.

18. B. Joseph Pine II and James H. Gilmore, "Welcome to the Experience Economy," *Harvard Business Review*, vol. 76, no. 4 (July–August 1998), 99.

19. Zha Jianying, *China Pop: How Soap Operas, Tabloids, and Bestsellers Are Transforming a Culture* (New York: New Press, 1995).

20. This phenomenon is described in detail in Matthew Collin, *Altered State: The History of Ecstasy Culture and Acid House* (London: Serpent's Tail, 1997), 219.

21. See Robert Violette, ed., *Leigh Bowery* (London: Violette Editions, 1998).

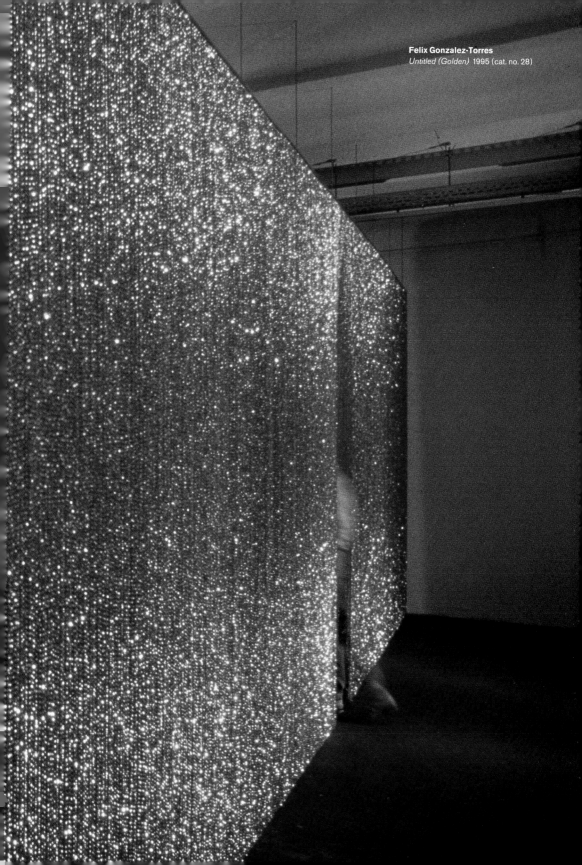

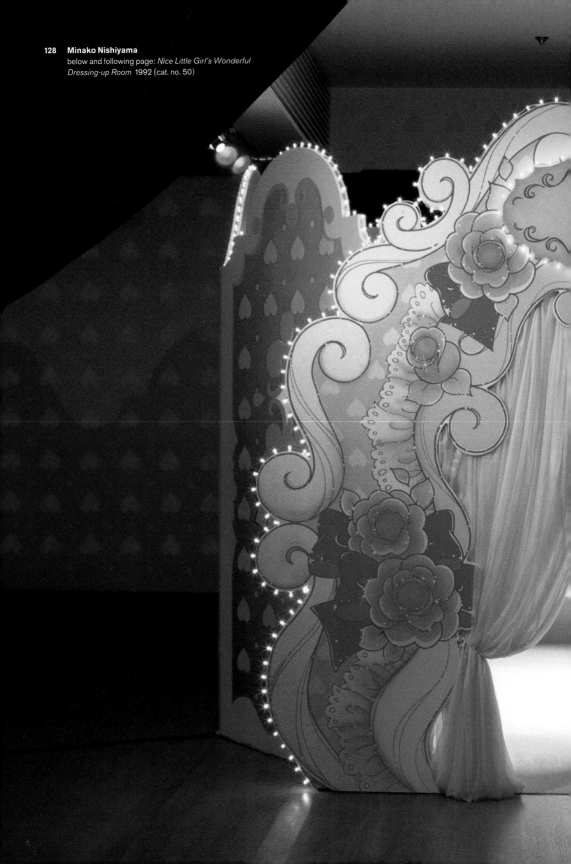

below and following page: *Nice Little Girl's Wonderful
Dressing-up Room* 1992 (cat. no. 50)

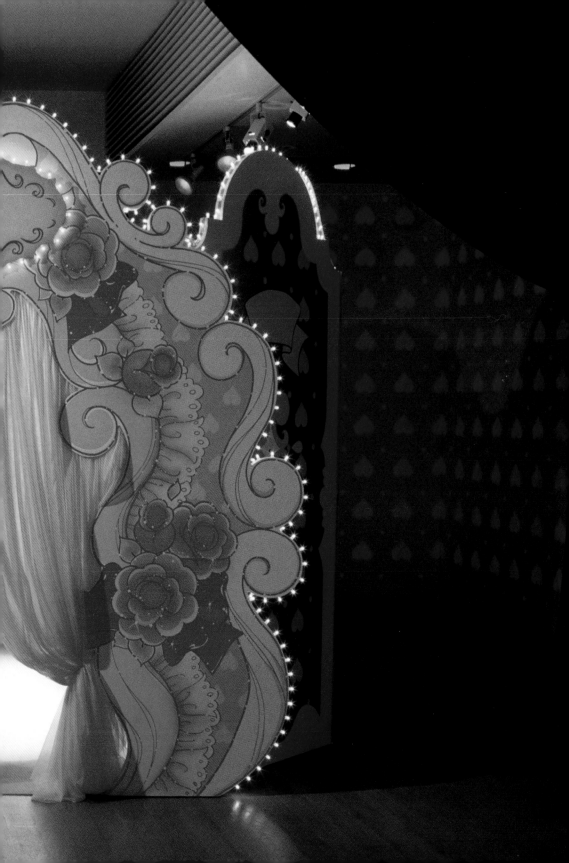

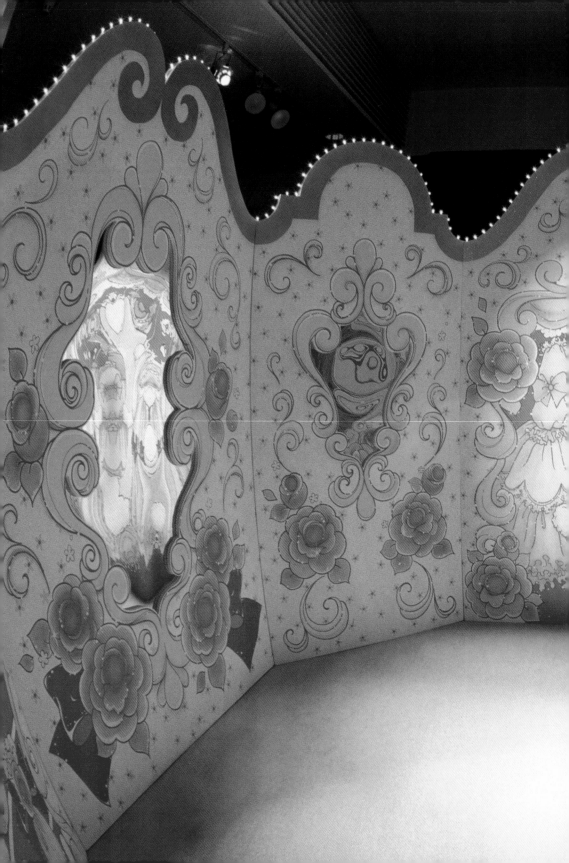

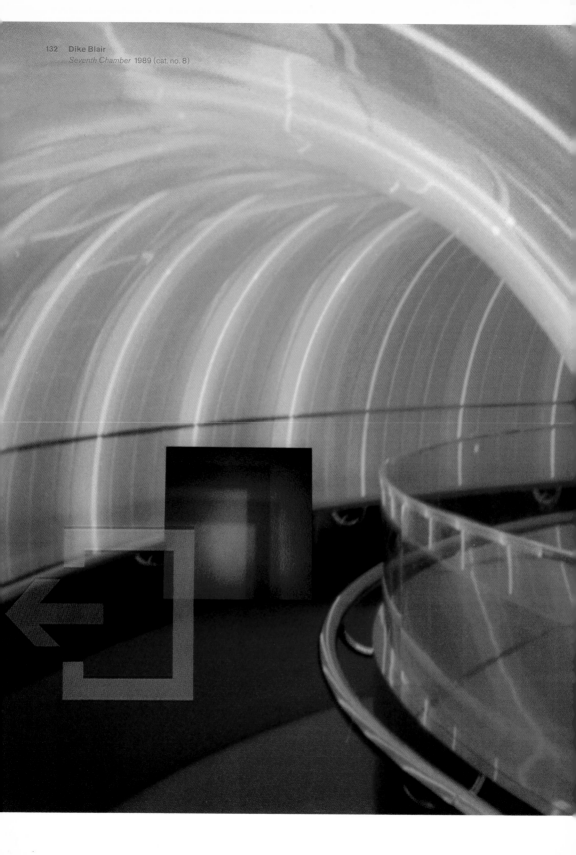

R&D for Social Life:
Entertainment Retail and the City
Susan G. Davis

For more than a decade, architects, geographers, and cultural critics have explored the privatization of public space, describing a speculative and spectacular postmodern city built on foundations of grinding inequality. This is, in Michael Sorkin's phrase, the city as theme park, where corporately built public spaces have helped kill the street and cash out democracy.[1]

The notion of the city as theme park makes rough metaphorical sense of scores of urban transformations and suburban projects, but in this discussion an important question has been overlooked. The urban reshapers are increasingly, and literally, the theme park builders, the conglomerate media corporations that now lead the international economy.[2] The Walt Disney Company's central role at "ground zero" of the redevelopment of Forty-second Street and Broadway in Manhattan is the obvious example, but Time-Warner, Viacom, Seagram's Universal Studios, and Sony are also commissioning, designing, and financing massive real estate projects. So the neglected question: why are these mega-media conglomerates moving beyond the construction of literal theme parks and helping to rebuild downtowns, reshaping malls and suburbs, and even designing residential and work communities? The same media behemoths that have brought the world a revolutionary and supposedly placeless electronic transnational culture are demonstrating a powerful interest in the problem of space and place. But why, and with what implications for collective and cultural life?

In what follows, I draw on entertainment and real estate industry literature, selecting from a wide variety of entertainment building-boom projects, in an attempt to explore the rationales connecting media content, entertainment technologies, and the push to create new, urban-feeling places. An expressive term for this phenomenon hasn't crystallized yet, but company press releases call it "site-based entertainment," "entertainment retail," "the inside/outside strategy," and even "congregarium."[3] For lack of a better phrase, I will use "location-based entertainment," the most common industry term, because that pedestrian phrase best captures the media conglomerates' interest in space and their focus on making distinct and identifiable places.

More difficult is the task of assessing the broader stakes for public culture. Both the texture of shared space and its potential for collective experience are being thoroughly revised. In the first half of the twentieth century the entertainment conglomerates were central in creating a nearly all-penetrating national and international mass culture, first through film and later through animation, popular music, and televised sports. In the second half of the century, they brought this largely American mass culture thoroughly and extensively into the home, to hundreds of millions of people. At the cusp of the twenty-first, they are poised to weave the private realm with the collective, through the creation of dramatic and focused media-filled spaces. In the process, in addition to further displacing smaller businesses and heterogeneous uses of the streets, the media conglomerates are changing the relationships between public and private experience. They are creating public spaces defined by marketing criteria and shaped to the most profitable audiences. These spaces will be devoted to the circulation of well-tested, "safe" media content and will exclude experimental imagery and oppositional ideas. Privately produced collective spaces based on and filled with familiar mass-media con-

Let's Entertain
Life's Guilty Pleasures

R&D for Social Life:
Entertainment Retail and the City
Susan G. Davis

135

tent can create a kind of seamless world, one in which the home—currently devoted to extensive consumption of conglomerate culture—is tightly knit to and continuous with the outside. The city (or at least certain districts of the city), seen as dangerous in its diverse unpredictability, is being made safe imagistically as well as physically.

The Scale of the Boom

"Entertainment is the hottest topic in real estate circles," as one economic analyst has noted, but the reverse is just as true: real estate is now indispensable to an entertainment company's portfolio, its growth and promotional strategies.[4] While they worry about how the Internet will change their fundamental businesses, the media conglomerates are elevating their vice-presidents for real estate and development. These strategists are less visible publicly than executives in charge of film, television, and multimedia, but they are charged with doing more than building offices. They speak of the old-fashioned ideas of place and community as growth opportunities for their companies.[5]

No recent statistics summarize the extent of location-based entertainment projects, but they are ubiquitous.[6] In today's rebuilt metropolitan downtowns, they are important conceptual, architectural, and speculative interventions. In Philadelphia, Denver, Baltimore, Atlanta, New Orleans, Cleveland, San Francisco, and Washington, D.C., these new projects have been born out of the political clout of developers using state and federal redevelopment funds, the skills of prestigious architects, and tourism promotion policies.[7] At their core are buildings that integrate product, predominantly media product, into space more fully than ever before, using architecture to synthesize marketing goals with the creation of awe and personal identification.

As usual, Manhattan provides striking examples. On the East Side, within the few blocks between Fifty-seventh and Fifty-fifth Streets, is a cluster of entertainment retail projects. The Warner Bros. Store features 75,000 square feet of licensed merchandise, twenty-four video screens, "a giant zoetrope in a moving picture cafe," and hands-on interactive animation stations. Nearby Nike Town features a museum of Olympic medals and trophies; films of U.S. hockey, World Cup soccer, and Michigan football; and a three-story screen that descends from the ceiling every twenty minutes to show an inspirational sports film. Nike Town alone claims ten thousand visitors daily, evenly split between tri-state residents and tourists. A Disney Store is just a few blocks south, on Fifty-fifth Street, again filled with giant video, interactive toys, merchandise, and a travel and ticket agency to help customers connect with other Disney products, such as theme parks, cruises, and Broadway shows.[8] At Times Square, the Disney Company has anchored the area's "rebirth" as a film, theater, and "interactive entertainment" district. Forty-second Street is now a showplace for Disney's endless array of family-friendly products, and the New Amsterdam Theatre is not only the stage for Disney's new live theatrical enterprises but also a celebration of the company's vast international cultural power.[9] At Columbus Circle, on the site of the New York Coliseum, Time Warner will build Columbus Centre, its new world headquarters. Near Lincoln Center, Sony and the IMAX Corporation have built a large-screen film, cinema, and shopping complex. Here, and in San Francisco and Berlin, Sony's entertainment superstores and multi-story movie screens are being used to stoke commercial real estate expansion, bolster property values, and create central tourist destinations.[10]

previous page: *Brown Music* 1991 (cat. no. 6)

It is not only a question of metropolitan redevelopment. Location-based entertainment is integral to the centrally planned city or the new town built from scratch. These fully designed entertainment and shopping districts, punched up with postmodern pastiche or careful historical reconstructions, aim to attract locals and regional and international tourists to the replication of an older urban world. Their spaces, in the words of architect Jon Jerde, try to "break down the walls between cultures and between entertainment and shopping, pleasure and profit, the viewers and the viewed."[11] CityWalk, one of Jerde's expansive projects, is built on an old Universal Studios back lot. It expands the popular studio tour outward, first into a shopping center and now into a full-size urban-themed destination. CityWalk is designed to communicate architectural chaos and urban unpredictability. Its city–theme park combination has been so successful that Universal (a subsidiary of Seagram) plans to make it a central tourist destination in Los Angeles by doubling its five million square feet of buildings, adding new rides and a convention hotel. As one West Coast observer recently put it, "Hollywood used to be in the film business," and thus the popularity of Universal Studios Tours, where customers can see animators, costumers, actors, directors, and editors at work. "But Hollywood is now in the 'place' business, selling [a synopsis of] itself and its labors as an attraction and 'place sells.'"[12]

The entertainment city built from the ground up is an international phenomenon. Universal Studios Japan, in Osaka, will combine a theme park featuring rides based on the company's mostly American film holdings with studios for "state of the art motion picture and television production." The project has been described as an integrated, wired, high-tech media-production and media-consumption urban district, the centerpiece of the redevelopment of western Osaka. It is hoped that it will "attract software creators and other high-tech enterprises."[13] Disneyland Paris represents a similar strategy: Disney's extensive holdings at Marne la Vallée are being developed into a vast residential and commercial district surrounding the theme park. Film and animation production take place here, a way to bring out product that is local and international, both Disney and French.

The spectacular examples given above are only a few of the ones available. But the same phenomenon of the interjection of media content into shared social space can be seen repeated in many places on a smaller scale. For example, shopping and regional specialty malls around the United States are clustering new media venues and mini theaters near the familiar multiplex to try to create life, light, and a kind of busy, heterogeneous street of activity.[14] "We are trying to take the best attractions out of the theme park and put them in the cities," says Vito Sanzone, the chief executive of Iwerks, a specialty theater and film company. The goal is to create "action" that works to increase the number of visits to urban and suburban places.[15] Iwerks owns the largest simulator film library in the world and builds film-based rides. The company's Cinetropolis mini theme parks offer 50,000 square feet of simulator seats and virtual-reality wiring. Cinetropolis premiered in Japan, with twenty-five more "zones" planned to open across Asia by 2000. In the United States they have been combined with reservation-based casinos, shopping malls, and urban redevelopment initiatives.[16]

Sega, the mammoth video-game company, is engaged in very diverse large- and small-scale location-based projects. Its "interactive" sites in Yokohama and Osaka are

Let's Entertain
Life's Guilty Pleasures

R&D for Social Life:
Entertainment Retail and the City
Susan G. Davis

137

small theme parks that try to "make full use of [Sega's] newest and most advanced technology," that is, they take the Sega game out of the home and transform it into pay-to-enter urban recreation.[17] In 1994, after launching a 90,000-square-foot flagship game park in Tokyo, Sega announced that it would build fifty more virtual-reality and video-game parks across Japan. A huge Segaworld unveiled at Piccadilly Circus in London accommodates thousands of simultaneous, "interactive" players. Described as "a hybrid between a giant video arcade and a small theme park," Segaworld arranges the latest proprietary high-tech rides and games across themed zones spread over seven floors in four buildings.[18]

Sega is firing up GameWorks, an international software ride-game project, in collaboration with the media–theme park conglomerate Universal/Seagram and Stephen Spielberg's Dreamworks SKG studio. Starting in Seattle, Las Vegas, and Southern California, GameWorks plans to build a string of as many as one hundred play sites in the United States and to team up with Toronto-based Playdium Entertainment to build forty Sega Cities across Canada.[19] On another track, GameWorks is at work on a project with Cineplex Odeon called Cinescape, which will combine Sega game centers with movie theaters and restaurants, again in major retail outlets.[20]

As the Sega Cities show, location-based entertainment projects draw heavily on new high-impact film technologies, combining them in a flexible mix of simulator rides, video, and virtual-reality games; they also mix and match with large-format or 3-D film.[21] This suggests that location-based entertainment is not only exporting the theme park beyond its traditional boundaries and reworking the uses of video games, but it is also changing the texture of moviegoing. New uses of specialty film and exhibition technologies cluster around the twenty-screen multiplex, building districts for multiple kinds of viewing. To take only one example, the Ontario Mills Mall in Ontario, California, devotes more than one-quarter of its one million square feet of retail space to multiplexes (more than thirty screens at last count), interspersing discount stores with nature movie theaters, film rides, and a GameWorks. Not only is the vast mall a regional entertainment district, but shopping and media interpenetrate more thoroughly than before.

In lower-end retail, the media penetration of shared space is just as advanced, though it looks different. For example, *Advertising Age* reports that "marketers increasingly are realizing the potential of in-store entertainment fixtures, such as walls of TV screens, scattered TV monitors, or audio systems." Polaroid, for example, showed a commercial inside almost two thousand mass-merchandise malls around the country. In fall 1998 country singer Garth Brooks debuted a new album via a live concert broadcast exclusively into hundreds of Wal-Marts around the United States. Retailers have discovered that they can sell video or audio time in their own stores, and national mall management chains are currently negotiating similar deals with television networks as well as local television and radio stations. For example, Wells Park Group, a national mall manager, will offer "media partner[s] space in common areas or in stores in exchange for on-air promotions." In such common commercial space, parents and children will take a shopping break to watch commercial television.[22]

Also at the less affluent end of the spectrum are examples of the emerging pattern of turning local public services over to entertainment companies under the guise of community development. To the extent that it has been successfully promoted as pro-

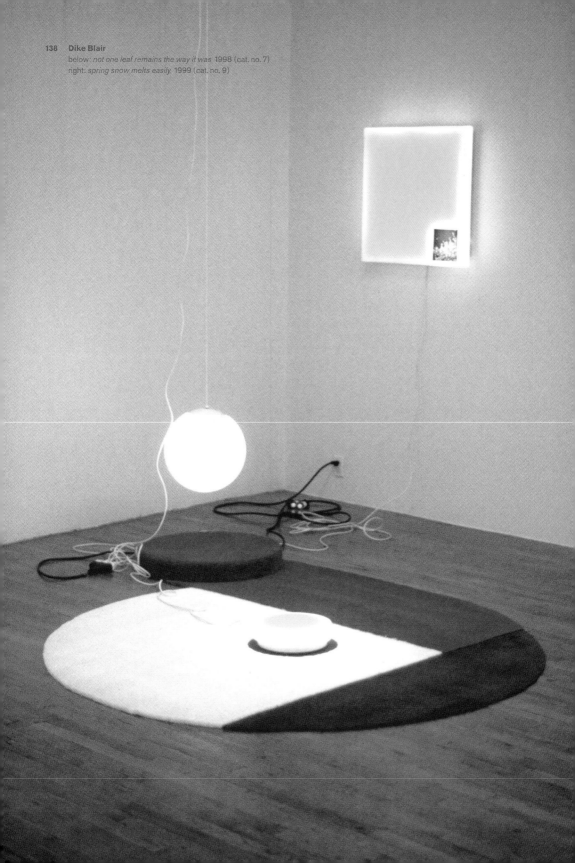

below: *not one leaf remains the way it was* 1998 (cat. no. 7)
right: *spring snow melts easily* 1999 (cat. no. 9)

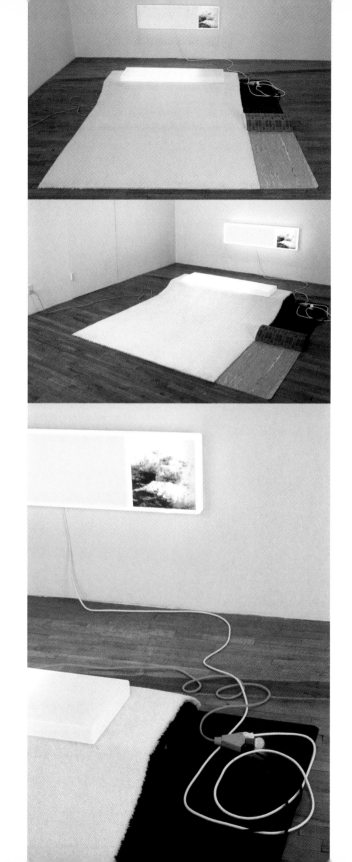

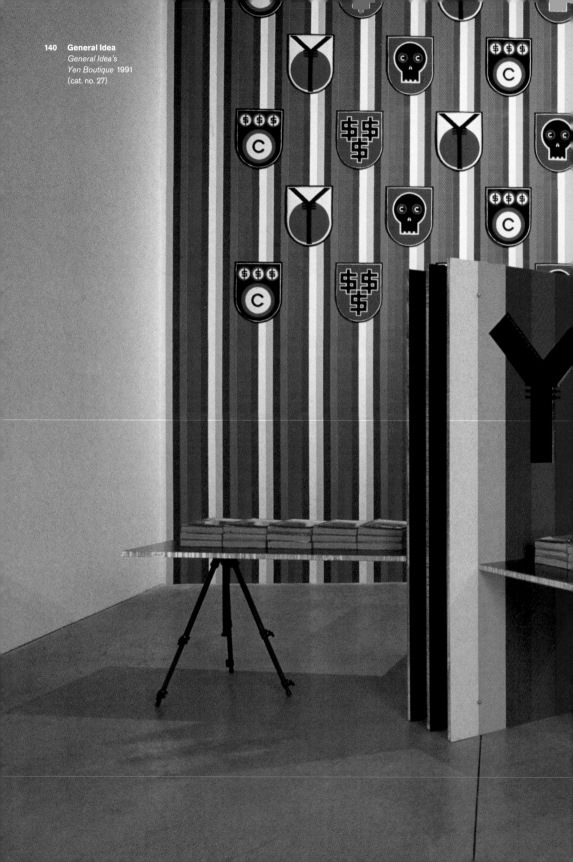

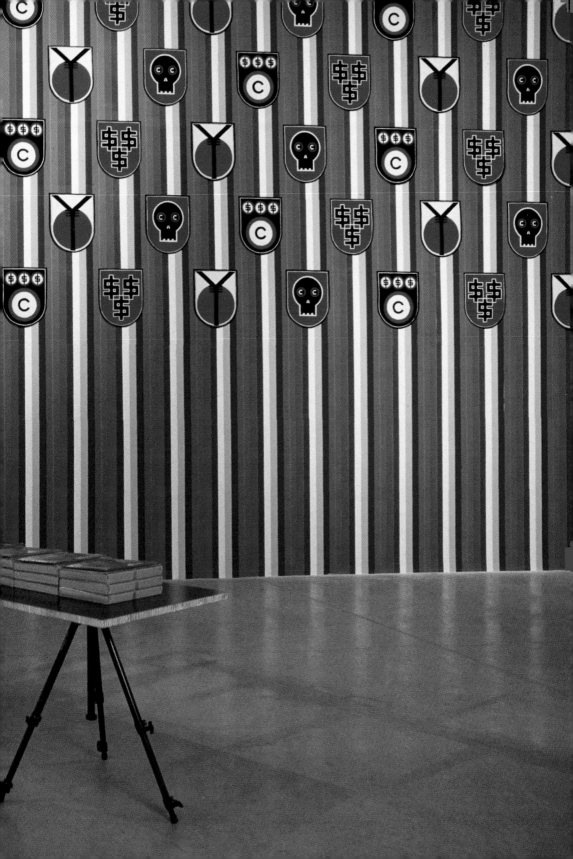

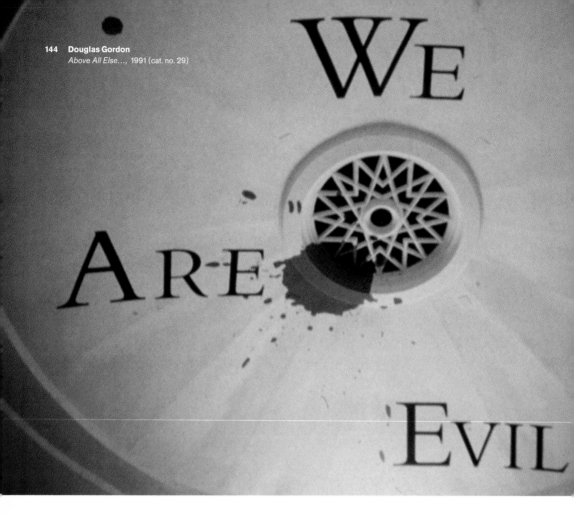

viding social amelioration—jobs, education, community centers, ways to keep kids off the streets—the entertainment-media-retail model of the city is reworking the fragments of an older public sphere.[23] In 1996 Austin, Texas, became the first municipality in the United States to build a publicly owned family entertainment center, "to aid the [largely Chicano east Austin] community in its search to give youth a safe place to hang out."[24] With city-purchased land and a HUD loan, the facility was constructed by the city but planned and run for a fee and incentives by a major leisure management company. Instead of an old-fashioned public recreation center, the Central City Entertainment Center is "all entertainment" for profit, geared to generate the maximum amount of revenue for concessionaires, the managing company, and other, similar real estate projects.

Similarly, the Battle Creek, Michigan, Parks and Recreation Department sponsored the Full Tilt Entertainment Mall as part of a downtown revitalization project. With single-ticket admission, Full Tilt contains a small water park, a video arcade, a food court, a gym franchise, a laser tag arena, and a teenage club, among other attractions. Described by its general manager as a "very aggressive...private enterprise sort of thing," Full Tilt operates on its own, without city funding.[25] Using tax-increment financing, taxes on Full Tilt's revenues do not return to the city's general fund for education and services, but are funneled into a special redevelopment district account to help expand similar projects.

Both the Austin and Battle Creek projects aim to attract and serve youth and fam-

Let's Entertain
Life's Guilty Pleasures

R&D for Social Life:
Entertainment Retail and the City
Susan G. Davis

145

ilies by modeling themselves on the corporate-produced theme park, including its concessionaires, leases, and, perhaps later, its pricing structures and promotional and sponsorship arrangements. The main difference is that each has been built almost entirely with public money, rather than the usual public-private financing blend.

The Rationale for the Entertainment Retail Boom

There are several powerful and intersecting reasons for the entertainment retail building boom. Real estate developers are partnering with entertainment corporations in part because retail and office space was overbuilt in the 1980s, and it remains so today as speculation runs far ahead of demand. Traditional shopping centers and malls, and even Jerde's elaborate plazas, are facing tremendous competitive pressure "as [American] incomes remain flat and retail space per capita increases."[26] For those with disposable income, the development of new shopping media and ways of selling to people in the home via catalogues, cable, infomercials, and the Internet is also forcing traditional retailers to be ever more inventive in order to reach the older, more affluent, though slower-consuming segment of the population. At the same time, these consumers are better understood than ever before; they have been subject to more than a generation of traditional and now computerized electronic and video information gathering. Market researchers now speak of knowing most of the consuming population as niches, each with its particular tastes, habits, and preferences.[27]

Entertainment retail is a strategy to get people out of the house. From the point of view of landlords, retailers, and especially the vast coalitions of real estate investors called REITs (Real Estate Investment Trusts, essentially mutual funds investing in real estate), the injection of entertainment content into commercial spaces is a coordinated way to differentiate one retail space from another, to bring people out to shop, and, in metropolitan locations, to capture the important tourists. In this effort, media conglomerates like Disney, Sony, MCA, and Time-Warner—which own the widely familiar film, television, and sports imagery—have a long head start. In the risky and overbuilt retail sector, the already-tested media content bolsters investor confidence, as do Hollywood's corporate deep pockets. Here Pocahontas, Daffy Duck, and the Tazmanian Devil are a kind of insurance that the customers will keep coming. Indeed, they provide sure ways to locate and appeal to important groups within the broad population.

In the current mall boom, developers are building regional specialty complexes of one to two million square feet, not including parking. Location-based entertainment and conglomerate content are helping developers exploit this space more efficiently by filling large and small chunks of the floor plan with diverse and highly flexible attractions. The location-based entertainment technologies have "smaller space applications," so "entertainment experiences can take place in smaller areas," and from a retail perspective, they produce better performance per square foot. The new small (in some cases transportable) movie theaters, the huge screens showing thirty-minute attractions, the simulator rides and video parlors can be wedged into smaller spaces in suburban malls and "higher-value locations" such as festival marketplaces and downtowns.

The technologies multiply moviegoing into short specialty and feature-length experiences. Retail developers have discovered that this variety can "produce much higher revenue per unit than a traditional cinema." Theater operating costs are lower and

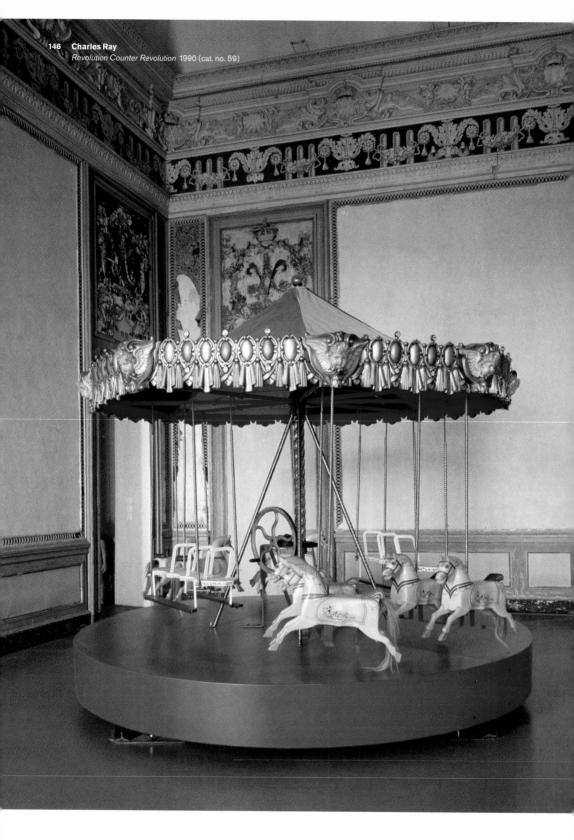

Let's Entertain
Life's Guilty Pleasures

R&D for Social Life:
Entertainment Retail and the City
Susan G. Davis

147

turnover of audiences quicker, while the "special" film experience can be priced not much lower than the two-hour feature.[28] A film ride typically takes five to ten minutes, and a 70mm film typically takes forty-five, so a visit to an IMAX or Iwerks theater can be fit in between dinner and a first-run movie. Small theaters, virtual-reality games, and simulators can be reprogrammed and rethemed quickly, often at the flick of a disk, so that content and theme rotate—there's always something new, and something spectacular. The audience's time is also more efficiently exploited. Time spent waiting in line at the movie theater can be absorbed into another attraction when a small theater or arcade is added to the multiplex lobby; time spent waiting for a restaurant table can be filled with a film ride or video game.

Like developers, media conglomerates and theater chains have a range of important reasons to support entertainment retail experiments. Theatrical film exhibitors feel pressure to get people out of the house, to break down the cocoon of television, cable, home video, computer and video games, and the Internet. The video game industry sees the problem similarly. One manager of a Seattle virtual-reality parlor put it this way: "What we're doing, and what everyone else is experimenting with, is 'What does it take to get people out of the house to spend time with other people?'…What is the right mix? In a sense this is an R&D project."[29]

New technologies are an important differentiating draw for the game arcades and specialty theaters. The special-format film producers, for example, speak in terms of increasing the difference between their products and both moviegoing and staying home with a video by intensifying the film experience through technological differentiation. As a number of film critics have noticed, the promoters of IMAX and the new mini-ride theaters are trying to re-create filmed entertainment as a kinetic, sensory, aural, and even olfactory experience, and so they are resurrecting the claim to "total cinema," the cinema of advanced and perfected perception, engaging all the senses with complete realism.[30] Special-format film promoters speak of "total immersion." According to Iwerks' Vito Sanzone: "The core attraction [of the big-screen simulator theater] is that it's a totally immersive, visual and audio experience. . . . You're battered and flabbergasted for five minutes," in a way that breaks through the "inundation" of everyday life.[31] So, too, do the new video and virtual-reality products from Sega and GameWorks claim to offer more intense experiences based on technologies that engulf the player in a whole environment. Here the "inundation" of everyday life, which must be shattered, means not only the routines of suburb, freeway, and workplace but also the rest of the media world: video, television, advertising, radio, and print.

Yet from the media conglomerates' perspective it is not just a question of breaking through the "cocoon" of home entertainment. Oddly—or perhaps not—what is being used to get people out of the house is the material that has been saturating it for forty years. The largest media conglomerates have realized that they need what Michael Eisner has called an "inside/outside" strategy, encompassing both the inside (media consumption in private and domestic spaces) *and* the outside (traditional and new forms of media consumption in public). The two spheres must work together and be mutually supportive. Eisner "wants to keep luring people out of their homes to see Disney's movies and visit its theme parks, while giving them an increasing number of products to entertain and inform themselves when they do stay home."[32] But now the

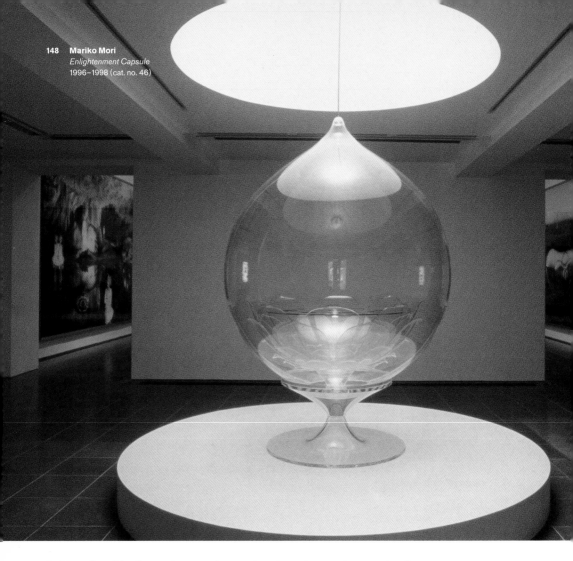

inside and outside of entertainment culture are interdependent, as, for example, when a successful film box office drives home video sales or ABC Sports enhances interest in the ESPN Zone restaurants. These companies not only can but must work on both the inside and the outside. Finding new ways to occupy space gives the conglomerates a new grounding for their mobile cultural products.

Aesthetic Strategies

From an aesthetic point of view, location-based entertainment projects face a central and perhaps paradoxical problem. Inserted into standardized and relentlessly exploited commercial spaces, they must create—out of whole cloth—a sense of place. Place is the product on offer, built up out of the design strategies learned in the theme park industry. The key theme park lessons applied to retail-entertainment are, first, shape and manage spaces to appeal to the most economically desirable customers, making sure to exclude the undesirables through price, marketing, or explicit policy. Because so much retail-entertainment space is entirely privately owned, in shopping malls and theme parks, screening of visitors can be subtle but intense. Most retail-entertainment spaces have developed careful entrance and exit control; set back from the street, they are effectively

Let's Entertain
Life's Guilty Pleasures

R&D for Social Life:
Entertainment Retail and the City
Susan G. Davis

149

gated, since visitors enter through a hotel, from a freeway off-ramp, or from huge parking garages or special plazas.[33] They have also developed architectural and security techniques to discourage undesirables—the homeless, who may panhandle, or teenagers who will spend little money, for example.[34] At the same time, surprisingly detailed information gathered by covert surveillance cameras is fed back into the pool of retail and market research data to help further refine the design and control of space.[35]

The same spatial control can be accomplished and supported by theming, which, when successful, applies strong narratives to spaces while eliminating undesirable or conflicting images, ideas, or experiences. Themes themselves—preexisting and well-understood narratives—can help control these spaces by drawing in and confirming the identities of the desired customers. Themed space carefully coordinates design elements, from the shape of open areas and the forms of buildings to paint, lighting, sound, signage, and sometimes costume, all referring to a cultural story. In addition to creating an attraction, the point of theming is to achieve as much experiential coherence as possible, even if the theme itself is one of heterogeneity, carnival, or even chaos. So Universal CityWalk's theme is "city," a collage and repackaging of pieces of Los Angeles' mass cultural image, occasionally even including references to grit and danger. This compressed, selected Hollywood gives eating, shopping, and people-watching a charge; they become theatrical experiences, performances in themselves.[36] Again, media companies have a long head start in building themed space; they've spent decades specializing in narratives and the icons that compress narratives, and, indeed, they own outright huge banks of images and stories.

At the heart of the location-based entertainment projects is this paradox: within the context of themed space, they aim to reproduce a sense of authentic space, and this means evoking the diversity and unpredictability of the older city using carefully calibrated recipes. The projects aim to reproduce a life and liveliness that looks like the older commercial downtown, but in order to do this profitably, in order to turn out the right sort of crowd, they must control mixing and reduce real unpredictability. The appeal of GameWorks, Disney Stores, Rainforest Cafes, and ESPN Zones for mall developers is not just the increased rents and sales per square foot; it is that, when successful, these venues create visible sociability—noise, movement, and the dense presence of people—inside and outside their doors. Whether they are installed in regional specialty malls, shoehorned into redeveloped downtowns, or added to the mix of mega-destinations like Orlando and Las Vegas, developers and investors hope that by combining upholstered lounges, Internet cafes, movie theaters, and restaurants with interactive media content, location-based entertainment can pull in the "destination audience." These are people twenty-five and older, especially couples, "looking for an evening that will combine food, going to a Virtual World, a nightclub, a movie."[37] "Destination audiences" can be persuaded to open their wallets at more than one attraction, and crowds, the sense of the mixed and heterogeneous city, are part of the attraction. Heavy mall traffic itself, like the crowd at the county fair or theme park, can loosen restraints on spending and overcome the sameness of the suburbs and the dispersal of the automotive city. The recipe results in small and large spaces that are close relatives of the theme park's ideal city, a closed city free from the uncertainty, poverty, and potential crime of the real streets.[38]

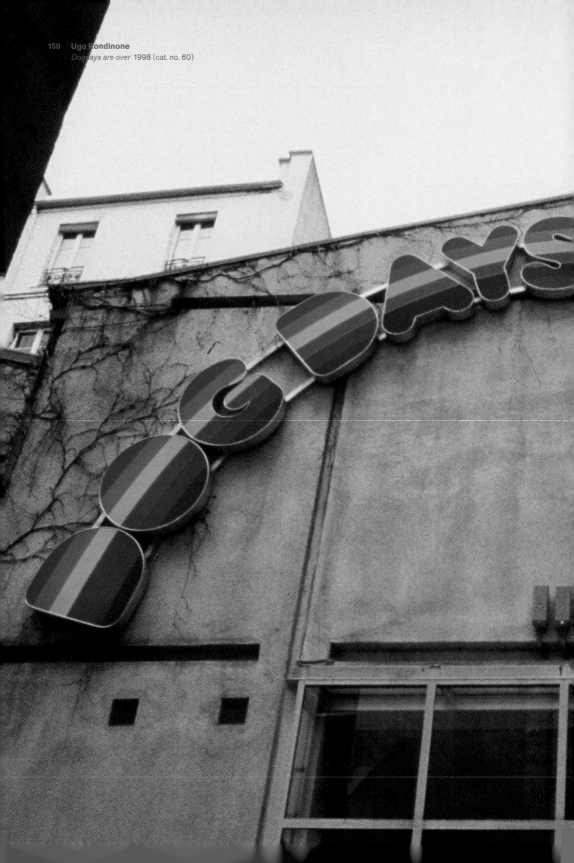

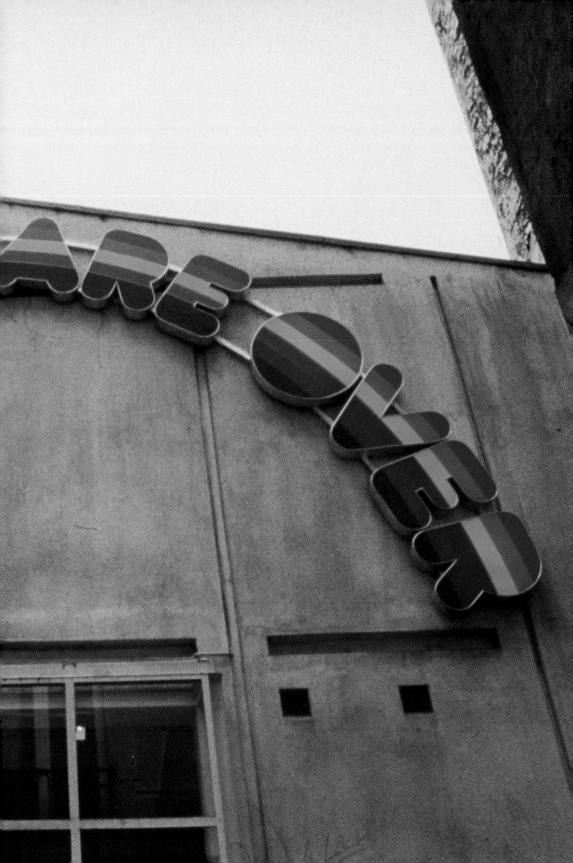

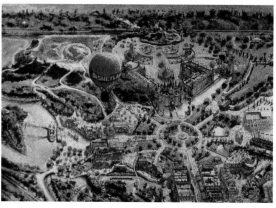

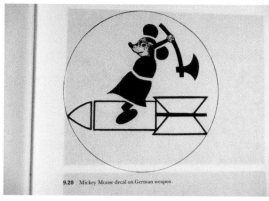

9.20 Mickey Mouse decal on German weapon.

154 **Paul McCarthy**
 previous page: *Documents*
 1995–1999 (cat. no. 45)

 Philippe Parreno
 facing page: *No More Reality*
 (Twin Peaks) 1991
 oil on wood
 Private collection

Materializing Media

The most important example of theming is, of course, the focus on media product as the central story of the retail space. Like the use of high-impact film and game technologies, the integration of Hollywood and television narratives aims to push new energy into a familiar experience and to bring people out. By all accounts the Walt Disney Company has been most farsighted and aggressive in finding endless three-dimensional and spatial forms for its media products. As is well known, Disney was the first to really undertake the meshing of mass-media content, merchandising, and promotion in its 1950s theme park. At Disneyland, films and animated cartoons became three-dimensional in the landscape. Robots and rides were media images that customers could touch, just as the park's live performances, parades, and theater could touch customers. In the 1990s all the major park chains are themed around proprietary media products, and they fold film, television, computer, and video games into their three-dimensional worlds.[39] But Disney is now materializing media far beyond its theme parks and Disney Stores, resorts, and cruises. Its New Amsterdam Theatre in Manhattan is total marketing strategy, a branded space where multiple and overlapping products are embodied and enacted. The company is also launching ESPN Zone sports cafes, a chain of DisneyQuest high-tech arcades, and a group of pay-to-enter children's centers called Club Disney, each of which have direct and overlapping network, film, and cyber-media content and connections.

Making media content three-dimensional and locating it in space have a variety of uses for the entertainment conglomerates. Entertainment merchandise stores—Disney has more than 450 in the United States—have already become widely familiar in the last decade. They supplement the all-important licensed merchandise sales tied to box-office hits.[40] In these stores, media content in the form of merchandise is a profit stream in its own right, contributing enormously to the bottom lines of the licensing and "creative content" divisions, which, in the case of Disney, usually contribute more than a third of annual gross revenues. Just as important, themed merchandise gives an added boost to the promotion of the latest film, television show, video game, book, or toy.

The Viacom Store experiment provides a good example of the combination of all these reasons to materialize media. It also illustrates the risks of the strategy. Opened in Chicago in spring 1997, the store "converged" the conglomerate's six most popular brands "under one roof in one retail environment": Nickelodeon (cable network), Nick at Nite (cable programming), MTV and VH1 (music TV programming), Paramount Pictures and *Star Trek* (current and historical film products). As a merchandising point, the store was designed to sell videos, music, and souvenirs based on such vintage shows and films as *I Love Lucy*, *Happy Days*, *The Brady Bunch*, and *The Godfather*, as well as newer product such as *Cheers*, *Forrest Gump*, and *Frasier*. Just as important, it aimed to promote these and many other film, music, and television products by selling various kinds of Viacom experiences. Thirty interactive stations allowed customers to "enter" into various Viacom TV and film products and literally "walk around" inside them. "By transitioning the design and layout of the store from one television era into another, customers curiously venture[d] into each level of the store and each segment of . . . merchandise," where they were addressed by interactive TV monitors, talking figures, "blasts from the past," and music from MTV history.[41]

Let's Entertain
Life's Guilty Pleasures

R&D for Social Life:
Entertainment Retail and the City
Susan G. Davis

155

At the same time, the store was designed as a test-marketing platform for Viacom, a place to try out new products and franchises on customers. The Chicago customers ventured through new lines of goods based on the animated television cartoon characters the Rugrats, Ren and Stimpy, and Beavis and Butthead.[42] Similarly, the Disney, Sega, and Microsoft location-based projects are designed to showcase and test proprietary "software, media or hardware technology" by offering customers an opportunity to play with "ever-more sophisticated games, simulators and virtual reality applications" and allowing the company to gauge customer reaction.[43]

The Chicago Viacom Store was so successful after a first year that in 1998 the company announced that it would build seventeen more. Only a year later, however, Viacom announced that it was closing all of its stores. One reason is saturation: Viacom had to compete with Disney, Sony, and Warner Bros. in an increasingly permanent, crowded, and expensive bricks-and-mortar world. At the same time, as licensed mer-

chandise has become more important to conglomerate profits and more closely tied to animated film promotion, the enormous retailers Wal-Mart, Target, and Sears now carry much the same licensed toys and clothing. The studio stores have helped to produce a glut, and their emphasis on the brand may make them, paradoxically, too dependent on their own product.[44]

Yet, even as their absolute number levels off, studio stores remain important internationally and in the United States, especially in the large cities. This is because, finally, entertainment retail, like the media saturation of public spaces generally, does more than sell particular products. The Viacom Stores were—and the Disney, Sony, Warner Bros. stores remain, like Nike Town—dedicated to the celebration of the company as a brand, of the idea, feel, and associations the name of the company evokes. The stores offer visitors a kind of journey through a world of brand-name concepts; the very concept of the company (and the power of conglomerate media ownership) is celebrated through products and product histories. These spaces are dedicated to corporate identification. As one Warner's executive put it, the stores create "a presence in the community"—and by this he meant a marketing presence—that is all the more effective because it is so much fun.[45]

To sum up, location-based entertainment projects have multiple and overlapping uses for media conglomerates: they help cross-promote media content, intensifying profits and adding new profit streams; they "bomb the brand" and act as walk-through public relations; and they provide a place to test new products and gather information about the customers. But beyond this, materialized mass-media content paradoxically creates a sense of the local. As the most familiar cultural material of all, transnational media content (originating largely in the United States) not only serves to give spaces stories, it also adds a powerful sense of history, linking the family or individual past to the shared social past. And its ability to pull familiar media content into collective space helps spaces communicate familiarity and authenticity—all-too-fragile commodities in standardized, controlled, and centrally designed spaces.

Traditionally, places have been made up out of the diverse activities and interrelations of people—acting unevenly, individually and collectively, economically and expressively, in coordinated and uncoordinated ways, often at cross purposes—in the physical environment. In this view, place is not the uses space is designed for, but the uses people find for space. This perspective should, on the one hand, prompt us to examine exactly how the new media-saturated spaces are being used and whether they can make room for unauthorized and non-consumption-driven activities and meanings. On the other hand, it should give us pause, since we have seen how energetically the entertainment space designers are moving beyond architecture and decoration to discover ways to encourage desirable persons to enter and participate in products, to keep out undesirables, and, generally, to turn every niche of space to promotional or marketing purposes. The entertainment–real estate boom suggests that there has been a remarkable acceleration in the management of relationships between people and products, that this management has moved even further into three-dimensional space, and that corporations with enormous creative talents and research budgets continue to try to find new physical, psychic, and cultural spaces to penetrate. The boom is evidence that the

Let's Entertain
Life's Guilty Pleasures

R&D for Social Life:
Entertainment Retail and the City
Susan G. Davis

157

mass-media corporations, especially, sculpt the physical world we move about in and the social space we share with neighbors and fellow citizens.

If entertainment-retail projects were only monumental—like CityWalk, Nike Town, or Times Square—these reconstructions of space would still be evidence of a deep, continual reworking of experience. After all, in the past monumental architecture has celebrated national identity, historical events, memories of suffering, narratives of loyalty and sacrifice. Now the most striking architectural points of pilgrimage cultivate awe for the brand and the magic of belonging through identification with the corporation. Like the old-fashioned monuments and memorials, they are sites where people connect with core cultural ideas and stories. In these new spaces, however, the core cultural ideas are not just embodied by products; they *are* products. Citizens are collapsed into consumers, and loyalty is a virtue that expands the bottom line. But, as I have suggested, these spaces are not only monumental but now also small and ubiquitous; they hook up the inside to the outside on a scale that is diurnal and ordinary. This is the other sense in which the media conglomerates are knitting our everyday lives more tightly into spectacle by remaking places.

Notes

This material was presented in various forms at the 1996 and 1997 American Studies Association Annual Meetings in Kansas City, Missouri, and Washington, D.C., respectively, and at the 1998 meetings of the Society for Cinema Studies in San Diego. I'd like to thank Dan Schiller, Cynthia Chris, Ellen Seiter, Bob McChesney, and Margaret Crawford for valuable suggestions.

1. Michael Sorkin, ed., *Variations on a Theme Park: The New American City and the End of Public Space* (New York: Hill and Wang, 1991). See also Herbert I. Schiller, *Culture Inc.: The Corporate Takeover of Public Expression* (New York: Oxford University Press, 1989), esp. 89–110.

2. On the primacy of media and communication in the global economy, see Edward S. Herman and Robert W. McChesney, *The Global Media: The New Missionaries of Corporate Capitalism* (London: Cassell, 1997).

3. Carey Goldberg, "Game Centers Lure Computer Loners to High-Tech Team Activities," *New York Times*, 4 August 1997.

4. Patrick Phillips, "Merging Entertainment and Retail," *Economic Development Review* 13 (spring 1995): 13–15 (online version: Abstracts of Business Information, 1–3); "Theme Parks: Feeling the Future," *Economist* 330 (19 February 1994): 74–79; Michael Hartnett, "Fun and Games," *Stores* 75 (October 1993): 62–66.

5. Strategic thinking about the location of entertainment is nothing new, as the history of Forty-second Street illustrates. There, between the end of the nineteenth century and the Great Depression, entertainment entrepreneurs helped create an extraordinary district that embodied American commercial culture's world dominance. Broadway was a space that promoted, tied in, and cross-promoted the plays, musicals, sheet music, celebrities, and films of the entertainment industries; it also was shaped into an extraordinarily liberated space for sexual minorities and sex workers of all kinds and so both moved and marked the boundaries of respectability. See Jean Christophe Agnew, "Times Square: Secularization and Sacralization," in *Inventing Times Square: Commerce and Culture at the Crossroads of the World*, ed. William R. Taylor (New York: Russell Sage Foundation, 1991), 2–15. This volume includes several other relevant essays: on real estate forces creating Times Square, see Elizabeth Blackmar, "Uptown Real Estate and the Creation of Times Square" (51–65), and David C. Hammack, "Developing for Commercial Culture" (36–50); on sexuality and space, see George Chauncey Jr., "The Policed: Gay Men's Strategies of Everyday Resistance" (315–28), and Laurence Senelick, "Private Parts in Public Places" (329–55).

6. See, for example, John Hannigan, *Fantasy City: Pleasure and Profit in the Postmodern Metropolis* (London: Routledge, 1998).

7. On redone downtowns, see M. Christine Boyer, "Cities for Sale: Merchandising History at South Street Seaport," in Sorkin, ed., *Variations on a Theme Park*, 181–204; on Atlanta, see Charles Rutheiser, *Imagineering Atlanta: The Politics of Place in the City of Dreams* (London: Verso, 1996), and Joshua Levine, "Zap-Proof Advertising," *Forbes*, 22 September 1997, 146–50; for studies of gentrification that include Philadelphia and Manhattan, see Neil Smith, *The New Urban Frontier: Gentrification and the Revanchist City* (New York: Routledge, 1996); on Cleveland and Los Angeles refurbishings, see Barry M. Bloom, "Ballpark Is a Hit in Cleveland," *San Diego Union-Tribune*, 9 July 1997; Michael A. Hiltzik and Lisa Dillman, "Who Wins in Stadium Shootout?" *Los Angeles Times*, 13 July 1997.

8. *Architectural Review* 201 (May 1997): 95; Randy Gragg, "Domination by Design," *Metropolis*, June 1997, 62–67, 83–85 (quote is from p. 84).

9. Brett Pulley, "Disney's Deal: A Mix of Glamour and Hardball Won Disney a Piece of Forty-second Street," *New York Times*, 29 July 1995; Monica Roman and Greg Evans, "Mouse in Manhattan: Beauty or Beast?" *Variety*, 1–14 July 1996, 1, 50; Marshall Berman, "Signs Square: Times Square," *Village Voice*, 18 July 1995, 23–26.

10. Tim O'Brien, "Branded LBEs Become Virtual Corporate Lands," *Amusement Business*, 24–30 June 1996, 1, 32.

11. Evelyn Iritani, "A Mall Master Takes Over the World," *Los Angeles Times*, 5 July 1996.

12. For more on CityWalk, see Donald Shillingburg, "Sense of Place: Hollywood Style," *Architectural Record* 182 (August 1994): 86–88; on Universal's expansion plans, see William Fulton, "From Making Dreams to Concocting Reality," *Los Angeles Times*, 22 June 1997, sec. M (quote is from Fulton).

13. Tim O'Brien, "MCA Announces Plans for Japan Studio Attraction," *Amusement Business*, 17–23 January 1994, 28; James Zoltak, "MCA's $1.6 Bil Japan Park Construction Starts in '98," *Amusement Business*, 18 February 1996, 1, 43. Meanwhile, MCA regards all Asia as "an auspicious region for expansion" and "a home run with bases loaded. . . . We are looking (at land and properties) everywhere" (MCA's CEO for development, David Weiztner, quoted in Zoltak, "MCA's $1.6 Bil Japan Park," 43). See also Evelyn Iritani, "Taking a Swipe at Disney: MCA Goes Head to Head . . . in Bid for Asia's Entertainment Dollars," *Los Angeles Times*, 19 May 1996, sec. D.

14. Phillips, "Merging Entertainment and Retail"; Hartnett, "Fun and Games."

15. Quoted in David Johnson "Iwerks Entertainment," *TCI* 29 (January 1995): 22–23.

16. Iwerks Company Annual Report (Burbank, Calif., 1996); Ron Grover, "Where Buying a Ticket Puts You Right in the Action," *Business Week*, 7 March 1994, 73–76, Susan Ray, "Iwerks Harvests Eleven Projects in Fertile Far East Marketplace," *Amusement Business*, 6–12 June 1994, 16–21. Saturation in the theme park industry gives a push to Cinetropolis-type projects: "Why risk $1 billion on a huge new theme park that will need to attract 12m visitors a year to turn a profit, when you can build 30 small Cinetropolis-like centers in shopping malls instead?" ("Theme Parks: Feeling the Future," *Economist*, 19 February 1994, 74–79). See also Linda Deckard, "Itochu-Iwerks Cinetropolis Projects Moving Forward in Far East, U.S.," *Amusement Business*, 19–25 April 1993, 24, 27.

17. Tim O'Brien, "Sega's New Joypolis Expands on High-Tech Theme Park Concept," *Amusement Business*, 1–7 August 1994, 3, 54; O. Katayama, "The Aim of the Game," *Look Japan*, July 1994, 18–19.

18. Tim O'Brien, "SegaWorld Expects 1.7 Mil First-Year Attendance," *Amusement Business*, 16–22 September 1996, 1, 34. The rides and themed areas are completely familiar from the theme park world: the "Sports Arena, The Carnival, Flight Deck, Sega Kids, Race Track, and Combat Zone." For example, "the Beast of Darkness is a ride through total darkness with scares coming from sounds and movements, and the Aqua Planet is an interactive adventure ride where visitors wearing 3-D glasses are immersed in an experience through 3-D computer graphic pictures, sound and motion."

19. The first Sega City, outside Ontario, is a $17 million (Canadian) sports- and film-themed entertainment complex with "more than 180 video simulators and interactive games." CEO Jon Hussman states that Playdium "was set up specifically for rolling out the LBE center concept that we've spent the last four years developing" (in James Zoltak,

Let's Entertain
Life's Guilty Pleasures

R&D for Social Life:
Entertainment Retail and the City
Susan G. Davis

159

"First Sega City Playdium Under Way near Toronto," *Amusement Business*, 24–30 June 1996, 31–32).

20. "Cineplex Odeon New Division," *Wall Street Journal*, 2 May 1996, sec. B; James Zoltak, "Destination Locations Prime Spots for Virtual World Attractions," *Amusement Business*, 8–14 January 1996, 24.

21. This complex of overlapping technologies is being developed by several competing companies. IMAX, Omnifilm, Sony, and Iwerks in 70mm format film and 3-D film are the largest; smaller companies like Ridefilm, Showscan, and Boss Film each have their own links to large-format film and the mega-content producers.

22. Alice Z. Cuneo, "Marketers Drawn to In-Store Entertainment: Polaroid Latest Using Video to Reach Consumers While They're Shopping," *Advertising Age*, 28 April 1997, 20.

23. As Thomas W. Hanchett has shown, vast tracts of today's hyper-consumption landscape have been built in part with public financing, and often at the expense of projects that would meet basic housing, schooling, and open-space needs for a broad public, including poor and working-class citizens ("U.S. Tax Policy and the Shopping Center Booms of the 1950s and 1960s," *American Historical Review* 101 [October 1966]: 1082–1110); in the same issue of *American Historical Review*, see Lizabeth Cohen, "From Town Center to Shopping Center: The Reconfiguration of Community Marketplaces in Postwar America" (1050–81); Kenneth T. Jackson, "All the World's a Mall: Reflections on the Social and Economic Consequences of the Shopping Mall" (1111–21). The developers and promoters of the entertainment retail projects rely heavily on financial and political help from state and local governments. As is well known, city governments, redevelopment authorities, planning commissions, state and local tax codes, tax abatements, and zoning ordinances all play an important role in smoothing the way for large-scale commercial real estate projects, and so they actively promote the high-consumption, and now retail-entertainment, redefinition of social space, as they have for less flamboyant real estate developers for decades. In California current state law makes it much easier to issue public debt to build a shopping center than to build a new school, a massive privileging of the interests of private speculation over the provision of public education, goods and services. See, for example, Mike Davis, "The Infinite Game," in *Out of Site: Social Criticism of Architecture*, ed. Diane Ghirardo (Seattle: Bay Press, 1991), 77–113.

24. Ray Waddell, "Austin Backing Multi-Million Dollar FEC; LMI Negotiating Mgmt. Deal," *Amusement Business*, 18 November 1996, 24.

25. Tim O'Brien, "City of Battle Creek to Build Family Entertainment Mall," *Amusement Business*, 7 April 1997, 1, 18.

26. Phillips, "Merging Entertainment with Retail." See also Mitchell Pacelle, "Simon DeBartolo Group to Invite Wide Variety of Firms into Malls," *Wall Street Journal*, 29 August 1997, sec. B.

27. Malcolm Gladwell, "The Science of Shopping," *New Yorker*, 4 November 1996, 66–75.

28. Phillips, "Merging Entertainment and Retail."

29. Quoted in Goldberg, "Game Centers Lure Computer Loners."

30. Paul Arthur, "In the Realm of the Senses: IMAX 3-D and the Myth of Total Cinema," *Film Comment* 322 (January–February 1996): 78–81.

31. Quoted in Johnson, "Iwerks Entertainment," 22–23.

32. For Disney, Internet-based cyber-entertainment will shortly join the ESPNs and Disney channels, increasing its in-home presence. Bruce Orwall, "Disney Cuts Costs, Plans Growth in Cyberspace," *Wall Street Journal*, 24 September 1998, sec. B.

33. For commentary on this, see Susan Straight, "Safe Indoors," *Hungry Mind Review* 41 (spring 1997): 9, 50.

34. Jon Goss, "The 'Magic of the Mall': An Analysis of Form, Function, and Meaning in the Contemporary Retail Built Environment," *Annals of the Association of American Geographers* 83, no. 1 (1993): 18–47.

35. Paco Underhill's research firm, Envirosell, has pioneered the research uses of video cameras in stores. Gladwell, "Science of Shopping," and Paco Underhill, "Kids in Stores," *American Demographics* 16 (June 1994): 23–26.

36. Goss, "Magic of the Mall"; cf. Mark Gottdiener, *The Theming of America: Dreams, Visions, and Commercial Space* (Boulder, Colo.: Westview Press, 1997).

37. James Zoltak, "Destination-Locations Prime Spots for Virtual World Attractions," *Amusement Business*, 8–14 January 1996, 24.

38. Jon Goss, "Disquiet on the Waterfront: Reflections on Nostalgia and Utopia in the Urban Archetypes of the Festival Marketplaces," *Urban Geography* 17 (April 1996): 221–47.

39. Susan G. Davis, "Theme Park: Global Industry and Cultural Form," *Media Culture and Society* 18 (July 1996): 399–422.

40. George White, "New Theme Player" (on Disney and ESPN stores), *Los Angeles Times*, 16 September 1997, sec. D. Licensed merchandise sales now account for more of the profits from a blockbuster film than do box office ticket sales.

41. On Viacom, see Don Muret, "Interactive Viacom Entertainment Store Merges Six of Its Most Popular Brands," *Amusement Business*, 9 June 1997, 5. In addition to its U.S. shops, Disney operates 191 abroad. Warner Bros. has 134 stores in the United States and 40 abroad. Store of Knowledge, Inc., operates stores themed to Public Broadcasting Service programming, and the Discovery Channel operates 17 Discovery Stores in the U.S. and one in Britain (White, "Theme Player").

42. Clara M. W. Vangen, "Interactive Retail," *Buildings* 92 (July 1998).

43. Phillips, "Merging Retail and Entertainment"; Goldberg, "Game Centers Lure Computer Loners." Disney projects building twenty to thirty more DisneyQuests in the next decade (Tim O'Brien, "Walt Disney Co. Moves into the World of LBE," *Amusement Business*, 18 August 1997, 1, 38).

44. Richard Morgan, "Retail Rut Hits Studio Glut," *Variety* 374 (22 March 1999): 7.

45. Similarly, Nike Town on Fifty-seventh Street, New York, was designed to be a "brand bomb" and "the face of the brand"; the goal is "to educate consumers about product design, research and sports in general" by "exploding Nike's image in the hottest retail district in the world" (Gragg, "Domination by Design," 84; Mike Duff, "Exploiting the Equity of a Name," *Discount Store News* 37 [11 May 1998]: 59, 88).

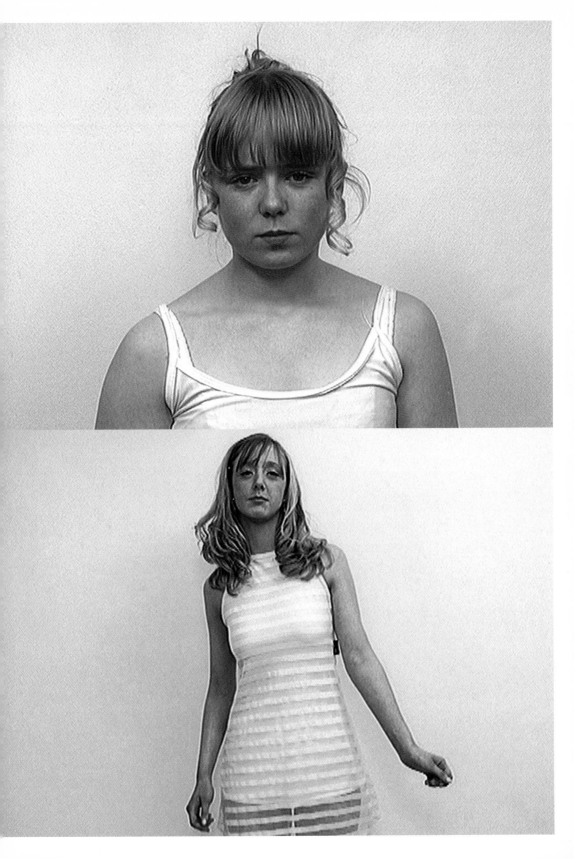

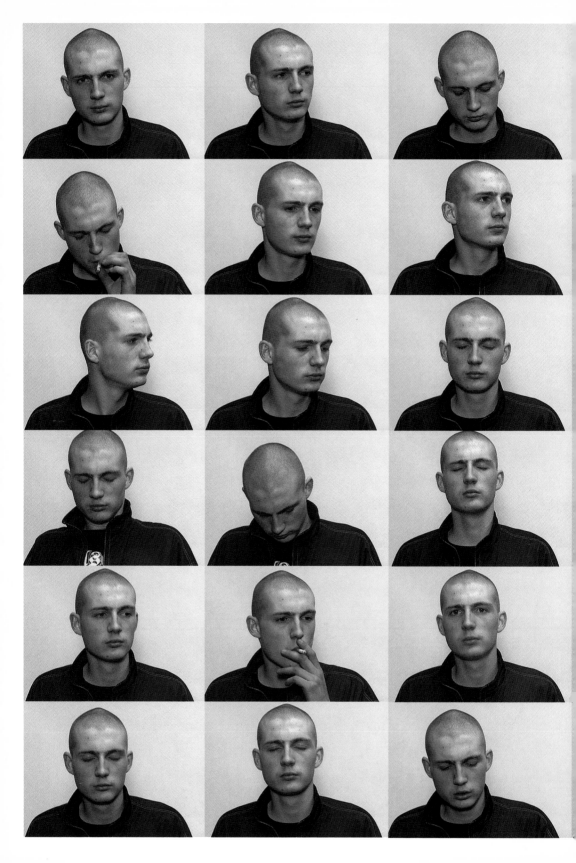

Branding, Bar Codes, and Other Assorted End Credits: Notes on the Decorated Self
Akiko Busch

My own tattoo is a tame affair, acquired some twenty years ago on the eve of getting married. When it occurred to me that a small, permanent emblem might serve as a more appropriate symbol of long-term commitment than a piece of jewelry, I got myself to the San Francisco studio of Lyle Tuttle, a tattoo artist whose legendary skills were matched by his archive of images. As I was browsing through Tuttle's graphic catalogue, a couple came in. He was a biker, and he wasn't shy about pulling off his shirt, but he was a little more sheepish about what was under it. Tattooed on his chest was the image of a scantily clad woman, and what she lacked in the way of clothes was made up for by a voluminous mane of hair, huge breasts, and sinuous calves. For all her graphic glory, however, she was not the woman with the biker now.

Tuttle examined the tattoo, analyzed its various graphic elements, noted how the passage of time had affected it, blurring the figure just slightly, and then he itemized the various illustrative revisions he could make. He could amend the hairstyle, for example, or add clothing. The background might be further decorated and elaborated upon with more abstract imagery. The image, in other words, might be entirely renovated and updated to be more consistent with the biker's current romantic involvement.

There is something about this anecdote that rings true. The biker in Lyle Tuttle's studio twenty years ago was onto something that is now almost commonplace in the graphic art and entertainment of body decoration. In her catalogue to the 1996 exhibition *Mixing Messages: Graphic Design in Contemporary Culture*, curator and designer Ellen Lupton describes contemporary graphic design as an active process:

> Since the rise of mass media in the mid-nineteenth century, graphic arts technologies have promoted the manipulation and collage of existing material. Never has the ability to mix disparate elements been greater than during the past fifteen years. Digital imaging, page layout programs, type design software, and video production technologies have given designers new ways to find, create, manipulate, and disseminate images and information. Graphic design as a process involves the making of visual statements and their use and revision by clients, audiences, and other designers. Mixing characterizes the social life of graphic design.[1]

If Lyle Tuttle was doing anything in his studio that day, he was promoting the manipulation and collage of existing materials; he was mixing messages. And while we are surely surrounded by such disparate images and messages—in signage, film, media, and animation, in cyberspace and every other aggregate of space imaginable—what is of greater interest here is the grace, the frequency, and the visual energy with which these mixed messages now appear on the human body. It is a condition that indeed renders the human body not so much a text as a stage or theater for a performance that concerns issues of shifting, ever-evolving identity.

The human body has long served as a decorative surface. In itself, that's nothing especially new. What is new, and more particular to our time, is the manner in which we devise these forms of decoration, adopting them, then shedding them, acquiring and

losing identities as a form of cultural entertainment. A host of computer animation tools such as Paintbox have made it easier to create, manipulate, and multiply imagery. But as our visual literacy evolves, we look to increasingly sophisticated visual strategies for marking ourselves. And when it comes to the self and the body, we direct that literacy to the need and the ability to customize ourselves and our experiences.

My children are fond of a series of books called Animorphs, in which a group of kids routinely metamorphose into eagles, bears, wolves, hawks, and other creatures in a process of transformation that apparently endows the morphee with the power, instinct, and vision of the wild animal. Such morphing is no longer restricted to children's stories. Indeed, it is an approach to identity that is consistent with a broader cultural outlook. As witnesses to the millennium, we have come to accept the notion that identity is fluid; who we are is changeable, malleable, and mutation is central to identity. And how often, how skillfully, and how gracefully we morph is often part of a larger cultural performance piece.

Writing about athletes and the equipment they use, writer and designer Steven Skov Holt has observed that this fluidity of identity "may also be in part due to the propensity of baby boomers and Gen-X to experiment with meditation, fasting, and mind-altering drugs. Pharmaceuticals have probably done more to subconsciously legitimize notions about the shifting nature of reality than any single movie, book, program, exhibition, or other cultural production."[2] But if we accepted the idea a generation ago that mind-altering drugs might offer us alternate realities, the idea has become more mainstream today. With the use of such legal prescription drugs as Prozac and Zoloft, the idea that the chemistry of the brain, and the behavior it induces, can be easily amended has become more widely accepted. And aside from pharmaceuticals, it has become conventional wisdom in the late twentieth century that a host of analytical, behavioral, and cognitive therapies can help transform the very core of our being.

The reconfigured self is indeed a convention of the times and has created an environment in which self-invention and reinvention approach being a form of cultural play. We aspire to the transformed self, fully accepting the illusion that such transformations are available to us, and we have become ingenious at finding ways to signal visually our serial and sequential identities. How we brand ourselves, along with the things we own, is often the visual equivalent of a sound bite. With unprecedented extravagance, indulging in a kind of visual channel surfing, we use imagery that is dense, chaotic, cut off, cut up, and layered. And, increasingly, the body is part of the language, an alphabetic component. It contains a code, albeit a code that is ever changing. And what the code reveals, of course, are the assorted reasons we have for desiring these constant transformations of self. It may be for a temporary alliance—with a sports team, a political view, an icon of glamour or celebrity. It may be part of an ongoing search for youth. It may be for purposes of camouflage and disguise. Or, possibly, it may simply be an expression of self-hatred.

For these reasons, and others, we search out ways to mutate and morph; personal reinvention is a game and an exercise we play out in a variety of contemporary arenas. A review of our compulsion to morph, and all its implicit creativity, might begin in the realm of sports, where examples range from the lavish body painting in team colors practiced by football fans to the myriad icons, insignias, and logos that contemporary sports equipment carries. In fashion, there has been a movement from the use of subtle

but potent single logos on clothing and accessories to designs and patterns painted directly on the body. More substantive personal reinvention is offered by assorted plastic and laser surgery procedures that resculpt and reshape the body, aligning it with some more youthful persona.

All of these are forms of branding that may ally us with a league, a team, a street culture, a club of one kind or another. And all of these may work as bar codes and brands, signals of our constantly shifting affiliations and allegiances. And as graphic devices that signal the value we attach to objects, to ideas, to people, they also serve as a means of customizing the self, raising issues of identity in an age of technology. Indeed, our compulsion and ability to constantly identify and reidentify ourselves through these decorative and structural techniques may be best summed up by the slogan on a T-shirt favored by tattoo artists: "I ink, therefore I am."

Holt discusses at length the theme of melding and morphing identities in sports equipment: bicycles that are a sum of parts—assembled individually with clipless pedals, new frame geometries, and electronic shifting mechanisms, in a customized collage of high-tech equipment—or skateboards that have been customized with abrasions, calligraphy, graffiti, decals, and "other assorted forms of advanced user-induced scarring."[3] This dense visual collage is not, however, restricted to sports equipment. The athlete as well is constantly morphing, mutating, and otherwise becoming customized, sometimes through the use of steroids and other performance- and body-enhancing drugs. Just as equipment manufacturers are constantly working to keep their products from becoming generic, so too do consumers customize their own recreational identities in a similar effort to avoid being generic athletes.

Like the young heroes of the Animorphs series, the graphics of professional sports leagues look to sharks, bears, wolves, raptors, and cobras in an effort to project the superhuman abilities of these creatures. Helmets, gloves, padding, and other types of sports armor reshape the athlete, constructing both a physical and a psychological persona. Cycling shirts are imprinted with Spiderman graphics to evoke cartoon heroics, while kids' bike helmets come with reptilian designs. Often drawing on insect, reptile, or alien references, the forms of the equipment and the graphics that mark it link the athlete to superhuman forces.

And then there are the shoes. Shoe manufacturers are deliberate and precise about how consumers wear the shoes and where the logo appears, and recreational athletes have become equally adept at their own individual brand management. Athletic footwear, we know, confers a mystique on the wearer. Nike's Air Jordans are perceived as conferring exceptional athletic ability, even the power of flight, upon those who wear the basketball shoes on or off the court. New Balance, by contrast, is more earthbound, suggesting that such footwear functions as a kind of moral accessory capable of making us better people. A full parade of personas is available through the assorted athletic shoes on the market today. It is as if our identities were cross-training just as strenuously as our bodies for the next exercise in transformation.

Likewise, fans are increasingly inventive in their efforts to affiliate themselves with their leagues and teams. Witness the football fans who paint their faces and upper bodies in team colors for the game. Through such adornment, they are, of course, demonstrating their loyalty to their teams. But the other part of their graphic innovation has to

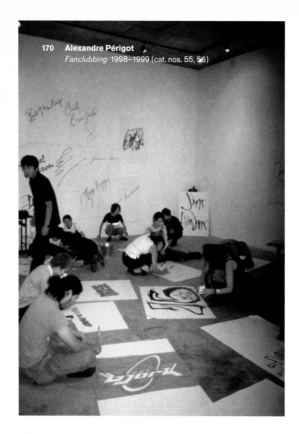

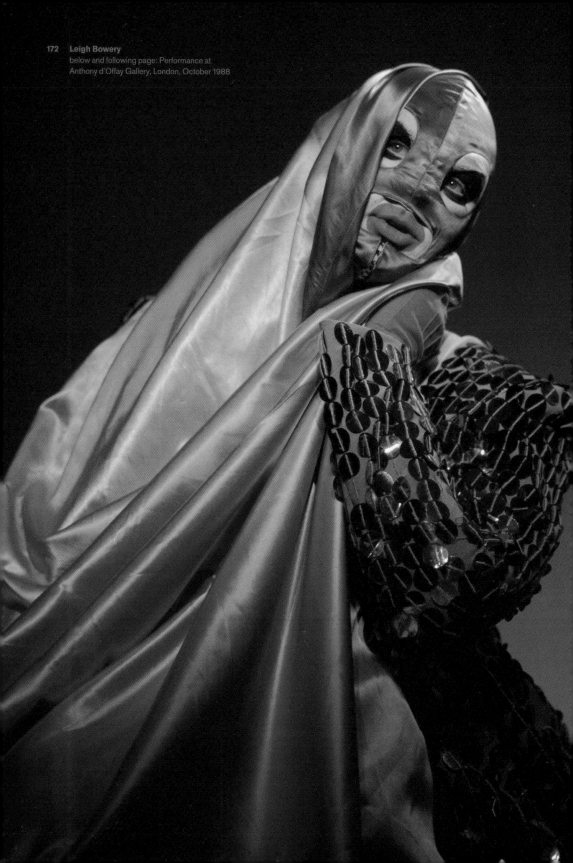

do with the ever-present camera there to record their performance. With their full body makeup, props in the form of signs, and coded gestures of support, frustration, or fury, these fans have extended the arena of performance to the stands and bleachers. Indeed, when the TV cameras scan the crowd, it's clear that the theatrical production in the stands can be as commanding and choreographed as that on the field.

The sports icon who is most expert and engaging in the ability to morph is, of course, basketball player Dennis Rodman, whose fluorescent hairdos, metallic hot pants, rhinestone dog collars, and other assorted props and personal supergraphics have been entertaining fans for years. For Rodman, identity seems almost cumulative—the more of them you can acquire, the more complete you'll be. He tells us that wearing a sequined halter top makes him "feel like a total person," and as a two-way player, he might be wearing gym shorts or he might be wearing a wedding dress, as he did in the summer of 1996 for his marriage ceremony. His bride? The world. Indeed, for all of Rodman's agile maneuvers on the court, his most graceful and athletic moves may be in how he negotiates these identities, combining personas of male and female, of sports professional and cultural icon, of athlete and pop performer. Even before he joined the Chicago Bulls, he flatly stated: "I'm already out of life in the NBA. I'm just living my life the way I want to. I'm not an athlete anymore. I'm an entertainer."

If the extravagance of sports performances suggests that identity is temporary, a quality or condition that comes and goes, it's a notion confirmed in the fashion world. A decade ago, relatively discreet signals such as a Gucci handbag or a LaCoste alligator served as the ID badges of the elite. Today the comparatively subtle quality of such icons seems a quaint anachronism, and the imagery has migrated from clothing to the body itself—witness the current popularity of the interlocked Chanel Cs or the Gucci logo as a tattoo that apparently functions as a satiric signal of worth.

Major cosmetics companies such as Lancôme offer colored body pencils that can be used to draw patterns and designs across not only the face but the hands, torso, and feet as well. Such products are inspired by practices such as *mehndi*, a traditional Indian form of body ornamentation in which a henna paste is used to draw designs on hands and feet. In wedding celebrations, the bride's hands and feet were covered with patterns resembling lace, which helped signal the personal and social transition that occurs during the bridal ceremony. The delicate images of birds and flowers and assorted abstract designs were intended to bring her good luck, prosperity, and safety in childbirth. Since *mehndi* is both impermanent and fragile (the images last only a week or two), the bride was also freed, at least temporarily, from any manual labor that might wash away or fade the design. Today *mehndi* is applied elsewhere on the body, around the navel, perhaps, or as a band around the upper arm. And while its wearers may profess a wish for prosperity and good fortune, its application at novelty cosmetic counters hardly signals a transition to a new life phase. Rather, as just another cosmetic exercise in contemporary fashion, it telegraphs a more fleeting identity.

On clothing itself, fashion labels and images are dense and layered, one piled atop the other in an animated branding war of logos and lettering, vibrant colors that spell out their own message. A Yankees baseball cap, an Yves Saint Laurent watch, the tartan plaid commemorating Princess Diana, a Prada handbag, and Calvin Klein's ubiquitous initials are only a few of the signals that might simultaneously "brand" the wearer.

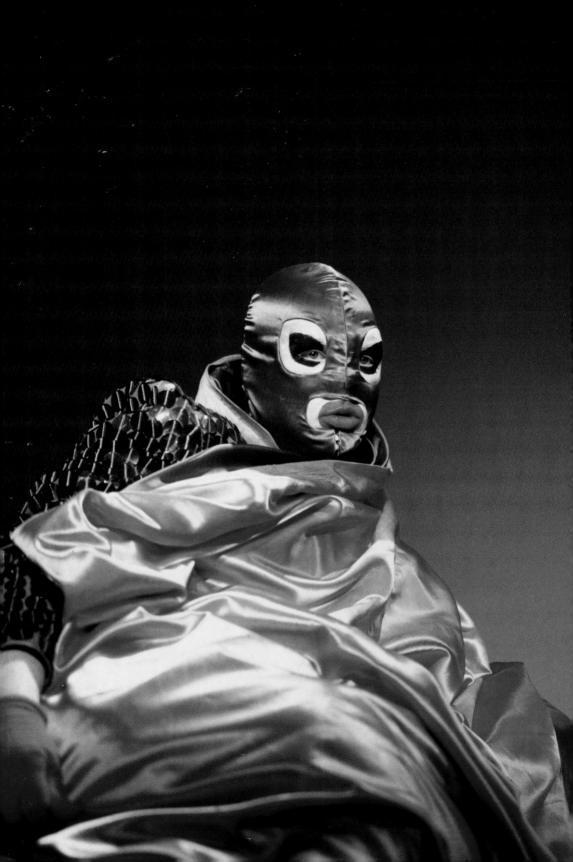

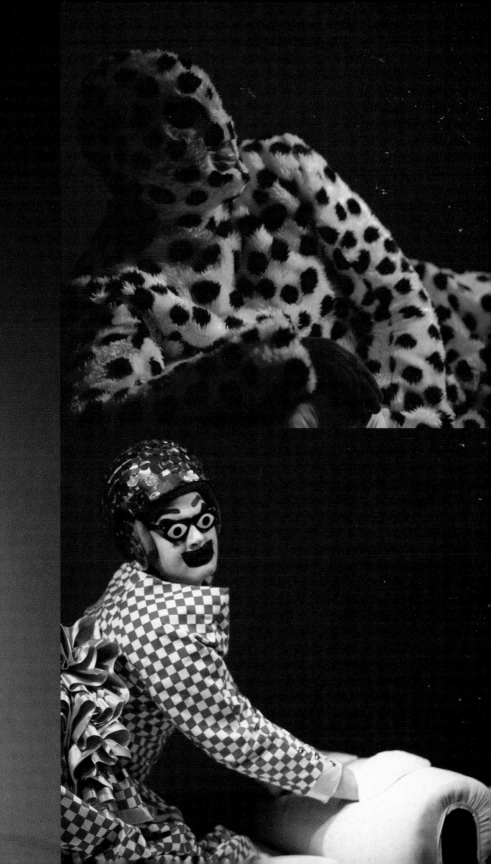

Annette Meyers is a New York artist who takes such "branding" a step further, using the imaging from one category of consumer goods and applying it to another. Her Bodywrapps realign the packaging of food as clothing. Following traditional and familiar lines—those of a business suit, for example—she cuts her clothes from the ordinary wrappers for such domestic staples as cake mix, tea, and cookies and crackers, taking fashion iconography to a new level of absurdity. By displacing brand identities from one realm (food packaging) to another (fashion), she underscores the essential pointlessness of fashion identities and our cultural obsession with them. Besides, assimilating food references is hardly inappropriate for material that covers the body.

Likewise, the provocative English fashion designer Andrew Groves uses his models as actors and his fashion shows as performances to convey a political message. At one recent show a model tore open her skirt, releasing a swarm of insects into the audience; at another, a model doused herself with lighter fluid to evoke the troubles in Northern Ireland. In Groves' jackets and frocks, cigarette burns are used as decoration, and the pieces themselves are worn as placards expressing political sentiments.[4]

The drama of such performances in sports and fashion is frequently matched by more mainstream morphing. And while this discussion has focused on surface treatments of the morphing self, we also engage regularly in more substantial mutations, resculpting, remolding, and otherwise reinventing our bodies. Gyms, spas, and health clubs all offer the means to reshape the body to conform to a variety of given standards. Likewise, the use of anabolic steroids, muscle-enhancing drugs, and assorted "nutritional supplements" is on the rise among athletes, who not only want to perform better but also want their bodies—and muscle mass—to reflect often unreal and grotesquely excessive images of masculinity.

Even more dramatic and substantial, of course, are the face-lifts, ultrasonic liposuction, collagen injections, laser resurfacing, and all manner of "aesthetic surgery" procedures that have become increasingly routine for middle-aged women. In recent years, however, the age of the clients for such procedures has dropped dramatically. An article in the *New York Times* documented the growing frequency of breast augmentation, collagen injections, eyelid surgery, liposuction, nose reshaping, and tummy tucks for girls under the age of eighteen. So inculturated are these physical mutations that it is not uncommon now for girls as young as fourteen to ask to have their breasts reshaped through surgery or their thighs resculpted by liposuction.[5] Such mutations are invariably perceived as a step toward some ideal of physical perfection. In short, physical reinvention is something we are willing to consider at the very moment that, if not before, the body has reached physical maturity.

These are all visible body parts, however, the features we present to the world at large. Physical reconstruction, no longer limited to our public personas, has also now entered a more private realm. Among the latest in trendy plastic surgery procedures is what is surely the ultimate accessory for the customized self. Routinely referred to as a "designer vagina," this cosmetic procedure allegedly tightens the vaginal muscles and gives the genital area a more youthful appearance with injections of fat taken from the inner thighs or abdomen. Suturing can be used as well to tighten the vaginal walls, which may have expanded during childbirth.

Hybrid toy-woman Cindy Jackson has taken this a step further in her efforts to

construct a totally new persona through a series of plastic surgery procedures. Although the motives for her surgical self-improvement remain unclear, Jackson has attempted to reinvent herself in the shape of that feminine icon of the 1950s, Barbie, and her measurements now conform more closely to the cartoon anatomy established by Mattel, the world's largest toy maker, than to any standard of human female anatomy.

Michael Jackson, the apotheosis of such reinvention, has taken the split-screen self to new extremes. He excels not so much in inventing new identities as in blurring them. Through surgery, lavish makeup, and alleged pigmentation, he has managed to put into question his race, his gender, and his age, all qualities that most people consider essential to their being. Jackson's identity is based on nonidentity, making every effort to accommodate black and white, male and female, child and adult. He is not establishing different identities so much as mutating them. Consider this 1991 scenario, a parody masquerade ball for one at Disneyland that surely could have been scripted by Tim Burton or some auteur of the absurd theater: So as not to be recognized, Jackson arrived at the gates in disguise (itself an act that strains credibility, as his very persona seems to be based on continual camouflage of one sort or another), wearing a wig, blue contact lenses, false teeth, and different makeup. When he tried to pay with his credit card, skeptical officials questioned its authenticity and his identity. The guards, themselves nothing less than sentries at the gateway to the landscape of American artifice, then made the inescapably ironic demand that Jackson prove his real identity, a requirement he apparently satisfied by moon-walking.

Pop icons like Dennis Rodman and Michael Jackson layer one identity atop another, but a parallel trend in reconstructing the body and its assorted personas is the impulse to break it down. Self-mutilation—that is to say, not restoring the body to its earlier pristine from, but breaking it down through self-inflicted wounds made by knives, razors, shards of glass, or any other reasonably sharp object—has almost a parallel appeal to many young people. Indeed, there is an increasingly thin line between self-perfection and self-mutilation, suggesting that the difference is sometimes clear only in the eye of the beholder.

In many cultures some sort of ritualistic significance has been attached to body modification. Among the Maori of New Zealand, a traditional form of tattooing known as *moko* called for facial skin to be cut or chiseled to form ridges, which were then colored, resulting in spiral-like designs that served several purposes. One was to create a fierce appearance that would frighten animals; the designs also conveyed information about the individual, revealing lineage, family history, heroic deeds. Imprinted on the face, it was part of one's life that could not be robbed. Similarly, the keloidal scarification of tribal African women, in which the skin is cut with a knife, then rubbed with dirt or other irritants to raise the scar tissue above the skin surface, also sends out specific signals. Such decorative scars distinguish the survival of the fittest; they may signal passage through initiation rites or serve as a visual catalogue of one's accomplishments. Or they may simply serve as a badge of one's strength of character and ability to endure pain.[6]

The body modification practiced in our culture, of course, has a very different significance. Psychologists suggest that self-inflicted wounds may be a means for abuse victims to express feelings of hurt and rejection or that the pain of cutting may serve more generally as a physical distraction from boredom, fear, anger, or depression. But

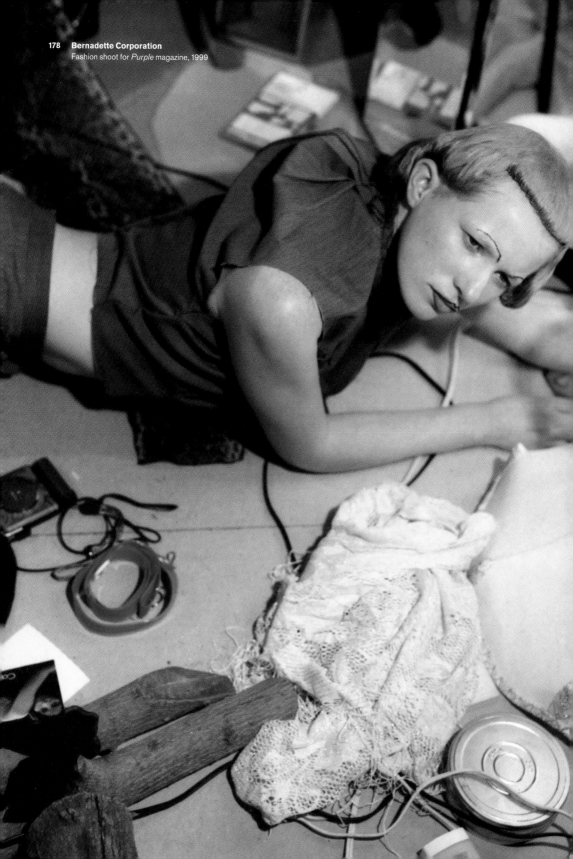

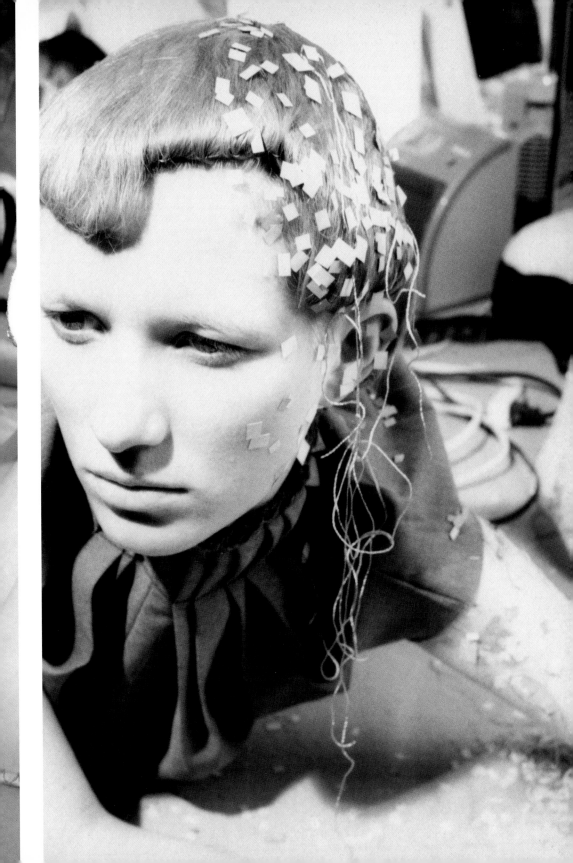

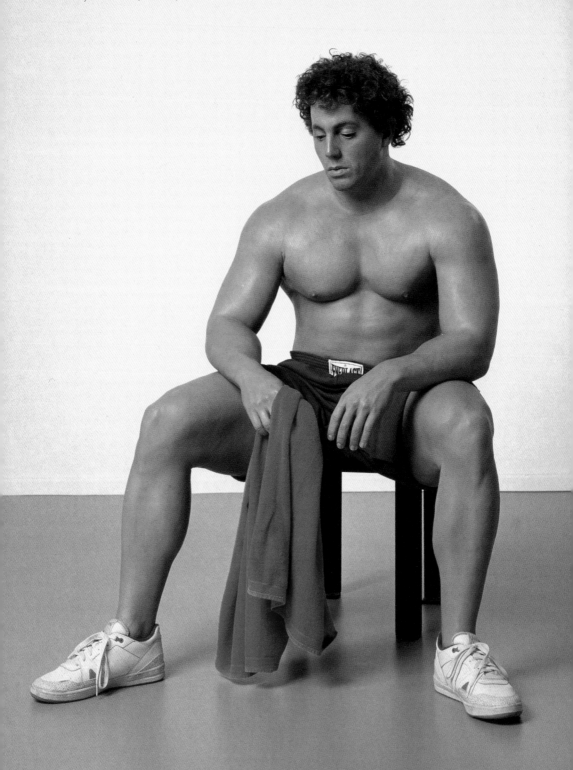

when scars from self-inflicted wounds accumulate, they are likely to evoke feelings of shame and loathing rather than pride in one's accomplishments or family history. Whereas participants in ritual body modification were thought to *acquire* identity through their scars and markings, emotionally disturbed people who injure themselves might be said to be looking for a way to *lose* identity. In tribal tradition, scar designs are meant to suggest that identity is accumulated through experience, but the scars resulting from self-injury are more reflective of self-loathing and the effort to surrender one's identity.

In our culture, even tattoos, traditionally thought to be indelible imprints, are simply other accessories of morphing. The tattoo itself is capable of mutation, viewed as a temporary mark to be improved upon, further embellished, or removed entirely. A friend of mine who is a poet has designed herself a tattoo, a postage stamp from a foreign country of her own imagining. "And someday in the future," she tells me, "at the right moment, I will get that stamp canceled." Cancer patients sometimes practice a similar "cancellation" of their radiation tattoos, the imprint put there so that medical technicians will know where to administer radiation. When the treatment has been completed, patients sometimes incorporate the medical mark into a more lavish and decorative design. Not unlike the biker in Lyle Tuttle's studio, intent on subverting and transforming an emblem of past experience, these survivors convert a crucial medical tool into a decorative and celebratory badge of endurance.

Traditionally the painted, pierced, and tattooed body—whether decorated for rituals of war, marriage, fertility, or death—has held out a primitive appeal, reflecting the compulsion, perhaps deeply embedded in the human psyche, to decorate ourselves. Among the most innovative and lavishly produced rituals we observe today are, of course, those of commerce. "Got Milk?" asks the well-known series of print advertisements that pose celebrities such as athlete John Elway or film celebrity Melanie Griffith branded with identical milk mustaches, which apparently affiliate them with a league of healthy and fit cultural icons who are so confident and successful that they are willing to let themselves be photographed looking slightly ridiculous. Likewise, in a recent print ad for Remy Martin cognac, the black-and-white image of a sophisticated consumer is marked by the imprint of a glowing, golden centaur, the logo for the drink, which has evidently landed on his forearm.

A more striking and dramatic image appeared in a 1999 ad for Absolut Vodka. The photograph of a black woman's curved back seems almost disembodied, purely sculptural, and its decorative quality is only reinforced by the pattern of acupuncture needles piercing her skin, forming the outline of a vodka bottle. The text beneath the image reads "Absolut Relaxation," suggesting that, despite all the resonant implications of primitive ritual and decorative mutilation, it is the combination of vodka and acupuncture that will really cool you out.

Hendrik Muller is a German commercial artist who goes one step further, painting the human body, then photographing it for advertising. Muller has painted the female form to resemble an assortment of vegetables—corn, zucchini, peppers—for restaurant menus; he has painted a woman to resemble a tube of paint, her outstretched arms a paintbrush. And he has gone so far as to arrange several people, then paint and photograph them as a rolling landscape of meadows and fields. For the BMW exhibit at the

Frankfurt International Motor Show in 1995, he constructed the quintessential biker chicks, painting and posing two women as the components of a motorcycle. Muller's hybrid graphics set out to animate inanimate objects. And for all their assorted hues, they do, in fact, function as rarified bar codes, lavish decorations that attempt to assign a human value to inanimate objects, in the process, presumably, increasing their commercial value.

In her studies of primitive body decoration, Jungian author and artist Tobi Zausner itemizes the traditional reasons people decorate themselves. The desire to transform nakedness, she says, is universal and cross-cultural. And the reasons for it may include affirming individual and group identities. It may signify social status, be an effort to attain group acceptance, enhance sexual allure, display roles of power and leadership, invite divine protection, or simply function as an invocation of the gods.[7] Zausner discusses the naming ceremonies of primitive cultures and the ways in which the decorated body reaffirms identity in such rituals.

Our aims today seem quite different. We devise our own naming ceremonies as well, but unlike traditional cultures in which identity is perceived as a product of accumulated experiences, we are more likely to perceive identity as a condition that is constantly changing. It is something, then, to be celebrated repeatedly. And if we accept alienation as a cultural condition of modern times, it is only because we have become so skilled at adopting these brands and bar codes as a way to mediate this alienation, a way to secure some sense of belonging first to one club, then to another and then another.

So for reasons of commerce or camouflage, for politics, for pure performance, or in the quest for physical perfection, we participate in innumerable naming ceremonies. With sports and fashion logos, tattoos, body piercing, *mehndi*, and all our other assorted personal frescoes, we observe these ceremonies as a constant component of everyday life, taking on one name, then another, then another. And just as TV and the Internet are expected to be fully integrated in the next several years, so too do different networks of visual information collide, converge, and collaborate on the body to produce their own personal and highly customized realm of information.

Perhaps, too, our compulsion to decorate the self has also to do with our increasing engagement with the immaterial realm. As we become ever more wired, increasingly engaged in such diversions as online gaming, virtual shopping, and the elusive exchanges of cyberspace, and as the infotech industry increasingly governs our social contact, is it any surprise that we compensate in a visual, tactile, physical manner? Cyberguru Nicolas Negroponte has said: "Bits have no size, shape or color, so we tend not to consider them in any morphological sense. But just as elevators have changed the shape of buildings and cars have changed the shape of cities, bits will change the shape of organizations, be they companies, nations, or social structures."[8] Indeed, if something without size, shape, or color—something transparent, invisible, and insubstantial—can so affect the essential structure of our lives, it is only logical that we devise sizes, shapes, colors, and other assorted visual and tactile components and then get as close to them as we possibly can—incorporating them, as it were, onto our bodies.

Perhaps, too, our increasing willingness to mark ourselves has to do with our innate knowledge that life is going to mark us. In a world that is increasingly chaotic, violent, and unpredictable, marking ourselves may be a way of exercising some control. The human

body is a finite canvas, and the less of it that is left to chance, the better. So for all the diversity, for all the cross-cultural imagery we scatter across our bodies, for all the seemingly random and chaotic signs and signals we apply as personal badges and emblems—tattoos in the form of Celtic crosses and Cuisinarts, pierced lips and tongues, resculpted eyes, painted hands, a collage of sports logos—there may be some logic to it, after all. All of this may simply be an effort to get there first, before life gets there.

The excess and extravagance of imagery reads something like the inflated end credits of contemporary movies. Traditionally movies credited the director, cinematographer, and actors, in recognition of the significance of their role in the overall film production. In recent film history, however, credits go to these parties, and then to every gaffer and grip, every extra, every member of the technical crew. And for all the democratic appeal of such widespread and generous recognition, for all its largesse, the underlying message is that all of these contributors were essential to the making of the film. Such a catalogue, by its nature, inflates the importance of the film. In much the same way, we want to list all our credits; we want to have all our allegiances and affiliations itemized and known and to acknowledge all of the "extras" in our own lives.

A friend of mine who lives in Amsterdam has told me about a T-shirt mall there, possibly a modern equivalent of the biblical Tower of Babel. An international mecca, Amsterdam is full of foreigners. And while English is the common language used in the city, it is a second language for almost all of the residents. "They sell T-shirts and sweatshirts printed with American slogans," she tells me. "But these are composed and printed up by people who barely speak English, and they are worn by people who barely speak English. And often, then, they are printed with nonsense. The message has become an absurdity. With slogans like 'Have a sunny nice' or 'Just It,' it's as though they have the code completely wrong."

And just as these codes, slogans, and icons have been emptied of their meaning, the myriad, constantly mutating signs and images with which we mark ourselves have less and less significance. Sometimes only a thin line separates multiplicity of meaning from a total loss of meaning—raising the question, in the end, of whether it is this loss of message that is the message.

Notes

1. Ellen Lupton, *Mixing Messages: Graphic Design in Contemporary Culture* (New York: Cooper-Hewitt National Design Museum, Smithsonian Institution, and Princeton Architectural Press, 1996), 11.

2. Steven Skov Holt, "Notes on an Infinity of Sports Cultures," in *Design for Sports: The Cult of Performance*, ed. Akiko Busch (New York: Cooper-Hewitt National Design Museum, Smithsonian Institution, and Princeton Architectural Press, 1998), 15.

3. Ibid., 7.

4. Martin Raymond, "Clothes with Meaning," *Blueprint*, October 1998, 34.

5. Jane Gross, "In Quest for the Perfect Look, More Girls Choose the Scalpel," *New York Times*, 29 November 1998, 1.

6. Tobi Zausner, "The Decorative Art of the Body" (lecture at the Bard Graduate Center for Studies in the Decorative Arts, New York, 6 November 1998).

7. Ibid.

8. Nicholas Negroponte, "On Digital Growth and Form," *Wired*, October 1997, 208.

Back Roads
Greil Marcus

For the last quarter century David Lynch has been an exemplar of the modern artist: an extremist, autonomous, and independent filmmaker who has both a subject and an audience, and who, working in Los Angeles, has been neither worn down by Hollywood nor marginalized by it.

Lynch's great subject is instability and displacement—a vision of being thrown back on yourself, of being in the wrong place at the wrong time. "I like the nowhere part of America," he has said,[1] but in Lynch's films nowhere is where you find it, or make it. Born in 1946 in Missoula, Montana—his family moved to Idaho when he was two months old, but his birthplace has remained a touchstone—Lynch grew up in Spokane, Washington; Durham, North Carolina; and Alexandria, Virginia. He started out as a painter, entering the Pennsylvania Academy of Fine Arts in Philadelphia in 1965, but eventually found his way into film; by 1970 he was in Los Angeles, working through the American Film Institute. Places send messages, Lynch says, but you can find the country he has mapped anywhere. "I want to make films that occur in America," he told interviewer Chris Rodley, "but that take people into worlds where they may never go; into the very depths of their being."[2]

Lynch's first feature film, *Eraserhead*, appeared in 1976 after five years of hand-to-mouth struggle; he then took on the studio projects *The Elephant Man* (1980) and *Dune* (1984). Most recently he has offered *The Straight Story* (1999), the tale of an old man who rides a lawn mower hundreds of miles across Iowa into Wisconsin to visit an estranged brother. But Lynch has drawn his strongest pictures in *Blue Velvet* (1986), *Wild at Heart* (1990), *Twin Peaks: Fire Walk with Me* (1992), and *Lost Highway* (1997)—films that as a set could just as well be called "SEX CRIME." There's a vision in these movies: a vision of an America where all boundaries—of familiarity, belief, place, body, and identity—can and will be used against you, where they will be torn up in your face. By means of lurid, sometimes soul-chilling scenes of incest, rape, mutilation, dismemberment, and murder, through brutal comedy and moments of drama so austere that they recall the most indelible moments of silent film, Lynch has pursued this vision where it led, sometimes so heedlessly that the speed of his passage has burnt up whatever trails a viewer might follow. The concessions he has made to entertainment, to pleasing, comforting, or flattering an audience—the happy endings of *Blue Velvet*, *Wild at Heart*, and *Fire Walk with Me*, which can seem as if they have grown out of the stories that have been told, even as they can also seem to be secured by thumbtacks—are few and mostly hidden. In *Lost Highway* there appear to be none.

Lost Highway opens from behind the wheel of a car speeding on a black road, a broken line down the middle—a yellow line here, as in an almost identical shot in *Blue Velvet*, a white line in the countless noir films of the 1940s and 1950s that used the same device.

Fred Madison, played by Bill Pullman, is a jazz saxophonist tortured by fears that his wife—Renee, played by a dark-haired Patricia Arquette—is seeing other men. One day she finds a video with the morning paper, and they play it: someone has taped the exterior of their house. They find a second video: its eye moves inside their house and, from an impossibly high angle, shows them asleep in their bed. They call the cops, who advise them to turn on their burglar alarm.

Let's Entertain
Life's Guilty Pleasures

David Lynch
this essay: *Lost Highway* 1997
film stills
Courtesy USA Films

185

At a party a drunken Renee hangs onto the host, a sleaze named Andy; Renee tells Fred to get her a drink. At the bar he throws down two quick shots and is accosted by his doppelgänger, a man in lipstick and white pancake makeup who claims to be inside Fred's house. When Fred calls his own number, the man standing in front of him answers the phone. Fred grabs Renee and drags her home.

Alone, Fred plays a third video that has turned up. Like the first two, it opens in black-and-white; then, in color, Fred is shown kneeling on his bedroom floor, with terror on his face and pieces of his wife, cut up like the Black Dahlia, scattered all over the room. "Tell me I didn't kill her!" he begs the police. Soon he is on death row.

In his cell he has a vision of a house set in sand, burning; then he is possessed by a violent seizure. When it is over, he is no longer himself; the man in the cell is twenty years younger, an auto mechanic named Pete Dayton, played by Balthazar Getty as a present-day James Dean. The baffled prison officials release him to his family. Baffled himself, but too young—or, with his slicked-back hair and black leather jacket, too cool—to really worry, Pete takes up his life where it apparently left off. Neither his girlfriend nor his parents, who days before witnessed his vanishing, will explain anything to him. He has sex with his girlfriend and goes back to his job.

Mr. Eddy, a.k.a. Dick Laurent, a gangster, arrives at the shop where Pete works; Pete is his favorite mechanic. He has Pete get into his Mercedes; there's a sound in the motor he doesn't like. Pete fixes the problem, and they go for a ride; when Mr. Eddy pulls over to let a tailgater pass, the man gives him the finger. Mr. Eddy runs him off the road and beats him to a pulp with a huge pistol. Mr. Eddy is screaming, but it's a civics lesson: "Get a driver's manual! Study it! I want you to obey the rules!" "I'm sorry about that, Pete," Mr. Eddy says. "But tailgating is one thing I can't tolerate!" Mr. Eddy is a funny guy; he's also dangerous. Pete can't say a word. Back in the shop, he's all nerves. Another mechanic has Fred Madison on the radio, playing frenzied bop; Pete snaps it off.

As Lou Reed sings "This Magic Moment" on the soundtrack, Mr. Eddy pulls his Cadillac into the shop, and Pete sees Alice, Mr. Eddy's girlfriend, Patricia Arquette as a gorgeous blonde: she steps out of the car in slow motion, her eyes on Pete, her expression blank and impenetrable. Alice seduces Pete, Mr. Eddy picks up the scent, and Alice offers a plan. They have to run, they need money, she knows a porn merchant named Andy they can rob, she'll set it up. When Pete sneaks into Andy's house, he is greeted by a giant projected image of Alice acting in a porn film, grimacing and then smiling as the penis of an unseen man plunges into her anus. When Andy—the same Andy Fred Madison met with Renee—comes down the stairs, Pete knocks him out; when Alice comes down to meet Pete, Andy attacks them and Pete hurls him into the air. When he turns to look, he sees Andy on his knees before a glass table, its corner driven five inches into his forehead.

They leave for the house Fred Madison saw in the vision he had in his cell; naked, they make love in the sand, bathed in the headlights of Alice's car. "I want you, I want you," Pete calls out. "You'll *never* have me," Alice hisses in a harsh, almost mystical roll of sound, in that instant her white body all but disappearing into the blinding white light. She gets up and strides away into the house. When the man in the sand rises, he is no longer Balthazar Getty as Pete Dayton, but Bill Pullman as Fred Madison. He puts on Pete's clothes and enters the house; there is no Alice, only his doppelgänger in the bad makeup.

Madison moves off to discover the rest of his story. In a desert motel he finds Mr. Eddy in bed with Renee. She leaves and Madison seizes Mr. Eddy. With the aid of his doppelgänger, Madison looks into a video camera and sees Renee and Mr. Eddy at a party, laughing as a snuff movie plays; he kills Mr. Eddy and returns to his own house, the house where long before he and Renee played their videotapes, then flees when he is

spotted by police. Heading back into the desert, he leads a long line of police cars as the yellow lines down the middle of the road rush at him faster and faster and his face breaks apart in a scream.

Lost Highway's beauty is at war with its absurdities, and the beauty—the film's ability to find a tone and sustain it, extend it, until you cease to care about anything but the depth of the image before you—wins. "We endlessly repeat stories that falsely reassure us that the social is also the real," Martha P. Nochimson says of the perspective Lynch's movies fight off.[3] Certain images in *Lost Highway* take the story that has produced them so far outside the social that the story ceases to seem real, yet the images are so complete that they convince you that the story contains a plain and simple truth. There is a sense in which the story unfolds solely to get Fred Madison to that point where he can take a car down a straight road at night as fast as it will go, never mind what's behind him.

The establishing shot of the movie shows Bill Pullman in extreme close-up, in dark red tones. "I'd seen him in several films," Lynch says of Pullman, "and I always saw something in his eyes—playing these mild-mannered, guy-next-door characters who most of the time don't get the girl—but I saw something in his eyes: a real edge there. I saw the possibility for rage, for insanity. His eyes—it was his eyes. There was a lot more going on there than he was asked to play."[4] Madison is in his house, smoking, thinking, holding the cigarette right to his mouth. His hair is disheveled, his cheeks puffy, his eyes milky; he looks as if he's just killed someone, or failed to kill himself. He looks half-dead, and as if he's waiting for the other half to come knocking on the door.

"Dick Laurent is dead," Madison hears through his intercom; the name means nothing to him. He puts the incident as far out of his mind as he can, which is not that far: he's a man at the edge of dissolution, caught up in a depression so bitter he can barely see his hand in front of his face. The last thing he wants in his life is a mystery, but this is where the mystery begins. Barry Gifford, who cowrote the movie with Lynch, says that the breach in the film—"the breakdown where you want to flee something in your mind"—takes place when Fred Madison is on death row: "Pullman takes on a fantasy which doesn't work out any better than real life."[5] But this breach—this flight into a fantasy where one prison, the prison of one's own paranoia and jealousy, leads only to the next, and to the one after that—is better understood as beginning right here, as the film's establishing shot opens into its first scene, with the film itself the story of both the unbreakable momentum the fantasy takes on and the capacity of the image of Madison's squinting eyes to enclose it. Right here, with Madison's face a mask of sweat, stubble, and doubt, everything that follows is present, foreseen, *desired*—only the details remain to be filled in. The intensity in his face is that of a man trying to follow his fantasy where it leads, trying to control it, to make it do what he wants, and failing.

When Pete Dayton replaces Fred Madison, the tone is that of a normal film. Events proceed according to a pace that does not need to be explained. People talk, they make jokes, they get angry. Even scenes of sex and violence seem to portray aspects of life that would produce sex or violence. It's this section of the film that allows the viewer to relax into it, to forget the film's premises, to follow the action as if it's taking place in a regular movie, but this respite also dramatizes the motionlessness of the first part of the film, the unreality of its lassitude and tension: how bizarre it all is. With each word out of his mouth shaped as if anticipating a rebuke, Madison sleepwalks through his waking hours, even when trying to make love to his wife—in one of the creepiest sex scenes ever put on film, shot in slow motion, Renee's breasts bobbing as if floating underwater and she herself as far away as the Lake of Dreams. "It's okay," she says, patting her husband's back, his flesh now made of shame, as hers is made of contempt. Inside their house the film could hardly be more silent; you begin to hear the ambient sounds of the

rooms themselves, as if the house is taking its space back from its occupants. Only when Madison plays his music in a nightclub, bent over and screaming though his horn ("Red Bats with Teeth," the piece is called on the *Lost Highway* sound-track album), can you connect this man to the gory scene he will watch on the videotape, and to the intensity of his self-loathing.

The intolerability of Madison's life and his inability to change it will send him out of it: in fantasy, he will try to preside over his own execution for his own terrible crimes. When that fails, he will try to live out his life in a different body, with a different name, with a different history, in a different world. But everyone Fred Madison meets in this new world—Andy, Pete Dayton, Mr. Eddy, Alice, the reappearing Renee—is, like his doppel-gänger, his alter ego: a projected creature made out of what he wants and what he fears. Whatever Fred Madison does to them he does to himself, and so when he kills Mr. Eddy, returns to his house, and says into the intercom, "Dick Laurent is dead," he is try-ing to prove that he has finally killed himself.

Lost Highway is the freest of David Lynch's movies, the least afraid of its audi-ence, with Lynch himself least afraid of his own movie. It is also his artiest film, the one that most calls attention to its own composition, its cleverness, its refusal to meet its audience where these days audiences expect to be met: in the audience's lap. The arti-ness produces the sense that the movie's claims to transcendence, its insistence on a secret hiding inside it, is a con—and that, I think, is because it is. The con is that inside this movie is not a secret, but another movie, one that would have been laughed out of town if it had ever claimed to be anything more than sixty-nine minutes long.

The day we met
I went astray
I started rolling down
That lost highway
 —Hank Williams, "Lost Highway" (1949)

I'm not the only pawn on the lost highway
 —Bob Holman, "Mirror Man Speaks" (1999)[6]

Lost Highway is not a rewrite or a remake of *Detour*, made in 1945 by Edgar G. Ulmer for Producers Releasing Corp., a factory on Hollywood's Poverty Row. (To cash in on the cult following the film had attracted since the late 1960s, *Detour* had already been remade in 1992, starring Tom Neal Jr., son of the original male lead.) *Lost Highway* is a reinhabiting of *Detour*; Lynch's movie emerges from Ulmer's, inside out.

David Lynch speaks the language of art, and others speak for him in the same vein. Lynch shows "ordinary reality as a cultural system continually breaking down yet remaining in place," Nochimson writes; his work demonstrates that "in the *ideal* of com-pleteness we find the human capacity for form, but in the *real* incompleteness of human systems, in their actual breaks and discontinuities, we find our capacity for truth."[7] Another way of saying the same thing is that Lynch can be seen as a maker of splatter films as readily as he can be seen as a maker of art films. Many good critics protested the violations of *Blue Velvet*, at least before the art cavalry rode over the hill to save the day; by the time of *Wild at Heart*, a dog running off with a hand in its mouth could be described as merely "Lynchian." Without the aura of art, of the artist struggling to glimpse the truth and make it known—as opposed to the entreaties of the entertainer, always eager to exchange good times for money—Lynch's sex crime films might be lumped in with *Natural Born Killers*, and Lynch, like Oliver Stone, named an enemy of the people. But what if Lynch had to become an artist not because he saw the stars

reflected in the gutter, but because he found himself thrilled by the filth?

Edgar G. Ulmer had an art background. Born in Germany in 1904, he was working as a designer and assistant director for F. W. Murnau, perhaps the greatest of all film directors, by the time he was twenty; in 1927 he followed Murnau to Hollywood to work on *Sunrise*, which may be the greatest movie ever made. By the 1930s he was shooting cheapie westerns, horror pictures, films in Ukrainian and Yiddish. In the 1960s he worked for Roger Corman's American International Pictures (AIP).

"The title is very commercial," interviewer Peter Bogdanovich said to Ulmer in 1970, two years before Ulmer died; he was speaking of Ulmer's 1943 *Girls in Chains*. "Of course!" Ulmer said. "That's what made the goddamned thing. At the beginning of the season, Fromkess would sit down with me and Neufeld, and we would invent forty-eight titles. We didn't have stories yet; they had to be written to fit the cockeyed titles. I am convinced when I look back that all this was a challenge. I knew that nothing was impossible. When *Double Indemnity* came out and was a huge success, I wrote a picture for Neufeld that we called *Single Indemnity*. We were able to write that junk in about two weeks."[8]

Here you cannot untangle the language of the artist, who believes that everything is possible, from that of the hack, willing to throw anything on the screen so long as it will sell. Opening with that broken line running down the middle of the highway, *Detour* is just as indecipherable, and on the most elemental and practical levels. "Were these actors, hoping for careers," critic David Thomson asks of Tom Neal and Ann Savage, *Detour*'s two hitchhikers who meet on Route 66 on their way to Los Angeles—or did Ulmer one day simply scrape them off the highway, "derelicts obliged to treat the idea of a movie with contempt?"[9] It's a story Ulmer almost tells, after the fact of the film, not before: "I was always in love with the idea and with the main character, a boy who plays piano in Greenwich Village and really wants to be a decent pianist. . . . And then the idea to get involved on that long road into Fate, where he's an absolute loser, fascinated me. The same thing, of course, with the boy who played the leading character, Tom Neal. He wound up in jail after he killed his own wife. He did practically the same thing he did in the picture."[10]

As Al Roberts, Tom Neal stands by the side of the road with his thumb out. We've already met him as an absolute loser, playing wildly, incoherently in a New York saloon after his girlfriend and singing partner has left him for Hollywood because his ambition doesn't match hers. But now he's heading out to meet her. In Arizona he gets a ride from a blowhard in a fancy convertible, Charles Haskell. As the car pulls out, Ulmer, shooting from behind, shows the two men as doubles: they're the same size, their suits are the same color, even their hats are blocked in the same way.

Haskell keeps asking Roberts for pills he keeps in the glove compartment. He brags about how he picked up a woman and tried to rape her, about the racehorse book he keeps in Florida, the family in L.A. he hasn't seen for fifteen years but there's money there and he's going to get some. "Yea*h*," Roberts says in a grimy close-up, cutting off the word as if it ended in a hard consonant. "Righ*t*." "Yea*h*." It's a fabulous scene. Roberts knows the wrong attitude could get him kicked out of the car, but he can't really say yes to what he's hearing. There's nothing in his face but sweat, stubble, shame, and anger. All the shared gestures of the Depression are present; in a mute affirmation of the Declaration of Independence, a man who has nothing tries to maintain some dignity and distance with a guy who acts like he has everything. Half a century later, with Pete Dayton sitting frozen in Al Roberts' seat next to Mr. Eddy's Haskell, the political dimension will have disappeared, but the feeling is the same.

Haskell tells Roberts to drive and falls asleep. It starts to rain; Roberts pulls over to put down the top, but when he tries to wake Haskell, he falls out of the car dead. "You're going to tell me you don't believe my story," Roberts says in a voiceover, startlingly

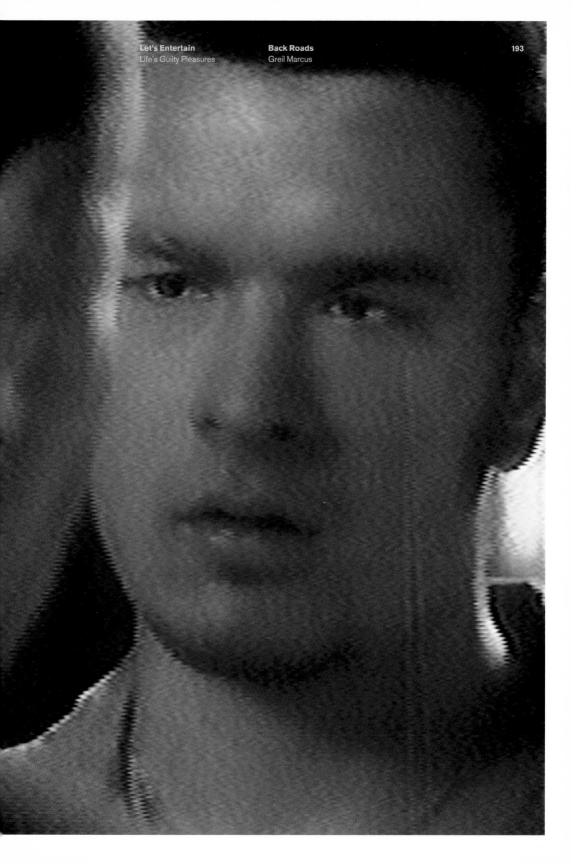

addressing whoever might have been expected to be present in whatever grindhouse *Detour* was playing in 1945: "I can see that don't-make-me-laugh expression on your smug faces." If you won't believe him, what chance is there the cops will? He explains how he had to hide the body, how he realized he had to take the car ("I couldn't leave the car here with him in the gully—that'd be like erecting a tombstone"), not to mention Haskell's money, his papers, and his clothes. He leaves his own identification with the body. "Al Roberts is dead," Roberts says in his voiceover; as Fred Madison will become Pete Dayton, Roberts becomes Haskell. As Fred Madison will again become himself, Roberts is only wearing different clothes; he cannot change.

Stopping for gas near the California border, he picks up Ann Savage ("You can call me Vera"). Her face is clenched, as if she needs to kill someone. She looks like a harder, thinner Gladys Presley, with the heavily shadowed eyes Gladys passed on to her Elvis, along with some tiny but unmistakable percentage of Negro blood. Puffy cheeks, a threatening nose, her big features shaped not by prettiness, but by wariness and mistrust—all speak for the bitter knowledge of the consumptive, which Vera is. And she knows everything. She rode with Haskell all the way from Louisiana; she's the woman Haskell tried to rape. Seeing Roberts in Haskell's car and Haskell's clothes, she draws the obvious conclusion. Just as quickly, she settles on the obvious solution: blackmail. They'll sell the car; she'll take that money and the cash Roberts took off Haskell's body. Then she'll let him go.

With Savage's eyes shooting out of their blackness, her voice is shrill, harsh, punishing, a complete explosion of every notion the three people sitting in the Crown on Market Street for the twenty-five-cent matinee brought with them of what a leading woman in a movie was supposed to sound like. "Just remember who's boss around here": Vera has sensed the weakness and passivity that Roberts' personality is made of, just as Renee and Alice will with Fred Madison and Pete Dayton. Roberts sinks into a slough of self-pity: "That Haskell wasn't dead yet. He wasn't stretched out still and cold in any Arizona gully. He was sitting right next to me, laughing like mad while he haunted me." But it's Roberts who is now Haskell; it's Vera who's his haunt.

In Los Angeles, as Mr. and Mrs. Charles Haskell, Vera rents them a cheap apartment: if they're going to sell the car, they're going to need front. In what might be the only direct homage *Lost Highway* pays to *Detour*, just as Pete Dayton can't listen to Fred Madison on the radio, Roberts can't stand the sound of a neighbor's saxophone. He and Vera settle into a routine of backbiting and boredom. "We'll be discussing politics next," she says with disgust after he's expounded on his the-game-is-fixed philosophy of life. It's a way of saying she knows they are the backwash of the republic, a last acting out of the promise that every citizen is free: free, now that all promises of equality and the pursuit of happiness have collapsed into the economy—into the specter of the Depression, as present in *Detour* as in any film made in the 1930s—to keep whatever he or she can steal. Drunk, she wants to sleep with him, but his flesh crawls not because she is repulsive, but because he is afraid of her. Roberts doesn't fuck Vera in the same way that Fred Madison does fuck Renee: the greater his weakness, the greater her contempt. "If this were fiction," Roberts says in his voiceover, looking back from a roadside diner, heading east, "I would fall in love with her, marry her, and make a respectable woman of her, or else she'd make some supreme Class A sacrifice for *me*, and die." "You *sap!*" she snarls, back in real time. Except for the love scene in the desert, which in 1945 could not be filmed for a public movie, Patricia Arquette's Alice walks in the footsteps of Ann Savage's Vera, and falls behind.

As Vera's plans for Haskell's money grow more and more grandiose, she and Roberts fight. Drinking hard, she threatens once more to call the cops on him; she runs into the bedroom with the telephone and locks the door, passing out on the bed with the

cord draped over her shoulders and the phone in her hand. In a panic Roberts pulls on the phone cord under the door, to break it, he says; when he breaks down the door, he finds Vera strangled to death. He runs; soon he learns that in Los Angeles Charles Haskell is wanted for murder. He is Al Roberts, but Al Roberts is dead. He walks down the highway in the middle of the night; a police van pulls up beside him.

As *Detour* ends, the beginning and the end of *Lost Highway* come together—just as when Bill Pullman rises naked from the sand, where, moments before, Pete Dayton was engulfed by Alice, he all but calls Tom Neal back from the dead. In Pullman's previous films—the best of them *Malice*, *The Last Seduction*, and *Independence Day*—his features were soft under sandy hair, unformed; in this moment they are, like Neal's, sharpened like weapons. "He had a really great haircut!" Lynch says.[11] Under dyed-black hair Pullman now moves like the killer Neal turned out to be, just as, in the first scene of *Lost Highway*, Fred Madison with his red face, trying to think and coming up with nothing, is *Detour* from beginning to end.

Shot in six days—on a budget, you can imagine, of pills for the crew and clothes the actors got to keep—*Detour* is as cruel and displacing, as austere and thrilling, as any film Hollywood has ever turned up, fixing precisely those qualities, or values, that David Lynch and Barry Gifford realized in *Lost Highway*. There the cauldron of dissolution is veiled by art, but the revel in it is never really hidden; the art in Ann Savage's performance, caught on film but never duplicated, is like an experiment that can be recorded but not repeated. In the language of cinema it can only be explained as too real; acting cannot enclose it, just as no story can satisfy the expression on Bill Pullman's face as *Lost Highway* begins. Where is the art, the will to pursue a vision to its end? Where is the entertainment, the wish to exploit an audience that can't tell an artist's vision from the commercial fairy tales they've bought all their lives? Does entertainment open the door for art? Does art drape the gaudy costumes of entertainment over the unspeakable visions of art, or is it the other way around? Playing one after the other, *Lost Highway* and *Detour* render these good questions absolutely moot.

Notes

1. Chris Rodley, *Lynch on Lynch* (London and Boston: Faber and Faber, 1997), 19.

2. Ibid., 114.

3. Martha P. Nochimson, *The Passion of David Lynch: Wild at Heart in Hollywood* (Austin: University of Texas Press, 1997), 175.

4. David Lynch, conversation with author, 1998.

5. Barry Gifford, conversation with author, 1998.

6. Bob Holman, "Mirror Man Speaks," from *Mirror Man—Act 1: Jack and the General*, by the Pale Orchestra, conducted by David Thomas, as performed 3 April 1998 in London as part of the festival "David Thomas: Disastodrome!" (Cooking Vinyl Records, 1999).

7. Nochimson, *The Passion of David Lynch*, 180, 200.

8. Peter Bogdanovich, "Edgar G. Ulmer" (interview conducted in 1970), in *Kings of the Bs: Working within the Hollywood System*, ed. Todd McCarthy and Charles Flynn (New York: Dutton, 1975), 399.

9. David Thomson, *A Biographical Dictionary of Film*, 3d ed. (New York: Knopf, 1994), 764.

10. Bogdanovich, "Edgar G. Ulmer," 403.

11. Lynch, conversation with author.

July 2, 1999—Augies, Minneapolis.
Olukemi Ilesanmi and Philippe Vergne continue their conversation at a popular strip club in downtown Minneapolis.

OI: I think it is quite appropriate that we are at Augies for this segment of our conversation.

PV: It's a strange place. Sad. Lap dancers and so on. The sleazy side of entertainment.

OI: You once told me this place evokes David Lynch films for you.

PV: That's because when you enter this bar, you understand that Midwestern American culture is laced with a weirdness that Lynch explores in his films. Greil Marcus describes this aspect of Lynch's work in his essay for this book. When you are in this kind of bar, you are in a very strange entertainment world. You're part of *Twin Peaks*, and you half-expect a dwarf to come and dance on your lap, saying, "We've already met,"[22] although you have no idea who he is.

OI: Concurrent with the exhibition, a Lynch retrospective is planned at the Walker.

PV: Yes, for me, the link between film and video is at the heart of Lynch's work, specifically *Lost Highway*, which I watched again last night. It is absolutely about going from one body to another and about transformation and alienation beneath the mundane surface of life. Marcus writes about what he calls "the American weirdness," the violence of everyday life in America as exposed and explored by Lynch. But this kind of dysfunction is not confined to America; America is simply a case study. Lynch is one of the symbols of the spirit we want to convey with this exhibition. As Marcus writes, "David Lynch speaks the language of art."

OI: Rather than a traditional exhibition catalogue, this is a book of essays and interviews that intervene in the field of cultural studies. How did this come about? Was there a deliberate avoidance of art criticism?

PV: It's not really a deliberate avoidance, as the idea is less to avoid art criticism than to do something else. I want to provide some other tools for reading the artworks. The art criticism can come through reviews of the exhibition. I don't want to prescribe any meta-truth about the exhibition through the writings. That's why you and I are having a conversation rather than an introductory essay proclaiming hard truths about the topic. Catherine David's catalogue for *documenta X* also used this more encompassing approach to looking at art and intellect.[23] The idea is to provide through the book something that is really about the many varied questions raised by the work.

The show evolved through numerous conversations over several years, and I wanted to keep the same rhythm in the book. I also think that our culture over the last twenty years has changed so dramatically and on so many different fronts—technology, economy, media, politics, geography—that it would be difficult to write one or two comprehensive texts. Since this publication is covering broad cultural topics, I hope it will reach a different audience than the usual art publication. For me, this is very interesting, again not because of a populist appeal, but to make information about an art project available in other contexts. I hope it will be a conversation across disciplines. This book is not an illustration of the artworks in the exhibition, but an enhancement, a wider context, for them. It stands alongside, but apart from, the exhibition. I also hope that it can serve as a fiction, a twisted one, or something between fiction and documentary.

OI: Does having an exhibition about entertainment within a museum space becomes a hopeless contradiction because the museum is ultimately a culturally elite space?

PV: It is a contradiction of sorts. The question recalls Douglas Gordon's observation about the lack of compatibility between museums and entertainment. But maybe this contradiction points to a philosophical shift in cultural institutions. From the way they are thinking about the architecture of their buildings to the way they program exhibitions and events, museums are moving ahead, trying to learn from the leisure industry and contemporary artists' practice.

When we recently sat on a panel together, Victor Burgin noted that the accepted definition of "elite" is a small group of people ruling a mass of people. Conversely, popular culture supposedly emerges from a groundswell of creative expression by a large group of people, the masses, and appeals to many. Multinationals such as Disney, Microsoft, and Nike, however, are currently defining our popular context, from movies and theme parks to architecture and retail experiences. They so define modern life that we're facing a situation where what we identify as popular and mass culture is in fact imposed by a very small group of people, getting smaller all the time. "Popular culture" looks decidedly "elite" under this lens. Perhaps the contradiction of *Let's Entertain* is that, against our will, the exhibition may be quite an elitist one.

What I would like to answer Victor Burgin, quoting the philosopher Pierre Lévy, is that nothing is finally forcing one to "choose between either or the other, the dialectic of utopia and business, games of the industry and the ones of desire."[24]

The light is kind of suave, as is the music. Lap dancers are moving in a very sensuous way around the bodies of the clientele. The music seems to stop, but the dancers do not. A dwarf in a little red suit comes to Philippe and Olukemi's table. He is very pale and starts talking in an eerie, raspy voice. "Hi, where is the entertainment tonight?"

Notes

22. A scene in David Lynch's *Lost Highway*.

23. Catherine David and Jean François Chevrier, eds., *Politics, Poetics: Documenta X, the Book* (Ostfildern-Ruit: Cantz, 1997).

24. Pierre Lévy, *Cyberculture: Rapport au Conseil de l'Europe* (Paris: Éditions Odile Jacob, 1997), 278. A translation of part of this volume is included in the present book. The totality of *Cyberculture* will be published in an English translation by University of Minnesota Press.

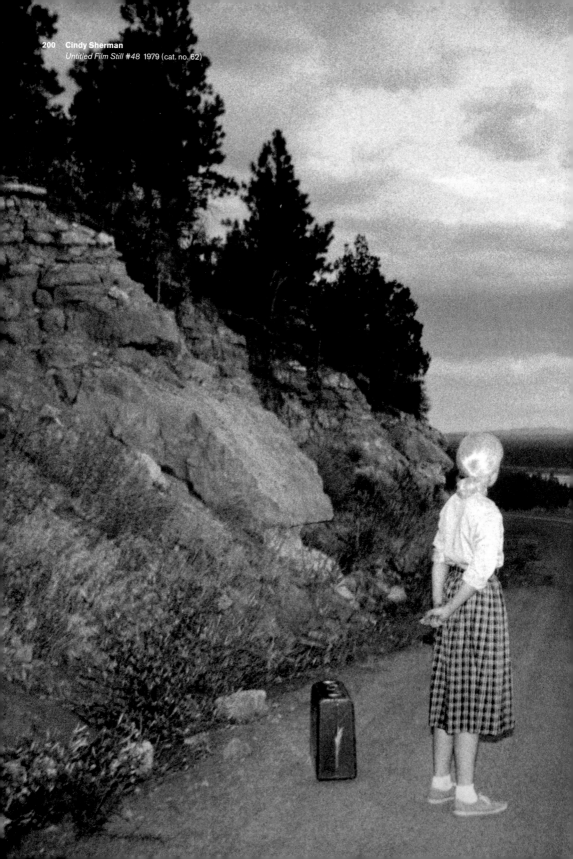

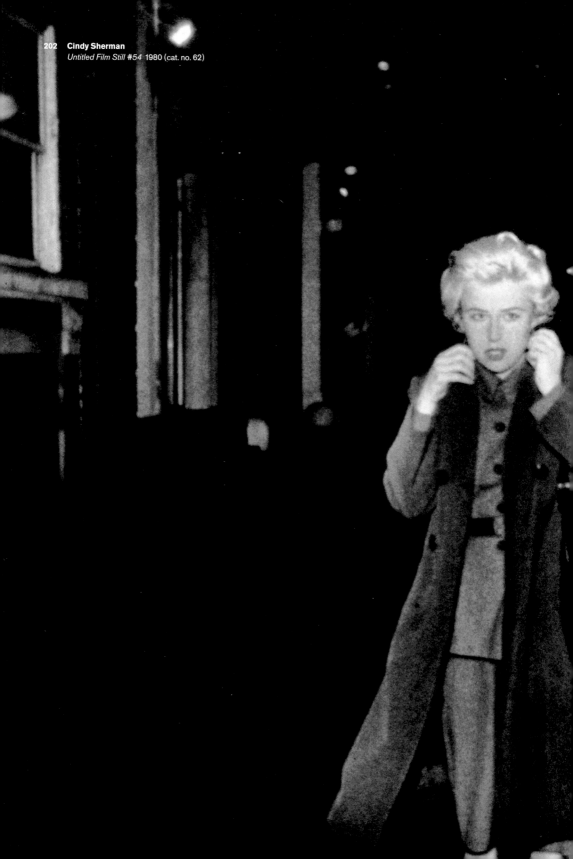

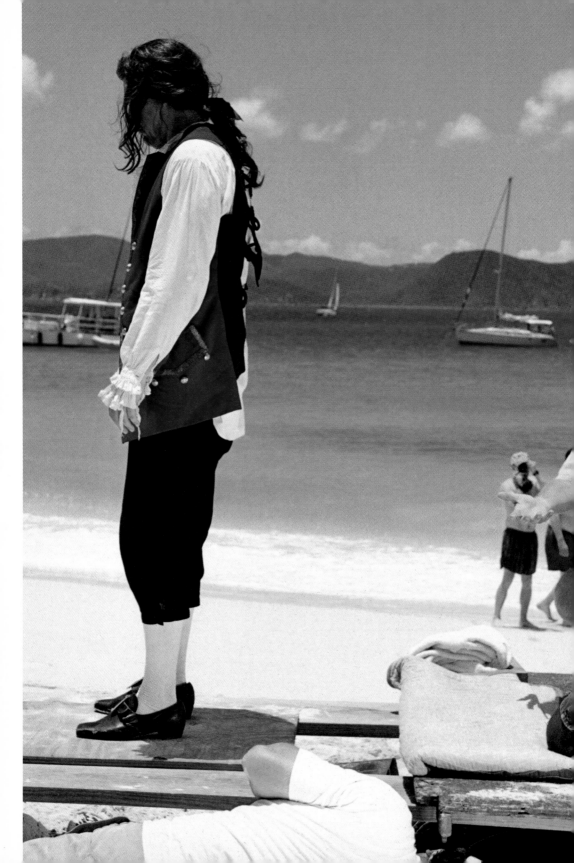

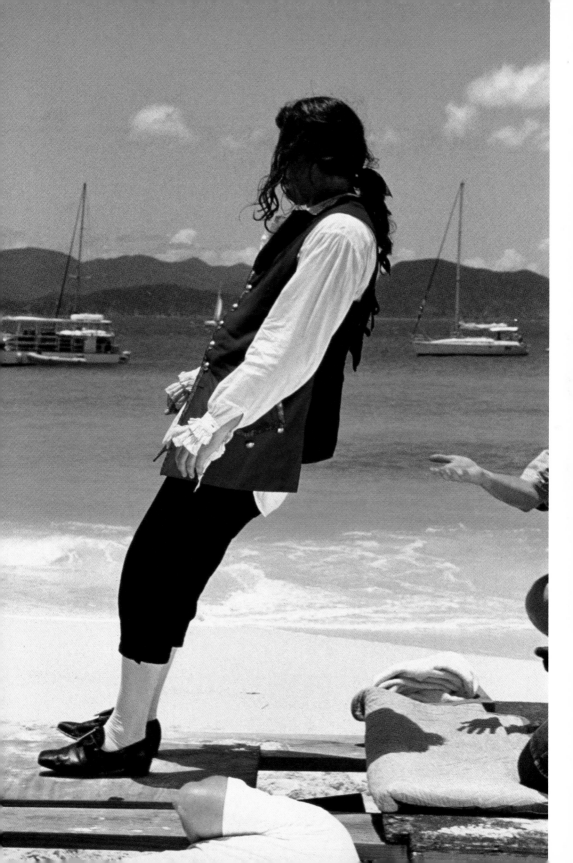

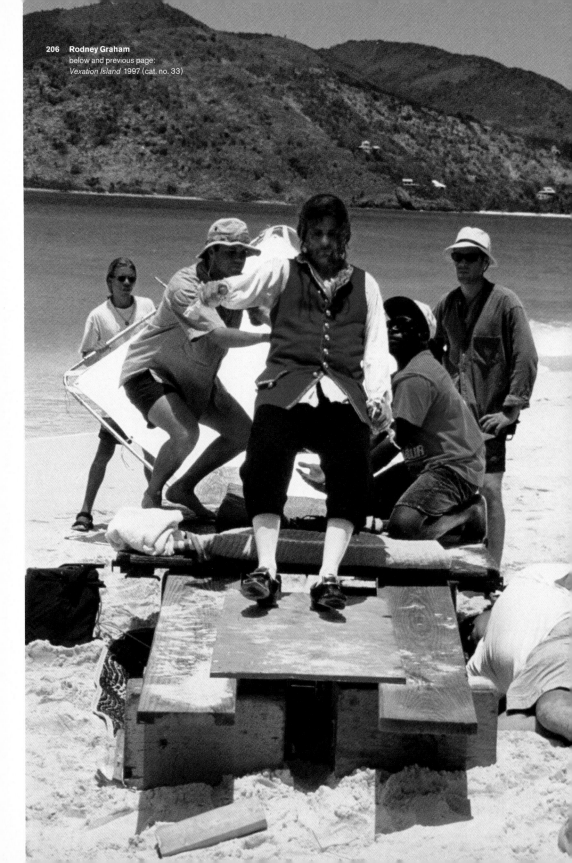

206 **Rodney Graham**
below and previous page:
Vexation Island 1997 (cat. no. 33)

Reach Out and Elect Someone
Neil Postman

In *The Last Hurrah*, Edwin O'Connor's novel about lusty party politics in Boston, Mayor Frank Skeffington tries to instruct his young nephew in the realities of political machinery. Politics, he tells him, is the greatest spectator sport in America. In 1966, Ronald Reagan used a different metaphor. "Politics," he said, "is just like show business."[1]

Although sport has now become a major branch of show business, it still contains elements that make Skeffington's vision of politics somewhat more encouraging than Reagan's. In any sport the standard of excellence is well known to both the players and spectators, and an athlete's reputation rises and falls by his or her proximity to that standard. Where an athlete stands in relation to it cannot be easily disguised or faked, which means that David Garth can do very little to improve the image of an outfielder with a .218 batting average. It also means that a public opinion poll on the question "Who is the best woman tennis player in the world?" is meaningless. The public's opinion has nothing to do with it. Martina Navratilova's serve provides the decisive answer.

One may also note that spectators at a sporting event are usually well aware of the rules of the game and the meaning of each piece of the action. There is no way for a batter who strikes out with the bases loaded to argue the spectators into believing that he has done a useful thing for his team (except, perhaps, by reminding them that he *could* have hit into a double play). The difference between hits and strike-outs, touchdowns and fumbles, aces and double faults cannot be blurred, even by the pomposities and malapropisms of a Howard Cosell. If politics were like a sporting event, there would be several virtues to attach to its name: clarity, honesty, excellence.

But what virtues attach to politics if Ronald Reagan is right? Show business is not entirely without an idea of excellence, but its main business is to please the crowd, and its principal instrument is artifice. If politics is like show business, then the idea is not to pursue excellence, clarity or honesty but to appear as if you are, which is another matter altogether. And what the other matter is can be expressed in one word: advertising. In Joe McGinnis' book about Richard Nixon's campaign in 1968, *The Selling of the President*, he said much of what needs to be said about politics and advertising, both in his title and in the book. But not quite all. For though the selling of a president is an astonishing and degrading thing, it is only part of a larger point: In America, the fundamental metaphor for political discourse is the television commercial.

The television commercial is the most peculiar and pervasive form of communication to issue forth from the electric plug. An American who has reached the age of forty will have seen well over one million television commercials in his or her lifetime, and has close to another million to go before the first Social Security check arrives. We may safely assume, therefore, that the television commercial has profoundly influenced American habits of thought. Certainly, there is no difficulty in demonstrating that it has become an important paradigm for the structure of every type of public discourse. My major purpose here is to show how it has devastated political discourse. But there may be some value in my pointing, first, to its effect on commerce itself.

By bringing together in compact form all of the arts of show business—music, drama, imagery, humor, celebrity—the television commercial has mounted the most serious assault on capitalist ideology since the publication of *Das Kapital*. To understand why, we must remind ourselves that capitalism, like science and liberal democracy, was an outgrowth of the Enlightenment. Its principal theorists, even its most prosperous

practitioners, believed capitalism to be based on the idea that both buyer and seller are sufficiently mature, well informed, and reasonable to engage in transactions of mutual self-interest. If greed was taken to be the fuel of the capitalist engine, then surely rationality was the driver. The theory states, in part, that competition in the marketplace requires that the buyer knows not only what is good for him but also what is good. If the seller produces nothing of value, as determined by a rational marketplace, then he loses out. It is the assumption of rationality among buyers that spurs competitors to become winners and winners to keep on winning. Where it is assumed that a buyer is unable to make rational decisions, laws are passed to invalidate transactions, as, for example, those that prohibit children from making contracts. In America, there even exists in law a requirement that sellers must tell the truth about their products, for if the buyer has no protection from false claims, rational decision-making is seriously impaired.

Of course, the practice of capitalism has its contradictions. Cartels and monopolies, for example, undermine the theory. But television commercials make hash of it. To take the simplest example: To be rationally considered, any claim—commercial or otherwise—must be made in language. More precisely, it must take the form of a proposition, for that is the universe of discourse from which such words as "true" and "false" come. If that universe of discourse is discarded, then the application of empirical tests, logical analysis or any of the other instruments of reason is impotent.

The move away from the use of propositions in commercial advertising began at the end of the nineteenth century. But it was not until the 1950s that the television commercial made linguistic discourse obsolete as the basis for product decisions. By substituting images for claims, the pictorial commercial made emotional appeal, not tests of truth, the basis of consumer decisions. The distance between rationality and advertising is now so wide that it is difficult to remember that there once existed a connection between them. Today, on television commercials, propositions are as scarce as unattractive people. The truth or falsity of an advertiser's claims is simply not an issue. A McDonald's commercial, for example, is not a series of testable, logically ordered assertions. It is a drama—a mythology, if you will—of handsome people selling, buying, and eating hamburgers, and being driven to near ecstasy by their good fortune. No claims are made, except those the viewer projects onto or infers from the drama. One can like or dislike a television commercial, of course. But one cannot refute it.

Indeed, we may go this far: The television commercial is not at all about the character of products to be consumed. It is about the character of the consumers of products. Images of movie stars and famous athletes, of serene lakes and macho fishing trips, of elegant dinners and romantic interludes, of happy families packing their station wagons for a picnic in the country—these tell nothing about the products being sold. But they tell everything about the fears, fancies, and dreams of those who might buy them. What the advertiser needs to know is not what is right about the product but what is wrong about the buyer. And so the balance of business expenditures shifts from *product* research to *market* research. The television commercial has oriented business away from making products of value and toward making consumers feel valuable, which means that the business of business has now become pseudo-therapy. The consumer is a patient assured by psychodramas.

All of this would come as a great surprise to Adam Smith, just as the transformation

of politics would be equally surprising to the redoubtable George Orwell. It is true, as George Steiner has remarked, that Orwell thought of Newspeak as originating, in part, from "the verbiage of commercial advertising." But when Orwell wrote in his famous essay "The Politics of the English Language" that politics has become a matter of "defending the indefensible," he was assuming that politics would remain a distinct, although corrupted, mode of discourse. His contempt was aimed at those politicians who would use sophisticated versions of the age-old arts of double-think, propaganda and deceit. That the defense of the indefensible would be conducted as a form of amusement did not occur to him. He feared the politician as deceiver, not as entertainer.

The television commercial has been the chief instrument in creating the modern methods of presenting political ideas. It has accomplished this in two ways. The first is by requiring its form to be used in political campaigns. It is not necessary, I take it, to say very much about this method. Everyone has noticed and worried in varying degrees about it, including former New York City mayor John Lindsay, who has proposed that political "commercials" be prohibited. Even television commentators have brought it to our attention, as, for example, Bill Moyers in "The Thirty-Second President," a documentary on his excellent television series *A Walk through the 20th Century*. My own awakening to the power of the television commercial as political discourse came as a result of a personal experience of a few years back, when I played a minuscule role in Ramsey Clark's Senate campaign against Jacob Javits in New York. A great believer in the traditional modes of political discourse, Clark prepared a small library of carefully articulated position papers on a variety of subjects, from race relations to nuclear power to the Middle East. He filled each paper with historical background, economic and political facts, and, I thought, an enlightened sociological perspective. He might as well have drawn cartoons. In fact, Jacob Javits did draw cartoons, in a manner of speaking. If Javits had a carefully phrased position on any issue, the fact was largely unknown. He built his campaign on a series of thirty-second television commercials in which he used visual imagery, in much the same way as a McDonald's commercial, to project himself as a man of experience, virtue, and piety. For all I know, Javits believed as strongly in reason as did Ramsey Clark. But he believed more strongly in retaining his seat in the Senate. And he knew full well in what century we are living. He understood that in a world of television and other visual media, "political knowledge" means having pictures in your head more than having words. The record will show that this insight did not fail him. He won the election by the largest plurality in New York State history. And I will not labor the commonplace that any serious candidate for high political office in America requires the services of an image manager to design the kinds of pictures that will lodge in the public's collective head. I will want to return to the implications of "image politics" but it is necessary, before that, to discuss the second method by which the television commercial shapes political discourse.

Because the television commercial is the single most voluminous form of public communication in our society, it was inevitable that Americans would accommodate themselves to the philosophy of television commercials. By "accommodate," I mean that we accept them as a normal and plausible form of discourse. By "philosophy," I mean that the television commercial has embedded in it certain assumptions about the nature of communication that run counter to those of other media, especially the printed

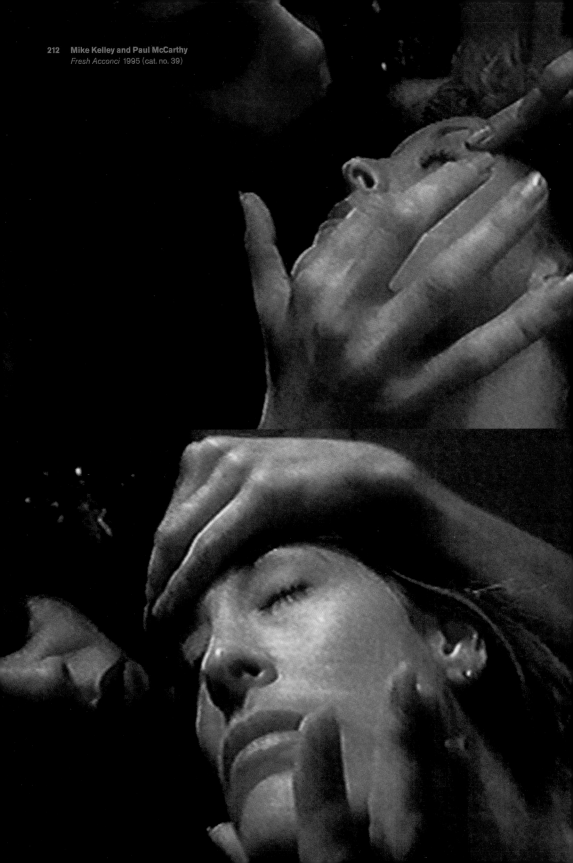

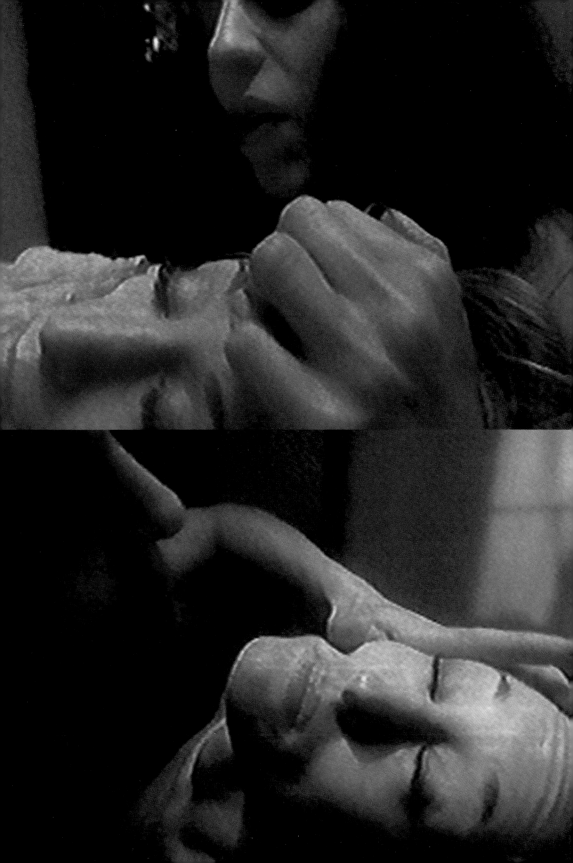

word. For one thing, the commercial insists on an unprecedented brevity of expression. One may even say, instancy. A sixty-second commercial is prolix; thirty seconds is longer than most; fifteen to twenty seconds is about average. This is a brash and startling structure for communication since, as I remarked earlier, the commercial always addresses itself to the psychological needs of the viewer. Thus it is not merely therapy. It is instant therapy. Indeed, it puts forward a psychological theory of unique axioms: The commercial asks us to believe that all problems are solvable, that they are solvable fast, and that they are solvable fast through the interventions of technology, techniques, and chemistry. This is, of course, a preposterous theory about the roots of discontent, and would appear so to anyone hearing or reading it. But the commercial disdains exposition, for that takes time and invites argument. It is a very bad commercial indeed that engages the viewer in wondering about the validity of the point being made. That is why most commercials use the literary device of the pseudo-parable as a means of doing their work. Such "parables" as The Ring Around the Collar, The Lost Traveler's Checks, and The Phone Call from the Son Far Away not only have irrefutable emotional power but, like biblical parables, are unambiguously didactic. The television commercial is about products only in the sense that the story of Jonah is about the anatomy of whales, which is to say, it isn't. Which is to say further, it is about how one ought to live one's life. Moreover, commercials have the advantage of vivid visual symbols through which we may easily learn the lessons being taught. Among those lessons are that short and simple messages are preferable to long and complex ones; that drama is to be preferred over exposition; that being sold solutions is better than being confronted with questions about problems. Such beliefs would naturally have implications for our orientation to political discourse; that is to say, we may begin to accept as normal certain assumptions about the political domain that either derive from or are amplified by the television commercial. For example, a person who has seen one million television commercials might well believe that all political problems have fast solutions through simple measures—or ought to. Or that complex language is not to be trusted, and that all problems lend themselves to theatrical expression. Or that argument is in bad taste, and leads only to an intolerable uncertainty. Such a person may also come to believe that it is not necessary to draw any line between politics and other forms of social life. Just as a television commercial will use an athlete, an actor, a musician, a novelist, a scientist, or a countess to speak for the virtues of a product in no way within their domain of expertise, television also frees politicians from the limited field of their own expertise. Political figures may show up anywhere, at any time, doing anything, without being thought odd, presumptuous, or in any way out of place. Which is to say, they have become assimilated into the general television culture as celebrities.

Being a celebrity is quite different from being well known. Harry Truman was well known but he was not a celebrity. Whenever the public saw him or heard him, Truman was talking politics. It takes a very rich imagination to envision Harry Truman or, for that matter, his wife making a guest appearance on *The Goldbergs* or *I Remember Mama*. Politics and politicians had nothing to do with these shows, which people watched for amusement, not to familiarize themselves with political candidates and issues.

It is difficult to say exactly when politicians began to put themselves forward, intentionally, as sources of amusement. In the 1950s Senator Everett Dirksen appeared as a

guest on *What's My Line?* When he was running for office, John F. Kennedy allowed the television cameras of Ed Murrow's *Person to Person* to invade his home. When he was not running for office, Richard Nixon appeared for a few seconds on *Laugh-In*, an hour-long comedy show based on the format of a television commercial. By the 1970s, the public had started to become accustomed to the notion that political figures were to be taken as part of the world of show business. In the 1980s came the deluge. Vice-presidential candidate William Miller did a commercial for American Express. So did the star of the Watergate hearings, Senator Sam Ervin. Former President Gerald Ford joined with former Secretary of State Henry Kissinger for brief roles on *Dynasty*. Massachusetts Governor Mike Dukakis appeared on *St. Elsewhere*. Speaker of the House Tip O'Neill did a stint on *Cheers*. Consumer advocate Ralph Nader, George McGovern and Mayor Edward Koch hosted *Saturday Night Live*. Koch also played the role of a fight manager in a made-for-television movie starring James Cagney. Mrs. Nancy Reagan appeared on *Diff'rent Strokes*. Would anyone be surprised if Gary Hart tuned up on *Hill Street Blues*? Or if Geraldine Ferraro played a small role as a Queens housewife in a Francis Coppola film?

Although it may go too far to say that the politician-as-celebrity has, by itself, made political parties irrelevant, there is certainly a conspicuous correlation between the rise of the former and the decline of the latter. Some readers may remember when voters barely knew who the candidate was and, in any case, were not preoccupied with his character and personal life. As a young man, I balked one November at voting for a Democratic mayoralty candidate who, it seemed to me, was both unintelligent and corrupt. "What has that to do with it?" my father protested. "*All* Democratic candidates are unintelligent and corrupt. Do you want the Republicans to win?" He meant to say that intelligent voters favored the party that best represented their economic interest and sociological perspective. To vote for the "best man" seemed to him an astounding and naive irrelevance. He never doubted that there were good men among Republicans. He merely understood that they did not speak for his class. He shared, with an unfailing eye, the perspective of Big Tim Sullivan, a leader of New York's Tammany Hall in its glory days. As Terence Moran recounts in his essay "Politics 1984," Sullivan was once displeased when brought the news that the vote in his precinct was 6,382 for the Democrat and two for the Republican. In evaluating this disappointing result, Sullivan remarked, "Sure, didn't Kelly come to me to say his wife's cousin was running on the Republican line and didn't I, in the interests of domestic tranquillity, give him leave to vote Republican? But what I want to know is, who else voted Republican?"[2]

I will not argue here the wisdom of this point of view. There may be a case for choosing the best man over party (although I know of none). The point is that television does not reveal who the best man is. In fact, television makes impossible the determination of who is better than whom, if we mean by "better" such things as more capable in negotiation, more imaginative in executive skill, more knowledgeable about international affairs, more understanding of the interrelations of economic systems, and so on. The reason has, almost entirely, to do with "image." But not because politicians are preoccupied with presenting themselves in the best possible light. After all, who isn't? It is a rare and deeply disturbed person who does not wish to project a favorable image. But television gives image a bad name. For on television the politician does not so much offer the audi-

216 **Pierre Huyghe**
Blanche-Neige Lucie (Snow White Lucie), 1997 (cat. no. 38)
(translation of subtitle: small resonant voice, childlike)

une petite v
très ent

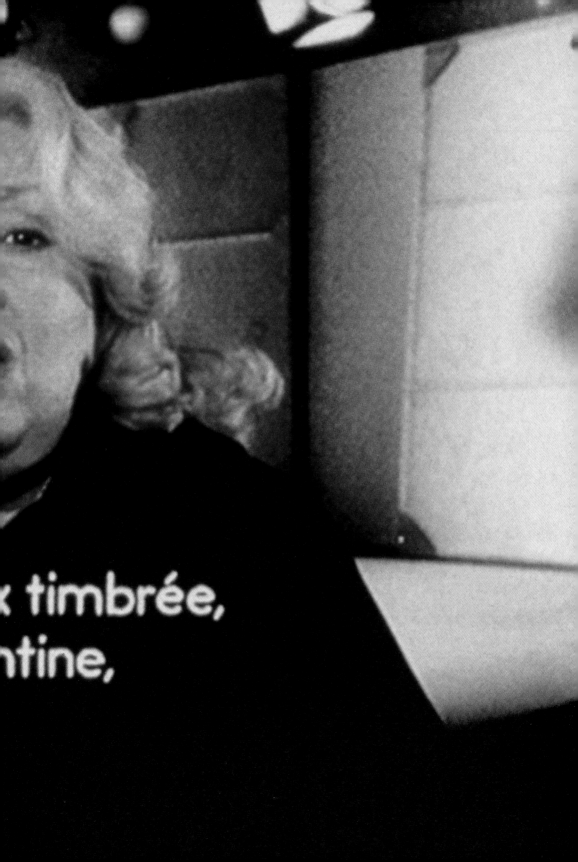

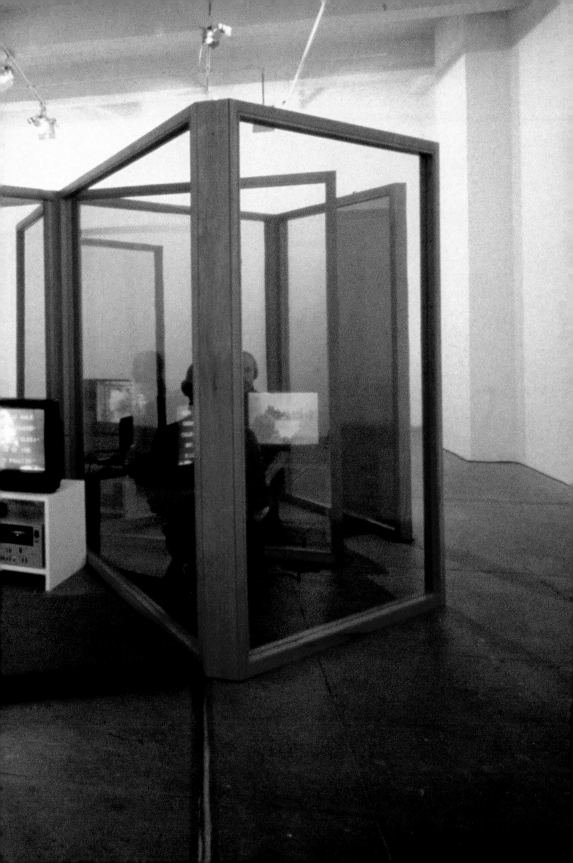

ence an image of himself, as offer himself as an image of the audience. And therein lies one of the most powerful influences of the television commercial on political discourse.

To understand how image politics works on television, we may use as an entry point the well-known commercial from which this chapter takes the first half of its title. I refer to the Bell Telephone romances, created by Steve Horn, in which we are urged to "Reach Out and Touch Someone." The "someone" is usually a relative who lives in Denver or Los Angeles or Atlanta—in any case, very far from where we are, and who, in a good year, we will be lucky to see on Thanksgiving Day. The "someone" used to play a daily and vital role in our lives; that is to say, used to be a member of the family. Though American culture stands vigorously opposed to the idea of family, there nonetheless still exists a residual nag that something essential to our lives is lost when we give it up. Enter Mr. Horn's commercials. These are thirty-second homilies concerned to provide a new definition of intimacy in which the telephone wire will take the place of old-fashioned co-presence. Even further, these commercials intimate a new conception of family cohesion for a nation of kinsmen who have been split asunder by automobiles, jet aircraft, and other instruments of family suicide. In analyzing these commercials, Jay Rosen makes the following observation: "Horn isn't interested in saying anything, he has no message to get across. His goal is not to provide information about Bell, but to somehow bring out from the broken ties of millions of American lives a feeling which might focus on the telephone.... Horn does not express himself. You do not express yourself. Horn expresses you."[3]

This is the lesson of all great television commercials: They provide a slogan, a symbol or a focus that creates for viewers a comprehensive and compelling image of themselves. In the shift from party politics to television politics, the same goal is sought. We are not permitted to know who is best at being president or governor or senator, but whose image is best in touching and soothing the deep reaches of our discontent. We look at the television screen and ask, in the same voracious way as the Queen in *Snow White and the Seven Dwarfs*, "Mirror, mirror on the wall, who is the fairest one of all?" We are inclined to vote for those whose personality, family life, and style, as imaged on the screen, give back a better answer than the Queen received. As Xenophanes remarked twenty-five centuries ago, men always make their gods in their own image. But to this, television politics has added a new wrinkle: Those who would be gods refashion themselves into images the viewers would have them be.

And so, while image politics preserves the idea of self-interest voting, it alters the meaning of "self-interest." Big Tim Sullivan and my father voted for the party that represented their interests, but "interests" meant to them something tangible—patronage, preferential treatment, protection from bureaucracy, support for one's union or community, Thanksgiving turkeys for indigent families. Judged by this standard, blacks may be the only sane voters left in America. Most of the rest of us vote our interests, but they are largely symbolic ones, which is to say, of a psychological nature. Like television commercials, image politics is a form of therapy, which is why so much of it is charm, good looks, celebrity, and personal disclosure. It is a sobering thought to recall that there are no photographs of Abraham Lincoln smiling, that his wife was in all likelihood a psychopath, and that he was subject to lengthy fits of depression. He would hardly have been well suited for image politics. We do not want our mirrors to be so dark and so far

from amusing. What I am saying is that just as the television commercial empties itself of authentic product information so that it can do its psychological work, image politics empties itself of authentic political substance for the same reason.

It follows from this that history can play no significant role in image politics. For history is of value only to someone who takes seriously the notion that there are patterns in the past which may provide the present with nourishing traditions. "The past is a world," Thomas Carlyle said, "and not a void of grey haze." But he wrote this at a time when the book was the principal medium of serious public discourse. A book is *all* history. Everything about it takes one back in time—from the way it is produced to its linear mode of exposition to the fact that the past tense is its most comfortable form of address. As no other medium before or since, the book promotes a sense of a coherent and usable past. In a conversation of books, history, as Carlyle understood it, is not only a world but a living world. It is the present that is shadowy.

But television is a speed-of-light medium, a present-centered medium. Its grammar, so to say, permits no access to the past. Everything presented in moving pictures is experienced as happening "now," which is why we must be told *in language* that a videotape we are seeing was made months before. Moreover, like its forefather, the telegraph, television needs to move fragments of information, not to collect and organize them. Carlyle was more prophetic than he could imagine: The literal gray haze that is the background void on all television screens is an apt metaphor of the notion of history the medium puts forward. In the Age of Show Business and image politics, political discourse is emptied not only of ideological content but of historical content, as well.

Czeslaw Milosz, winner of the 1980 Nobel Prize for Literature, remarked in his acceptance speech in Stockholm that our age is characterized by a "refusal to remember"; he cited, among other things, the shattering fact that there are now more than one hundred books in print that deny that the Holocaust ever took place. The historian Carl Schorske has, in my opinion, circled closer to the truth by noting that the modern mind has grown indifferent to history because history has become useless to it; in other words, it is not obstinacy or ignorance but a sense of irrelevance that leads to the diminution of history. Television's Bill Moyers inches still closer when he says, "I worry that my own business…helps to make this an anxious age of agitated amnesiacs…. We Americans seem to know everything about the last twenty-four hours but very little of the last sixty centuries or the last sixty years."[4] Terence Moran, I believe, lands on the target in saying that with media whose structure is biased toward furnishing images and fragments, we are deprived of access to an historical perspective. In the absence of continuity and context, he says, "bits of information cannot be integrated into an intelligent and consistent whole."[5] We do not refuse to remember; neither do we find it exactly useless to remember. Rather, we are being rendered unfit to remember. For if remembering is to be something more than nostalgia, it requires a contextual basis—a theory, a vision, a metaphor—*something* within which facts can be organized and patterns discerned. The politics of image and instantaneous news provides no such context, and is, in fact, hampered by attempts to provide any. A mirror records only what you are wearing today. It is silent about yesterday. With television, we vault ourselves into a continuous, incoherent present. "History," Henry Ford said, "is bunk." Henry Ford was a typographic optimist. "History," the Electric Plug replies, "doesn't exist."

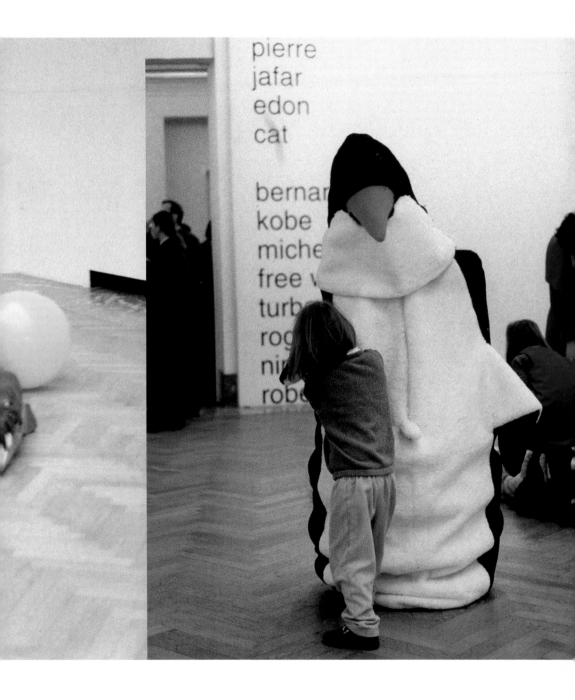

pierre
jafar
edon
cat

bernar
kobe
miche
free v
turb
rog
nir
robe

If these conjectures make sense, then in this Orwell was wrong once again, at least for the Western democracies. He envisioned the demolition of history, but believed that it would be accomplished by the state; that some equivalent of the Ministry of Truth would systematically banish inconvenient facts and destroy the records of the past. Certainly, this is the way of the Soviet Union, our modern-day Oceania. But as Huxley more accurately foretold it, nothing so crude as all that is required. Seemingly benign technologies devoted to providing the populace with a politics of image, instancy and therapy may disappear history just as effectively, perhaps more permanently, and without objection.

We ought also to look to Huxley, not Orwell, to understand the threat that television and other forms of imagery pose to the foundation of liberal democracy—namely, to freedom of information. Orwell quite reasonably supposed that the state, through naked suppression, would control the flow of information, particularly by the banning of books. In this prophecy, Orwell had history strongly on his side. For books have always been subjected to censorship in varying degrees wherever they have been an important part of the communication landscape. In ancient China, the *Analects* of Confucius were ordered destroyed by Emperor Chi Huang Ti. Ovid's banishment from Rome by Augustus was in part a result of his having written *Ars Amatoria*. Even in Athens, which set enduring standards of intellectual excellence, books were viewed with alarm. In *Areopagitica*, Milton provides an excellent review of the many examples of book censorship in Classical Greece, including the case of Protagoras, whose books were burned because he began one of his discourses with the confession that he did not know whether or not there were gods. But Milton is careful to observe that in all the cases before his own time, there were only two types of books that, as he puts it, "the magistrate cared to take notice of": books that were blasphemous and books that were libelous. Milton stresses this point because, writing almost two hundred years after Gutenberg, he knew that the magistrates of his own era, if unopposed, would disallow books of every conceivable subject matter. Milton knew, in other words, that it was in the printing press that censorship had found its true métier; that, in fact, information and ideas did not become a profound cultural problem until the maturing of the Age of Print. Whatever dangers there may be in a word that is written, such a word is a hundred times more dangerous when stamped by a press. And the problem posed by typography was recognized early; for example, by Henry VIII, whose Star Chamber was authorized to deal with wayward books. It continued to be recognized by Elizabeth I, the Stuarts, and many other post-Gutenberg monarchs, including Pope Paul IV, in whose reign the first *Index Librorum Prohibitorum* was drawn. To paraphrase David Reisman only slightly, in a world of printing, information is the gunpowder of the mind; hence come the censors in their austere robes to dampen the explosion.

Thus, Orwell envisioned that (1) government control over (2) printed matter posed a serious threat for Western democracies. He was wrong on both counts. (He was, of course, right on both counts insofar as Russia, China, and other pre-electronic cultures are concerned.) Orwell was, in effect, addressing himself to a problem of the Age of Print—in fact, to the same problem addressed by the men who wrote the United States Constitution. The Constitution was composed at a time when most free men had access to their communities through a leaflet, a newspaper, or the spoken word. They were

quite well positioned to share their political ideas with each other in forms and contexts over which they had competent control. Therefore, their greatest worry was the possibility of government tyranny. The Bill of Rights is largely a prescription for preventing government from restricting the flow of information and ideas. But the Founding Fathers did not foresee that tyranny by government might be superseded by another sort of problem altogether, namely, the corporate state, which through television now controls the flow of public discourse in America. I raise no strong objection to this fact (at least not here) and have no intention of launching into a standard-brand complaint against the corporate state. I merely note the fact with apprehension, as did George Gerbner, Dean of the Annenberg School of Communication, when he wrote: "Television is the new state religion run by a private Ministry of Culture (the three networks), offering a universal curriculum for all people, financed by a form of hidden taxation without representation. You pay when you wash, not when you watch, and whether or not you care to watch."[6]

Earlier in the same essay, Gerbner said: "Liberation cannot be accomplished by turning [television] off. Television is for most people the most attractive thing going any time of the day or night. We live in a world in which the vast majority will not turn off. If we don't get the message from the tube, we get it through other people." I do not think Professor Gerbner meant to imply in these sentences that there is a conspiracy to take charge of our symbolic world by the men who run the "Ministry of Culture." I even suspect he would agree with me that if the faculty of the Annenberg School of Communication were to take over the three networks, viewers would hardly notice the difference. I believe he means to say—and in any case, *I* do—that in the Age of Television, our information environment is completely different from what it was in 1783; that we have less to fear from government restraints than from television glut; that, in fact, we have no way of protecting ourselves from information disseminated by corporate America; and that, therefore, the battles for liberty must be fought on different terrains from where they once were.

For example, I would venture the opinion that the traditional civil libertarian opposition to the banning of books from school libraries and from school curricula is now largely irrelevant. Such acts of censorship are annoying, of course, and must be opposed. But they are trivial. Even worse, they are distracting, in that they divert civil libertarians from confronting those questions that have to do with the claims of new technologies. To put it plainly, a student's freedom to read is not seriously injured by someone's banning a book on Long Island or in Anaheim or anyplace else. But as Gerbner suggests, television clearly does impair the student's freedom to read, and it does so with innocent hands, so to speak. Television does not ban books, it simply displaces them.

The fight against censorship is a nineteenth-century issue which was largely won in the twentieth. What we are confronted with now is the problem posed by the economic and symbolic structure of television. Those who run television do not limit our access to information but in fact widen it. Our Ministry of Culture is Huxleyan, not Orwellian. It does everything possible to encourage us to watch continuously. But what we watch is a medium which presents information in a form that renders it simplistic, nonsubstantive, nonhistorical, and noncontextual; that is to say, information packaged as entertainment. In America, we are never denied the opportunity to amuse ourselves.

Tyrants of all varieties have always known about the value of providing the masses with amusements as a means of pacifying discontent. But most of them could not have even hoped for a situation in which the masses would ignore that which does not amuse. That is why tyrants have always relied, and still do, on censorship. Censorship, after all, is the tribute tyrants pay to the assumption that a public knows the difference between serious discourse and entertainment—and cares. How delighted would be all the kings, czars, and führers of the past (and commissars of the present) to know that censorship is not a necessity when all political discourse takes the form of a jest.

From *Amusing Ourselves to Death: Public Discourse in the Age of Show Business* by Neil Postman. Copyright ©1985 by Neil Postman. Used by permission of Viking Penguin, a division of Penguin Putnam Inc.

Notes

1. Elizabeth Drew, *Portrait of an Election: The 1980 Presidential Campaign* (New York: Simon and Schuster, 1981), 263.

2. Terence Moran, "Politics 1984: That's Entertainment," *Et cetera* 41 (summer 1984): 122.

3. Jay Rosen, "Advertising's Slow Suicide," *Et cetera* 41 (summer 1984): 162.

4. Quoted from a speech given on 27 March 1984 at the Jewish Museum in New York City on the occasion of a conference of the National Jewish Archive of Broadcasting.

5. Moran, "Politics 1984," 125.

6. From a speech given at the twenty-fourth Media Ecology Conference, 26 April 1982, Saugerties, New York. For a full account of Dean Gerbner's views, see "Television: The New State Religion," *Et cetera* 34 (June 1977): 145–50.

THE GREATEST TRAGEDY OF PRESIDENT CLINTON'S ADMINISTRATION

HAS BEEN HIS INABILITY (OR REFUSAL) TO ENACT THE HEALTH CARE REFORM THAT HE PROMISED AS PART OF HIS CAMPAIGN PLATFORM. OBVIOUSLY, THE WELL BEING OF THE NATION'S POPULACE SHOULD BE GOVERNMENT'S PRIMARY CONCERN. THE MAINTENANCE OF THE PEOPLE'S HEALTH IS OF FAR GREATER IMPORTANCE THAN THE CARE OF PUBLIC PROPERTY BECAUSE THE NATION'S POPULACE ITSELF IS ITS GREATEST NATIONAL RESOURCE. IT IS UNFORGIVABLE THAT ANY PERSON IN AMERICA SHOULD DIE BECAUSE OF HIS OR HER INABILITY TO PAY FOR HEALTH INSURANCE. HEALTH CARE MUST BE PROVIDED, ABSOLUTELY FREE OF CHARGE, TO ALL RESIDENTS OF THE UNITED STATES, AND THIS COVERAGE SHOULD, OF COURSE, INCLUDE MENTAL HEALTH CARE. PART OF THIS EXPANDED NOTION OF NATIONAL HEALTH WOULD BE A HEIGHTENED CONCERN FOR SEXUAL WELL-BEING.

IT'S TIME WE, AS A PEOPLE, TOSSED ASIDE OUR NATION'S PURITAN HERITAGE. AMERICA HAS TO BE REALISTIC AND ACCEPT THE FACT THAT WE ARE A SEXUAL PEOPLE. WE MUST ALSO RECOGNIZE THE SAD CONNECTION BETWEEN PHYSICAL AND MENTAL DYSFUNCTION, AND EMOTIONAL AND SEXUAL FRUSTRATION. BEING A HEALTHY AND PRODUCTIVE MEMBER OF SOCIETY CAN ONLY BE POSSIBLE IF ONE IS A SATISFIED, SEXUALLY FUNCTIONING, MEMBER OF SOCIETY. THUS, PROSTITUTION SHOULD NOT ONLY BE DECRIMINALIZED, IT SHOULD BE SOCIALIZED AND MADE AVAILABLE, AT NO COST, TO EVERY MAN, WOMAN AND CHILD.

UNFORTUNATELY, THE DAMAGE HAS ALREADY BEEN DONE. WE ARE A POPULATION SO SEX-STARVED, WE HAVE CREATED FOR OURSELVES A POPULAR CULTURE INDUSTRY THAT BOMBARDS US CONTINUALLY WITH A PANTHEON OF FANTASY FIGURES OF DESIRE. THIS ELITE, COMPRISED OF MOVIE AND TELEVISION ACTORS, PORN STARS, POP SINGERS, ROCK MUSICIANS, ATHLETES, SUPER MODELS AND THE PAMPERED CHILDREN OF THE WEALTHY, IS THE OBJECT OF OUR COLLECTIVE MASTURBATORY DREAMS. THESE FIGURES ARE PAID ENORMOUS SUMS OF MONEY AND LIVE IN A MAGICAL WORLD YOU AND I ARE DENIED ACCESS TO. THEY ARE FREE FROM THE RULES AND OBLIGATIONS THAT APPLY TO EVERYDAY PEOPLE. THEY ARE GRANTED ALL THAT SOCIETY HAS TO OFFER, YET GIVE BACK NOTHING TANGIBLE IN RETURN. IN THE END, THESE "SUPER HEROES" PROVIDE ONLY FRUSTRATION. THE TIME HAS COME TO ERADICATE THE REMOVED CULTURAL ZONE THESE PERSONS OCCUPY. IT'S TIME THESE "STARS"

BECOME CITIZENS AND PROVIDE A REAL SOCIAL SERVICE, THE SAME ONE THEY ONLY HINT AT PRESENTLY. IT'S TIME THEY ACTUALLY PLEASURE THE POPULATION THEY CONTINUOUSLY TITILLATE.

I PROPOSE THAT THESE RITUALIZED PUBLIC FIGURES BE REQUIRED BY LAW TO PUT IN TIME AT GOVERNMENT-SPONSORED SEX CLINICS, WHERE THEY WILL BE ACCESSIBLE TO ALL. OBVIOUSLY, IT IS NOT PHYSICALLY POSSIBLE FOR THIS SMALL NUMBER OF CELEBRITIES TO ENTERTAIN, IN PERSON, EVERYONE WHO HAS BEEN EXPOSED TO THEM THROUGH THE MASS MEDIA. THE SOLUTION TO THIS PROBLEM IS TO MAKE AVAILABLE, TO ANYONE WHO WANTS IT, FREE PLASTIC SURGERY ENABLING HIM OR HER TO BECOME THE "DOUBLE" OF ANY CELEBRITY THEY WISH. THE ONLY PRICE FOR THIS OPERATION WOULD BE SERVICE IN THE PUBLIC SEXUAL-SATISFAC-TION WORK FORCE. THIS MOBILIZA-TION OF POPULAR ENTERTAINERS AND THEIR FANS, INTO A SEXUAL WORK FORCE IS ONLY MEANT TO BE TEMPORARY, FOR ONCE THE GENER-AL POPULATION FINDS SEXUAL SAT-ISFACTION THERE WILL NO LONGER BE THE NEED FOR A MASS CULTURE INDUSTRY. ONCE EVERYONE FINDS WITHIN THEIR GRASP THE MEANS TO PLEASURE ON A DAILY BASIS, A RITUALIZED ARENA OF SPECTACULAR FANTASY FIGURES WILL SERVE NO CULTURAL PURPOSE. PEOPLE WILL CONSTRUCT THEIR OWN DESIRE FREE FROM THE EFFECT OF ANY PREFABRICATED STANDARD. WITHIN A GENERATION, SEXUAL REPRESSION WILL CEASE TO BE A MAJOR FACTOR AS A CAUSE FOR MENTAL AND PHYSICAL ILLNESS. AS A PUBLIC HEALTH CONCERN, IT WILL BECOME AS INCONSEQUENTIAL AS THE COMMON COLD.

IN THE MEAN TIME, BEFORE THESE SOCIAL PROGRAMS ARE PUT INTO EFFECT, I OFFER UP SOME HAND MADE CELEBRITY SURROGATES AS A STOPGAP MEASURE. THE PEOPLE ARE DAMAGED AND SHY; THEY ARE UNWILLING TO TAKE THE FIRST STEPS TOWARD FREEING THEMSELVES OF SEXUAL REPRESSION AND THEIR RELIANCE ON FANTASY SEX OBJECTS. KNOWING THEIR LIMITATIONS, I HAVE PROVIDED THEM WITH SIMPLE, SQUARE ONE, TACTILE PLEASURES, HOPING THAT THEY MAY USE THESE AS SPRINGBOARDS TO MOVE ON TO MORE COMPLEX EROTIC ONES.

SPEND A LITTLE TIME WITH THESE INANIMATE FRIENDS, LISTENING TO THE MUSIC, EXPLORING YOUR FEELINGS. TAKE A FEW BABY STEPS. BUILD UP THE COURAGE TO LEAVE ART, AND THE FETISH, BEHIND. MOVE FORWARD INTO REALITY, THEN MOVE ON TO ECSTASY.

MIKE KELLEY

JANUARY 23 - FEBRUARY 20, 1999 PATRICK PAINTER, INC 2525 MICHIGAN AVENUE SANTA MONICA CA USA 90404 TELEPHONE 310.264.5988 FACSIMILE 310.264.5998

A Stopgap Measure

The greatest tragedy of President Clinton's administration has been his inability (or refusal) to enact the health care reform that he promised as part of his campaign platform. Obviously, the well being of the nation's populace should be government's primary concern. The maintenance of the people's health is of far greater importance than the care of public property because the nation's populace itself is its greatest national resource. It is unforgivable than any person in America should die because of his or her inability to pay for health insurance. Health care must be provided, absolutely free of charge, to all residents of the United States, and this coverage should, of course, include mental health care. Part of this expanded notion of national health would be a heightened concern for sexual well-being.

It's time we, as a people, tossed aside our nation's Puritan heritage. America has to be realistic and accept the fact that we are a sexual people. We must also recognize the sad connection between physical and mental dysfunction, and emotional and sexual frustration. Being a healthy and productive member of society can only be possible if one is a satisfied, sexually functioning, member of society. Thus, prostitution should not only be decriminalized, it should be socialized and made available, at no cost, to every man, woman, and child.

Unfortunately, the damage has already been done. We are a population so sex-starved, we have created for ourselves a popular culture industry that bombards us continually with a pantheon of fantasy figures of desire. This elite, comprised of movie and television actors, porn stars, pop singers, rock musicians, athletes, super models, and the pampered children of the wealthy, is the object of our collective masturbatory dreams. These figures are paid enormous sums of money and live in a magical world you and I are denied access to. They are free from the rules and obligations that apply to everyday people. They are granted all that society has to offer, yet give back nothing tangible in return. In the end, these "super heroes" provide only frustration. The time has come to eradicate the removed cultural zone these persons occupy. It's time these "stars" become citizens and provide a real social service, the same one they only hint at presently. It's time they actually pleasure the population they continuously titillate.

I propose that these ritualized public figures be required by law to put in time at government-sponsored sex clinics, where they will be accessible to all. Obviously, it is not physically possible for this small number of celebrities to entertain, in person, everyone who has been exposed to them through the mass media. The solution to this problem is to make available, to anyone who wants it, free plastic surgery enabling him or her to become the "double" of any celebrity they wish. The only price for this operation would be service in the public sexual-satisfaction work force. This mobilization of popular entertainers and their fans, into a sexual work force is only meant to be temporary, for once the general population finds sexual satisfaction there will no longer be the need for a mass culture industry. Once everyone finds within their grasp the means to pleasure on a daily basis, a ritualized arena of spectacular fantasy figures will serve no cultural purpose. People will construct their own desire free from the effect of any prefabricated standard. Within a generation, sexual repression will cease to be a major factor as a cause for mental and physical illness. As a public health concern, it will become as inconsequential as the common cold.

In the mean time, before these social programs are put into effect, I offer up some hand made celebrity surrogates as a stopgap measure. The people are damaged and shy; they are unwilling to take the first steps toward freeing themselves of sexual repression and their reliance on fantasy sex objects. Knowing their limitations, I have provided them with simple, square one, tactile pleasures, hoping that they may use these as springboards to move on to more complex erotic ones.

Spend a little time with these inanimate friends, listening to the music, exploring your feelings. Take a few baby steps. Build up the courage to leave art, and the fetish, behind. Move forward into reality, then move on to ecstasy.

Mike Kelley

The Sunday Telegraph
Sunday October 18, 1998

Hollywood wins fight to tame paparazzi

HOLLYWOOD stars have won an important victory in their campaign against the paparazzi with the passing of tough laws to prosecute them for trespass if using telephoto lenses, even on public property.

The legislation, just passed by state authorities, is a victory for a lobby of movie stars including Arnold Schwarzenegger, Tom Hanks and George Clooney, who want to curb the intrusions of the media into their personal lives.

California now has some of the toughest privacy laws in the world to protect its privileged wealthy stars. The legislation could become the model for similar laws to cover the rest of America.

The state is responding to pressure from the Screen Actors' Guild, which represents many of the biggest names in the film industry. California's law is aimed specifically at the paparazzi and the "stalkerazzi" who, using video cameras, attempt to record the intimate moments of celebrities.

Pete Wilson, the governor of California, said last week: "The so-called stalkerazzi will be deterred from driving their human prey to distraction, or even death."

The law, which takes effect on January 1, makes it possible to take action when a person is photographed or filmed "in circumstances where they had a reasonable expectation of privacy."

Photographers can also be charged if the subject felt "in physical jeopardy." Photographs and film shot from long distances using telephoto lenses could be included, using a controversial new definition of trespass.

California media organizations who, with the paparazzi, would be liable for triple punitive damages if found guilty by a court, have attacked the measures. The California Newspaper Publishers' Association and the American Civil Liberties Union say that it threatens the freedom of the press under the American Constitution.

Film stars in the US have become increasingly combative over intrusions, particularly after the death of Diana, Princess of Wales, which they say shows the deadly consequences of rogue media.

Perhaps more significantly, there has been a huge increase in paparazzi in Hollywood and Los Angeles, as hostile reaction to the Princess' death in Europe drove many to lucrative new markets in the US.

American courts have become increasingly sympathetic to public figures who prosecute intrusive photographers. In February, two photographers were sent to prison for three months after hounding Schwarzenegger and his wife Maria Shriver.

The paparazzi had chased Schwarzenegger and his pregnant wife shortly after his heart surgery last year as they drove their three-year-old son to the nursery. The two men, a stills-photographer and a video cameraman, were working for

Splash, an agency based in Santa Monica and founded by expatriate Fleet Street tabloid journalists. One of the lawyers for the men later described the verdict as "movie star justice."

Last July another film star, Alec Baldwin, was ordered to pay a photographer $4,500 (pounds 2,720) after a fight outside his house. The case was seen as a moral victory for Baldwin, who is married to the actress Kim Basinger. The photographer, whose glasses were broken in the scuffle, had claimed $85,000 (pounds 53,000) for medical treatment and loss of earnings, but a court held him partially responsible for the incident.

California's film stars have exerted enormous influence to secure the new laws. Among those lobbying a committee of state lawmakers was Barbra (sic) Streisand, who said she was "a prisoner in my own home."

The actress Sharon Stone, who married a San Francisco newspaper editor earlier this year and is best known for her role in the film Basic Instinct, said she was "a citizen who cannot safely walk down the street, safely drive alone in her car or share a movie date with her family on a Sunday afternoon."

Tom Hanks, a three-time Oscar winner, said: "Ordinary family events such as shopping for shoes in the neighborhood has often found our family being pursued by professional photographers who are specifically seeking a picture of myself with my children."

Many news organizations see more than a hint of hypocrisy from stars who are more than anxious to court publicity when it suits them, especially if there is an expensive movie to promote.

Even publications which do not use paparazzi photographs have said the law is a threat to free speech. Tom Newton, the head of the California Newspaper Publishers' Association, said the bill would "give those who would punish the press for aggressive news-gathering a new tool."

"It is an undeniable fact that if newspapers are doing their job, people are going to become upset," he said.

Despite the objections, there is every sign that the California law will become the model for similar legislation before the American Congress this autumn.

A bill to jail or fine photographers who "persistently" follow celebrities was proposed by Sonny Bono, a Congressman and former pop star, who died during a skiing accident this year. It is being promoted by Mary Bono, his widow, who succeeded him in Washington. Other proposals include a ban on the sale of "visual or auditory enhancement devices"—microphones and telephoto lenses.

James Langton

Three times in recent months, the supervising judge of the Los Angeles Superior Court's criminal division has taken the highly unusual step of sealing all documents in high-profile cases—the latest involving director Steven Speilberg.

A man newspapers say has been charged with stalking filmmaker Steven Speilberg planned to handcuff and rape his victim, according to court papers released Wednesday. The papers—transcripts of a grand jury hearing—refer to the alleged victim only as "John Doe," although it has been reported that he is the Oscar winning director.

Media reports have accused officials of giving Spielberg special treatment by keeping his name secret and sealing all documents.

Two months after the county grand jury indicted Jonathan F. Norman, 31, for allegedly stalking Spielberg, both the indictment papers and the transcripts of the grand jury proceedings remain under seal. Further, at the request of the district attorney's office, Judge John Reid removed Spielberg's name from the indictment after it was issued and replaced it with "John Doe", a source said.

Deputy district attorney Rhonda Saunders said the case was "not about celebrity. This was about someone who was frightened, frightened for his family and frightened for himself."

The sealing orders on grand jury transcripts have been agreed to by both the district attorney's office and the public defender's offices.

"It's extremely unusual to do any of this," said Santa Monica defense attorney Charles English, whose clients have included Jack Nicholson, Alex [sic] Baldwin and Robert Downey Jr.

Without commenting on the merits of the actions to date, English said they do reflect part of a growing trend toward secrecy in what once were routine, though still sensitive proceedings.

And in this particular case, he said: "It certainly gives rise to the notion Steven Spielberg is getting some special treatment by the system. Knowing Judge John Reid, I don't think that is the case. But when the case finally becomes public, that is something the courts and the D.A.'s office will have to answer. Why was the secrecy deemed necessary?"

The authorities sealed the evidence, as is usually the case in the secret proceedings of grand juries, but it has now been made public because of a legal petition by the media. Spielberg has declined to discuss the matter, but stalking has now become a significant fear among Hollywood celebrities.

The release of the court records—which date from October—followed a challenge from the Los Angeles Times and other media organizations over the secrecy surrounding the investigation. They argued that the secrecy was unwarranted and that Spielberg had been given special treatment because of who he was. They also noted a growing tendency for celebrities to be given anonymity in court cases. The judge described the secrecy in this case as "overkill" and ordered the records unsealed.

A HOMOSEXUAL stalker with a fixation on Steven Spielberg was found near the director's house armed with a knife, and carrying handcuffs and adhesive tape, authorities in Los Angeles have disclosed.

Jonathan Norman's letters, verbal threats and unwarranted visits were not aimed at a former wife or girlfriend, nor even at a woman he wanted to date. Instead, the 31-year-old body-builder and would-be screenwriter spent two months last summer stalking another man: film producer and director Steven Spielberg.

LOS ANGELES—A violent ex-con with sexual fantasies about Steven Spielberg stalked the superstar director while armed with razors, duct tape, and handcuffs.

A 31-year-old former body-builder is accused of stalking Steven Spielberg last year because he was sexually fixated on the famous film director.

An unemployed man who prosecutors said wanted to handcuff and rape filmmaker Steven Spielberg was convicted yesterday of stalking the famous movie director.

Jonathan Norman, a body-builder and would-be actor who was arrested near the filmmaker's home, will be sentenced at a later date.

On July 11, the guard, an off-duty police officer, again saw Norman's four-wheel drive vehicle, which was in the

driveway facing the gates, as if Norman was gauging how to crash them. As the officer approached, Norman fled, but a neighbor found him with his "eyes on fire" in her back garden, holding a curtain rod over his head "like a javelin."

Police arrested Norman last July outside the director's gated mansion in a Los Angeles seaside suburb, where the director lives with his wife, the actress Kate Kapshaw [sic], their seven children and his mother. Mr. Norman was carrying a "rape kit", including handcuffs and duct tape. He had backed his 4x4 vehicle in, with the apparent intention of crashing the gates.

Mr. Norman was arrested in July near the Spielberg home in the Pacific Palisades area of Los Angeles carrying a list of the names of Mr. Spielberg's seven children and a "rape kit", containing a knife blade, razor blades, tape and handcuffs. In his car were two more pairs of handcuffs.

"I was concerned that he brought so many handcuffs. . . I could only speculate that what he wanted to do to me, he might also want to do to someone else in my family," Spielberg said, taking his one and only glance at the defendant letting out a deep breath.

Police also discovered a book with a shopping list of tools they say Mr. Norman planned to use on Mr. Spielberg, including three eye masks, three sets of handcuffs, four pairs of nipple clips, and three dog collars.

Specifically, authorities charge, Norman first attempted to enter Spielberg's property on June 29, driving a sport utility vehicle. But he was turned away about 6 p.m. by off-duty Los Angeles Police Det. Steve Lopez, who has worked for 10 years for a private security company that guards Spielberg's residence. Lopez, who was the first witness called Thursday, also was one of about 20 people summoned before the grand jury, most of them police officers or private security guards.

Their testimony, contained in a 209-page transcript of the grand jury proceedings, depicts Norman as a sexually obsessed stalker who used a variety of stories to try to gain access to Spielberg, including telling others that he was the director's adopted son.

On July 11, Lopez testified, he again saw Norman just outside the property. This time, however, Norman was driving a blue Land Rover that was almost identical in color and style to one driven by Spielberg's wife, actress Kate Capshaw, according to authorities.

Spotting Norman outside the property, the officer said he first called the police and then watched as Norman backed the large vehicle up against the huge front gates of Spielberg's residence as if to find out how much force would be needed to break through them.

Later, authorities allege, he abandoned the vehicle and ran through the neighborhood in an unsuccessful attempt to escape. One resident told the grand jury that she saw Norman in her back yard, his "eyes on fire." At the time, she testified, he also was holding a drapery rod over his head "like a javelin."

Mr. Norman discovered the filmmaker's address by buying a $4.50 tourist map of stars' homes and spent a month watching the mansion. He failed to gain admission by telling security guards he was a worker there.

He also carried a diary with the names of Mr. Spielberg's family and business associates. Prosecutors claimed that Norman was sexually obsessed with Mr. Spielberg, and planned to rape him and even make his wife, the actress Kate Capshaw, watch. The court heard that he went to the Spielberg estate at least four times, once driving a Land Rover similar to Ms. Capshaw's, and told people he was the director's adopted son.

Police officers and private guards told the grand jury that Norman was found lurking outside Spielberg's home several times in late June and early July and was sent away.

During the trial, several police officers testified that Norman, who was caught lurking near Spielberg's Pacific Palisades, Calif. estate, told them he planned to rape the movie director for a sexual "turn-on." Spielberg was in Ireland filming a movie at the time of the incident.

Once, Norman told a guard he worked for Geffen. Another time, he said he was Spielberg's adopted son.

On the evening of July 11, he was seen running through one of Spielberg's neighbor's yards. When police caught and frisked him, they found duct tape and handcuffs tucked in his pants, and a box cutter in his pocket.

Norman had been using methamphetamine, or speed, and had not slept for three days, police said.

The evidence states that Norman, aged 31, had been on a sleepless, three-day methamphetamine ("speed") binge when he was arrested after several visits to the Spielberg home in a private estate in the seaside community of Pacific Palisades.

Citing Norman's bizarre behavior and evidence of a methamphetamine binge before his arrest, defense attorney Lawson said he found it unconscionable that his client could be imprisoned for decades.

Norman should have been treated as a drug abuser—he purportedly was on a crystal methamphetamine binge at the time of his arrest—with psychiatric problems but not a criminal, the lawyer added. Lawson said Norman was "delusional" and believed if he could meet Spielberg he could get into show business.

"I would characterize my client as being mentally ill and being mentally ill you cannot leapfrog into saying that that person is naturally a predator, or an evil person or a bad person," Lawson said. He said he did not pursue an insanity defense for Norman because it is too difficult to be supported under the law.

And the part-time writer and actor's efforts to reach Spielberg, Lawson said, were part of a "delusional, drug-induced" belief that if he could get close enough to the director, he could succeed in the film industry.

Norman's lawyers argued their client was not stalking Spielberg and never intended to rape him. Instead, they said, he simply wanted to get the attention of the Oscar-winning director in hopes of getting a job with his studio.

But Norman's companion, Chuck Markovich, an unemployed accountant, testified that Norman had mused on raping Spielberg. He went to act out a screenplay, to be recorded on the security camera, Mr. Markovich said. Then Spielberg would say, "This guy is creative," and Norman would break into movies.

Norman allegedly told his best friend and former lover that he viewed the director both as a "father figure" and as a rape target.

"He did say he wanted to, that night, go there to rape him," Charles Markovich testified.

Markovich said Norman even confided he fantasized he was the baby Tyrannosaurus Rex in the movie "The Lost World" and that Spielberg and Geffen were the father and mother in the film's dinosaur family.

Markovich also said that Norman's book contained sexually explicit pictures, including one in which he cut the head off a naked man and pasted Spielberg's head in its place.

Norman's lover, Charles Markovich, told the grand jury: "He is schizophrenic."

Norman, 31, was found guilty in March of lurking outside the award-winning director's Pacific Palisades estate in July armed with handcuffs, duct tape and a box cutter. Spielberg was in Ireland at the time. After his arrest, Norman told cops he wanted to rape the director.

The UCLA graduate had in his possession sets of handcuffs, duct tape and box-cutting type razors that Saunders dubbed "a rape kit." Norman was also found with a day planner that included a list of sex toys he wanted to use on Spielberg and a cutout picture of Spielberg's face taped to a picture of a younger man's body.

Norman purportedly said he planned to restrain Spielberg's wife, actress Kate Capshaw, and make her watch while he sexually assaulted the director.

He was apparently intent on raping the director and had written details about the Spielberg family, and a list of items to obtain that included eye masks, chloroform and dog collars.

At the time of his arrest last year, according to testimony, Norman had handcuffs, duct tape and a box cutter knife. Further investigation turned up a day planner that not only contained details about Spielberg and his family but also a bizarre shopping list that included eye masks, dog collars, and chloroform.

Norman was arrested on July 11 when Spielberg happened to be in Ireland working on a film. But police believe that Norman, who had tried to enter the estate near the end of June but was turned away by a security guard, posed a danger to the Spielberg family.

Norman was arrested at the star's Pacific Palisades home with three sets of handcuffs, duct tape, a razor blade and pictures of Spielberg's family.

Earlier, Spielberg's security adviser, Rick Vigil, testified that he asked Norman "what he was going to do with the handcuffs and the duct tape" in a jail house interview after Norman's arrest on stalking charges.

Norman told him "he planned on using them to tie up Mr. Spielberg and rape him," Vigil said. He said he explained to Norman that "Mr. Spielberg was a heterosexual and would not be interested in such an encounter."

"He (Norman) told me he had an obsession. . . He said he believed that (Spielberg) wanted to be raped by him," police Detective Paul Wright told the secret panel in October.

Prosecutors said Norman was sexually obsessed with Spielberg and went to the filmmaker's gated estate on four different occasions, the last time with a "rape-kit" consisting of handcuffs, duct tape and a knife.

He also had a notebook containing a list of sex toys such as nipple clips he allegedly wanted to use to rape Spielberg, deputy district attorney Rhonda Saunders said during a two-week trial.

Saunders also contended that Norman wanted to handcuff Spielberg and his actress wife, Kate Capshaw, and force her to watch as he sexually assaulted the filmmaker.

The man, Jonathan Norman, was detained in July after a chase through the elite Los Angeles suburb of Pacific Palisades. Police found a Jurassic Park sticker, a videotape of the film E.T. and cut-out pictures of dinosaurs in his car. He was on parole after serving a prison term for assault. A police detective, Paul Wright, said Norman told him he had an obsession: "He believed that Spielberg wanted to be raped by him."

Norman, 31, carried a black book filled with pictures, personal data about Spielberg and cutouts from "Jurassic Park," one of Spielberg's many blockbusters.

Norman's black book contained a shopping list for the intended crime that included "eye masks, three sets of cuffs . . . and three dog collars," Wright testified.

In addition, Norman had scribbled the names of Spielberg's children, noting two were adopted and that son Max was "by ex-wife Amy Irving." It also included the names of Spielberg's three sisters, his mom, and the names of his DreamWorks SKG business partners Jeffrey Katzenberg and David Geffen, with the notation "learn more about Geffen."

The obsession continued after his arrest, and in January, prison guards found papers in his cell that included the names of Mr. Spielberg's family and a map of his neighborhood marked with a heart and the initials "S.S."

Mr. Norman had also written the names of some of Mr. Spielberg's friends and business associates, including actor Tom Hanks and his partners in the DreamWorks SKG film studio, David Geffen and Jeffrey Katzenberg.

Spielberg, who won an Oscar in 1994 for Schindler's List and also directed the Jurassic Park films, testified before a grand jury last summer about the stalker, Jonathan Norman, who is to go on trial next month for stalking.

The director said: "He was on a mission. Thank God he was caught—he would have completed his mission. I really felt my life was in danger."

SANTA MONICA, CA. A visibly shaken Steven Spielberg yesterday glanced quickly across the courtroom at the muscular man who had stalked and plotted to kidnap him and said he would "live in fear" if the man ever gets out of jail.

The dark-haired Norman, who was dressed in bright yellow and blue jail garb, was wired with an electric shocker device in case he misbehaved in court. But he remained calm and looked sad when the movie mogul asked the judge to throw the book at him.

Norman was wired with an electronic shock device, hidden under his jacket, to prevent him from lunging at Spielberg during his testimony. The device, controlled by court officers, was not used.

"I ask that Jonathan Norman be given the maximum sentence. May I please be excused from court?" a nervous Spielberg asked at the conclusion of his statement.

The judge dismissed Spielberg, and he left with his head in his hands, flanked by several private guards and assistants.

Norman's lawyer, Charles Kreindler, begged for leniency, asking the judge to negate one or both of Norman's previous felony convictions so he wouldn't face California's mandatory 25-years-to-life sentence as a three-time felony convict.

Before his July arrest for alleged stalking, Norman was convicted of assault with a deadly weapon for a March 1995 assault on a group of Jewish immigrants in Santa Monica.

Norman, who pleaded no contest to the assault charge, was sentenced to three years in state prison and was released shortly before his arrest for allegedly stalking Spielberg, a Pacific Palisades resident.

Norman is being held on $1 million bail pending his next court appearance in the stalking case Jan. 13.

At the time of his arrest, he was on parole for two accounts of assault with a deadly weapon, including a March, 1995 attack on a group of Jewish immigrants.

In 1995, Norman pleaded guilty to two counts of assault. He allegedly plowed his red Jeep Wrangler into a group of Russian immigrants walking down a Santa Monica alley and then beat a man and woman.

Norman could face 25 years to life in jail under California's three strikes law because the jury, in a separate hearing after the verdict was announced, decided it was his third felony offense. He had been convicted and jailed for two previous accounts of assault stemming from the same incident when he started a fight with a group of Russian Jews as they were crossing a street.

Because Norman pleaded guilty two years ago to two accounts of assault, the jury went back into deliberations yesterday on whether he should qualify for the harsh sentences prescribed by the "three strikes" law—a minimum of 25 years. Even without it, Norman faces a substantial jail term.

The jury in Santa Monica found Mr. Norman guilty after deliberating for little more than three hours.

They had heard Mr. Spielberg testify that he and his family still live in lingering, daily fear of Mr. Norman, who boasted to police that he wanted to rape Mr. Spielberg while the director's wife, actress Kate Capshaw, watched.

Notified in a telephone call from his longtime attorney and friend that Norman had been arrested, Spielberg said he was first stunned and then terrified over the alleged assailant's plans to attack him.

"I reacted to the information at first with disbelief . . . and then I became quite frightened," Spielberg told the seven-woman, five-man jury.

The verdict, reached in less than four hours, sets the stage for an April 22 sentencing that could send Jonathan Norman to prison for 25 years to life.

The jury of six men and six women left the courthouse without discussing the case with reporters.

Jurors reached their verdict after four hours of deliberations on Tuesday, but the reading of the verdict was delayed until yesterday.

Norman, who did not blink when the verdict was announced, has been in custody in lieu of $1 million bail since he was arrested last summer outside Spielberg's Pacific Palisades estate for violating parole. The violation arose from a 1995 Santa Monica case in which Norman pleaded no contest to assault after driving his car toward a group of tourists during an argument.

The judge then sentenced Jonathan Norman to 25 years to life in prison, the maximum penalty allowed.

The sentence in Santa Monica, California, means Jonathan Norman, an unemployed body-builder, aged 31, cannot get parole until he is 56, and he could remain behind bars for the rest of his life. He was sentenced under California's "three strikes and you're out" rule, which is intended to remove career criminals from society.

In sentencing Norman, Judge Steven Suzukawa said: "I find his behavior obsessive and frightening. I think he does present a danger to society."

Norman must serve 25 years before he is eligible for parole.

Spielberg seemed uneasy as he stood at a podium about 10 feet from Norman and read quickly from a type-written victim-impact statement.

"Had I encountered Mr. Norman, I genuinely believe I would have been raped or maimed or killed. . . The thought of him on the street is beyond frightening to me. If he's out on the street, I'll live in fear that he's prowling my neighborhood," said Spielberg.

But as his client sat quietly, sometimes scribbling on a note pad, deputy public defender John C. Lawson II

portrayed Norman as a fanatical follower of Spielberg whose sexual fantasies, however bizarre, were never directly conveyed to the director.

"As far as I know, our legislators have not made it illegal to be weird, to have strange thoughts, to have strange fantasies," Lawson told the courtroom of Steven C. Suzukawa.

"Stalking," he added, "is not a crime about thoughts."

"I'm absolutely elated," Deputy Dist. Atty. Rhonda Saunders told reporters after the verdict was announced. "Number one, it shows that in California we can protect victims of stalking. And number two . . . that our stalking law really, really works."

California became the first state to institute an anti-stalking law in 1990. Celebrity stalkers range from cold-blooded killers to love-sick losers. Most often they are male, and their victims are female. Male stalkers are most prone to want to destroy their targets, or commit a violent act as part of a game plan of gaining more fame or notoriety.

JONATHAN Norman, the homosexual bodybuilder facing life in prison for stalking the movie director Steven Spielberg, is part of a growing trend of obsessive harassment in America. Every year, hundreds of cases of stalking—perhaps the greatest fear for a Hollywood star—are investigated by Los Angeles police.

Male stalkers tend to be violent and predatory, driven by a desire to control their victim.

Many Hollywood celebrities have been stalked, according to the criminologist Mike Rustigan, a university professor who teaches a course on stalking to police in California.

He said: "It is an increasing trend because of America's celebrity-obsession and the increasing isolation of many individuals."

Little so far has come out about Jonathan Norman's thinking in pursuing Spielberg. "He probably idolized Spielberg and wanted a piece of that," said Rustigan, adding that his intent to rape must mean that he also wanted to punish and humiliate the film director for his fame.

"In effect, raping Spielberg would be an attempt to bring him down. It's not a love obsession."

poster (back) 1999
Courtesy Patrick Painter Inc., Los Angeles

The Sunday Telegraph

Hollywood wins fight to tame paparazzi

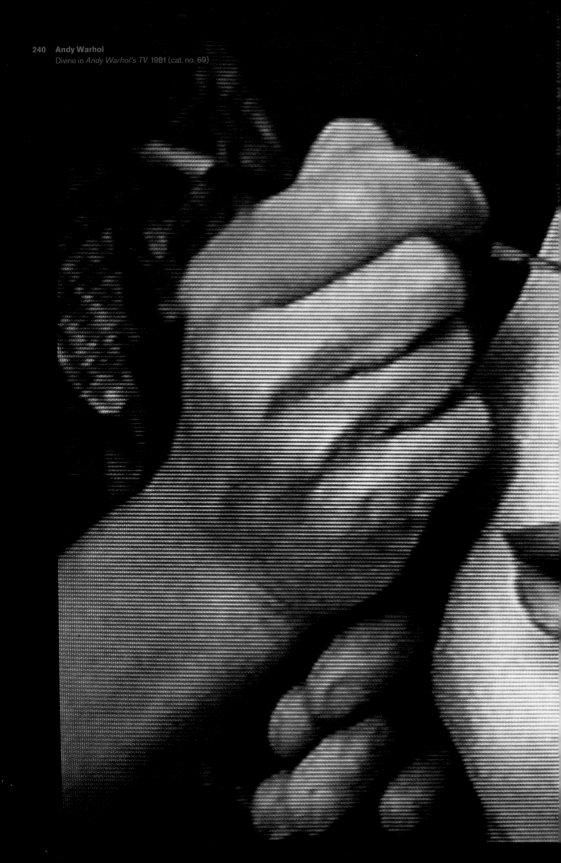

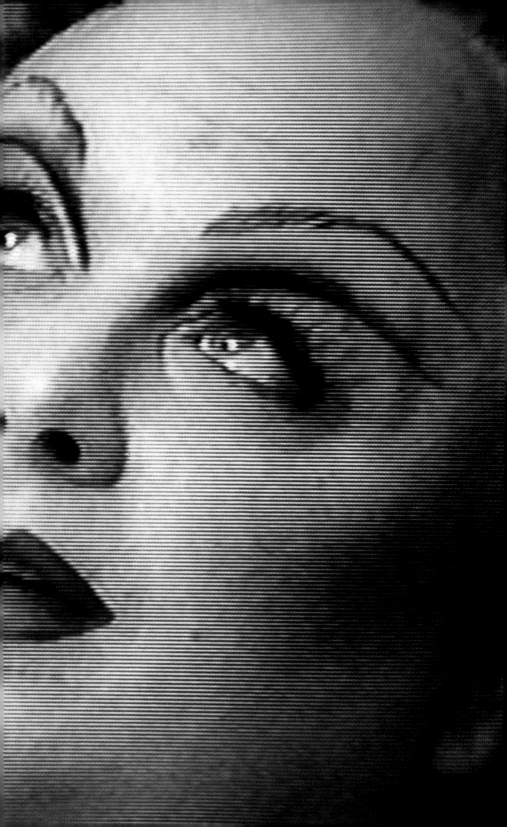

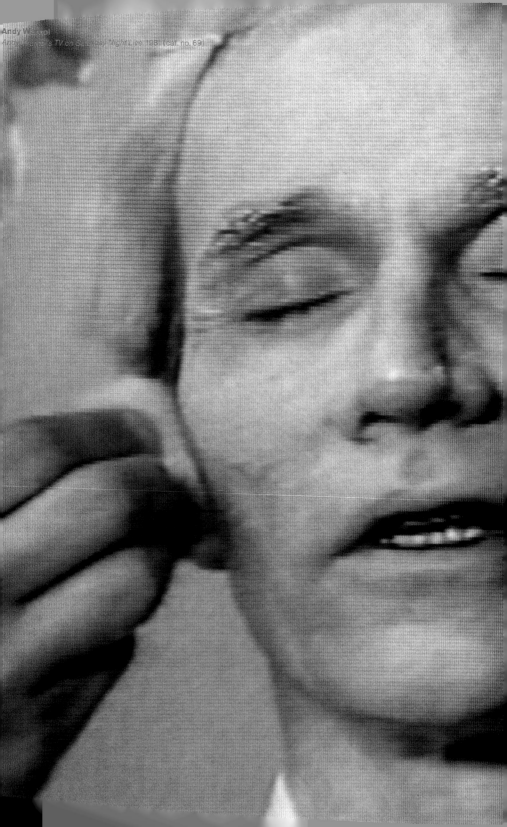

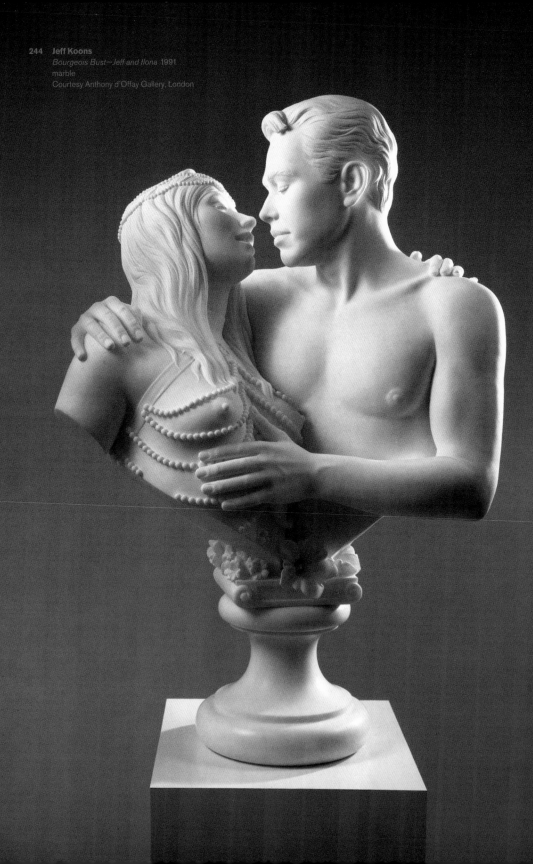

Celebrity, Democracy, Power, and Play
Joshua Gamson

It is weird, although not unprecedented in American history, to know the kinds of beneath-the-facade, behind-the-zipper, off-camera details we have come to think we know about an American president. Knowing how and where the President ejaculated, and on whose dress, and what color that dress was, and the things he did with a cigar and a telephone, certainly makes it difficult to maintain the heroic, look-up-to-me image typically taken as presidential: a person who is different from the rest of us, without the ordinary foibles that trip us up, who has risen to his position because his character and talents are extraordinary, a person who is what he claims to be, famous because he deserves to be. One can take the lesson that presidents—and most politicians, for that matter—have finally and fully become celebrities, more suited for irreverent tabloid headlines, talk-show joke lines, and tell-all bestsellers than for the reverent history books, as famous for their entertaining lives as for their roles as superpower leaders.

For many cultural critics, this seems just one more step on the long decline into the celebrification of American culture. Once upon a time, the story goes, we had heroes. They did amazing things and became famous for the great things they did. Then, with the growth of electronic media, heroes began to be edged out by celebrities, manufactured pseudo-heroes known, as Daniel Boorstin put it, for their knownness.[1] Merit and fame became detached.

While it is tempting to see the history of fame in this light, historians like Leo Braudy have shown that action and fame, merit and celebrity, have never been simply and tightly aligned.[2] In fact, especially in the twentieth century, American celebrity is more accurately seen as the story of two stories. In one, the great and talented and virtuous and best-at rise to the top of the attended-to, aided perhaps by rowdy promotion, which gets people to notice but can do nothing to actually make the unworthy famous. Fame—from the Latin for "manifest deeds"—is in this story related to achievement or quality. In the other story, the publicity apparatus itself becomes a central plot element, even a central character; the publicity machine focuses attention on the worthy and unworthy alike, churning out many admired commodities called celebrities, famous because they have been made to be. Contrary to popular mythology, these two stories have actually coexisted for more than a century, usually in odd but harmonious combinations. Over the course of this century, however, the balance between them has shifted.

As technology and publicity apparatuses grew, they became more and more publicly visible, integrated into discussions of celebrity. This visibility increasingly posed a threat to the reigning myth that fame was a natural cream-rising-to-the-top phenomenon. In the first half of the century this threat was largely controlled. It was not entirely muted, however, and a number of changes in the discourse developed, seemingly defusing the challenge. Audiences began to be invited inside the "real lives" of celebrities. Texts affirmed meritocratic fame by "training" audiences in discerning the reality behind an image and by suggesting that publicity apparatuses were in the audience's control. Beginning around 1950, changes in the celebrity-building environment—the breakdown of studio control, the rise of television, a boom in the "supply" of celebrities—significantly destabilized what had been a tightly integrated celebrity system. The publicity enterprise then began a move toward center stage in the celebrity discourse, with man-

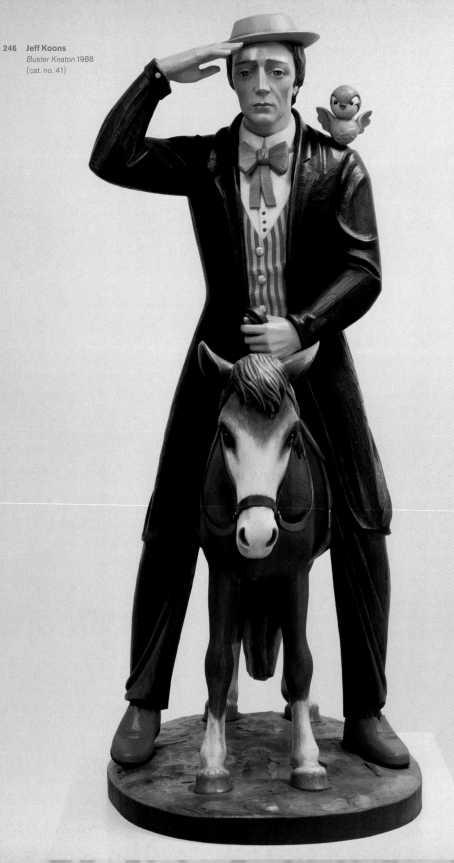

Let's Entertain
Life's Guilty Pleasures

Celebrity, Democracy,
Power, and Play
Joshua Gamson

247

ufacture becoming a serious competitor to the organic explanation of fame. A new coping strategy began to show itself in texts: audiences were now invited not only behind the image but also behind the scenes to image *production*. The relationship between image and reality gradually became less a problem than a source of engagement. Previously flattered as the controllers of the direction of publicity spotlights, audiences were now flattered as cynical insiders to the publicity game.

As the logic of entertainment celebrity has come to dominate other social domains—politics, most notably—the peculiar, strained relationship between the discourse of deserving heroes and that of artificial celebrities has moved with it. And so, therefore, has people's engagement with political celebrities. The lessons, I think, are considerably more complicated than the replacement of genuine political heroes with cheesy political celebrities.

Celebrity in Politics
In the [1990] film *Reversal of Fortune*, the character of Klaus von Bulow, about to go on trial for attempting to murder his own wife, is offered the best table in an elegant Newport restaurant. In America, he dryly notes to the character of lawyer Alan Dershowitz, fame rather than class gets one such privileges. He overstates the case, of course, but the point is undeniable: celebrity is a primary contemporary means to power, privilege, and mobility. Audiences recognize this when they seek brushes with it and when they fantasize about the freedom of fame and its riches and about the distinction of popularity and attention. They recognize it when they assert their own power to tear down the star. They recognize it when they seek to watch and be a part of the media spectacle. They recognize it when they speak admiringly of the celebrity's capacity to achieve, maintain, and manage a public image: if fame is power, the capacity to achieve it is an even greater one.

. People in diverse industries have recognized the power of celebrity. The logic and nascent production arrangements of entertainment celebrity have spread rapidly, taking hold in arenas beyond entertainment: fashion, architecture, grassroots social movements, literature, art, medicine, academia, and especially in electoral politics.[3] This much is obvious, even trite, but bears repeating: one does not need to travel farther than the supermarket to pick up on the coincidence of entertainment and political celebrity.

The July 20, 1992, *People* cover story, for instance, features presidential candidate Bill Clinton; his wife, Hillary; and their daughter, Chelsea, in their backyard in Little Rock. The article offers talk about "tag-team parenting, their bruising run for the White House and staying in love," talk about "friends, family, faith—and pierced ears." Mixed in with Bill's and Hillary's thoughts on issues such as race relations and public service are the personal tidbits usually offered on celebrities. Chelsea (first names only here) plays for a dentist-sponsored softball team called the Molar Rollers, and her dad sometimes embarrasses her by yelling too loud and jumping up and down. Bill recently took Chelsea to her first R-rated movie, *Lethal Weapon 3*. The family "relaxes by playing pinochle and other card games with Chelsea or taking her to the mall." If his house caught fire, the record album Bill would save would be Judy Collins' *Colors of the Day*. When Hillary introduced herself to Bill at Yale and asked his name, he "was so surprised that he forgot his name." Bill proposed marriage by buying a "prairie bungalow

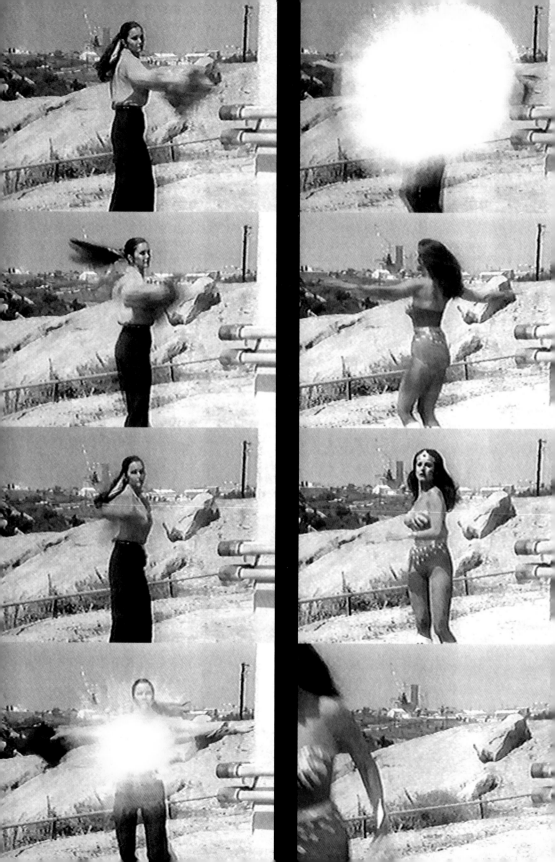

Dara Birnbaum
Technology/Transformation:
Wonder Woman 1978–1979
(cat. no. 5)

Let's Entertain
Life's Guilty Pleasures

Celebrity, Democracy,
Power, and Play
Joshua Gamson

249

with beamed ceilings and a bay window" that Hillary had admired in passing. The photos are all home shots: in the living room, outside in the hammock, Hillary playing softball.[4]

The magazine story, an "exclusive," bears a remarkable resemblance to the Clinton video produced for the Democratic National Convention by television sitcom producers Harry Thomason and Linda Bloodworth-Thomason. The video is a *People* story set to sentimental music. The story of the name-forgetting introduction to Hillary is here, along with Chelsea's description of her father's embarrassing softball cheering. Bill Clinton talks about his small-town roots, and Hillary Clinton tells how baby Bill's mother tacked playing cards on the drapes to teach him to read. Later, over shots of a jet in the sunset, Bill lets on that "sometimes, late at night on the campaign plane, I look out the window and think how far I am from that little town in Arkansas, yet [shots of small town] in many ways I know that all I am or ever will be came from there." Bill tells the nameless, invisible interviewer how amazing it was to be present for his daughter's birth; Chelsea recalls Bill speaking in a funny voice when as a little girl she would squeeze his nose. Bill and his mother, in cross-cutting interview snippets, tell the story of Bill's confrontation with the drunken stepfather ("Don't you ever, ever lay a hand on my mother again") who replaced Bill's biological father, a car-accident victim. Later, over snippets from Clinton home videos, Bill describes the "sadness in me that I never heard the sound of my father's voice or felt his hand around mine."

Beyond the get-to-know-them video, the entire 1992 Democratic convention—like most electoral campaigns—was unapologetically scripted. At the Republican National Convention twenty years prior, the revelation of such tight control was scandalous, a CNN commentator points out. This time, the Democrats not only scripted it, they distributed the script openly. "We all have a copy of the script," he tells viewers. "They're packaging a very slick show for television." The packagers are continually pointed out: the "image managers," the spokespeople, the "spin doctors." Indeed, like entertainment television audiences, convention audiences become performers. The delegates, CNN reports, "know they're props in the show, that they're really set decorations. They're wearing the funny hats, they're applauding when they're supposed to applaud, because they want to make sure it goes smoothly."[5] Spectators impersonate themselves rather than respond naturally.

In San Francisco's Mission District two weeks later, there is little to distinguish Clinton's appearance from a movie premiere. Crowd members are perched in trees, on telephone poles, on each other's shoulders, on tiptoes. The candidate's speech turns out to be quick and stale, five minutes of rehearsed stump rhetoric, performed by both candidate ("Are you ready to take your country back?") and supporters (loud cheers), not only for each other but for the cameras. But the crowd is satisfied, concerned not with substance but with a glimpse of the original being whose name and image they have seen on television and magazines and newspapers. "Now he is standing under that pole with the flag on it," tall people report to their shorter neighbors. "Now he is shaking people's hands." This is the primary level of the experience: to see in person the model for the hologram, to get an unmediated look at the original object, however distant, and report back to friends.[6] Spectators are charged as much by a glimpse of the face as by the spoken words, the policies presented, the leadership qualities.

The territory is familiar. The "politics of personality," commonly opposed to the

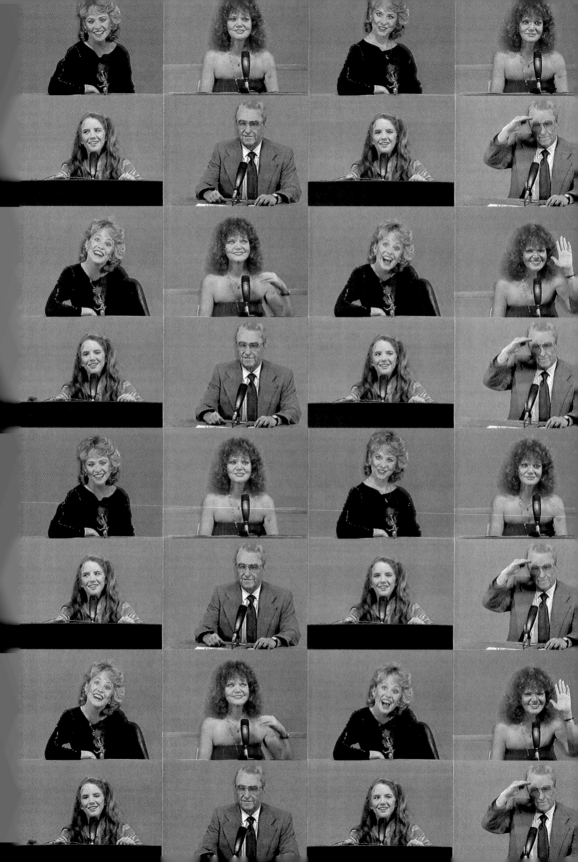

Dara Birnbaum
Kiss the Girls:
Make Them Cry 1979
(cat. no. 4)

Let's Entertain
Life's Guilty Pleasures

Celebrity, Democracy,
Power, and Play
Joshua Gamson

251

"politics of substance," has become institutionalized in contemporary American politics. "Political manipulation and its cynicism are as American as apple pie," wrote one analyst; they go back to the early republic but have intensified in recent years.[7] The production setting in which political figures come to public attention mimics, and sometimes borrows techniques directly from, entertainment celebrity. Ronald Reagan epitomized the borrowing: the actor as president and the president as actor.[8] Like entertainers, politicians are coached, handled, wardrobed, made up, carefully lit. Publicity practitioners have a central role, often building a conventional celebrity sell, inviting citizens to get to know the family just a bit. Intimacy is offered and identification fostered through accounts of personal traumas or idiosyncrasies or stories. Political figures read scripts often written by others, have questions often answered for them by others, are pitched as much on personality as on ability. They perform "as themselves" in public appearances and, more recently, on talk shows and MTV.

As in entertainment, commercial news reporters are heavily dependent on their sources and thus are professionally constrained from seriously crossing them. Like entertainment reporters, they often do not successfully resist the attempts of interested parties to replace them as information gatekeepers.[9] Reporting (the *People* story) and controlled promotion (the convention video) are often indistinguishable. Indeed, the professional and commercial conflicts are resolved in political personality texts much like they are in celebrity discourse: through the intimacy-stirring circulation of the personal details of love and pain and leisure, through gossip, through the cynic-flattering focus on image making and image management themselves, through the pragmatic mix of "man" and "myth," and the continual promise to sort out one from the other, to reveal the real person behind the image.

Yet, as Joshua Meyrowitz has pointed out, "because politics is a dramatic ritual, it is ultimately impossible to separate the thread of reality from the thread of performance."[10] Increasingly, politics is spoken in the middle-range language of semifiction. Take as an example a campaign sound bite from vice-presidential candidate Al Gore: "George Bush and Dan Quayle trying to use oil re-refining as a photo opportunity is like Bonnie and Clyde going back to the scene of the crime wanting a free toaster."[11] Even out of context, the quote rings rehearsed, but Gore was speaking from the same makeshift stage at the same oil recycling plant where Bush had appeared weeks earlier. The battle is eerie and typical: this is my photo opportunity, Gore says, my image, my symbol, my sales pitch. Self-conscious performance is taken for granted. Candidates not only attempt to point out a mismatch between image and policy; they charge each other with poor self-symbolizing, the inability to properly choose and control their own personas. Political leaders are more than ever explicit about being at once themselves and not themselves, like happy men and women testifying on detergent commercials, at once real people and advertisements for themselves.

All of this is regrettable. A concern for the vitality and depth of political life lies behind the complaint that a celebrity culture is a debased one, an "idiot culture."[12] Critics have warned that these practices pose dangers to informed participation in decisions that matter, that democratic choices require authentic voices. There is reason for alarm. Entertainment celebrity is an imperialist phenomenon, moving into new arenas and making them over in its own image.

Let's Entertain
Life's Guilty Pleasures

**Celebrity, Democracy,
Power, and Play**
Joshua Gamson

255

Some comfort can be taken from the fact that the takeover is never complete, and the conquering armies, as we have seen, are wracked with internal conflict. Entertainment-celebrity production suggests characteristics that may make certain domains less conducive to celebrity logic: a heavier dependence on a display of skills that cannot be easily mimicked or manufactured, a lesser dependence on the visual, an institutional autonomy from the mass media. These characteristics can be nurtured, the places where "the electronic ensemble does not penetrate" (local cultures, for example) can be protected.[13]

Politics, however, is not one of these places.[14] The picture of entertainment celebrity presented here has been continually revised to include its complexities and conflicts, a landscape that depicts much of the terrain of public life to come. It is a strange world, one in which "the oppositions that traditionally organized both social life and social critique, oppositions between surface and depth, the authentic and the inauthentic, the imaginary and the real, the signifier and the signified, seem to have broken down."[15] It is a cynical world as well, one in which people are commodified for financial or ideological profit.

Horror and dismay at the "celebrification" process are appropriate, if tired, responses. Shock and surprise are not. The entertainment-celebrity model takes over because it is a rational one, one that meets professional and commercial needs. The blurring of fact and fiction is not a conspiracy but a practicality; the uncoupling of merit and notoriety, hardly new or complete but certainly very advanced, is the result of the routine pursuit of profit.[16] That entertainment celebrity colonizes arenas beyond it is predictable. A society so heavily dependent on mediated information invites attempts to control that mediation; a society in which so many bits of information compete for attention invites attempts to encapsulate, dramatize, emotionalize. The spread of rationalized celebrity culture is perhaps inevitable, especially in the political arena, where consumption (in this case, votes) is so similarly affected by attention. However much one might wish it all away, however much one might want to keep celebrity logic out of the political realm, however much one might want to do away with television and its demands, there is no question of turning back. This is our situation.

Refusal, Withdrawal, Gullibility, Amusement

As politics adopts celebrity-industry practices, it also adopts its seams and its familiar cues. George Bush, for example, was reported to flub his answers when questions at a photo opportunity were asked out of order, when the prepared script was not followed.[17] Citizens continually encounter the botched lines, the handlers, the gossip, the coaches, the makeup artists, the *People* covers, the interview strategies, the talk-show appearances, the personal-life stories, the photo opportunities. The audience for politics is converted into an audience for celebrity. If we consider the positions thus triggered, the situation seems bleaker still.

At one extreme is the traditional believer. This position deflects reasoned evaluations of policy in favor of fantasy or personal-identification relationships and is plainly vulnerable to political manipulation. The believing watcher reads, moreover, a partially real text as realistic: the politician is what he says he is, seeing is believing, tough talk means a tough candidate. This undeniably gullible position has always been a threat to informed

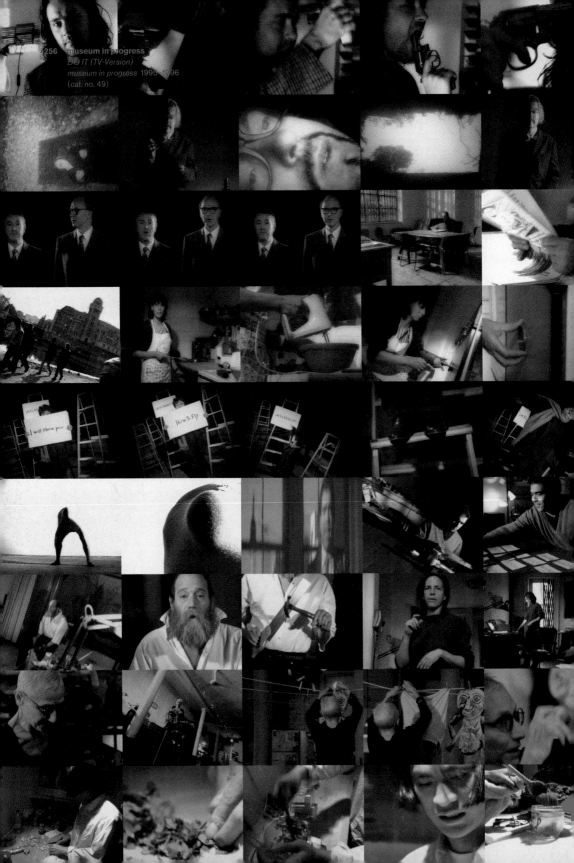

DO IT (TV-Version)
museum in progress 1995–1996
(cat. no. 49)

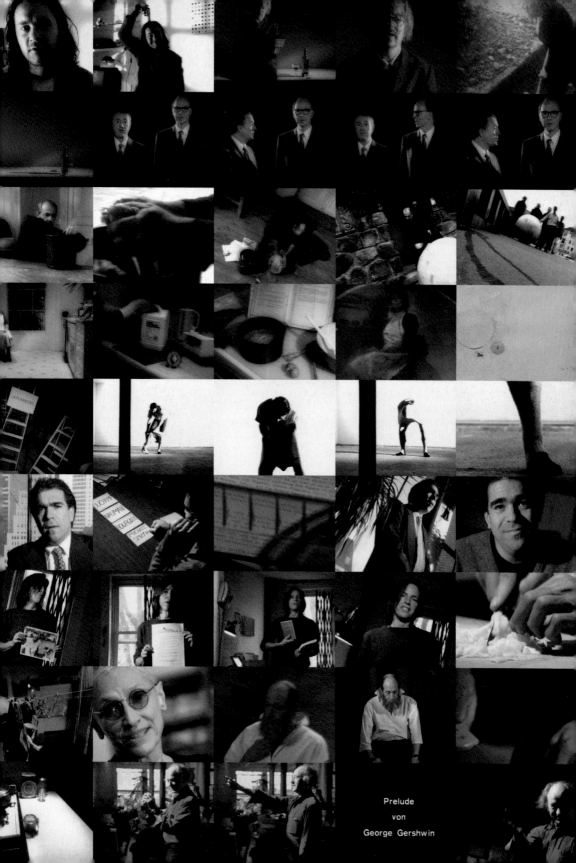

Prelude
von
George Gershwin

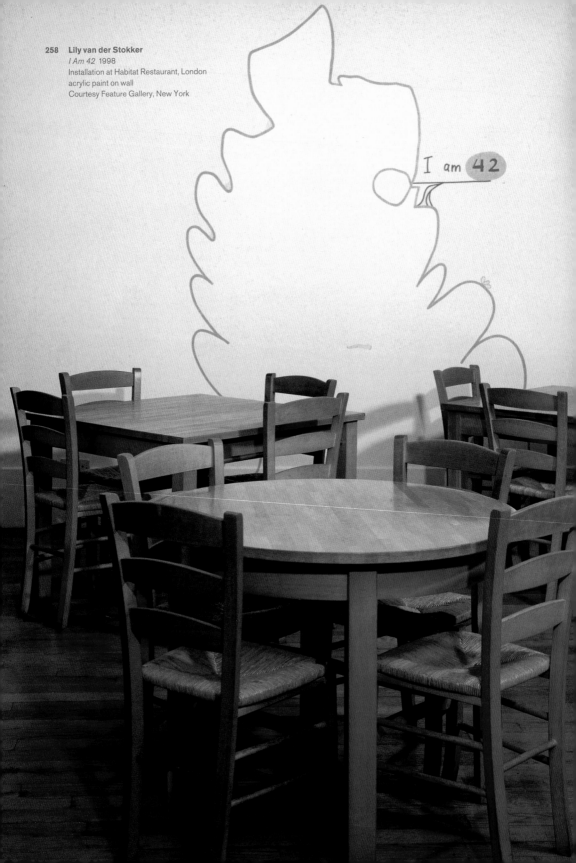

258 **Lily van der Stokker**
I Am 42 1998
Installation at Habitat Restaurant, London
acrylic paint on wall
Courtesy Feature Gallery, New York

Let's Entertain
Life's Guilty Pleasures

Celebrity, Democracy,
Power, and Play
Joshua Gamson

259

participation in public life; a dupe is a dupe. The believer position is now likely more rare, however, given the visibility of publicity-oriented activities. There is too much one must not see.

The citizen reading through the postmodern lens, at the other extreme, believes there is nothing much to see beyond publicity, "no there there." He or she is entirely cynical; exposing manipulative activities only feeds the cynicism. Political figures simply join others to be deconstructed. This is perhaps the most insidious of positions for democracy: it negates the possibility for authenticity and thus maintains the status quo; producing "the paradox of a people who fancy themselves tough but are in practice passive,"[18] it "is a form of legitimation through disbelief," a "mocking attitude that is in fact the opposite of critical."[19] All is performed. Political participation and the search for authentic voices are seen as ludicrous endeavors. A postmodern engagement in political celebrity is fundamentally disengaged from politics.

This position in pure form, we have seen, is also very rare. Celebrity watchers typically form a wide middle between these two positions; they are both cynical and believing.[20] Indeed, this broad middle makes sense; celebrity speaks not in lies but in a different language of neither lies nor truth. Celebrity watchers in one common middle-ground interpretive position believe in some because they are incredulous about most; "no one believes in truth like a person surrounded by liars." Spotting evidence of manipulation is adopted as self-flattery: I can find my way to reality through the maze of images. Even when they do not quite believe, second-order believers settle on a truth of suspended disbelief, putting the "postmodern savviness about contrivance" to use in the search for "solid, reliable grounding," a "channel of truth," a "domain of the unretouchable."[21] As Todd Gitlin has pointed out, the urgency of the need to get beneath the surface "can lead us astray, as the cultural industry and its attendants learn to exploit our old-fashioned, linear, unhip longings. That the taste for truth persists in a society supersaturated with fluff doesn't mean that we are going to get a culture with historical depth."[22] As this position is triggered, authenticity does remain pursued and salient. Skepticism and publicity literacy do not disengage from celebrity politics, but neither do they protect from the dangers to informed democratic participation.

Perhaps the most daunting prospect of all comes from the large portion of celebrity watchers whose game playing is fed by the revelation of celebrity production. Given the familiar cues that politics operates like celebrity, audiences are offered the chance to play their favorite celebrity games. On the one hand, gossips hold onto a kernel of rebellion, taking a position of refusal, rejecting the myths and reverence, playing games of diversion and group storytelling. Similarly, detection game players are literate in the peculiar semifictional celebrity language, engaged by the recognition that authenticity is problematic. They take pleasure in the very activity of uncovering, undoubtedly a healthy process for a democracy.

On the other hand, neither game includes an *endpoint*. That is one of the main requirements: the game is made possible and fun by the fact that none of it matters, that the outcome is inconsequential. To the degree that politics continues to be a realm that makes a lived difference, there is a tiny glimpse of hope, because the invitation to play a game with politics may be and often is rejected on the grounds that politics is not a game. But to the degree that the political arena is used by audiences for gossip and the

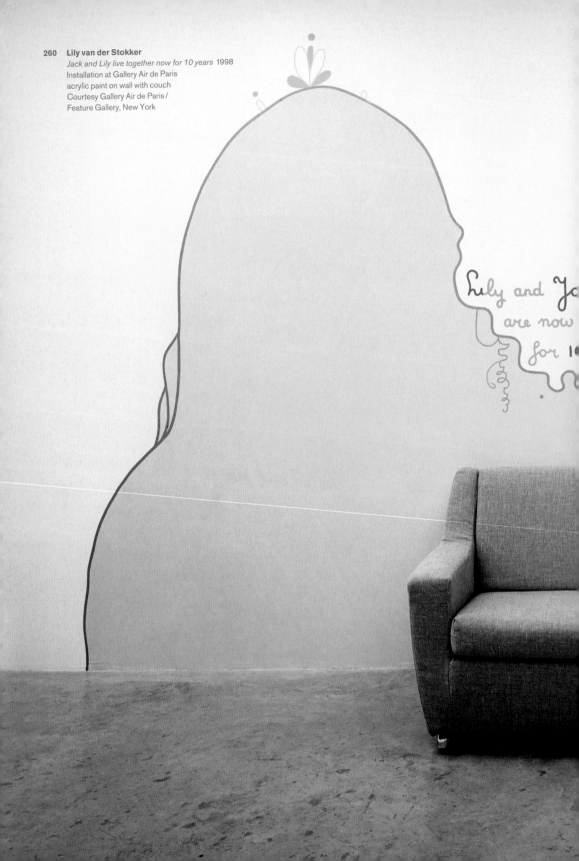

260 **Lily van der Stokker**
Jack and Lily live together now for 10 years 1998
Installation at Gallery Air de Paris
acrylic paint on wall with couch
Courtesy Gallery Air de Paris /
Feature Gallery, New York

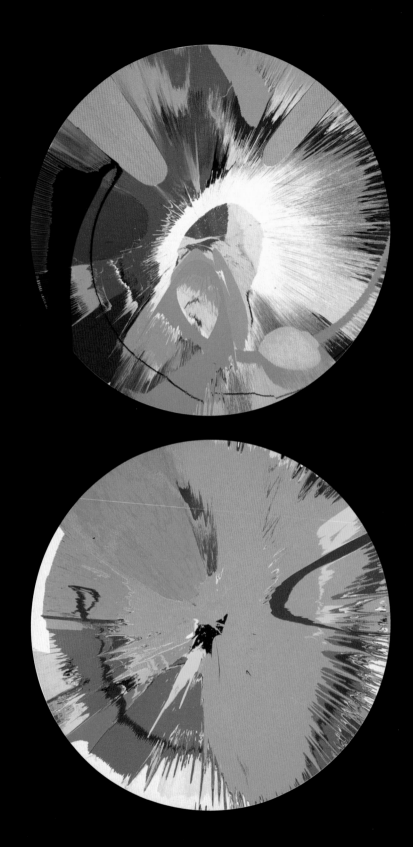

Damien Hirst

Let's Entertain
Life's Guilty Pleasures

Celebrity, Democracy,
Power, and Play
Joshua Gamson

263

top: *beautiful, insane,*
insensitive, erupting
liquid ice 1995
(cat. no. 36)

bottom: *beautiful,*
unfashionable, space-age,
red, green, yellow, blue, pink,
orange, turquoise, brown,
white, purple, magenta,
exploding rainbow, whirling
vortex, spinning hurricane,
chaotic crashing tornado,
earth shattering, exploding
planet painting (creating an
overall mood of optimistic
heaven) 1996
(cat. no. 37)

amusing image-reality play (did Bill Clinton really sleep with Gennifer Flowers, or is she a publicity-seeking liar? does the Bushes' dog Millie have lupus?), one can recognize a severe alienation from the democratic process that is very difficult to change. If these games are fun, the political arena is indeed empty, *already* experienced as having no direct impact on lives, as a commercial-cultural realm in which neither truth nor consequences matter, a realm good for nothing but play.

Hope from a Parallel World

A person can call for the revelation of the workings of the celebrity-production system, hoping to build a populace educated in the mechanics of political illusion. A person can call for the reform of political journalism, hoping to make certain that the organizational structure pushes away from rather than toward that of entertainment celebrity. A person can call for the reform of political leadership management, hoping to restrict the activities of handlers and public-relations managers. These pleas are well intentioned and deserve continued discussion, but they are also sociologically and politically naive. Promise springs not from the cries of critics for demystification or responsible journalism or political reform, but from the most unlikely of places, the place from which the dangers also spring: from the free-floating world of entertainment celebrity and its active, meaning-making audiences.

Consider two nostalgias. The first comes from a pair of writers criticizing "the unreality industry," echoing Daniel Boorstin.

We have killed off—literally, in some cases—the conditions that make it possible for heroes to emerge, to lead, to sustain, to nourish us. . . . [Society's] present idols (celebrities) no longer are worthy of the role and the title "heroes," let alone "gods," because the modern process of the deliberate manufacturing of pseudo-heroes is at complete variance with the one by which true heroes historically have arisen.[23]

The second comes from Norma, a fifty-seven-year-old retired secretary.

When I was younger, they were much more glamorous. It was so different. I miss that. Now they are all alike to me. Today almost anybody's a star. And they're all very unglamorous. They're not as big. They're not larger than life like they used to be. You know, MGM and those guys used to have the starlets dating, and they went out in furs for premieres. Those men realized that they were selling America a dream, and they made those people tow the line, and they made them disciplined, and lose weight and all that. Today you've got a bunch of very ordinary people. They're not that admirable.

The nostalgia of social criticism longs for "true heroes" and looks back to a time before celebrity manufacture and the divorce of fame from merit. In the name of democratic society, it longs for an aristocracy of the naturally deserving. The nostalgia of the glamour seeker craves the time when celebrity manufacture was more centralized and controlled, when artifice was done right. It rebels against the democratization of fame, craving an elite of the extraordinarily well manufactured. In its own way each nostalgia

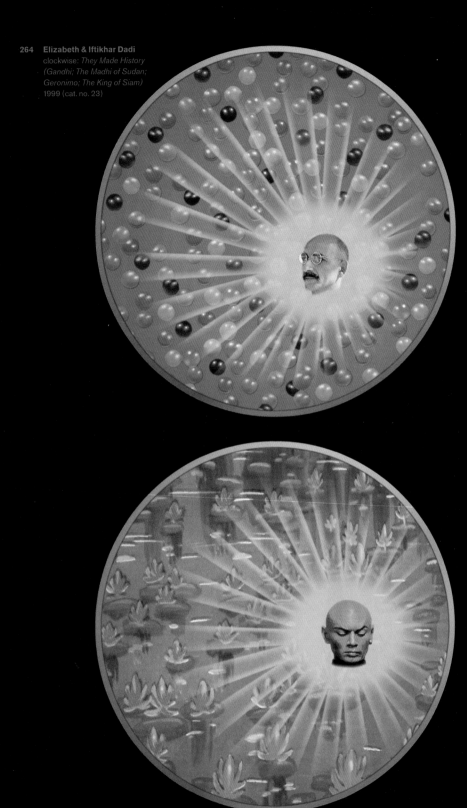

264　**Elizabeth & Iftikhar Dadi**
clockwise: *They Made History*
(Gandhi; The Madhi of Sudan;
Geronimo; The King of Siam)
1999 (cat. no. 23)

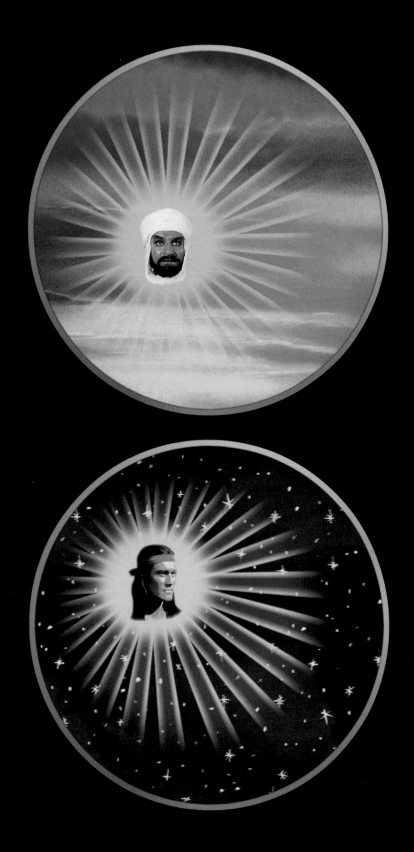

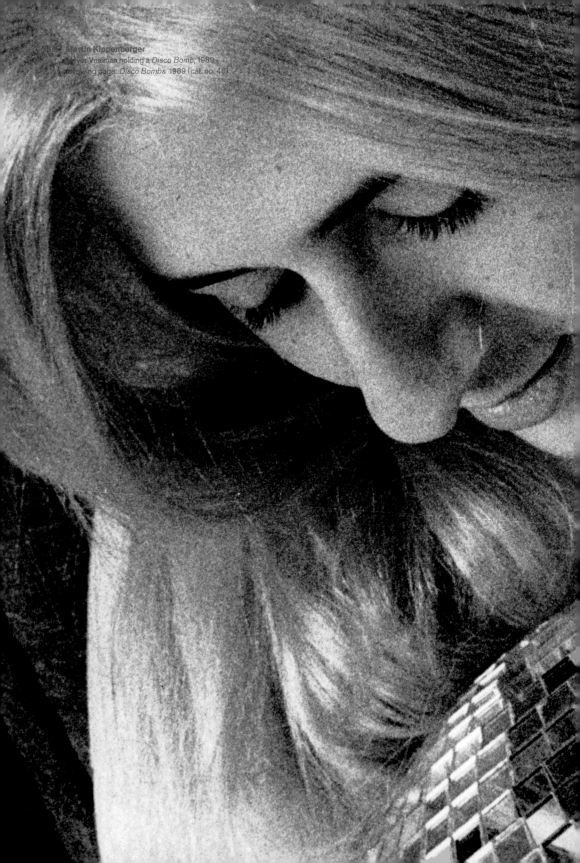

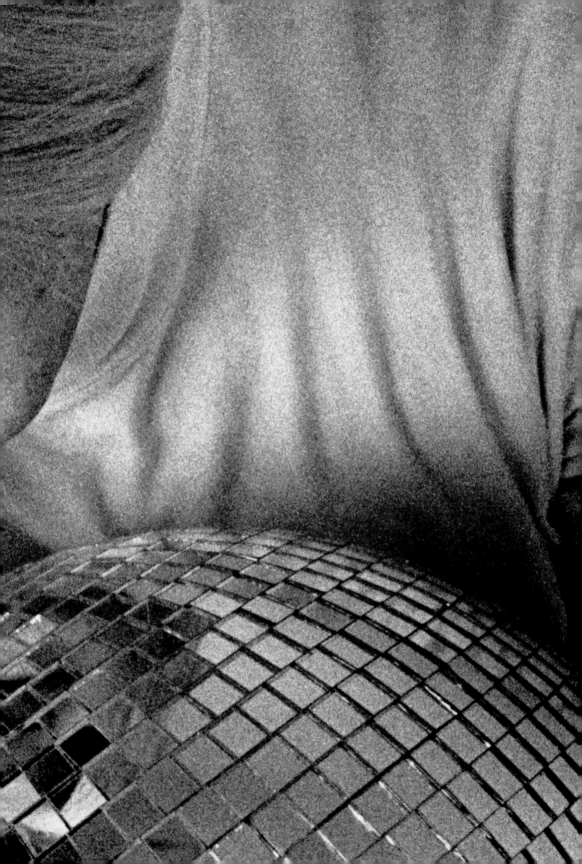

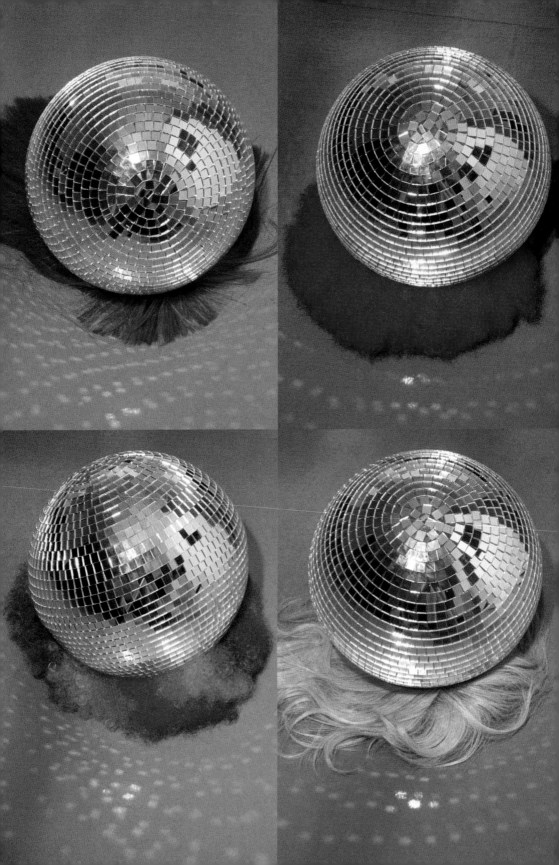

also expresses profound ambivalence about power in public life: who should have it, on what basis? They bring out as well anxieties about the relationship of commercial publicity apparatus to power: who controls it, to what end?

The fame discourse contains and provokes such ambivalence. Contemporary celebrity is composed of a string of antinomies: public roles opposing private selves, artificial opposing natural, image opposing reality, ideal opposing typical, special opposing ordinary, hierarchy opposing equality. Texts simultaneously celebrate effort and achievement as the open democratic routes to success and hold up for admiration the celebrity elite, successful because of inborn, extraordinary qualities. They simultaneously point out that, through marketing and the commercial system, ordinary people can become famous and rich and that one must always be on the lookout for ordinary people trying to pose as deserving celebrities. They contain a concurrent promotion of and distaste for equality. They at once demonize and idolize the commercial production system.

The cultural critics and the retired secretary, the traditional believer and the cynical believer are each making arguments in a crucial cultural conversation. Indeed, the key to the celebrity industry's ability to sustain itself while revealing artificial manufacturing processes is its adapted openness to interpretation and commentary on the predicaments of life in a commercial culture: the critical strains between merit and hierarchy and equality, the difficulty of finding the real amid the role playing, the new confrontation with media-based forms of power. When audiences play with celebrity, they are playing with the dilemmas of democratic power.

It is crucial that the conflicts that celebrity comprises remain salient in everyday discussion, especially as entertainment-celebrity logic becomes a fixture of American politics. In most territories, politics particularly, this conversation among citizens is hampered by fear, anger, frustration, anxiety, suspicion, alienation, depth of consequence. The ultimate danger is that the conversation will be given up, the questions run from, treated as resolved by others or as unresolvable.

The dilemmas that compose contemporary celebrity most often dissolve into interesting ironies: the uniquely normal star, the elite of the not necessarily deserving, the reality of the image, the democratization by inauthenticity, the fiction that is also truth. Hope emerges from a final paradox.

Celebrity is a world in which organization and professional conflicts resolve in simulation, performance, mimicry, blurring; a world in which authenticity is deferred and superficial fragments circulate. Therein lie its dangers, but also its promise: to keep alive the conflict-ridden questions of power, role playing, equality, and authority, to dwell in a cultural conversation that is elsewhere distorted or given up, indeed to protect it through its superficiality and triviality. The very characteristics that sustain entertainment celebrity and make it dangerous to democracy also make it absolutely essential. The parallel world of entertainment celebrity, so strange and familiar, so superficial yet so deeply alluring, offers the most free space of all in which to have the conversation: a world much like our own, but a world where nothing really matters.

**Revised and updated version of "Celebrity, Democracy, Power, and Play,"
from *Claims to Fame: Celebrity in Contemporary America* by Joshua
Gamson. Copyright © 1993 The Regents of the University of California.**

Notes

1. Daniel J. Boorstin, *The Image: A Guide to Pseudo-Events in America* (New York: Harper and Row, 1961).

2. Leo Braudy, *The Frenzy of Renown: Fame and Its History* (New York: Oxford University Press, 1986).

3. See, for example, Jeff Blyskal and Marie Blyskal, *PR: How the Public Relations Industry Writes the News* (New York: William Morrow, 1985); Deyan Sudjic, *Cult Heroes* (New York: W. W. Norton, 1989). On the impact of celebrity on social movements, see Todd Gitlin, *The Whole World Is Watching: Mass Media in the Making and Unmaking of the New Left* (Berkeley: University of California Press, 1980), chap. 5.

4. Landon Y. Jones, "Road Warriors," *People*, 20 July 1992, 68–79.

5. CNN coverage of the Democratic National Convention, 15 July 1992.

6. "If, as Walter Benjamin has argued, mechanical reproduction results in the loss of the aura of the real object, then the star system might be seen as a peculiar attempt to replace it," writes Richard deCordova (*Picture Personalities: The Emergence of the Star System in America* [Urbana: University of Illinois Press, 1990], 146). "That replacement is never fully achieved, however. In effect, the dialectic of presence and absence remains." See also Walter Benjamin, "The Work of Art in the Age of Mechanical Reproduction," in *Illuminations* (New York: Schocken, 1968).

7. Jeffrey Goldfarb, *The Cynical Society: The Culture of Politics and the Politics of Culture in American Life* (Chicago: University of Chicago Press, 1991), 10. Goldfarb offers a fascinating account of the historical and cultural roots of cynical political practices and beliefs. See also Kathleen Hall Jamieson, *Packaging the Presidency: A History and Criticism of Presidential Campaign Advertising* (New York: Oxford University Press, 1984).

8. See, for example, Michael Rogin, *Ronald Reagan, the Movie, and Other Episodes in Political Demonology* (Berkeley: University of California Press, 1987).

9. See, for example, Mark Hertsgaard, *On Bended Knee: The Press and the Reagan Presidency* (New York: Farrar Straus Giroux, 1988), and Leon Sigal, *Reporters and Officials: The Organization and Politics of Newsmaking* (Lexington, Mass.: D. C. Heath, 1973).

10. Joshua Meyrowitz, *No Sense of Place: The Impact of Electronic Media on Social Behavior* (New York: Oxford University Press, 1985), 277.

11. "Gore's Speech at Bay Plant Challenged," *San Francisco Chronicle*, 4 August 1992.

12. Carl Bernstein, "The Idiot Culture," *San Francisco Chronicle*, 26 July 1992, This World sec.

13. Todd Gitlin, "On Being Sound-Bitten: Reflections on Truth, Impression, and Belief in a Time of Media Saturation," *Boston Review*, December 1991, 17.

14. Even in politics, it is important to notice, the dominance of personality politics does not mean that democratic institutions are eliminated. "Though our political life is strikingly imprecise and emotional rather than rational, it still is democratic," Jeffrey Goldfarb cautions (*Cynical Society*, 7). "A fog of cynicism surrounds American politics, but they are still animated by fully institutionalized democratic norms and traditions."

15. Rogin, *Ronald Reagan*, 9. See also Stuart Ewen, *All Consuming Images: The Politics of Style in Contemporary Culture* (New York: Basic Books, 1989).

16. Recall that the uncoupling of merit and renown did not begin in this century: visibility has always been one means to social and political gain; there have always been attempts to gain it by appearing to have the valued qualities. Recall also that the celebrity-production system does not push uniformly toward separating celebrity and merit: some organizations must emphasize the celebrity's work, while others emphasize the celebrity's person. Yet with the industrialization of the means to recognition, that uncoupling has become widespread and fully institutionalized.

17. "Bush Is Overheard Asking If He Gave 'Proper Answer,'" *San Francisco Chronicle*, 27 November 1991.

18. Richard Sennett, "The Decline of Public Discourse," *Contemporary Sociology* 21 (1992): 16.

19. Goldfarb, *Cynical Society*, 1, 22. Goldfarb effectively argues, along the same lines I am pursuing here, that cynicism is often confused "with democratic deliberation and political wisdom" (p. 2).

20. W. Russell Neuman argues that about seventy-five percent of the American population falls in a "great middle stra-

Let's Entertain
Life's Guilty Pleasures

Celebrity, Democracy,
Power, and Play
Joshua Gamson

271

tum" of political sophistication. As opposed to a small apolitical group (about twenty percent) and an even smaller activist stratum (about five percent), the middle group "are marginally attentive to politics and mildly cynical about the behavior of politicians, but they accept the duty to vote, and they do so with fair regularity." They "can communicate political ideas, but they are hunt-and-peck typists" (*The Paradox of Mass Politics* [Cambridge: Harvard University Press, 1986], 171–72).

21. Gitlin, "On Being Sound-Bitten," 16.

22. Ibid., 17.

23. Ian Mitroff and Warren Bennis, *The Unreality Industry: The Deliberate Manufacturing of Falsehood and What It Is Doing to Our Lives* (New York: Carol Publishing Group, 1989), 49. The historical claim, we saw early on, is overstated.

The Art of Cyberculture
Pierre Lévy

Cyberculture and Society

The canonical genre of cyberculture is the *virtual world*. This should be interpreted not in the narrow sense of the term, as a computerized simulation of a three-dimensional universe, which we explore with a stereoscopic headset and data gloves, but as a digital store of sensory and informational virtualities that are actualized only through interaction with human beings. Depending on the technology, this actualization can be more or less creative and unpredictable, with a variable component that is dependent on human initiative. Virtual worlds can be collectively enriched and experienced, thus becoming a meeting place and communications medium shared by their participants.

The *engineer of worlds* will be the major artist of the twenty-first century. He will create virtualities, design communication spaces, build the collective hardware of cognition and memory, structure the sensorimotor interaction with the data universe. The World Wide Web, for example, is a virtual world that promotes collective intelligence. Its inventors—Tim Berners-Lee and the people who programmed the interfaces for navigating it—were engineers of worlds. Software developers, video game designers, and the artists who explore the boundaries of interactive devices and televirtual systems are also engineers of worlds.

In general we can distinguish two major types of virtual worlds: (1) those that are limited and editorialized, such as CD-ROMs and "closed" (offline) installations by artists; and (2) those that are accessible over a network and infinitely open to interaction, transformation, and connection with other virtual worlds (online). There is no reason to contrast online and offline, as we have done in the past. They are complementary relations, feeding and inspiring each other.

Offline works of art can conveniently provide partial and temporary projections of collective intelligence and imagination, which can be disseminated in a network environment. They are able to take advantage of more favorable technical environments, specifically, freedom from low bandwidth limitations. And they help constitute original or creative isolates outside the continuous flow of communication.

Similarly, virtual worlds accessible online can be supplied with offline data and feed them in turn. These are essentially interactive communication environments. But in this case the virtual world operates as a message depot, a dynamic context accessible to everyone, a communal memory that is collectively fed in real time.

The development of the technical infrastructure of cyberspace opens the perspective of interconnected virtual worlds. The gradual reunion of digitized texts on the planet in a single immense hypertext[1] is only the prelude to a more general form of interconnection, which will blend all digitized information, including film and interactive[2] three-dimensional environments. In this way the network will provide access to a gigantic, heterogeneous virtual metaworld, which will embrace the eruption of particular virtual worlds and the dynamic links, interconnecting passages, corridors, and burrows that characterize this digital wonderland. The virtual metaworld, or cyberspace, will become the principal locus of communication, economic transaction, learning, and entertainment for human societies. In it we will experience the beauty stored in the memory of ancient cultures, together with the forms specific to cyberculture. Just as cinema did not replace the theater but created a new genre with its own tradition and codes, the emerg-

ing genres of cyberculture, like techno music and virtual worlds, won't replace earlier
ones. They'll add to civilization's heritage while reorganizing the communication econ-
omy and the system of the arts. Features such as the demise of the author and the
recorded archive won't affect art or culture in general but only those works specifically
associated with cyberculture.

Even offline, the interactive work demands the involvement of those who experi-
ence it. The interactant participates in structuring the message he receives. Like the
creations of the engineer of worlds, multiplayer virtual worlds are the collective cre-
ations of their explorers. The artistic artifacts of cyberculture are works of flow, process,
and incident that do not lend themselves to archiving and conservation. In cyberspace
every virtual world is potentially linked to all others, enveloping them and being con-
tained by them according to a paradoxical topology that intertwines inside and outside.
Even now, many works of cyberculture art have no clear boundaries. These are "open
works,"[3] not only because they admit a multitude of interpretations but also—and espe-
cially—because they are physically receptive to the active immersion of an explorer and
materially interconnected with other works on the network. The extent of this openness
is obviously variable; the more the work exploits the possibilities offered by interaction,
interconnection, and the tools of collective creation, however, the more typical it is of
cyberculture and the less it behaves as a "work of art" in the traditional sense.

The cybercultural work achieves a certain kind of universality through its ubiquitous
presence on the network, its connection to other works and their copresence, and
through a material openness, rather than its association with some universally valid
meaning. This form of universality through contact goes hand in hand with a tendency
toward detotalization. And the guarantor of the totalization of the work, the closure of the
meaning associated with it, is the author. Even if the meaning of a work is said to be
open or multiple, an author must still be presupposed if we intend to *interpret* his inten-
tions, to decode a project, a social expression, or even an unconscious mind. The author
is the condition of possibility for any perspective of stable meaning. Yet it has become
commonplace to claim that cyberculture calls into question the importance and function
of the signatory. The engineer of worlds signs not a finite work, but an environment that
is essentially incomplete. It is the explorers of these worlds who will construct not only its
variable, multiple, and unexpected meaning but also the order of reading it and the
work's perceivable forms. The continuous metamorphosis of adjacent works and the vir-
tual environment that supports and penetrates the work will help dispossess a potential
author of his prerogatives as a guarantor of meaning.

Fortunately, sensitivity, talent, ability, and individual creative effort are still popular.
But these can apply just as much, and perhaps more appropriately, to the interpreter, the
"performer," the explorer, the engineer of worlds, to each member of the construction
team, as they do to an increasingly nebulous author.

After the author, the second condition for totalization or the closure of meaning is
the physical closure associated with the work's temporal fixity. The record, the archive,
the artwork that can be conserved in a museum, are *finished* messages. A painting, for
example, an object of conservation, is both the work itself and its archive. But the work-
as-event; the work-as-process; the interactive, metamorphic work; the interconnected,
crisscrossed, indefinitely co-constructed work of cyberculture, is difficult to record as

such, even if we photograph a moment in its process or capture a partial trace of its expression. To create a work, record, or archive no longer has—no longer can have—the same meaning that it had before the information deluge. When there are few archives, when they are harder to circumscribe, the process of discovery will again involve entering the flow of memory. But when memory is practically infinite, in flux, overflowing, fed each second by myriad sensors and millions of people, *entering the archives of culture will no longer enable us to make distinctions*. The act of creation par excellence will then consist in creating an event, here and now, for a community, in constituting the collective in which the event will occur, in partially reorganizing the virtual metaworld, the unstable landscape of meaning that shelters us and our works.

The pragmatics of communication in cyberspace erase the two leading elements of traditional totalization: *intentional* totalization by the author and *extensional* totalization through recording. Using the concepts of the rhizome and the plane of immanence, Gilles Deleuze and Félix Guattari[4] have philosophically described an abstract schema that comprises: (1) the a priori unlimited proliferation of connections among heterogeneous nodes and the mobile multiplicity of centers within an open network; (2) the agitation of intertwined hierarchies, the holographic effects of partial—and everywhere different—envelopment of wholes in their parts; and (3) the autopoietic and self-organizing dynamic of mutant populations that extend, create, and transform a qualitatively varied space, a landscape punctuated by singularities. This schema is actualized socially through the life of virtual communities, cognitively through the process of collective intelligence, and semiotically as the great hypertext or virtual metaworld of the Web.

The cybercultural work participates in these rhizomes, this plane of immanence in cyberspace. It is riddled with tunnels and faults, which expose it to an unidentifiable exterior, and interconnected (or awaiting connection) to people and the flow of data.

This is the global hypertext, a virtual metaworld in perpetual metamorphosis, an abundant musical or iconic flow. Everyone is asked to become a singular operator, qualitatively different, in the transformation of the universal and untotalizable hyperdocument. A continuum extends between the visitor and the engineer of virtual worlds, between those who are content merely to visit and those who will design systems or sculpt data. This reciprocity is in no way ensured by our technological evolution; it is only a fortunate possibility exposed by the new means of communication available to us. It is up to our social actors and cultural activists to take advantage of it. In doing so, they will avoid reproducing in cyberspace the malignant dissymmetry that characterizes mass media.

The Universal without Totality: Text, Music, Image

For each great modality of signs—alphabetic texts, music, images—cyberculture produces new forms and new ways of interacting. The text folds, folds again, divides, and adheres to itself in bits and pieces; it mutates into hypertexts, and then these connect to one another to form the indefinitely open and mobile hypertextual plane of the Web.

Music certainly lends itself to discontinuous navigation through hyperlinks (the listener can move from sound unit to sound unit), but it gains much less than text. Its most important mutation in the conversion to a digital format is characterized by the recursive process opened through sampling, mixing, and rearrangement—the extension of a virtual musical ocean continuously fed and transformed by a community of musicians.

below: *Courtesy Mathieu Briand*

right: *SYS*03.RefN*01/GrE*01\RoF−10* 1998
Courtesy Galerie Roger Pailhas, Marseilles

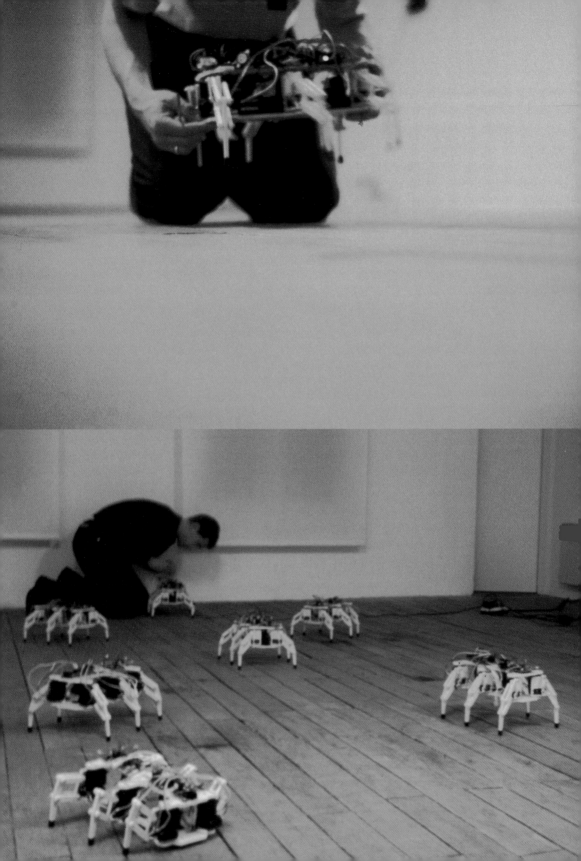

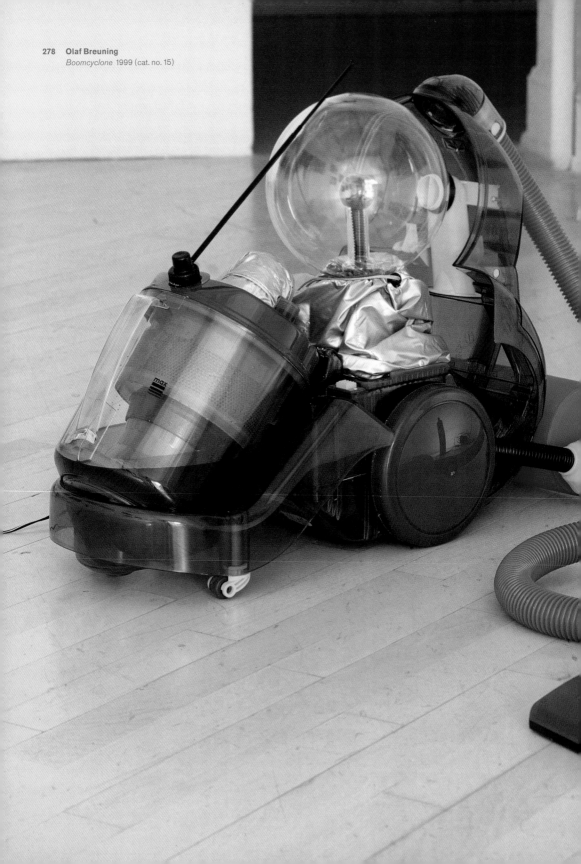

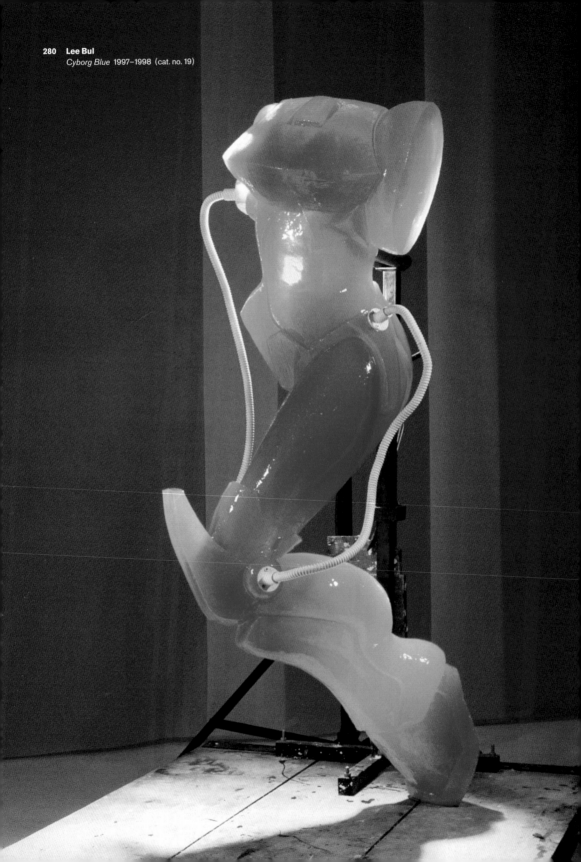

The image loses its exteriority as spectacle and opens itself to immersion. Representation makes room for the interactive visualization of a model; simulation replaces resemblance. Drawings, photographs, and films are voided; they welcome the active explorer of a digital model, a collective of workers or players engaged in the cooperative construction of a data universe.

We have, therefore, three principal forms in cyberspace: (1) the networked read-write hyperdocument for text; (2) the recursive process of creation and transformation of a memory-flow by a community of differentiated cooperators, in the case of music; and (3) the sensorimotor interaction with a set of data, which defines the virtual status of the image. None of these three forms, however, excludes the others. What's more, each of them can actualize the same abstract structure of the untotalizable universal differently, and in one sense each contains the others.

We navigate within a virtual world as we do in a hypertext, and the pragmatics of techno also assume a principle of virtual, offline navigation in musical memory. Even some real-time musical performances implement the techniques of hypermedia.

In my analysis of new trends in digital music, I have highlighted the cooperative and continuous transformation of an informational reserve that serves as both channel and shared memory. Yet this type of situation affects collective hypertexts and virtual worlds of communication as much as it does techno. Image and text are being increasingly subjected to sampling and rearrangement. In cyberculture every image is potentially the raw material for another image, and every text can serve as the fragment of a larger text composed by an intelligent software "agent" during a specific search.

Finally, interaction and immersion, which are typical of virtual realities, illustrate a principle of the immanence of the message for its receiver, which can be applied to all digital modalities: the work is no longer remote but is nearby. We participate in it, transform it, are its authors in part.

The immanence of messages for their receivers, their openness, the continuous and cooperative transformation of a memory-flow by groups of humans—all these traits actualize the decline of totalization.

As for the new universal, it is realized in the dynamic of interconnection that typifies online hypermedia, participation in the mnemonic or informational ocean, the ubiquity of the virtual within the networks that carry it. Universality arises from the fact that we all bathe in the same information flow and from the loss of totality of its diluvial flood. Not content to flow forever, Heraclitus' stream has overrun its banks.

The Author in Question

Authors and archives guarantee the totalization of works of art, ensure the conditions for an all-encompassing comprehension and stable meanings. If the essence of cyberculture lies in the nontotalizing universal, we must examine, if only as a hypothesis, the guises that art and culture need to assume for these two figures to fade into the background. For it is unlikely, having experienced a state of civilization in which the memorable archive and creative genius have been so consequential, that we could conceive of a situation (putting aside some cultural catastrophe) where author and record have entirely disappeared. Yet we need to envisage a future state of civilization in which these two custodians of waning totalization will play only a modest role for those who pro-

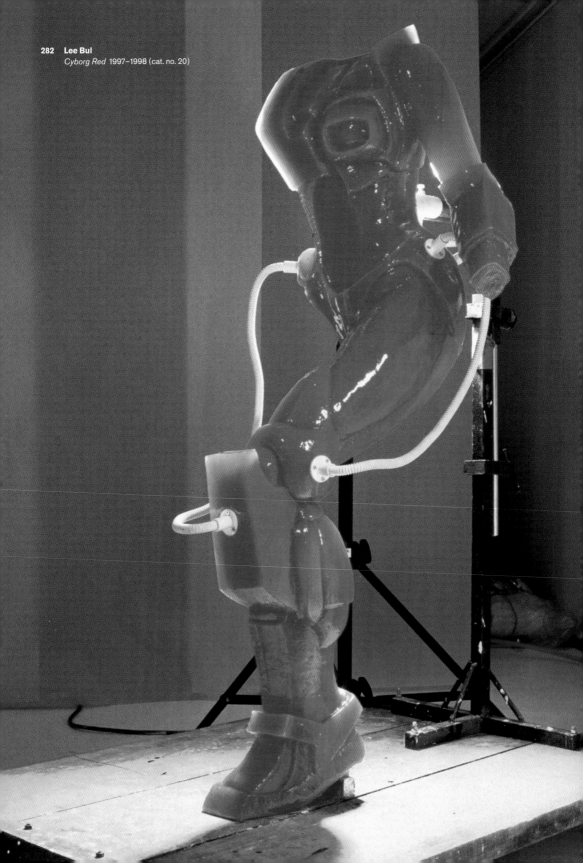

Lee Bul
Cyborg Red 1997–1998 (cat. no. 20)

duce, transmit, and experience the works of the mind.

The concept of the author in general, like the various notions of the author in particular, is strongly linked to certain forms of communication, to our social relations on the economic, legal, and institutional level. In those societies where the principal mode of transmitting explicit cultural content is speech, the concept of the author is minimized, and sometimes nonexistent. Myths, rites, traditional plastic or musical forms are timeless, and we generally do not associate them with a signature or mythic author. Even the concept of a signature, like that of personal style, implies writing. Artists, singers, bards, storytellers, musicians, dancers, and sculptors are generally considered to be interpreters of an immemorial theme or pattern, which is part of the heritage of the community. Within the diversity of epochs and cultures, the concept of the interpreter (along with our ability to distinguish and appreciate the great interpreters) is much more widespread than that of the author.

Obviously this begins to assume increasing depth with the appearance of writing. Up until the end of the Middle Ages, however, writers of original texts weren't necessarily considered authors. The term was reserved for an "authoritative" source, such as Aristotle; the commentator or copyist who provided the gloss was not referred to as an author. With the arrival of printing and the industrialization of text reproduction, it became necessary to define precisely the economic and legal status of writers. Consequently the modern concept of the author developed in tandem with the notion of author's "rights." Similarly the Renaissance witnessed the arrival of the artist as a creative demiurge, an inventor or designer, and no longer as an artisan, an inventive bearer of a tradition.

Are there any great works, great cultural creations without an author? Obviously, yes. Greek mythology, for example, is one of the jewels of our cultural heritage. Yet it is unquestionably a collective creation, authorless, arising from an immemorial past, polished and enriched by generations of inventive retransmitters. Homer, Sophocles, and Ovid, as celebrated interpreters of this mythology, have obviously given it a certain luster. But Ovid is the author of the *Metamorphoses*, not of mythology; Sophocles wrote *Oedipus Rex*, he didn't invent the saga of the kings of Thebes.

The Bible is another example of a major work arising from humanity's spiritual and poetic past that has no distinct author. Hypertext before the fact, its construction results from a selection (sampling) and belated amalgamation of a large number of heterogeneous texts written at different times. The origin of these texts can be traced to the ancient oral traditions of the Jews (Genesis, Exodus). But it also bears the influence of the Mesopotamian and Egyptian civilizations (certain parts of Genesis, the Song of Solomon) in its heightened moral reaction to a certain political and religious actuality (the books of the prophets), its poetic and lyrical expansiveness (Psalms, Canticle of Canticles), its desire for legislative and ritual codification (Leviticus) and preservation of a historical memory (Chronicles, etc.). Yet we rightly consider the Bible to be a work, the bearer of a complex religious message embodying an entire cultural universe.

Within the Jewish tradition, an interpretation by a legal scholar doesn't assume its fullest authority until it becomes anonymous, when the name of the author has been integrated within a shared heritage. Talmudic scholars constantly cite the advice and comments of the wise men who preceded them, thus rendering the most precious

aspect of their thought immortal in a way. Yet, paradoxically, the sage's greatest accomplishment consists in no longer being cited by name and disappearing as an author so that his contribution is identified with the immemoriality of the collective tradition.

Literature isn't the only field where major works of art remain anonymous. *La Chanson de Roland*, Indian ragas, the paintings at Lascaux, the temples of Angkor, and the Gothic cathedrals are all unsigned.

There are great works of art without authors. Still, it appears difficult to experience beautiful works without the intervention of great interpreters, without talented individuals able to follow the thread of a tradition, reactivate it, and add to it a special brilliance. These interpreters may be well known but still remain nameless. Who was the architect of Notre-Dame de Paris? Who sculpted the portals of the great cathedrals of Chartres and Rheims?

The figure of the author emerges from a media ecology and highly specific economic, legal, and social configuration. It shouldn't be surprising that it would fade into the background when the communication system and social relations are transformed, destabilizing the cultural compost that witnessed its growth. This may be less serious than it appears, however, since the preeminence of the author determines neither the explosion of culture nor artistic creativity.

The Decline of Recording

I noted earlier that creating or recording a work, leaving a trace, no longer has the same meaning or value as it did before the informational deluge. The natural result of the inflation of information is its devaluation. From that point on, the focus of the artist's work shifts to the event, that is, toward the reorganization of the landscape of meaning, which fractally inhabits all levels of the communication space, group subjectivities, and the sensible memory of individuals. As with human tissue, *something is happening* within the network of signs.

Let's be perfectly clear. The above process does not involve the anticipated displacement of the resolutely material "real" preserved in museums by a labile "virtual" in cyberspace. Did the irresistible rise of the "imaginary museum" extolled by Malraux—the multiplication of art catalogues, books, and films—reduce museum attendance? On the contrary. As awareness of the recombinable elements of the imaginary museum spread, so did the number of publicly accessible facilities designed to house and exhibit art. Nonetheless, if we examine the fate of a given work of art, we find that most people experience a reproduction rather than the original. Similarly, it is unlikely that virtual museums will ever compete with real museums; rather, they will serve as a kind of publicity department. They will, however, become the principal interface through which the public experiences art, just as more people were exposed to Beethoven and the Beatles through records than through concerts. The mistaken notion of the substitution of a feigned "real" with an unknown and depreciated "virtual" has resulted in a great deal of misunderstanding.

The above is obviously true of the "classic" plastic arts. With respect to the specific aspects of cyberculture, the virtual remains their natural setting; brick and mortar museums can provide only an imperfect projection of that reality. We cannot "exhibit" a CD-ROM or a virtual world. We can only navigate them, immerse ourselves in them, interact

with them, participate in processes that demand our time. An unexpected consequence of this is that for the arts of the virtual, "originals" are bundles of events in cyberspace; "reproductions" in museums will provide only an impoverished experience of their reality.

The genres of cyberculture are similar to performing arts such as dance or theater, the collective improvisations of jazz, the commedia dell'arte, or the traditional poetry competitions of Japan. Like installation art, they demand the active involvement of the receiver, his displacement in a symbolic or real space, the conscious participation of his memory in the construction of the message. Their center of gravity is a subjective process, which frees them from any spatio-temporal closure.

By organizing our participation in events rather than spectacles, the arts of cyberculture will rediscover the great tradition of games and rituals. The most contemporary is joined to the most archaic, to the very origins of art in anthropology. For isn't the very essence of civilization's great ruptures and true "progress"—actively criticizing the tradition with which it breaks—paradoxically, a return to the beginning? In games and rituals, neither the author nor the archive is important, just the collective act, here and now.

An engineer of worlds ahead of his time, Leonardo da Vinci organized revels for the princes of Italy, which the crowds animated with their costumes and dances, their ardent existence…and of which nothing remains. Although we cannot join them, other celebrations are being prepared for tomorrow.

Translated by Robert Bononno from *Cyberculture: Rapport au Conseil de l'Europe* by Pierre Lévy. Copyright ©1997 Éditions Odile Jacob, Paris.

Notes

1. Through the use of HTML, the current World Wide Web standard.

2. This too will take place on the World Wide Web through the use of tools such as VRML and Java.

3. See Umberto Eco, *The Open Work*, trans. Anna Cancogni (Cambridge: Harvard University Press, 1989).

4. See Gilles Deleuze and Félix Guattari, *A Thousand Plateaus: Capitalism and Schizophrenia*, trans. Brian Massumi (Minneapolis: University of Minnesota Press, 1987), and idem, *What Is Philosophy?*, trans. Hugh Tomlinson and Graham Burchell (New York: Columbia University Press, 1996).

September 1, 1999—Metreon, San Francisco.
Olukemi Ilesanmi and Philippe Vergne are meeting at the "computer bar" in Metreon, the Sony Corporation's new entertainment and retail complex. They are sampling video games in the $85 million, 350,000-square-foot complex, which is not called a mall because of the passive, cookie-cutter connotations of that term, but is instead described as an "urban entertainment destination."

Let's Entertain
Life's Guilty Pleasures

Dialogue Part IV
Philippe Vergne and
Olukemi Ilesanmi

287

OI: Could you talk about the inclusion of Web-based art in this exhibition?

PV: We asked Steve Dietz, the Director of New Media Initiatives at the Walker Art Center, to curate a companion exhibition on the Web for *Let's Entertain*. I think, like video art a few decades ago, digital art is a new and potentially revolutionary trajectory being explored by today's artists. That is the reality in art practice right now. Artists are using digital technology to produce a kind of art that is very different in terms of methodology and familiarity to visual arts curators. I asked Steve Dietz to handle this section of the show because I don't have the full knowledge base to do it justice myself. It is a very different cast of characters playing in a very different field.

OI: I was recently chatting with a friend about the many possibilities we have to look forward to as the generation that has grown up with the Web comes of age as artists. What will they produce with this tool that will be so familiar to them, in a way that it is not to you and me? Artists like Douglas Gordon and Takashi Murakami grew up in the golden age of cable and the VCR. These were the norms, so it makes perfect sense that they would traverse that territory in their art-making. Now digital culture, the Web, is the norm for the upcoming generation of artists. In the next few years, curators will have to adjust to this new reality, and this show's inclusion of Web-based art reflects that.

PV: These digital artists, and the curators working with them, have a very different way of working. The best way for me to describe it is through the notion of a hyperessay, which challenges the linearity of reading and our access to information and culture. These interactions shape our mind into a very different machine. First, I feel that digital art is very space-related, no more linear reading but an experience close to Mallarmé's spatialization of the text on the page.[25] The access to meaning, more than to information, is free and subjective, active and nonlinear, and, like a hyperessay, community-oriented and reciprocal. There are as many meanings and narrations as there are readers. With digital art, we are thinking through interconnection of ensembles, tri-dimensionally, no longer in terms of lists. The second characteristic that fascinates me is its relationship to the world of media and spectacle, as Pierre Lévy describes it.[26] He writes that "spectacle"—drawing from the writings of Guy Debord and the Situationists[27]—is the epiphany of capitalist domination and oppression. The real revolution is coming through cyberspace because it allows us to forget about publishers, distributors, producers, or any kind of intermediary. Texts, music, and intellectual production in general can be made available through the virtual world, widely and somewhat democratically. Unlike media such as television, which isolate consumers in a passive attitude, cyberspace offers more direct, interactive, and collective communication. That is why I think that digital culture and digital art are part of what we should look at as curators. It is not a "geek" ghetto. It is a cultural mutation that, in terms of art, involves a participatory and playful aspect as well as collaboration with other discipline and skills. And as the artist Mathieu Briand says, "Please do not label these works New Technology!"

Notes

25. Stéphane Mallarmé, *Un coup de dés jamais n'abolira le hasard* (Paris: Nouvelle Revue Français, 1914).

26. Pierre Lévy, *Cyberculture: Rapport au Conseil de l'Europe* (Paris, Éditions Odile Jacob,1997).

27. Guy Debord, *La société du spectacle* (Paris: Buchet-Chaste, 1967).

aen.walkerart.org
Art Entertainment Network

<META name="keywords"
content="CONVERGENCE: accident,
accompaniment, alteration, appearance, avalanche,
beginning, blow, bonanza, break, case, change,
collapse, concomitant, contact, contingency,
conclusion, connection, co-occurrence, crash,
destiny, disappearance, discharge, ending, episode,
eventuality, example, experience, failure, fate, flash,
fortuity, goldmine, happening, impinging, incident,
instance, interruption, joining, juncture, manna from
heaven, marvel, miracle, modification, motion,
movement, natural event , news event, occasion,
occurrence, outburst, periodic event, recurrent
event, representation, reverse, reversal, setback,
sound, striking, success, thing, union, wonder">

WordNet 1.6
www.cogsci.princeton.edu/~wn/

For artists' biographical information see: http://aen.walkerart.org/mediatheque/artists/

Selected Artists
>
Mark Amerika
Daniel Andujar
Joachim Blank
Natalie Bookchin
Sawad Brooks
Claude Closky
Vuk Cosic
Alison Craighead
Margaret Crane
Andy Deck
Bernd Diemer
Jesse Gilbert
Ken Goldberg
Group Z
Jenny Holzer
Auriea Harvey
Karl Heinz Jeron
Marc Lafia
Geert Lovink
Lev Manovich
Kevin&Jennifer McCoy
Mongrel
Robbin Murphy
Prema Murthy
Mark Napier
Mark River
rtMark
Julia Scher
Vivian Selbo
Alexei Shulgin
Eddo Stern
Beth Stryker
Eugene Thacker
Jon Thomson
Helen Thorington
Marek Walczak
Noah Wardrip-Fruin
Tim Whidden
Jon Winet
Maciej Wisniewski
Eric Zimmerman

"WHAT IS CINEMA? The answer to this question is no easy matter. Long ago the Japanese novelist Shiga Naoya presented an essay written by his grand-child as one of the most remarkable prose pieces of his time. He had it pub-lished in a literary magazine. It was entitled 'My Dog', and ran as follows: "'My dog resembles a bear, he also resembles a badger, he also resembles a fox...." It proceeded to enumerate the dog's special characteristics, comparing each one to yet another animal, developing into a full list of the animal kingdom."
—Akira Kurosawa, *Something Like an Autobiography*, 1982

In the digital realm, components of media—text, image, moving images, sound—are converted to the unitary platform of binary notation: ones and zeros. Through networking, forms of media—broadcast, film, publishing, computing, telephony—converge. The dog of our entertainment resembles the fox of our art. This is more than the concatenation of terminology: edutainment, artutainment, teledildonics. Networked digital technologies enable—some might argue incite—the interpenetration of all sorts of boundaries—between private and public, biological and artificial, close and far, real and virtual, art and entertainment. The artists in *Art Entertainment Network* revel in operating in the neutral zones between these boundaries.

Another way to think about this convergence of art and entertainment in the network is to imagine the destination of Bill Gates' "Where do you want to go today?™" as Jose Luis Borges' "Library of Babel."

"When it was proclaimed that the Library contained all books, the first impres-sion was one of extravagant happiness. All men felt themselves to be the masters of an intact and secret treasure. There was no personal or world problem whose eloquent solution did not exist in some hexagon.... As was natural, this inordinate hope was followed by an excessive depression. The certitude that some shelf in some hexagon held precious books and that these precious books were inaccessible, seemed almost intolerable."
—Jorge Luis Borges, "The Library of Babel," *Labyrinths,* 1988

Search Alta Vista and it appears that the knowledge we seek must indeed be at our fingertips, somewhere among the 20,000 hits. With equal certainty, some further gloss of enlightenment is always just one more "hexagon" away in the infinite portal of Babel.

Art Entertainment Network is constructed, both on the Web and in the galleries, as a revolving-door portal. The exhibition Web site looks familiar, like a portal should. It has zones and searches and real time updates and customization features. It has web-cams and tells you the time in both Swatch and hexidecimal. Yet its appearance is contingent. Recurring events change, collapse. This is no accident.

"It is good for the artist to insinuate himself into the open mesh of any sys-tem—not in a provocative and visible way, but mimetically, using their same mediums."
—Maurizio Cattelan, *Flash Art Italia* (October–November 1991), p. 83

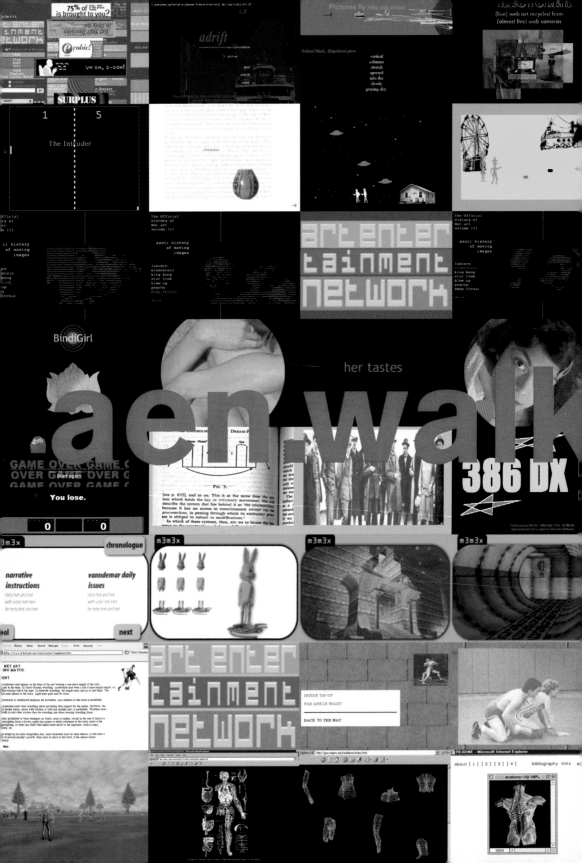

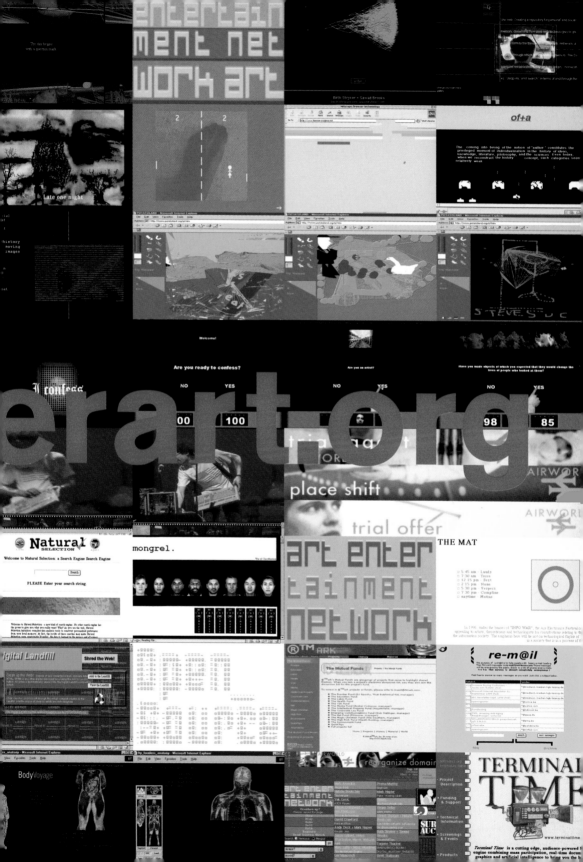

Afterword

Today's consumer society is submerged in a flood of images, texts, and sounds emanating from old and new communication devices and entertainment structures, including television, movies, radio, newspapers, magazines, billboards, posters, banners, designer logos, and the Internet. The persistence of these messages and mechanisms— attached to the garments we choose to articulate our individuality as well as engraved in our public spaces and sequestered in our private domains—simultaneously obscures and highlights their penetration. The necessity of selecting, either consciously or unconsciously, from this heartbeat of signals, often disguised as entertainment, is part of our daily rhythm, and this three-dimensional collage transforms our everyday life into an endless loop of spectacles in which we participate with varying degrees of pleasure, skepticism, and guilt.

Artists from around the globe have explored the ways in which these entertainment structures have infiltrated our lives, even emerging within the cultural and educational institutions that harbor an ambivalent relationship to these experiences and strategies. This exhibition, multidisciplinary and global in nature, focuses on work that reflects this social phenomenon, partaking equally of the hedonistic extravaganzas and melancholy sobriety peculiar to our age. While the artists in this exhibition have adroitly adopted the techniques used by many corporations to create a spectacle of quotidian experience, their intentions are various: some critique the homogeneous impulse at the heart of these strategies while others use them to create a common language that may attract a broader audience. The entertainment structures insinuated by the artist into the viewing experience include popular music, movies, media, fashion, sports, video games, and themed architecture (or what Rem Koolhaas calls "shoppertainment"). Through the guilty pleasure that entertainment provides the museum visitor, these artists alter the protocols of display, including the detached relationship between the audience and the object as well as the expected behavior of the audience. There are floors to be danced on, games to be played, sculptures to be worn. But beware: this participatory fairy tale may have a cruel but necessary ending. While these artists explore the contradictions, illusions, and dreams of what thirty years ago came to be called the "Society of Spectacle," they acknowledge that we no longer are passive witnesses to the blurring of high and low culture, but captive protagonists obliged to make sense of the fog.

Like any exhibition of this ambition and complexity, *Let's Entertain* would not have happened without the very generous contributions of those who allow us to dare to dream. We are deeply grateful for the financial support of The Bush Foundation;The Andy Warhol Foundation for the Visual Arts; PRO HELVETIA Arts Council of Switzerland; the Asian Cultural Council; Étant donnés, the French-American Fund for Contemporary Art; SamGoody.com; the British Council; and Mondriaan Foundation Amsterdam for the advancement of the visual arts, design, and museums. A crucial gift also was provided by Gary and JoAnn Fink, who have continued to support global programming involving young artists, both recognizing and relishing the risk and the ways in which those risks undergird this institution's mission. Additional in-kind support was provided by Gallery Shimada and Tate Access Floors, Inc. The *Art Entertainment Network* was made possible by generous support from Aveus. I would also like to thank the Centre Georges Pompidou for its trust in coproducing the exhibition, and its complicity in expanding notions of curatorial practice by inviting the Walker to reconfigure this project in Paris as *Sons et lumières*.

I want to thank Visual Arts Curator Philippe Vergne for his extensive investigation into the subject of art and entertainment, which produced an extraordinary exhibition and catalogue, including essays with unusual reach and cross-disciplinary focus; for the challenges he posed and the grace with which he stretched the institution; for his devotion to young artists from across the globe; and for his ability to convince other institutions of the importance of this endeavor. I also thank Visual Arts Intern Olukemi Ilesanmi, who worked with Philippe, for her mastery of all the details, her incisive questions, and her assistance at every turn. I am extremely grateful to The Lila Wallace-Reader's Digest Fund, which made her internship possible and has allowed us to bring exemplary young scholars to the Walker so we can broaden the diversity of the curatorial field.

Kathy Halbreich, Director

Acknowledgments

I would like extend my heartfelt thanks to all the people who helped me realize this exhibition and publication.

First and foremost, I thank the artists in the exhibition because they are the ones who are taking risks. Without their complicity and trust none of this would have been possible.

We are deeply grateful to each and every one of our lenders, without whose cooperation there would be no exhibition.

Thanks to the following galleries and dealers for their priceless and necessary collaboration:

Air de Paris: Edouard Merino and Florence Bonnefous
Galleri Paul Andriesse, Amsterdam: Christel Vesters
Arndt & Partner, Berlin: Matthias Arndt
arsFutura Galerie, Zurich: Nicolas von Senger
Blum & Poe, Los Angeles: Tim Blum and Jeff Poe
Gavin Brown's enterprise, New York: Gavin Brown and Kirsty Bell
Deitch Projects, New York: Jeffrey Deitch
Anthony D'Offay Gallery, London: JiMi Lee Brighi, Anthony D'Offay,
 Marie-Louise Laband, Lorcan O'Neill
Electronic Arts Intermix, New York: Stephen Vitiello
Gagosian Gallery, New York: Lisa Kim and Kay Pallister
Barbara Gladstone Gallery, New York: Barbara Gladstone
Marion Goodman Gallery, New York: Elaine Budin and
 Marion Goodman
Galerie Hauser & Wirth, Zurich: Eva Presenhuber
Jablonka Galerie, Cologne: Raphael Jablonka and Birgit Muller
Lisson Gallery, London: Barry Barker
Matthew Marks Gallery, New York: Leslie Cohan and Jeffrey Peabody
Galleria Massimo de Carlo, Milan: Uwe Schwarzer
Metro Pictures, New York: Jeff Gauntt, Janelle Reiring, and Helen Winer
Galerie Mot & Van den Boogaard, Brussels: Jan Mot
Maureen Paley Interim Art, London: James Lavender and Maureen Paley
Andrea Rosen Gallery, New York: Andrea Rosen and Michelle Reyes
Shimada Gallery, Tokyo: Chisa Misaka and Keiko Shimada
Galerie Micheline Szwajcer, Antwerp: Samuel Plompen and
 Micheline Szwajcer
303 Gallery, New York: Brian Doyle and Lisa Spellman
Voice Gallery, Kyoto: Megumi Matsuo
Galleri Nicolai Wallner, Copenhagen: Nicolai Wallner
David Zwirner Gallery, New York: David Zwirner

The commitment of our colleagues at the tour venues has ensured a broader audience for this project:

Portland Art Museum: John E. Buchanan Jr., director, and Kathryn Kanjo,
 curator of contemporary art
Musée national d'art moderne, Centre Georges Pompidou, Paris:
 Bernard Blistène
Museo Rufino Tamayo, Mexico City: Maria Teresa Márquez
 Diez-Canedo, director, and Aurora Montoña, co-director
Miami Art Museum: Suzanne Delehanty, director, and Peter Boswell,
 assistant director for programs and senior curator

At the Centre Georges Pompidou:

Jean-Jacques Aillagon, Président du Centre national d'art et de
culture Georges Pompidou; Guillaume Cerutti, Directeur général;
Werner Spies, Directeur du MNAM-CCI; Martin Bethenod, Directeur
des Editions; Jean-Pierre Biron, Directeur de la Communication;
Sophie Aurand, Directeur de la Production; Martine Silie, Chef du
Service des Manifestations; and Bernard Blistène, Directeur-adjoint du
MNAM-CCI, co-curator for the presentation of the exhibition
Sons et lumières in Paris, assisted by Liliane Decaen, with the
participation of Sophie Blasco and Hervé Derouault

At the Walker Art Center my gratitude goes to:

Director Kathy Halbreich for her bold dedication to ideas, and for entertaining my insanity;

Chief curator Richard Flood for humoring my sanity;

Curatorial Intern Olukemi Ilesanmi, who, with her grace and elegance, allowed me to be her worst nightmare during the project, and for years to come;

Visual arts assistant Lynn Dierks, who never says no and who managed, with humor, innumerable details related to the project;

Steve Dietz, director of new media initiatives, and Louis Mazza, digital media designer, for their work on the *Art and Entertainment Network*; they demonstrate that "virtual" is not opposed to "real";

Walker librarians Rosemary Furtak and Michael Boe, for their research assistance, and Barbara Elam, slide librarian, who is a walking music-video encyclopedia;

Registrars Elizabeth Glawe and Elizabeth Peck, who keep the show on the road, in the air, on the sea, and finally in the galleries;

Andrew Blauvelt, design director, for his proactive subtlety, and graphic designer Santiago Piedrafita, for his joyful creativity and collegiality;

Editor Karen Jacobson, who makes editing an art;

Michelle Piranio, magic publications manager, and Pamela Johnson and Kathleen McLean, merveilleuses copy editors, for tying all the pieces together;

Cameron Zebrun and his staff in program services—especially Phil Docken and Kirk McCall—for whom "installation" means conversation, attention, and pleasure;

Peter Murphy, Jason Spafford, and Eleanor Savage for their audio-visual expertise;

Christopher Stevens, development director, Kathryn Ross, director of special projects fundraising, Aaron Mack, special projects coordinator, and Sarah Sargent, grant writer, for making dreams come true;

Howard Oransky, assistant director for program planning, and Mary Polta, finance director, for keeping me on track;

Philip Bither and Doug Benidt, in the Performing Arts Department, for their trust; and

Sheryl Mousley and Dean Otto, in the Film/Video Department, for the *Love Boat* story.

**At Antenna Design New York Inc. for their design of the
Art Entertainment Network portal:**

Masamichi Udagawa
Sigi Moeslinger

My very personal appreciation goes to the following individuals, who over the years have helped me through conversation to elaborate this project:

Nathalie Abou-Isaac
Yuji Akimoto, Benesse Corporation
Taro Amano, Yokohama Museum of Art
Tobias Bando, Kyoto
Prof. Ute Meta Bauer
Philippe Bérard
Michel Blancsubé
Francesco Bonami
Frédéric Bonnet
Caroline Bourgeois
Nathalie Boutin
Cati Chambon
Sylvia Chivaratanond
Lapo Cianchi, Pitti Immagine, Firenze
Chantal Crousel
Editions Odile Jacob and Nathalie Gellé
Simon Fisher-Turner
Elein Fleiss, Paris
Douglas Fogle
Dana Friis-Hanson
Simone Fukayuki
Hisanori Gogota, ICC, Tokyo
Toshio Hara, Hara Museum, Tokyo
Yuko Hasegawa
Russell Haswell
Joanna Heyler, Eli Broad Foundation
Antonio Homen, Sonnabend Gallery
Hudson, Feature Gallery
Yoshiko Isshiki
Eungie Joo
Shinji Kohmoto, The National Museum of Modern Art, Kyoto
George Koshi, Asian Cultural Council, Tokyo
Tomio Koyama, Tomio Koyama Gallery, Tokyo
Atsuko Koyanagi, Koyanagi Gallery, Tokyo
Francis Lacloche, Caisse des Dépôts et Consignations, Paris
Véronique Legrand
Pierre Leguillon
Gabriela López
Michele Maccarone, Luhring-Augustine Gallery
Daniel McLean
Hervé Mikaëloff, Caisse des Dépôts et Consignations, Paris
Emmanuelle de Montgazon
Kio Obigane, Asahi Shimbun
Mariko Oikawa
Miki Okabe, Japan Foundation, Tokyo
Roger Pailhas, Galerie Roger Pailhas, Marseille
Jenelle Porter
Conny Purtill
Almine Rech, Paris
Junko Shimada, Gallery Side 2, Tokyo
Eric C. Shiner, Osaka
Junichi Shioda, Museum of Contemporary Art Tokyo
Yoko Uchida, Hara Museum, Tokyo
Koichhi Watari, The Watari Museum of Contemporary Art, Tokyo
Kunio Yaguchi, Museum of Contemporary Art, Tokyo
Olivier Zahm, Paris

Checklist

1. Doug Aitken
these restless minds 1998
3 video monitors, 3 laserdiscs (color, audio)
wood platform, wood benches
Running time 8 minutes
variable dimensions
Courtesy 303 Gallery, New York

2. Carlos Amorales
Amorales Interim 1997
video monitor, laserdisc (color, audio)
Running time 9:48 minutes
Courtesy Galerie Micheline Szwajcer, Antwerp, Belgium

3. Bernadette Corporation
Creation of a False Feeling 2000
video monitor (color, audio), mixed media
Courtesy American Fine Arts Gallery, New York

4. Dara Birnbaum
Kiss the Girls: Make Them Cry 1979
video monitor, laserdisc (color, audio)
Running time 6:50 minutes
Collection Walker Art Center, Minneapolis

5. Dara Birnbaum
Technology/Transformation: Wonder Woman 1978–1979
video monitor, laserdisc (color, audio)
Running time 5:50 minutes
Collection Walker Art Center, Minneapolis
T. B. Walker Acquisition Fund, 1999

6. Dike Blair
Brown Music 1991
C-prints, epoxy, oil paint on sandblasted glass
48 x 48 in.
Courtesy the artist and Feature Inc., New York
T. B. Walker Acquisition Fund, 1999

7. Dike Blair
not one leaf remains the way it was 1998
fluorescent lights and carpet
floor: 90 x 72 in.; wall: 25 1/2 x 25 1/2 in.
Courtesy the artist and Feature Inc., New York

8. Dike Blair
Seventh Chamber 1989
C-prints, epoxy, oil paint on sandblasted glass
48 x 48 in.
Courtesy the artist and Feature Inc., New York

9. Dike Blair
spring snow melts easily 1999
fluorescent lights and carpet
floor: 8 x 7 ft.; wall: 13 1/2 x 50 in.
Courtesy the artist and Feature Inc., New York

10. Leigh Bowery
Death in Vegas 1994
video monitor, laserdisc (color, audio)
Running time 6:20 minutes
Director: Mark Hasler
Actors: Leigh Bowery, Sue Tilley, Gillian King, Joe Wright, Roland Gift
Courtesy Anthony d'Offay Gallery, London

11. Leigh Bowery
Garment from Italy club performance 1990
hat, bra, belt, boots, pubic wig
Variable dimensions
Courtesy Nicola Bateman, East Sussex, Great Britain

12. Leigh Bowery
Ruined Clothes—Garment 1 1988
dress, tights, shoes, gloves
Variable dimensions
Courtesy Nicola Bateman, East Sussex, Great Britain

13. Leigh Bowery
Ruined Clothes—Garment 2 1988
dress, shorts, tights, shoes
Variable dimensions
Courtesy Nicola Bateman, East Sussex, Great Britain

14. Leigh Bowery
Ruined Clothes—Garment 3 1988
dress, tights, shoes
Variable dimensions
Courtesy Nicola Bateman, East Sussex, Great Britain

15. Olaf Breuning
Boomcyclone 1999
vacuum cleaner with audio and light
20 x 40 x 16 in.
Courtesy arsFutura Galerie, Zürich

16. Mathieu Briand
*SYS*05.ReE*03/SE*1\ MoE*2–4* 2000
4 video glasses, 4 backpacks
Collection Caisse des Dépots et Consignations, Paris

17. Jessica Bronson
Jessica Bronson Presents an Evening with the Dick Slessig Combo…Minneapolis, 2000 2000
wood, fluorescent light fixtures, steel, audio
16 x 168 x 158 in.
Courtesy the artist, CRG Art, New York, and Goldman Tevis Gallery, Los Angeles

18. Roderick Buchanan
Chasing 1000 1994
video monitor, laserdisc (color, audio)
Edition of 6
Running time 90 minutes
Courtesy Lotta Hammer Gallery, London

19. Lee Bul
Cyborg Blue 1997–1998
silicone, paint pigment, steel pipe support and base
63 x 27 1/2 x 43 in.
Courtesy Ssamzie, Seoul, Korea

20. Lee Bul
Cyborg Red 1997–1998
silicone, paint pigment, steel pipe support and base
63 x 27 1/2 x 43 in.
Courtesy Ssamzie, Seoul, Korea

21. Maurizio Cattelan
Stadio (Stadium) 1991 (reconstructed 2000)
wood, steel, glass, etc.
47 1/2 x 275 1/2 x 27 1/2 in.
Collection Cellula and Galleria de Carlo, Milan

22. Choi Jeong-hwa
Advanced Nation: A Late Bloomer 1996 (reconstructed 2000)
lightbulbs, hard board paper
63 x 34 x 34 in.
Courtesy the artist, Seoul, Korea

23. Elizabeth & Iftikhar Dadi
They Made History (Gandhi; The Madhi of Sudan;
Geronimo; The King of Siam) 1999
inkjet prints in circular, neon-backlit frames
18 x 18 in.
Courtesy the artists

24. Rineke Dijkstra
The Buzz Club/Mystery World 1996–1997
2 laserdiscs (color, audio)
Running time 26:40 minutes
Variable dimensions
Courtesy Galleri Paul Andriesse, Amsterdam

25. Stan Douglas
Monodramas 1991
video monitor, laserdisc (color, audio)
Running time 18:35 minutes
Collection Walker Art Center, Minneapolis
T. B. Walker Acquisition Fund, 1996

26. Peter Friedl
Peter Friedl 1998
garments, mixed media
13 costumes as following: Lion, 4 elements; Gorilla, 1 element;
Unic Horn, 2 elements; Crocodile, 1 element; Duck, 1 element;
Ostrich, 1 element; Giraffe, 1 element; Blue Bear, 4 elements;
Cat, 2 elements; White Bird, 1 element; Donkey, 1 element;
Penguin, 2 elements; Kangaroo, 1 element; yellow gymnastic ball
Courtesy Arndt & Partner, Berlin

27. General Idea
General Idea's Yen Boutique 1991
mixed-media installation with table, multiples, wallpaper, video monitor,
laserdisc (color, audio)
Variable dimensions
Running time 30 minutes
Courtesy A. A. Bronson

28. Felix Gonzalez-Torres
Untitled (Golden) 1995 (reconstructed 2000)
gold-plated beads
Variable dimensions
Courtesy Andrea Rosen Gallery, New York

29. Douglas Gordon
Above all else..., 1991 (reconstructed 2000)
wall text, typeface Bembo, paint
Variable dimensions
Weltkunst Collection

30. Douglas Gordon
Something between My Mouth and Your Ear 1994
audio installation (auto-reverse cassette deck, amplifier,
loudspeakers, blue room)
Variable dimensions
Private collection

31. Dan Graham
Rock My Religion 1982–1984
video monitor, laserdisc (color and black-and-white, audio)
Running time 55:27 minutes
Collection Walker Art Center, Minneapolis
T. B. Walker Acquisition Fund, 1999

32. Dan Graham
Three Linked Cubes/Interior Design for Space Showing Videos 1986
wood-framed clear and two-way mirrored glass panels
8 panels, each 91 1/4 x 61 7/8 x 2 3/4 in.
Collection Whitney Museum of American Art, New York
Gift of The Bohen Foundation and purchase, with funds
from the Painting and Sculpture Committee

33. Rodney Graham
Vexation Island 1997
cinemascope video projection, laserdisc (color, audio)
Running time 10 minutes
Variable dimensions
Courtesy 303 Gallery, New York

34. Andreas Gursky
May Day III 1998
C-print
74 x 87 1/2 in.
Private collection; Courtesy Matthew Marks Gallery, New York

35. Duane Hanson
Body Builder 1990
polychromed bronze, with accessories
Life-size
Courtesy Wesla Hanson, Davie, Florida

36. Damien Hirst
beautiful, insane, insensitive, erupting liquid ice 1995
gloss household paint on canvas
84 x 84 in.
Courtesy Peggy and Ralph Burnet, Minneapolis

37. Damien Hirst
beautiful, unfashionable, space-age, red, green, yellow,
blue, pink, orange, turquoise, brown, white, purple, magenta,
exploding rainbow, whirling vortex, spinning hurricane,
chaotic crashing tornado, earth shattering, exploding planet
painting (creating an overall mood of optimistic heaven) 1996
gloss household paint on canvas
84 x 84 in.
Courtesy Barbara Goldfarb, New York

38. Pierre Huyghe
Blanche-Neige Lucie (Snow White Lucie) 1997
video monitor, laserdisc (color, audio)
Running time 3:29 minutes
Courtesy Marian Goodman Gallery, New York

39. Mike Kelley and Paul McCarthy
Fresh Acconci 1995
video monitor, laserdisc (color, audio)
Running time 45 minutes
Collection Walker Art Center, Minneapolis
T. B. Walker Acquisition Fund, 1999

40. Martin Kippenberger
Disco Bombs 1989 (reconstructed 2000)
Mirrored disco balls, colored wigs
Published by Edition Julie Sylvester, New York and Bermuda
Courtesy Julie Sylvester, New York

41. Jeff Koons
Buster Keaton 1988
polychromed wood
63 3/4 x 50 x 26 1/2 in.
Private collection; Courtesy Sonnabend Gallery, New York

42. Kyupi Kyupi
Kyupi Kyupi I++ 1999–2000
video monitor, laserdisc (color, audio)
Running time 9 minutes
Courtesy the artist, Kyoto, Japan

43. Peter Land
Pink Space 1995
video monitor, laserdisc (color, audio)
Running time 4:30 minutes
Courtesy Galleri Nicolai Wallner, Copenhagen

44. Peter Land
The Cellist 1998
video monitor, laserdisc (color, audio)
Running time 9:28 minutes
Courtesy Galleri Nicolai Wallner, Copenhagen

45. Paul McCarthy
Documents 1995–1999
silver gelatin prints
Courtesy the artist

46. Mariko Mori
Enlightenment Capsule 1996–1998
plastic, solar transmitting device, fiber optic cables
108 x 83 x 83 in.
Courtesy Deitch Projects, New York

47. Takashi Murakami
Hiropon 1997
painted fiberglass
71 x 41 x 48 in.
Courtesy Eileen and Peter Norton, Santa Monica

48. Takashi Murakami
My Lonesome Cowboy 1998
FRP resin, fiberglass, steel tubing, steel plate, acrylic paint
90 x 57 x 43 in.
Courtesy Eileen and Peter Norton, Santa Monica

49. museum in progress
DO IT (TV-Version) museum in progress 1995–1996
video monitor, laserdisc (color, audio)
Running time 17 minutes
Courtesy museum in progress, Vienna

50. Minako Nishiyama
Nice Little Girl's Wonderful Dressing-up Room 1992
acrylic on wooden panels, lightbulbs, acrylic one-way mirror, cloth,
carpet, mixed media
94 1/2 x 126 x 126 in.
Courtesy Gallery Shimada, Tokyo

51. Gabriel Orozco
Horses Running Endlessly 1995
wood
4 3/8 x 34 5/8 x 34 5/8 in.
Courtesy Marvin and Elayne Mordes, Baltimore

52. Philippe Parreno
untitled 2000
video projection
Variable dimensions
Produced by the Centre Georges Pompidou, Paris

53. Philippe Parreno
Speech Bubbles 1997
cloth balloons, nylon, mylar
Variable dimensions
Collection FRAC Nord-Pas-de Calais, Dunkerque, France

54. Alexandre Périgot
Fanclubbing 1998–1999
video monitor, laserdisc (color, audio)
Courtesy Voice Gallery, Kyoto, Japan

55. Alexandre Périgot
Fanclubbing 1998–1999
posters
Variable dimensions
Produced by Crestet Centre d'Art, France

56. Alexandre Périgot
Fanclubbing 1998–1999
slides (color)
Collection Caisse des Dépots et Consignations, Paris,
on long-term loan to Mamco, Geneva

57. Jack Pierson
Applause 1997
light box
Edition of 35
Published by New Museum of Contemporary Art and Printed Matter,
New York
10 1/4 x 25 1/4 x 6 5/8 in.
Collection New Museum of Contemporary Art, New York

58. Richard Prince
Brooke Shields (Spiritual America) 1983
Ektacolor print
Edition of 10, 9/10
24 x 20 in.
Courtesy Barbara Gladstone Gallery, New York

59. Charles Ray
Revolution Counter Revolution 1990
wood, mechanism, steel
115 x 164 x 164 in.
Courtesy Massimo Sandretto, Torino
Long-term loan to Castello de Rivoli, Museo di Arte Contemporanea,
Rivoli–Torino, Italy

60. Ugo Rondinone
Dogdays are over 1998
perspex, fluorescent tubes
130 x 303 in.
Courtesy Matthew Marks Gallery, New York

61. David Shea
Let's Entertain Soundtrack 2000
audio installation
Courtesy the artist

62. Cindy Sherman
Untitled Film Stills series 1977–1980
69 silver gelatin prints
17 3/4 x 51 in. and 10 x 8 in.
Edition: AP 2/2
Courtesy the artist and Metro Pictures, New York

63. Andreas Slominski
Untitled 1992
child's bicycle, engine
17 3/4 x 51 x 33 1/2 in.
Courtesy Jablonka Galerie, Cologne

64. Lily van der Stokker
Site-specific wall-painting 2000
acrylic paint on wall, couch
Courtesy the artist and Feature Inc.

65. Uri Tzaig
Desert 1996
video monitor, laserdisc (color, silent)
Running time 30 minutes
Courtesy Galerie Mot & Van den Boogaard, Brussels, Belgium

66. Uri Tzaig
Play 1996
wooden table and video projector, laserdisc (color, silent)
Running time 36 minutes
24 x 63 x 31 1/2 in.
Courtesy Galerie Mot & Van den Boogaard, Brussels, Belgium

67. Piotr Uklański
Dance Floor 1996 (reconstructed 2000)
plexiglass, lightbulbs, audio, mixed media
Variable dimensions
Courtesy Gavin Brown's enterprise, New York

68. Andy Warhol
Andy Warhol's Fifteen Minutes 1987
video monitor, laserdisc (color, audio)
Running time 30 minutes/episode
Andy Warhol TV Productions for MTV Network.
Conceived by Andy Warhol. Director: Don Monroe.
Producer: Vincent Fremont. Executive Director: Andy Warhol.
Associate Producer: Fred Hughes. Production Manager: Sue Etkin.
©1987 The Andy Warhol Museum, Pittsburgh,
a museum of Carnegie Institute. All rights reserved.

69. Andy Warhol
Andy Warhol's TV 1981
video monitor, laserdisc (color, audio)
Running time 30 minutes/episode
Conceived by Andy Warhol. Director: Don Munroe.
Producer: Vincent Fremont. Executive Producer: Andy Warhol.
Production Manager: Sue Etkin.
©1987 The Andy Warhol Museum, Pittsburgh,
a museum of Carnegie Institute. All rights reserved.

70. Gillian Wearing
The Regulator's Vision 1995/1996
video projection, laserdisc (color, audio, running time 17 minutes)
video monitor, laserdisc (color, audio, running time 7 minutes),
assorted furniture
Variable dimensions
Courtesy Maureen Paley/Interim Art, London

Artists' Biographies

Doug Aitken Born 1968 Redondo Beach, California

Doug Aitken uses video and photography as artistic tools to investigate the global landscape. A member of the first generation raised on music videos, the artist engages the thrilling and seductive strategies of that entertainment medium to create art that is exceedingly pleasurable even as it raises questions of global displacement, disappearing landscapes, and the often overwhelming hyperkinesis of contemporary life. For *Monsoon* (1995), Aitken traveled to Jonestown, Guyana, to visit the site of the 1978 People's Temple mass suicide, only to find that this historic place was being reclaimed by the rain forest that surrounds it. *Let's Entertain* includes a three-monitor video installation, *these restless minds* (1998; pp. 210–211), which examines a different kind of geography and spectacle—the contemporary American landscape and the distinct poetry of the American auctioneer. Seated by escalators and standing in empty parking lots, the auctioneers call nameless lots to absent auction crowds. These scenes are intercut with images of highways, truck stops, oil wells, and radar installations, which seem to comment on our need to communicate and remain in motion as the nearly unintelligible linguistic somersaults of the auctioneers wash over us. The spinning, frenzied vortex of sound alludes to the overload of information that pervades contemporary society. Aitken seeks to "bring the viewer toward something a bit more intangible, providing... a sense of discovery and questioning." He was awarded the International Prize at the 1999 *Venice Biennale* for his installation *Electric Earth* (1999).

Carlos Amorales Born 1970 Mexico City

Like many artists of his generation, Carlos Amorales has a complicated notion of homeland. He was born in Mexico, currently lives in Amsterdam, and disseminates his art through a variety of global outlets, including the Internet. He is interested in the Mexican popular culture of free wrestling, a world of fantastically costumed, masked wrestlers whose "real" identities are hidden behind superhero costumes. One such figure is Superbarrio, a wrestler and folk hero who leads political demonstrations. Amorales has conducted a number of interviews with him and recorded performances by this character and his creator, Marcos Ramos. Included in *Let's Entertain*, *Amorales Interim* (1997; pp. 102–105) consists of a video monitor placed on the floor, which shows a wrestling match in three rounds between two masked men who try to push each other out of the video frame. Amorales describes his work as "an attempt to discuss and understand how physical and psychological confrontation between "self" and "other" shapes our understanding of personal identity and of social image."

Bernadette Corporation Founded 1993; based in New York

Bernadette Corporation (BC) is a shifting collective-collaborative, deliberately sidestepping precise categorization, made up of young artists, fashion designers, stylists, and filmmakers. The organization has begun to function as its own kind of cultural institution, providing an authentic, legitimizing context for otherwise marginalized modes of expression and talent. BC began producing multimedia events and situations in 1993, starting with after-opening parties and evolving to art and fashion flea markets and bazaars in SoHo parking lots and the broadcast of *A Fashion Event for Fashion Week* on Manhattan Cable Public Access. For the past few years, its work has centered almost exclusively around fashion. BC has produced several very successful lines of clothing, and its exceptional fashion shows—incorporating video, photography, music, and choreography—have received impressive notices in *Artforum*, *The Face*, *Harper's Bazaar*, *Index*, and the *New York Times*. Since 1998 BC has been working on the publication of a fashion magazine, *Made in USA*, which exposes and investigates the conventions of the worlds of fashion, music, and art. *Let's Entertain* features an installation of photo and video documentation of a fashion shoot titled *Creation of a False Feeling* (2000).

Dara Birnbaum Born 1946 New York

Dara Birnbaum has been recognized internationally for her video and installation works. Her work has been exhibited in *documenta*, the *Whitney Biennial*, and the *Carnegie International*. Other outlets for her work have included broad-

cast television, MTV, video/music clubs, and public spaces such as New York's Grand Central Station. She was part of the first generation of video artists who appropriated and deconstructed television imagery. Her interest in reexamining mass-media representation has itself been a response both to the changing nature of access to television and to advances in video technology. Her interactive *Rio Videowall*, installed in Atlanta in 1989, was heralded as the first large-scale permanent outdoor video installation in the United States. *Let's Entertain* includes two of her early videos. *Technology/Transformation: Wonder Woman* (1978–1979; p. 248) is a deconstruction and reconstruction of images from the popular 1970s television series. Through Birnbaum's stuttering edits, the "real" woman is repeatedly symbolically transformed into the superhero, Wonder Woman, subverting conventional meanings. *Kiss the Girls: Make Them Cry* (1979; p. 250) is a bold deconstruction of the formulas of gender representation in pop culture imagery and music. Birnbaum isolates and repeats moments from the TV game show *Hollywood Squares* to expose the gendered, stereotyped gestures of its celebrity participants while spelling out the lyrics of disco songs of the era (one of which gives the piece its title). The work offers a powerful analysis of the meaning of gestures in our media-saturated society.

Dike Blair Born 1952 New Castle, Pennsylvania
Dike Blair has practiced his art for more than two decades, working in a variety of media, including painting, photography, sculpture, and installation. His work presents a cool analysis of an aesthetic available in "everyday America" through the framework of interior design and the visual conventions of places such as highways and motels, strip clubs and strip malls, industrial and theme parks, airport lounges and bank lobbies. His contributions to *Let's Entertain* include two photo and glass "paintings" that reference Disney's EPCOT Center as well as two sculptures composed of fluorescent lights, carpeting, and photographs (pp. 132, 134, 138–139). He thinks of his sculptures as "physical haikus" that combine elements of the often ignored, generic interior environments that serve as a backdrop for our lives with literal yet abstract landscapes like those we view through the automobile or aircraft window. In the early 1990s Blair began to write about art and various other topics for magazines such as *ArtByte*, *Flash Art*, and *Purple*. Over the last few years he has published a series of interviews, many of which feature personalities who design elements of our everyday experience. Several of these interviews are included in this volume.

Leigh Bowery 1961–1994; born Sunshine, Australia
Leigh Bowery was a performance artist, fashion designer, nightclub sensation, art object, pop star, leader of the art-rock band Minty, and above all an icon whose influence traversed many worlds. He arrived in London in 1980, where he began a collaboration with the English choreographer Michael Clark, designing dance costumes that included elements such as platform shoes, T-shirts with cone-shaped breasts, and padded clothing. Thanks to his flamboyant appearance, he became the public face of the infamous Taboo nightclub and an icon of London nightlife. He was the entertainer par excellence. By the late 1980s his reputation extended well beyond the club scene. In 1988 the Anthony d'Offay Gallery in London presented a solo exhibition in which Bowery wore different costumes and struck poses in front of a one-way mirror. By that time, he was beginning to think of his performances as a form of art as well as entertainment. Bowery is represented in *Let's Entertain* by *Ruined Clothes* (1988), which consists of several costumes he planned to exhibit, randomly placed on the floor in a way reminiscent of Marcel Duchamp's *3 Standard Stoppages* (1913–1914). The film *Death in Vegas* (1994; p. 118) reimagines Elvis Presley's final hours, providing an analysis of American celebrity and excess and the flawed mythology of rock-and-roll legends.

Olaf Breuning Born 1970 Schaffhausen, Switzerland
Olaf Breuning uses quotation and juxtaposition to examine issues of present-day art production through multidisciplinary work. He combines the triviality of computer games and fairy tales with strategies that respond to the work of artists such as Matthew Barney, Ugo Rondinone, and Cindy Sherman. Like a latter-day Walt Disney steeped in twentieth-century art history, Breuning produces unique worlds that oscillate between the fictional and the real. His multi-

sensory sculpture *Boomcyclone* (1999; pp. 278–279) is a fantastical cross between a Fisher Price toy and an iMac computer—a deliciously colored vacuum cleaner, light show, and boom box, all in one. The artist disassembled and then reassembled a popular new Hoover vacuum cleaner, adding embellishments of sounds and lights. Using a computer program, he created the music from samples of airplane noise and popular music. No longer functional as a cleaning tool, the piece spectacularizes the domestic space and household chores through design, color, and sound. Almost a distant cousin of Donald Judd's Jell-O-like sculptures, it turns the mundane machine-made object into something sensational. Breuning's complex works mine the conjunction of the absurd with the concerns of contemporary life to great effect.

Mathieu Briand FONDATION23@hotmail.com

Mathieu Briand's work challenges our notions of a visual language by drawing on sources outside traditional art practices. He embraces a domain that encompasses electronic media and music, the sciences, new technology, architecture, phenomenology, and virtual space, as well as games and rituals. His work is often made in collaboration with other artists, scientists, engineers, and philosophers, thereby calling into question notions of authorship and altering the experience of art. The language that Briand elaborates is far from the subculture of digital technology. Rather, he uses technology to explore the psychological, physical, and sociological shifts inherent in a culture that is flooded by information from all directions. For *Let's Entertain*, he has created a device that blurs the boundaries of physical and virtual perception through the disruption of the senses and memory. Using video glasses and TV transmitters and receivers, *SYS*05.ReE*03/SE*1\MoE*2-4* (2000) allows users to switch from their own to another user's perception, in an endless loop of visual intrusions. As a result, the users' experiences change on a random basis. Their connections through this device create a meta-space within the galleries, a mental space within the architectural space. Even though Briand's method is to exploit the tools and strategies of entertainment technology, the result is what the artist calls a "controlled schizophrenia," or a metaphysical reflection on our collective consciousness.

Jessica Bronson Born 1963 Minot, North Dakota

A Los Angeles–based artist working with video and audio, Jessica Bronson is interested in the poetics of video effect and the disruption of "real" time through repetition. Although her work has been exhibited in major museums—including a solo project and installation at the Museum of Contemporary Art, Los Angeles, an accompaniment to her 1998 Emerging Artist Award—Bronson often embraces the "lowbrow," showing her work in bars and other environments of leisure. For *Let's Entertain*, the artist is collaborating with the Dick Slessig Combo—Carl Bronson, Steve Goodfriend, and Mark Lightcap—a band known for repetitious and reduced covers of musical standards by the likes of Pharaoh Saunders and Ramsey Lewis. Working with Carl Bronson, she has designed a curvilinear bandstand that is lit from below so that it appears to float in a pool of light. The band will perform on the stage on the opening night of the exhibition, leaving behind the lights and a looped compact disc of the performance for the duration of the exhibition. This empty stage with disembodied voices evokes notions of virtual pleasure and performance, the empty dreams of Hollywood, and the underbelly of spectacle. The machinery of fame—illumination, spectacle, performance—is laid bare, and the lack of a nice Hollywood ending suggests a disrupted narrative. This piece also engages in a dialogue with the "light and space" works of Robert Irwin and the architectural pieces of Dan Graham.

Roderick Buchanan Born 1965 Glasgow

Roderick Buchanan's work often focuses on team sports, particularly soccer. This activity serves as a point of entry for a critical but humorous examination of issues of community, identity, difference, and allegiance. Many of his works have been critically site-specific, politicizing public space and the body. In a series of photographs of Turkish Berliners wearing New York Yankees baseball caps, apparel becomes a marker of cultural nomadism and malleable identity, indicating preferences and loyalties that are just as easily adopted as discarded. In *Chasing 1000* (1994; pp. 42–43) Buchanan and artist Paul Maguire are shown within a fixed frame, shot from above, in an anonymous gymnasium setting. They are dressed from head to toe in box-fresh basketball gear, but instead of playing basketball, they start performing a soccer drill, heading the ball back and forth for ninety minutes. An on-screen counter keeps track of vol-

leys. The goal is to reach 1000, but the counter returns to zero each time the ball falls, lending a sense of absurdity to the exercise. Buchanan has taken the street game of his home country and combined it with that of another culture, the United States. The work alludes to the basketball culture blossoming in the United Kingdom, pointing out, with a sweet irony, how sports and other popular phenomena affect and alter notions of cultural identity. Buchanan's work was included in the 1999 *Venice Biennale*.

Lee Bul Born 1964 Yongwol, South Korea

South Korean artist Lee Bul has spent more than a decade investigating issues of man and machine, technology and sociocultural context, and art and gender. Multidisciplinary in approach, she first became known for street perform-ances that caught her audience "disarmed" and sculptures that incorporated decaying fish, unusually foregrounding the sense of smell in an art-gallery setting. Her *Cyborg Blue* and *Cyborg Red* (both 1997–1998; pp. 280, 282) are sculptures of female cyborgs with missing heads and limbs, inspired by Japanese *anime* and *manga* (animated car-toons and comic books) as well as current developments in bioengineering. The artist mines the "in-between" of man and machine through her use of silicone (a material also used in medicine, particularly plastic surgery). Like the car-toon characters that inspired them, her hybrid creatures have superhuman strength, yet they retain traditionally fem-inine sexual features. Through these feminized beings, Bul questions the supposed gender neutrality of technology. She also examines the male fantasies that have shaped the way technology is interpreted, delving into the interface between art, bioengineering, and feminist social science. Bul's work was included in the 1999 *Venice Biennale*.

Maurizio Cattelan Born 1960 Padua, Italy

Maurizio Cattelan is known for his humorous and at times aesthetically subversive interventions into the art world. His art takes an innovative approach, often combining sculpture and performance. At his 1998 solo show at the Museum of Modern Art in New York, for instance, museum visitors were greeted by a person disguised as Pablo Picasso. Cattelan's 1999 *Venice Biennale* entry involved an Indian fakir buried in the sand for extended periods of meditation. He uses all available artistic forms to reflect on the structures and mechanisms that rule our lives. While he does not offer solutions, he shows that one can survive and use the system without being consumed by it. In *Stadio (Stadium)* (1991; p. 32), Cattelan created an extra-long foosball table that allows eleven players (an entire soccer team) to compete on each side. In its original incarnation, the work played on the Italian obsession with soccer as well as the anxiety of a nation facing a rising immigrant population: the artist staged foosball games between an Italian football league team and a team made up of Senegalese immigrants (pp. 30–31). As Cattelan has remarked, "When a work is successful, it must allow you to play with everybody, to make sensibilities vibrate. The interpretation we give here is only one possibility, but it's not the only one, luckily."

Choi Jeong-hwa Born 1961 Seoul

Mixing elements of fun, silliness, "fashionable kitsch," and everyday materials, Choi Jeong-hwa creates works, using various media, that run the gamut from rough and austere to gaudy and oversized. Fascinated with the "real" within the excess of Korean popular and commercial culture, Choi's work often "hovers between celebration and memorializa-tion." He was instrumental in forming a Korean art underground when he joined several fellow Seoul artists in the late 1980s to form a group called Museum. The group pushed conventional boundaries by mixing genres and using out-rageous media like rotting food and live chickens, taking their work into bars and the streets. Simultaneously influ-enced by and rebelling against Western Pop Art and Minimalism as well as Korea's populist and political Minjung culture (whose art emphasizes a connection to the public), Choi comments on the rapid economic, technological, and media changes that have transformed South Korea in the last two decades. Constantly blurring the lines between art, life, and artifice, as well as those between high and low culture, he has also worked as an interior designer and art director for films. *Advanced Nation: A Late Bloomer* (1996; p. 272) is composed of lightbulbs and wire elements that refer to the ostentatious faux-crystal chandeliers that grace many prefab apartments across Korea. These chandeliers have become a signifier of Korean middle-class status, culled from mass-media representations imported from foreign movies and television programs. The meeting of cultures in his work reflects evolving values and signifiers that now

define Korean class identity. His work offers a commentary on contemporary reliance on technological and consumerist promise in light of vanquished military rule in Korea. Choi's work was included in the 1998 *São Paulo Bienal*.

Elizabeth Dadi Born 1957 Seattle **Iftikhar Dadi** Born 1961 Karachi, Pakistan

Elizabeth and Iftikhar Dadi often make their art in collaboration with Pakistani craftsmen. They view popular cultural practices as a viable means of addressing local concerns. A source of inspiration is the vibrant culture of the Third World city, which, in the absence of a high art tradition and a museum context, assumes an important role for urban society. The Dadis' work appropriates some of the exciting cultural forms emerging in these areas, while addressing issues of colonial hangovers and national culture, cultural purity, multinationals, and global media pressures. Four computer-generated light-box portraits from the larger series *They Made History* (1999; pp. 264–265) are included in *Let's Entertain*. Each is a portrait of a great non-Western man as played by a Western actor—for instance, Chuck Connors in the film *Geronimo*. The Dadis conceive of these works as an interrogation into the legitimization of greatness and history as measured by the insertion of these heroes into the popular medium of cinema. In a culture in which the public consciousness of historical figures is often shaped by powerful media outlets, these works suggest the possibility of suppressed or alternative histories. The Dadis' work was included in the 1998 *São Paulo Bienal*.

Rineke Dijkstra Born 1959 Sittard, the Netherlands

Rineke Dijkstra is best known for a series of beach portraits, candid shots of individual bathers at the water's edge, which she took while traveling through the United States, England, Poland, and Belgium. In 1996 she photographed street children in Ghana for UNICEF, and the following year her work was exhibited at the Museum of Modern Art in New York as part of its New Photography series. Her recent video portraits of teenagers at schools and nightclubs in England and in the Netherlands—including *The Buzz Club/Mystery World* (1996–1997; pp. 161–166)—have been shown at various venues, including the Stedelijk Museum, Amsterdam, and the 1998 *São Paulo Bienal*. Isolated from their peers, her adolescent subjects seem visibly hyperaware of their bodies and their vulnerability as the object of the camera's gaze. The artist describes these pieces as "not really about specific persons but about a psychological encounter in a more general sense." *The Buzz Club/Mystery World*, the artist's first video piece, was made at dance clubs in Liverpool and Zaandam. Dijkstra videotaped young clubbers in a makeshift studio right off the main dance floor. While never giving precise direction, she did offer them certain scenarios: "Imagine you want to dance, you are at the edge of the dance floor, and you move a bit, but not really…" Not much happens: her subjects confront or avoid the camera's gaze, sway to the beat, blow smoke rings, or suddenly let loose with frenetic dancing. It is a spectacle of the ordinary. Entirely mesmerizing, the large-scale projection envelops us in the world of teenagers struggling to define themselves and project a certain self-image, seeking conformity with their friends but simultaneously aiming for the distinctly individual.

Stan Douglas Born 1960 Vancouver, Canada

Stan Douglas' work often deals with the social and physical damage wrought by development and progress in the last half of the twentieth century. As one critic has written, through the tools of mass media—video, broadcast television, and photography—Douglas "slyly raises abstruse scholarly material to lyrical intensity." At once seductive and deconstructive, his work flirts with the traces of sentiment and memory embedded in the contemporary urban landscape. For instance, in *Win, Place, Show* (1998), he takes viewers to the Vancouver neighborhood of his youth through the architectural plans for a housing project that was almost built there in the 1950s. Douglas links this social engineering initiative to the utopian, modernist ideals of Le Corbusier as perverted by the social realities of 1950s Canada. *Let's Entertain* features the video work *Monodramas* (1991; p. 114), a compilation of ten short vignettes produced for insertion between regular broadcast television programs. These pieces, often focusing on the mundane, were intended to confound, intrigue, and challenge the assumptions of the viewer. As much about social commentary as about political discourse, the work holds up a mirror to the viewer's dysfunction. Douglas explores the intersections of memory, truth, and identity through the familiar vehicle of television, but in his hands the medium is not as familiar as previously assumed. Douglas' work was featured in *documenta X* in 1997.

Peter Friedl Born 1960 Oberneukirchen, Austria

Creating artwork that operates as an open field of signs and actions, Peter Friedl mixes conceptual rigor with socio-cultural investigation. He frees viewers to participate in and interpret his works with their own subjective knowledge while blurring the lines between form and politics, private and public, self and other. *Peter Friedl* (1998; pp. 222–223) was originally conceived and shown during a retrospective of his work at the Société des Expositions du Palais des Beaux-Arts in Brussels. The artist asked all sixteen employees of the museum to name an animal they would like to become and create a new name for it. Friedl then had costumes of the animals made in adult and children's sizes and placed in a heap in the middle of a gallery. Visitors donned and discarded the costumes at will throughout the exhibition, leaving them behind like a trail of convenient but now-forgotten identities. The work, a kind of invitation to masquerade, suggests the mutability of the self as well as a certain melancholy. It also seems to evoke social hierarchies, such as those between a parrot and a crocodile, a parent and a child, a visitor in costume and one not. Through play, Friedl explores the hidden social systems and political hypocrisies of our time. His work was included in *documenta X* in 1997.

General Idea 1968–1994; based in Toronto

In 1968 AA Bronson, Jorge Zontal, and Félix Partz reinvented themselves as the artists' group General Idea, produc-ing films, videos, performances, and photographs, all of which functioned in unison. As they stated in 1975, "General Idea is basically this: a framing device within which we inhabit the role of the artist as we see the living legend." They reimagined themselves as figures of popular culture, courting fame, fortune, and glamour. If an investigation into the nature of glamour was the principal concern of their early works, it found its quintessential expression in the various beauty pageants that they started to develop in 1970. More specifically, the 1984 Miss General Idea Beauty Pageant and the subsequent 1984 Miss General Idea Pavilion elaborated framing structures that reference forms of popular entertainment. General Idea sought the pleasures of the so-called entertainment industry, devising different modes of dissemination—for instance, publicity/promo shots of their various masks of identity and a video documenting the orchestrated and programmed cheers of an audience. In *Let's Entertain*, General Idea is represented by *General Idea's Yen Boutique* (1991; pp. 140–141), which features several General Idea multiples.

Felix Gonzalez-Torres 1957–1996; born Güaimaro, Cuba

Felix Gonzalez-Torres habitually conferred an aura of art on the most mundane objects—hard candies, wall clocks, lightbulbs, jigsaw puzzles—and often invited the viewer to activate his art through interaction. Versed in the language of Minimalism and Conceptualism, the artist infused these well-worn ideas with social commentary born of the urgency of living in a time of AIDS. His work—ambiguous, subtle, and highly metaphoric—often broke down the boundaries between "us" and "them." His seemingly banal readymades were democratic in accessibility, leading viewers "through a maze of images that describe a society in crisis" while simultaneously evoking "bittersweet epipha-nies of temporary communion and ultimate solitude." For instance, *Untitled (Placebo)* (1991) consists of a six-by-twelve-foot carpet of shiny silver wrapped candies whose weight totals the combined weights of the artist and his lover, who died of AIDS. Viewers are invited to each take a candy, thus altering the sculpture, and, perhaps, to con-template or discuss art, loss, memorials, AIDS, and public policy. This exhibition features *Untitled (Golden)* (1995; pp. 126–127), a curtain of gold plastic beads dividing one gallery from another. Resembling a wall of golden light, these shimmering, rustling strands invite the viewer to touch and pass through. They transform the architecture of the space and constantly change in shape as each person moves through them. They embody the sensual intensity of Baroque sculpture while also acting as a penetrable boundary between the known and the unknown. Like most of Gonzalez-Torres' work, they manifest a sense of melancholy while offering the spectacle of pleasure and illumination. He often thought of his beaded curtain pieces as alluding to bodily fluids and medications associated with fighting HIV. This piece is an "unsentimental mixture of pure seriality and disturbing content" in the best possible sense.

Douglas Gordon Born 1966 Glasgow

Through his appropriation of the communication structures of contemporary society, Douglas Gordon explores the mind's proclivity to create meaning, encouraging the viewer's active participation. Beyond their formal differences, his

works are unified by the theme of memory, especially collective memory, and a focus on the act of perception through an evocation of intertwining private and public experience. This evocative power is especially evident in the pieces created using preexisting visual or audio sources. *Something between My Mouth and Your Ear* (1994; pp. 142–143) is a sound installation of songs popular in the months immediately preceding and following the artist's birth in 1966. Gordon is interested in this cultural context as a hidden influence on his perception of the world, an influence that possibly had its origin outside his real experience but that may have shaped his reading of reality nonetheless. *Let's Entertain* also features the large-scale text installation *Above all else…* (1991; p. 144), which ends with the ominous but eerily comical words "We are evil," the chant of a local football group that Gordon read about in the newspaper. Placed on the ceiling, this piece disrupts the symmetry, physical and metaphorical, of the architectural space in which it is installed. It is both present and hidden by its location, waiting to be discovered and pondered by a visitor who dares to look upward. Gordon received the 1998 Hugo Boss Prize from the Solomon R. Guggenheim Museum in New York and also participated in the 1999 *Venice Biennale*.

Dan Graham Born 1942 Urbana, Illinois
A conceptual artist, architect, photographer, performer, video artist, and critic, Dan Graham began in the 1960s to reflect on the artistic system, focusing particularly on the mechanism of perception offered by works in different contexts. Since the early 1970s the ideology that underpins social phenomena such as rock music and architecture has been at the center of his work. Inquisitorial ads in newspapers, revealing contributions to magazines, antirational architectural works, and exterior and interior pavilions than combine formal simplicity with visual complexity are some of the many means through which Graham has explored his theories. His video work *Rock My Religion* (1982–1984; pp. 252–253) explores how rock music as an art form parallels the development of the Shaker religion in America, especially its emphasis on ecstatic spirituality and trance experience. *Three Linked Cubes/Interior Design for a Space Showing Videos* (1986; pp. 218–219) consists of a series of rectangular bays with alternating two-way mirrors or transparent glass. Video monitors and speakers have been placed inside to allow separate programs for audiences divided into different groups. The work is at once a piece of architecture and a work of optical art; the mix of reflective and transparent surfaces allows viewers to see both the videos and their own and others' reactions to the videos as the exhibition space becomes a social space. Borders between private and public, separate and collective, inside and outside are all questioned within this structure. Graham's video viewing structures were included in *documenta X* and the *Whitney Biennial*, both in 1997.

Rodney Graham Born 1949 Vancouver, Canada
In the work of Rodney Graham, human estrangement from nature is of paramount concern. Despite attempts to bridge the rift between the two spheres, Graham's vision always ends with some sort of abyss continuing to divide them. Working with photography, film, and book art, he spins classic narratives with a contemporary Freudian twist, often featuring neurotic heroes who are doomed to a Sisyphean existence of endless repetition. Such a figure, played by the artist, is at the center of *Vexation Island* (1997; pp. 204–206), in which an eighteenth-century sailor is marooned on an archetypally lush, paradisiacal desert island. The sailor lies unconscious on an empty beach, eventually rising to shake a coconut from a nearby tree; the coconut falls on his head, thus returning him to his unconscious state, and the cycle repeats. Created for the Canadian Pavilion of the 1997 *Venice Biennale*, this film is presented in the vivid Technicolor and wide-screen Cinemascope of a Hollywood film or advertisement for a Caribbean getaway cruise. Incredibly pleasurable to savor, it is nonetheless a study in frustrated storytelling as its continual loop denies the viewer the gratification of a narrative that progresses. In Graham's desert-island adventure, nature always triumphs over the vain struggles of man.

Andreas Gursky Born 1955 Leipzig, Germany
German artist Andreas Gursky is best known for his billboard-size photographs that inhabit a space between painting and photography, landscape and human concern, animate and inanimate. He often places his large-format camera at a high-angled distance from his subject, creating images that suggest mapping stills from outer space or cyber-

technology. Sometimes computer manipulated, his images of corporate architecture, environmental contemplations such as pebbly earth, and mass groups of people freeze-framed mid-motion often reference the geometric forms of Minimalist Art and the "allover" quality of a Jackson Pollock painting. Our eyes dance across his dense, often slightly abstracted images, which display strong formal elements as they blend relationships between nature, culture, and technology. He is particularly concerned with capturing motion and creating a moment of stillness in that space. His work is "as much akin to the physics of motion as it is to the philosophy of convergence." *Let's Entertain* features a large photograph of a mass of youthful partygoers titled *May Day III* (pp. 8–9). This hazy, overcast image evokes film stills, apocalyptic imaginings, mass demonstration news documents, and other associations from our collective consciousness. One critic commented that Gursky's images "depict social and geographical stresspoints… involve people who are drawn into a kind of geographical or social unity, if an imperfect one." This mass gathering of ravers suggests that some of us are caught in a moment when cultural tropes such as music present the only viable and desirable opportunity for collective engagement. Politics has been usurped by culture and identities are formed through these moments of common ecstatic abandon. Through highly dramatic means, Gursky at once documents and remaps this party as an instance of promise, failure, confusion, and hope.

Duane Hanson 1925–1996; born Alexandria, Minnesota
Although he wavered between abstraction and figuration early in his career, Duane Hanson landed squarely in the latter camp by the late 1960s. Drawing on Pop Art and earlier art appropriation impulses, he used fiberglass and resin to create his well-known catalogue of American social types, including the tourist, the cowboy, the shopper, the cheerleader. His work dealt with space and form through hyperrealism at a time when many artists were addressing these issues through abstraction. His carefully painted trompe l'oeil figures often get mistaken for real people, highlighting present-day obsessions with virtual reality and our persistent inability to distinguish between reality and its reflection. *Body Builder* (1990; p. 180) plays on that blurred distinction and carries a psychologically charged undercurrent similar to that experienced in displays of "reality" on TV talk shows and MTV's *The Real World*. As one critic noted, Hanson's "sculptures trigger full-blown narratives, daily American tragedies, almost before you know it."

Damien Hirst Born 1965 Bristol, England
Controversial, obsessive, and eclectic in practice, Damien Hirst played a key role in reigniting the British art scene in the 1980s and 1990s with multidisciplinary works that range from paintings and sculptures to installations and films. Hirst fearlessly and often playfully captures the heartbeat of contemporary life in works that investigate the meeting of art, science, media, and popular culture. Although the artist is best known for his animals in formaldehyde tanks, a meditation on our obsession with death and dying, he has also created sculptures that tempt gravity and other laws of physics as well as a series of spin paintings, two of which are included in *Let's Entertain* (p. 62). Hirst called a different series of paintings based on pharmaceuticals "visual candy," and that description fits these works as well. In these colorful creations, Hirst elevates a popular children's arts and crafts activity to high art, using a special spin wheel, huge round canvases, and glossy house paints. These machine-made paintings, which take five minutes to produce, raise larger questions about the definition of art and authorship and simultaneously allude to the role of entertainment and pleasure in art-making.

Pierre Huyghe Born 1962 Paris
Pierre Huyghe's works make evident the temporary feelings of alienation one experiences on a daily basis. He attempts to decipher our systems of social exchange in an analysis of the structure of time—real time, deferred time, free time, work time—in each case envisioning time as a consumable product. In *Remake* (1995), a refilming of Alfred Hitchcock's *Rear Window*, Huyghe produces a shift by using unknown actors and working on location in the suburbs of Paris. He exhibits the bare bones of the project, stripped of its Hollywood aura and fetishistic nostalgia. Through this process he introduces the notion of an art conceived as a production of infinitely reusable models, scenarios subject to daily reinterpretation. *Blanche-Neige Lucie (Snow White Lucie)* (1997; pp. 216–217) also deals with issues of reinterpretation. This video work features Lucie Dolène, who in 1962 dubbed the French version of Disney's ani-

mated film *Snow White*, humming "Some Day My Prince Will Come" as subtitles run below describing her legal battle with Disney to regain rights to the use of her own voice. We never hear her speak. The relationships between a French actress, a cartoon character, and a multinational corporation create a complex parable about voice, identity, and the hard business of entertainment. Huyghe was represented in the 1999 *Venice Biennale* and the *Carnegie International* exhibitions.

Mike Kelley Born 1954 Detroit
Mike Kelley, based in Los Angeles, has created a provocative and far-reaching body of work that includes performance art, installation, and sculpture. His work treads a highly charged terrain of desire, dread, and dysfunction in everyday American life while attempting to dispel the cynicism and self-satisfaction that has accompanied the triumphs of the "American century." He often reinvents childhood toys and everyday objects, investing them with subversive meanings. A raging satirist, Kelley has used the freewheeling intermedia approach of Conceptual Art to forge a series of inventive works that challenge prevailing notions of taste, influence, moral authority, social responsibility, and art's transcendent function. In *Fresh Acconci* (1995; pp. 212–213), Kelley, in collaboration with Paul McCarthy, remade video-art pioneer Vito Acconci's performance works from the 1970s, using B-movie actors as performers. *Fresh Acconci* alludes both to the resurgence of the 1970s in pop culture and the art world and to Hollywood B movies and the soft-core porn made in the Hollywood Hills. The work raises questions about the avant-garde as a style to be adopted, discarded, or revised like any other. This book also includes a reproduction of a double-sided poster that the artist created for his 1999 exhibition at Patrick Painter Inc., Los Angeles (pp. 228–238). A sharp satire on America's celebrity culture and sexual dysfunction, it includes three texts. The first, written by Kelley, is a hilarious send-up of the roles of pleasure, sex, and celebrities in the post–Clinton scandal era. The second is a London newspaper's report on the 1998 passage of an anti-paparazzi law in California. Finally, Kelley collages together several slightly different media reports on an incident involving director Steven Spielberg and a man who staked out his Los Angeles home. At once hilarious and chilling, this piece points to the slippage between fiction and truth in a town that specializes in illusion. A collaborative work by Kelley and Tony Oursler was included in *documenta X* in 1997.

Martin Kippenberger 1953–1997; born Dortmund, Germany
For Martin Kippenberger, sculpture, painting, photography, drawing, music, poetry books, invitation cards, and posters were all equally valid forms of artistic expression. A member of the generation of German artists who reacted against the legacy of Joseph Beuys, Kippenberger challenged style, good taste, and social conventions. He galvanized Vienna by organizing the "First Viennese Cab Race," and in 1978 he created the Kippenberger Office in Berlin, offering his services to various clients. During the same period he became the manager of the bar SO 36, finding himself at the heart of a movement that repudiated the values of the "deadbeat" 1970s subculture. In the mid-1980s Kippenberger became increasingly involved in extravagant projects that pushed back conventional exhibition boundaries. Expanding his sphere of activities, he established himself as director of the Museum of Modern Art, Syros (MOMAS), which opened in 1993 with the mission statement that no work was to be shown in the building. His *Disco Bombs* series (1989; p. 268) consists of nine mirrored disco balls combined with colorful wigs. Displayed on the floor, these "bombs," at once melancholic and inviting, reflect on fame, glamour, and the role of the artist. Kippenberger was artist, showman, impresario, critic, collector, and creator of exhibitions. His work was included in the *Venice Biennale* and *Carnegie International*, both in 1999.

Jeff Koons Born 1955 York, Pennsylvania
Since his emergence in the 1980s Jeff Koons has blended the concerns and methods of Pop, Conceptual, and appropriation art with craft-making and popular culture to create his own unique art iconography, often controversial and always engaging. His work explores contemporary obsessions with sex and desire; race and gender; and celebrity, media, commerce, and fame. A self-proclaimed "idea man," Koons hires artisans and technicians to make the actual works. For him, the hand of the artist is not the important issue: "Art is really just communication of something and the more archetypal it is, the more communicative it is." *Let's Entertain* features *Buster Keaton* (1986;

p. 246), a painted wood sculpture, exaggerated in scale and hinting at rococo, that is really a seamless collage of banal images from mass culture. Keaton's haunted, melancholy gaze seems to be searching for something, but we are left wondering what that might be. With a common material that the artist sees as connected to the "security of religion" and a subject that is definitively kitsch, this work is a comment on social hierarchy through the signifier of taste. Seemingly familiar, beautiful, and slightly absurd all at once, *Buster Keaton* gives visual pleasure to the audience, perhaps a guilty pleasure, at the same time as it questions monuments, reproductions, and taste, art and artifice, high and low. Koons has had a significant impact on a number of artists included in this exhibition. His retrospective *Jeff Koons* traveled to the Walker Art Center in 1993, and he was represented in the 1997 *Venice Biennale*.

Kyupi Kyupi Founded 1996; based in Kyoto, Japan
Kyupi Kyupi is an artists' collective that includes Yoshimasa Ishibashi, president; Koichi Emura, graphic designer; Mazuka Kimura, art director; and Mami Wakeshima, costume designer. In addition, they often work with members of Dumb Type, the well-known Japanese avant-garde performance art group. Fostering a volatile and often harmonious clash of different cultures and drawing inspiration from a variety of sources—such as Op Art, science fiction, theater, Disney, graphic design, Monty Python, Japanimation, and cabaret—the collective combines cinema, drama, performance, video art, and live music. They seek to present "free art that ignores genres and can express in any genre… the ideal shape of media art." Their videos, a selection of which will be shown in *Let's Entertain* (pp. 94–98), combine eye-poppingly colorful sets, extravagant costumes, and cabaret music with campy sci-fi homages. The group builds its own sets, which often include homemade gadgets; writes and performs its own music; and choreographs its own movement, often hilarious and erotically charged. For instance, *Pizza Erect* (1999) features actors with green tentacles emerging from their heads or dynamically colored wigs and dangerously high heels seeming to reimagine *Star Trek* as an erotic and humorous romp, complete with pizza delivery ladies and a lecherous master of the universe. In the near future Kyupi Kyupi is planning to publish a magazine and a picture book; produce CDs, DVDs, and a television program; and establish a Kyupi Kyupi television station.

Peter Land Born 1966 Aarhus, Denmark
Peter Land uses his video camera to record failure, his own failure, again and again. It's the Sisyphus myth turned slapstick. A zealous aesthetic of failure surges through various scenarios starring the artist himself, yet the audience is invited to cry or laugh at, and with, the performer. Adopting the style of tragicomic figure Lenny Bruce, Land explores the extremes of exhibitionism and voyeurism through this confrontation with audience response. *Pink Space* (1995; pp. 10–11) shows the artist as an entertainer decked out in a sparkling blue jacket and bow tie. Spotlighted and holding a bottle of gin, he makes repeated attempts to mount a stool but falls down each time. In *The Cellist* (1998; pp. 10–11), Land tries again and again but can never successfully begin his concert. Through these decidedly unmasculine antiheroes, the artist seems to mirror our daily travails, which carry the equal possibility of success or failure.

Paul McCarthy Born 1945 Salt Lake City
Starting in the early 1970s in Los Angeles, Paul McCarthy gained a reputation for creating grueling, psychologically charged events in which suggestive foodstuffs—including ketchup, mayonnaise, and hot dogs—and intimations of bodily functions played important roles. Largely improvised, his performances and works spare neither the taboo nor the sacred cow, desecrating everything from the family to colonialism to painting. Like other performance artists of his generation, such as Vito Acconci and Chris Burden, McCarthy has tested limits that often seemed as much physical and social as aesthetic. His work explores notions of artifice and spectacle through aberrant behavior that has little obvious political, cultural, or psychological purpose. His transgressions can also act as a tool, however, to provoke viewers to examine the ties between the sacred and the profane, politics and leisure, morality and decadence. *Let's Entertain* features several dozen photographs from an ongoing series, *Documents* (1995–1999; pp. 152–153), in which the artist photographed seemingly innocent amusement parks and Las Vegas architectural elements and juxtaposes these images with Nazi-era city plans and Nazi memorabilia actively collected but often hidden from public view. In McCarthy's viewfinder, these elements congeal into an ambiguous, slightly surreal, re-presentation of the

heretofore familiar. As we confront these varied, often disturbing, images of Americana, we come face to face with the alienated spectacle of the American dream. He is also represented by the video *Fresh Acconci* (1995; pp. 212–213), a collaboration with Mike Kelley.

Mariko Mori Born 1967 Tokyo

Mariko Mori uses a wide range of cutting-edge multimedia technologies to explore concepts of beauty, futuristic alienation, spirituality, and Japanese female stereotypes. Always imaginative and willing to push boundaries, she emerged on the art scene in the early 1990s. She was trained in fashion and art, and her work can be seen as an investigation of the impact of media on the cultural construction of identity and notions of self-mythology. Her panoramic photographs and video installations, often featuring the artist, present fantastical tableaux that mix past, present, and future. Her pioneering three-dimensional video *Nirvana* (1997) was included in the 1997 *Venice Biennale*. Many of her recent works—such as *Enlightenment Capsule* (1996–1998; p. 148), a huge plastic lotus blossom that radiates solar light through a high-tech fiber-optic cable—draw upon traditional Far Eastern spirituality and mesh elements of both Japanese and Western popular culture. The irony in Mori's work lies in her witty use of the diverse clichés of modern society, which she expresses by employing advanced technology and photographic techniques.

Takashi Murakami Born 1962 Tokyo

Takashi Murakami is often associated with and draws on *manga* and *otaku*, the ultrasophisticated Japanese subcultures of animation, comics, and technology. His work brings together such diverse elements as plastic models, cartoons, advertising balloons, Pop Art, and Conceptual Art strategies. Murakami uses this mass-media imagery and the charms of media communication to highlight the specificity and the contradictions of Japanese culture, particularly in its encounters with the West. For instance, his creation of the unique cartoon character DOB, based in part on Mickey Mouse and the Japanese cartoon character Astro Boy, comments on the "Disneyfication" of society and how the cuteness of a product is one way to guarantee its success. Murakami's *Hiropon* (1997; p. 110) and *My Lonesome Cowboy* (1998; p. 113) are figurative life-size cartoon sculptures that celebrate sexual-spirituality. Art critic Dave Hickey, writing for *Artforum* in December 1998, compared the baroque extravagance of *My Lonesome Cowboy* to Gian Lorenzo Bernini's *Ecstasy of Saint Theresa*. Murakami uses popular iconography to challenge and update traditional Japanese and Western art as he explores three-dimensional representation. His work was included in the 1999 *Carnegie International*.

museum in progress Founded 1990; based in Vienna

museum in progress is an art association founded in 1990 in Vienna on two principles: the acquisition of new media and the tearing apart of traditional modes of disseminating art. museum in progress mainly curates contemporary art smuggled directly from the everyday world. It uses the media, expertly transforming gaps in its outlets into free artistic space. Works are produced and presented, wherever possible, through modern information channels such as newspapers, publicly displayed posters, or television, with the idea that new vehicles should not be used to transport old content, but rather that artistic content should be extracted through the audience's confrontation with the medium. *Let's Entertain* includes *DO IT (TV-Version) museum in progress* (1995–1996; pp. 256–257), a series of video clips that were broadcast as a television program, in which artists such as Gilbert & George, Damien Hirst, Ilya Kabakov, Jonas Mekas, Yoko Ono, Steven Pippin, Michelangelo Pistoletto, Rirkrit Tiravanija, Michael Smith, and Erwin Wurm each give a different recipe for something to do.

Minako Nishiyama Born 1965 Hyogo, Japan

Kawaii, meaning cute or pretty, has emerged as a significant branch of 1990s Japanese Pop Art, and Minako Nishiyama is one of its foremost practitioners. In her paintings, sculptures, and installation works, she uses various shades of pink, delicate flower motifs, and fairy-tale elements that refer to contemporary Japanese "girl culture" as well as to nineteenth-century French Rococo style. In Japanese culture, the color pink, a key feature in Nishiyama's work and Kawaii art in general, symbolizes both cuteness and the thriving Japanese sex industry. Thus, the artist's work is

charged with multiple meanings relating to issues of desire, beauty, and fantasy. Her large sculpture *Cinderella's Dream Stage* (1997) is based on an audition TV show from the 1970s called *A Star Is Born*. It brings to mind both traditional Western fairy tales and our contemporary cultural obsessions with the superstar-making process of celebrity. *Let's Entertain* features Nishiyama's 1992 sculptural environment *Nice Little Girl's Wonderful Dressing-up Room* (pp. 128–131). A grown-up version of a doll's dressing room, this very pretty piece plays with the notions of identity construction that so often accompany a girl's doll play. Nishiyama reminds us that even as adults we still adorn ourselves, changing and discarding various costumes—physical, mental, and otherwise. Her work offers a playful yet metaphorically complex intervention into contemporary social, sexual, and commercial relations.

Gabriel Orozco Born 1962 Veracruz, Mexico
Born in Mexico, but now working mainly in New York, Gabriel Orozco engages the legacy of modernist sculpture with a kind of artistic nomadism that "succeeds in imbuing its original iconography with a fresh, poetically abstract quality, giving rise to a new object that can obviously comply with several definitions of sculpture." He borrows sculptural techniques from various phases of art history and applies them to simple things, transforming ordinary objects into sculptures in the classical sense without erasing their original status as "things." Creating personal variations on common things, he often uses altered games as a metaphor for social development and interaction. The pieces are only complete with the input of the viewer because the games have no rules; the players must bring their own rules to the game. *Let's Entertain* includes *Horses Running Endlessly* (1995; pp. 44–45), a beautiful chess table without kings, queens, bishops, rooks, or pawns. It has only the knights, the horses. In the traditional form of chess, horses can only be moved sideways, creating endless circular loops. Those attempting to play this version must choose between that fate and the possibility of creating new rules on the spot. Breaking with convention is the artist's seeming directive. As one critic has written, "[Orozco] is an activist in the sense that his daily activity confronts the shortcomings of our perception of reality." In making the familiar strange and exciting, the artist offers a poetic meditation on play, social engagement, and the ephemerality of everyday experience. Orozco's work was included in *documenta X* in 1997 and the 1999 *Carnegie International*.

Philippe Parreno Born 1964 Oran, Algeria
In the last ten years Philippe Parreno has developed an oeuvre that he defines as belonging to a humanistic philosophy of proximity. He arranges environments in which the hierarchy between the creator and the spectator evaporates. In doing so, he reverses the relationship of the consumer and the producer, and the viewer becomes the protagonist of the work. In his 1995 exhibition *L'Etablie (Workbench)* at the Esther Schipper Gallery, Cologne, Parreno invited people to come to the gallery to work on their hobbies, assembly-line style. In so doing, he integrated them into his *usine à nuages* (factory of clouds), namely, a great assembly line of weekend hobbies, the omnipresent industry of leisure and "free time." *Let's Entertain* includes two works by Parreno. *Speech Bubbles* (1997; pp. 16–17) is a mass of cartoonlike three-dimensional white speech bubbles trapped against the gallery ceiling. Unmarked and floating in our real space, these bubbles act as a kind of frozen narrative waiting for the visitor to inject this vacuity of language with meaning—our prerogative as protagonists in a story. The white cloud created by the bubbles changes the nature of the architecture in which it is contained, suggesting a slick, high-tech environment that wouldn't be out of place on a science fiction film set. Parreno is also producing a new video installation (2000), based on a pastime from his childhood, that will confront a vision of nature within the context of utopian dreams embodied by a 1970s housing project. A static shot of a tree swaying in the wind in front of such a complex serves as a backdrop for a running text. Resembling movie credits, this commentary written by Parreno becomes a reflection on film codes as well as a sweet analysis of the social and political statements grounding modernist architecture: a "dolce utopia." His work was included in the 1999 *Venice Biennale*.

Alexandre Périgot Born 1959 Paris
For a number of years Alexandre Périgot has investigated the sense of seduction felt by a society dominated by spectacle. Referring to sport, spectacle, film, cinematography, media, and technology, he gives us a view not of the

stage set, but of the world backstage. He tests our capacity to construct ourselves and examines our behavior in the face of an illusory world. Périgot's *Fanclubbing* (1998–1999; pp. 170–171) is an apparatus that invites the public to choose the signature of a star of his or her choice. This signature is then projected on paper, and the viewer may reproduce the autograph with colored felt markers and either take it home or leave it on exhibit. Beyond the topics of celebrity and fame, *Fanclubbing* raises the issue of identity through "stars." This project states that teenagers' affinities for popular culture and rock stars as well as their choices in clothing and music are major markers of their emancipation and self-identification. Périgot's piece is also a way to notice how perceptions of popular culture vary according to one's culture, gender, and demographic. Using popular culture as a starting point, Périgot's work is mainly an analysis of social and cultural phenomena. In *Let's Entertain*, *Fanclubbing* will also include collaborations with London-based composer Simon Fisher-Turner and Japanese gender illusionist and performer Simone Fukayuki.

Jack Pierson Born 1960 Plymouth, Massachusetts
Since his first solo exhibition in 1990, Jack Pierson has worked in a wide array of media, including photography, drawing, painting, installation, and sculpture. Taking his material from popular culture and urban subcultures, Pierson demonstrates a fascination with cliché. He uses various media to enact melancholic and romantic meditations on the pathos of daily life as experienced through memory. His work is about the yearning for glamour and celebrity and is perhaps allied with that of Andy Warhol and the Factory. Much of Pierson's work refers to the desire for fame that so often ends in broken dreams and failed hopes. As the artist himself puts it: "I see the work document the disaster inherent in the search for glamour—glamour being that which is not real." Pierson's *Applause* (1997; pp. 2–3) is a light box with the word *Applause*, referring to the cues used to direct the audience's reactions during live TV shows.

Richard Prince Born 1949 Panama Canal Zone
Richard Prince started his career as a figure painter, but around 1975 he started to make collages using photographs and text. In 1977 he produced a series of four photographs of living rooms lifted from the *New York Times*. This act of rephotographing cast doubt on basic assumptions about authorship, the authenticity of photographic images, the ownership of public images, and the nature of invention. In the Jokes series, started in 1986, Prince chronicles America's sexual fantasies and frustrated desires through one-liners, stand-up comedy, and burlesque-like jokes. Revealing the darker side of American life and the pathology of Middle America, his work exposes several false distinctions: the presumed dichotomies between the copy and the original, the normal and the uncanny, public and private, fact and fiction. Prince's appropriated photograph *Brooke Shields (Spiritual America)* (1983; p. 254) shows the ten-year-old actress standing in the bath, her androgynous child's body contradicted by her sophisticated, womanly attitude. The title of the work alludes to Alfred Stieglitz's photograph of the same name, which depicts the groin of a castrated horse. When this work was first shown in an exhibition organized by Prince himself, the image was at the center of a lawsuit between Shields' mother and the original photographer. Prince's controversial display of the photograph raises issues of voyeurism and commodification of images.

Charles Ray Born 1953 Chicago
Making the commonplace strange is central to the work of Los Angeles–based artist Charles Ray. Often creating hybrid forms, he embraces diverse mediums—including sculpture, photography, performance, and film—to communicate his slightly absurd take on the familiar objects that surround us: tables, shelves, clocks, automobiles, department-store mannequins. His work has been called "conceptual realism," as he often melds intriguing abstract ideas with a figurative tradition rooted in classical art technique. Keystones to his work are immaculate craftsmanship, simple trompe l'oeil devices, odd shifts in scale or expected relationships between viewer and object, and displacements in time. He has commented that for him, "the struggle is to bring [an] idea into the world in a non-trite way, so that it reenchants the world or activates it, somehow." *Let's Entertain* features *Revolution Counter Revolution* (1990; p. 146), a sculpture of a carousel one might find in an old-fashioned carnival. A hand-turned mechanical device moves the carousel in two directions simultaneously, thus causing the horses and sleds to appear perfectly still. At once witty and subtle, the work transports us to a somewhat hallucinatory space where time has stopped. The dis-

crepancy between what the eye appears to "see" and the actuality of the situation destabilizes our notions of reality and calls the very idea of a "still life" into question. The precision of the timing and the mechanism that controls this sculpture are indicative of the artist's exacting attention to detail. The merry-go-round, a traditional icon of the county fair and simple values, becomes part of a contemporary and private game that freezes and questions the spectacle of the family and entertainment. In a world filled with predictable mass-media images, Ray provides new models for contemplation and enchantment.

Ugo Rondinone Born 1963 Brunnen, Switzerland
Using the diverse artistic practices of installation, video, photography, painting, objects, and sound, Ugo Rondinone often emphasizes theatricality and atmosphere in his work. The artist has several signature motifs, including the bucolic landscape, the target, and the clown, all of which share a super-saturated color wheel of bright rainbow hues. For Rondinone, nature and artifice are foils for each other, and he uses mannequins as trompe l'oeil figures and creates landscape murals with doorways cut into them. The bright colors and clown figures in his work suggest a lightness of being, which is complicated by the sadness, confusion, or plain ambiguity of emotion and intent often suggested in the pieces. In the huge light box *Dogdays are over* (1998; pp. 150–151), Rondinone continues to blur the lines between artifice and nature, decoration and high art, conveying to the viewer a mix of emotions.

David Shea Born 1965 Springfield, Massachusetts
David Shea uses sound sculpturally to create aural landscapes. A breed of composer for whom nothing is alien, he takes inspiration from sources as diverse as Hollywood cinema, techno beats, Tex Avery cartoons, classical ensembles, cult TV, martial arts films, and easy-listening music. One critic has described his sound as "rigorously ecstatic; it's a place where the ambient, the exotic, the easy, and the simply strange juxtapose judiciously." Shea's work includes free improvisation, turntables, samplers, electronics, and video. Although he often works as a club DJ, Shea has made his biggest impact through several full-length CD compositions in which the music itself is the action. One of them, *Tower of Mirrors*, composed of twenty-four pieces with a combined playing time of more than seventy-five minutes, is based on a seventeenth-century Chinese novel about the dreams of a monkey. According to one commentator, it is "unquestionably a film without images." He has collaborated with a range of artists and ensembles, including fellow composer John Zorn, choreographer Karole Armitage, BBC Productions, and Johan Grimonprez on his film *Dial History*. For *Let's Entertain*, Shea created a sound track that incorporates the diverse style, confident improvisation, and eclectic sampling that is characteristic of his work.

Cindy Sherman Born 1954 Glen Ridge, New Jersey
Cindy Sherman pioneered a significant shift in photographic practice. Not a photographer, but an artist who uses photography in her work, she infused the practice with conceptual heft and sociocultural concerns while mining issues of gender and mass culture. Her influence on the work of artists of the next generation, including Lee Bul and Mariko Mori, has been extraordinary. Sherman emerged from the feminist art movement of the 1970s with her first major body of work, the *Untitled Film Stills* series (1977–1980; pp. 29, 200–203, 292, 319). Widely regarded as one of the most original and influential achievements in art of the past two decades, the series comprises an imaginative catalogue of female roles derived from Hollywood movies of the 1940s to the 1960s, all played by Sherman herself. With originality, wit, and intelligence, she used pop culture as a ready-made artistic vocabulary to map a particular constellation of fictional femininity that emerged in postwar America. All sixty-nine photographs will be interspersed in small groupings throughout the exhibition, acting as signposts that draw attention to the role of mass media in our lives and the ways in which it shapes our personal identities. For each photograph, Sherman created a specific mise-en-scène (props, costume, lighting, pose) evoking a generic type of female role, never a specific actress or film. At once evocative and frustrating, the stills hauntingly remain fragments without a whole, film stills without a film.

Andreas Slominski Born 1959 Meppen, Germany
German artist Andreas Slominski has been described as a "fool" in pursuit of his own innocence, one who indulges in

"hilarious lampoonery, ribald tricks, and slyly idiotic stunts." Known for his highly convoluted and fantastical animal traps and other schemes—which play on cruelty, functionality, and the absurd—Slominski usually opts for the path of greatest resistance. For *Self-Portrait with Sombrero* (1998), for instance, the artist drilled two holes at the top of a gallery wall, altered a wide-brimmed sombrero, climbed a ladder while wearing the hat, and took a photograph by sticking his hand through one hole, his face framed by the other. His mechanized "sculpture" of a child's bicycle with the wheel turned upside down and constantly spinning (1992; pp. 36–37) evokes the scene of an accident or crime. A sense of foreboding and sadness hangs over the piece. Through such simple but complicated measures, Slominski attracts and retains the gaze of his viewer.

Lily van der Stokker Born 1954 Hertogenbosch, the Netherlands

Lily van der Stokker's lushly exuberant wall drawings are reminiscent of 1970s concert posters, teenage notebook doodles, and child-friendly wallpaper, thus raising questions of taste. She uses decorative motifs, symmetry, bright and shiny colors, cute doodles, friendly words (*happiness*, *love*, *kisses*), pointing arrows, and rudimentary floral designs to produce work that "seeks happiness and friendship" and deals with things that seem to be forbidden in art, especially the decorative, the sentimental, and the "nice." In doing so, she exaggerates the "sweetness" of these motifs to the point where it becomes cloying. Yet van der Stokker's work is laced with melancholy, perhaps arising from a loss of innocence or the realities of living in an unpretty world. She calls her style "non-shouting feminism" as she addresses stereotypical femininity, particularly the adolescent variety. Where Sol LeWitt's wall drawings are rational and perceptual, van der Stokker's are intuitive, emotional, and personal. Often large-scale and site-specific, her works are fully encompassing and alter the architecture of the space they occupy as they billow out in all their candy-colored, psychedelic glory.

Uri Tzaig Born 1965 Kirjat Gat, Israel

Uri Tzaig turns the familiar into the unfamiliar, the standard into the unique, through the disruption of games such as football, basketball, or rugby. His videos involve a shift of focus. Familiar modes of perception are disrupted, and an open interpretation is introduced in their place. By subtly changing the rules or adding equipment to the game, the artist questions and makes impossible the usual end goal of winning in such sporting activities. The players of these reinvented games are forced to make new rules or simply enjoy playing for the sake of playing, and the spectators must likewise adjust to the unexpected twists of the game. The artifice and rigidity of the standard game are exposed in *Desert* (1996; p. 39) when Tzaig introduces two balls into a game of basketball. Viewers are confronted with the problem of having no common focal point. The linearity of the game is interrupted, and new choreography is introduced. This video piece also raises issues of knowledge production and translation through simultaneous subtitles in Hebrew and English. A second video, *Play* (1996; p. 40), shows a lawn game with two balls and no predetermined rules. Through the tension derived from a confrontation with the unknown, Tzaig interrogates the symmetry of time and spaces, rules and unscripted experience, cultural identity and homogenized game-play. He has remarked, "I am interested in art that teaches me to move in a different way every time." His work was included in *documenta X* in 1997.

Piotr Uklański Born 1969 Warsaw

Through performance, photography, and installation, Piotr Uklański deals with notions of good and bad taste. His work says as much about the sweet happiness of beauty as it does about the guilt that contributes to the enjoyment of the experience. Finding beauty between the familiar and the banal in places that have been forgotten or never thought of, he involves the audience in environments ruled by a "feel-good" aspect, which conveys sentimentality, desire, and nostalgia. Uklański's *Dance Floor* (1996; pp. 4–5), consists of a grid of multicolored lights flashing in time to the beat of contemporary dance music. The dance floor is installed as an unobtrusive part of the natural architecture of the gallery, thus proving unavoidable for visitors. While the piece calls to mind the hedonistic quality of a nightclub, there is also the frustration of not being able to abandon oneself to the environment and the music as one might in a regular club. There is a necessary tension between the space, place, desire, and expectation. This work also reinforces Uklański's ironic affiliation to modernism and the work of artists such as Carl Andre and Dan Flavin. Going beyond

simple spectacle, *Dance Floor* comments on self-representation, individual and collective memory, and identity construction through popular iconography, even as it acts as a seductive yet misleading passageway through the gallery.

Andy Warhol 1928–1987; born Forest City, Pennsylvania

A multimedia artist *avant la lettre*, Andy Warhol was painter, printer, filmmaker, magazine founder, and all-around media star from the early 1960s until his death in 1987. The seminal progenitor of American Pop Art and purveyor of the glamorous celebrity lifestyle uttered the now-clichéd statement, "In the future, everyone will be famous for fifteen minutes." With this simple utterance, Warhol captured the volatile mix of desire, artifice, glamour, fickleness, and information overload that would define our celebrity-obsessed culture. His celebrated silkscreen paintings were often serialized portraits of rich, famous, and sometimes tragic figures of music, screen, and popular culture—such as Marilyn Monroe, Elizabeth Taylor, Elvis Presley, and Jackie Kennedy. In his Factory of the late 1960s and early 1970s, he created "superstars" with that "It" quality that separated them from the ordinary. He made films that starred his creations, including *Poor Little Rich Girl* with Edie Sedgwick and *Sleep* with John Giorno. Taking part in all areas of the creative world, mainstream and underground, he was involved in the 1960s underground music scene with his musical protégés the Velvet Underground and was also instrumental in the success of Studio 54, the disco-era New York club that became the archetypal high-profile celebrity hangout. While helping to highlight, define, and foster America's obsession with the rich and famous, in 1969 Warhol also created a vehicle to both critique and celebrate that culture: *Interview* magazine. He also made a number of forays into television. Apart from appearing, as himself, in popular television series such as *Love Boat*, he also hosted two cable programs in the 1980s: *Andy Warhol's TV* (pp. 240–243) and *Andy Warhol's Fifteen Minutes*. The episodes included in this exhibition feature segments with artists Eleanor Antin and Yoko Ono, musicians The Ramones and Debbie Harry, and filmmaker John Waters and his star Divine, among many others. Warhol was the pioneer who paved the way for such current celebrity media outlets as *E! Entertainment Television* and *In Style* magazine. In addition, he has had an extraordinary influence on many of the artists in this exhibition.

Gillian Wearing Born 1963 Birmingham, England

Gillian Wearing is an agile creator of video works that adapt a documentary style while ably raising questions about the line between documentary and fiction. She creates a sense of unease through odd juxtapositions; for instance, having the speech of children emanate from the bodies of adults and vice versa in *Two into One* (1997). While the speeches are "true," the corporeal representations of the speakers are not, thus complicating the nature of truth and confession. In *The Regulator's Vision* (1995–1996; pp. 6–7) real-life cowboy "wannabes" were filmed by surveillance cameras as they acted out fantasies of violence, capture, and rescue in London's Hayward Gallery. As Wearing commented, "Those white spaces usually command such respect, and I like the complete disrespect of it." In this English setting, the American West becomes a nostalgic space, idealized and exoticized. Issues of cultural identity and transgression are paramount in this modern-day western, which draws on popular culture and mythology to explore ideas of morality, heroism, fictionalization, and art. In 1997, Wearing was awarded the Turner Prize.

Index

Page numbers in *italics* refer to illustrations.

Reproduction Credits

Air de Paris; photo: Philippe Parreno 16–17; photo: Marc Domage 155
Air de Paris and Feature Gallery, New York 260–261
Carlos Amorales 102–105
Apple Computers 65, 67, 69
Arndt & Partner, Berlin; photo: Peter Friedl 222–223
arsFutura Galerie, Zurich; photo: Christian Minichshofer 278–279
Bernadette Corporation; photo: Cris Moor 178–179
Dike Blair 138–139; photo: Dike Blair 70, 80; photo: Paul Jason 62–63
Blum & Poe, New York; photo: Joshua White 110, 113
Mathieu Briand 276; courtesy Galerie Roger Pailhas, Marseille 277
Jessica Bronson; photo: Fredrik Nilsen 106, 108–109
Gavin Brown's Enterprise 4–6
Roderick Buchanan 42–43
Lee Bul; photo: Yoon Hyung-moon 280, 282
Galerie Gisela Capitain, Cologne 266, 268
Choi Jeong-hwa 272
Coldwell Banker Burnet; photo: Stephen White 262 (top)
Elizabeth and Iftikhar Dadi 264–265
Daroff Design Inc. 72, 75–79
Deitch Projects, New York 148
Rineke Dijkstra 161–166
©Disney Enterprises, Inc. 48–49
Anthony d'Offay Gallery, London 118 (director: Mark Hasler), 244; photo: Nils Jorgensen/Rex Pictures 172, 174–175
Electronic Arts Intermix 212–213, 248, 250, 252–253
Feature Gallery, New York 258
Gagosian Gallery, New York 262 (bottom)
Barbara Gladstone Gallery, New York 254
Marian Goodman Gallery, New York 44–45, 216–219; photo: Fabbri 32; photo: Masotti 30–31
Grove/Atlantic, Inc. 88 (cover by John Gall), 91 (top left: cover by High Design; top center: cover by John Gall; top right: cover by Miguel Santana)
Wesla Hanson 180
HarperCollins UK 91 (bottom left: cover by The Pinpoint Design Co.; illustration by Peter Andrew Jones)
Jablonka Galerie, Cologne; photo: Arno Declair 36–37
Kyupi Kyupi 94–98
Lisson Gallery, London; photo © Raimund Zabowsky 142–143; photo © R. King Lassman 144
Matthew Marks Gallery, New York 8–9
J Mays Studio 54, 56, 58
Paul McCarthy 152–153
Metro Pictures, New York 29, 200–203, 292, 319
museum in progress 256–257
New Museum of Contemporary Art, New York 2–3
Nike 83, 86
Minako Nishiyama 128–131
Patrick Painter Inc., Los Angeles; photo: Dan Dennehy 228, 238
Maureen Paley/Interim Art, London 6–7
Photo: Alexandre Périgot 170–171
The Power Plant Contemporary Art Gallery, Toronto 140–141
Ronald Reagan Library 226
Galerie Almine Rech, Paris 150–151
Andrea Rosen Gallery, New York; photo: Thorsten Monschein 126–127
Collection Massimo Sandretto, Torino 146
Gallery Shimada, Tokyo 128–131
Sonnabend Gallery, New York 246
303 Gallery, New York 204–206, 210–211
Tor Books 91 (bottom center; bottom right: cover by John Berkey)
Uri Tzaig 39–40
USA Films 184–197
Galleri Nicolai Wallner, Copenhagen 10–11
The Andy Warhol Museum, Pittsburgh 240–243
Ealan Wingate Gallery; photo © Zindman/Fremont 134–135
Koury Wingate Gallery; photo © Zindman/Fremont 132–133
David Zwirner, New York 114

29.95

700.9049 Let's entertain.
L

DATE			